BEING BOND

A DANIEL CRAIG RETROSPECTIVE

MARK SALISBURY

TITAN BOOKS

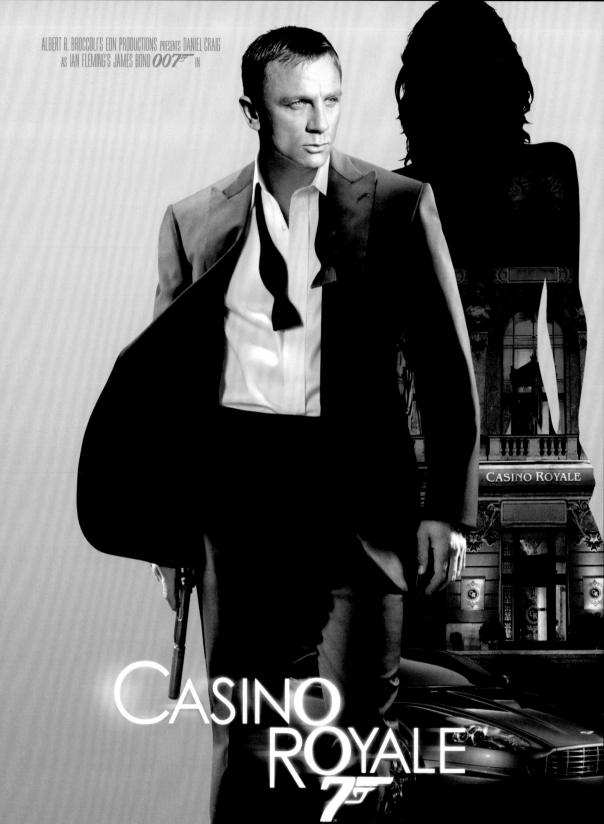

ALBERT R. BROCCOLI'S EON PRODUCTIONS PRESENTS DANIEL CRAIG
AS IAN FLEMING'S JAMES BOND 007 IN

QUANTUM
OF
SOLACE

007™

ALBERT R. BROCCOLI'S EON PRODUCTIONS PRESENTS DANIEL CRAIG AS IAN FLEMING'S JAMES BOND 007

007.COM

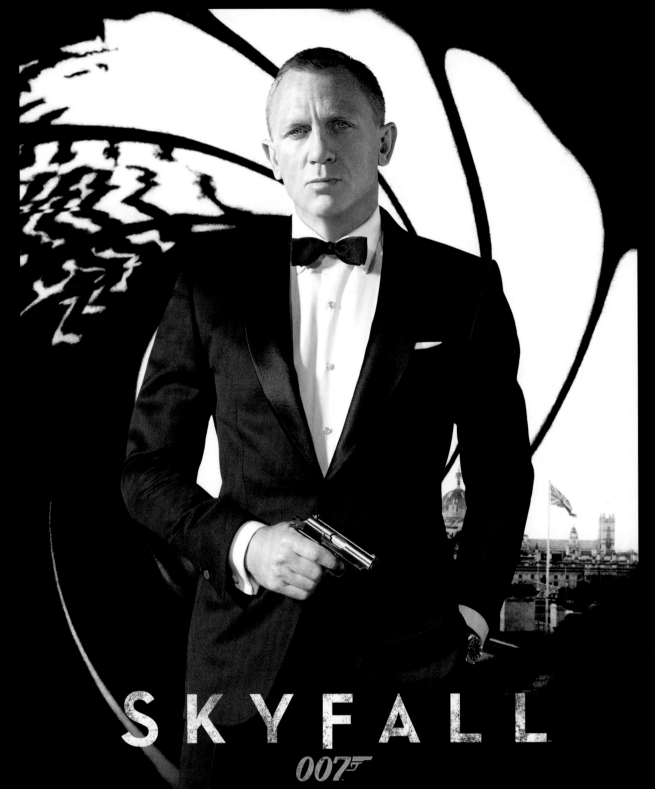

SKYFALL

007

ALBERT R. BROCCOLI'S EON PRODUCTIONS PRESENTS DANIEL CRAIG AS IAN FLEMING'S JAMES BOND 007 IN "SKYFALL"

JAVIER BARDEM · RALPH FIENNES · NAOMIE HARRIS · BERENICE MARLOHE WITH ALBERT FINNEY AND JUDI DENCH AS "M" CO-PRODUCERS ANDREW NOAKES · DAVID POPE

MUSIC BY THOMAS NEWMAN COSTUME DESIGNER JANY TEMIME EDITOR STUART BAIRD A.C.E. PRODUCTION DESIGNER DENNIS GASSNER DIRECTOR OF PHOTOGRAPHY ROGER DEAKINS ASC BSC EXECUTIVE PRODUCERS CALLUM McDOUGALL

WRITTEN BY NEAL PURVIS & ROBERT WADE AND JOHN LOGAN PRODUCED BY MICHAEL G. WILSON AND BARBARA BROCCOLI DIRECTED BY SAM MENDES

MGM #Skyfall Score Album on Sony Classical COLUMBIA PICTURES

FEATURING SKYFALL PERFORMED BY ADELE

NO TIME TO DIE

007

MGM

CONTENTS

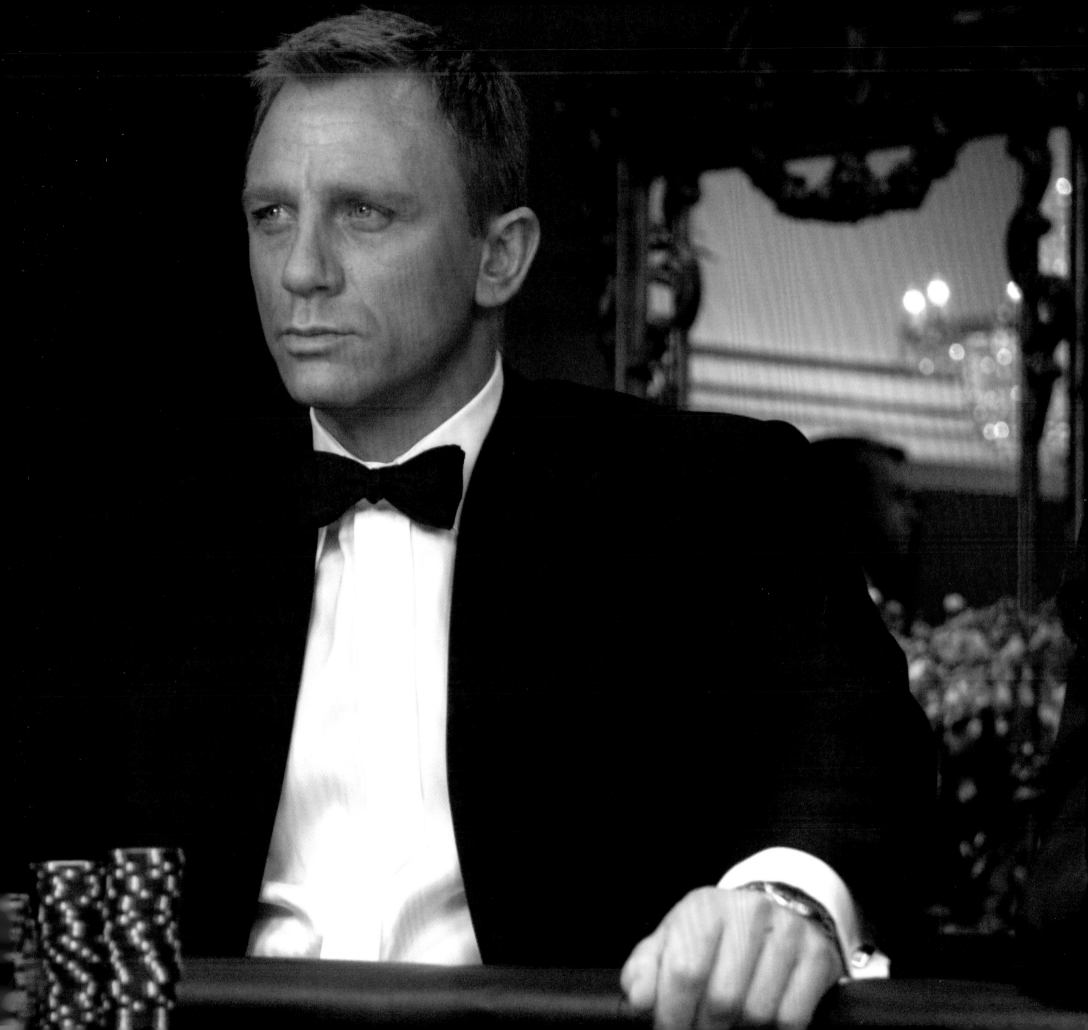

CASINO ROYALE

When London-based American producer Albert R. Broccoli and Canadian theatre and movie producer Harry Saltzman partnered in the early 1960s, forming Eon Productions to produce a series of films based on Ian Fleming's highly successful James Bond novels, the two men had assumed their deal with the author included the first Bond book, *Casino Royale*, published in 1953. To Broccoli and Saltzman's dismay, *Casino Royale*, along with *Thunderball*, wasn't included. "Which was a bit of a shock to them," reveals Barbara Broccoli who, along with her brother, Michael G. Wilson, has produced every Bond film since *GoldenEye* (1995), continuing on from their father Albert "Cubby" Broccoli.

Casino Royale had been adapted for television by Fleming himself in 1954 as an hour-long live episode of US anthology show *Climax!*, starring Barry Nelson as *American* agent "Jimmy" Bond and Peter Lorre as the villainous Le Chiffre. The film rights were picked up the following year by Gregory Ratoff and Michael Garrison, who tried to set the project up at 20th Century Fox before, in 1960, Ratoff's widow sold them to producer Charles K. Feldman. "Of course, Cubby and Harry ended up making *Dr. No* as the first Bond film," continues Broccoli, "but they always coveted and wanted to do the *Casino Royale* story."

Released in 1962, the low-budget *Dr. No* starred part-time model and jobbing actor Sean Connery as British secret agent James Bond 007 and was a huge hit, propelling Connery to stardom, kickstarting the longest-running series in film history, and introducing a template – action, stunning sets, exotic locations, gadgets and glamorous women – that would change the cultural

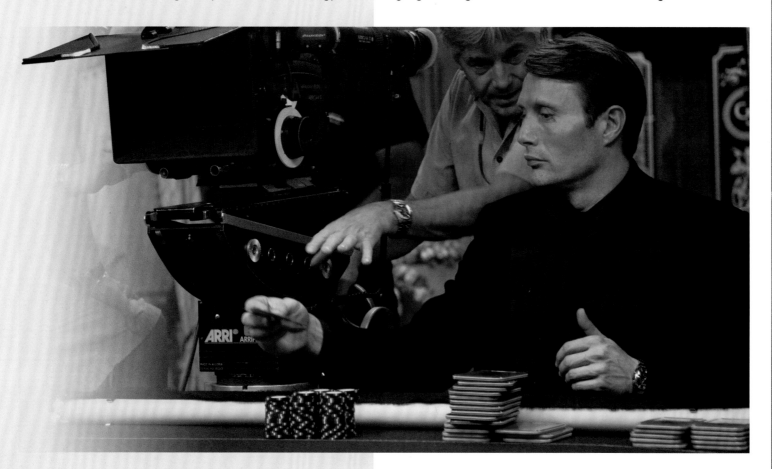

ABOVE: Mads Mikkelsen and Bernie Hearn (props department) discuss a shot.

RIGHT: James Bond (Daniel Craig) in the public area of Casino Royale.

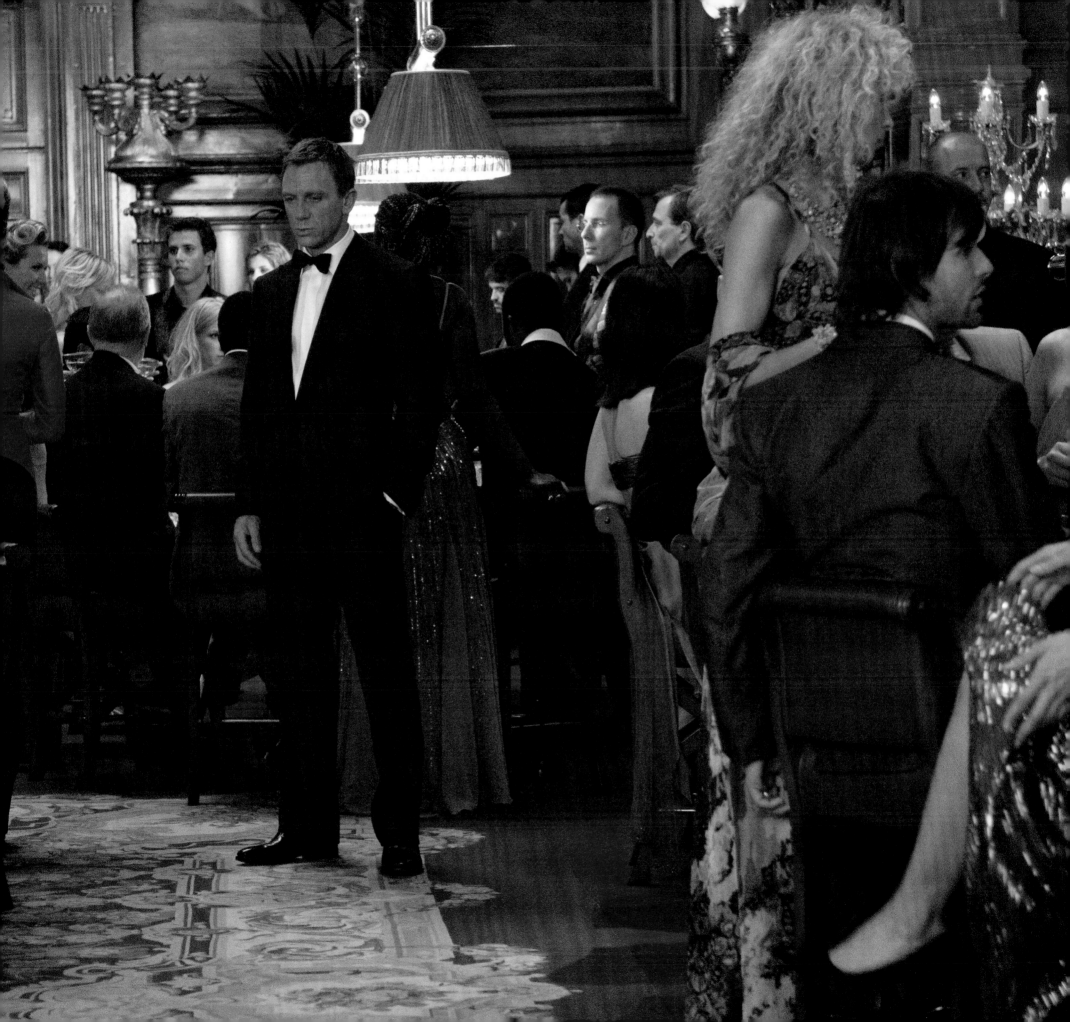

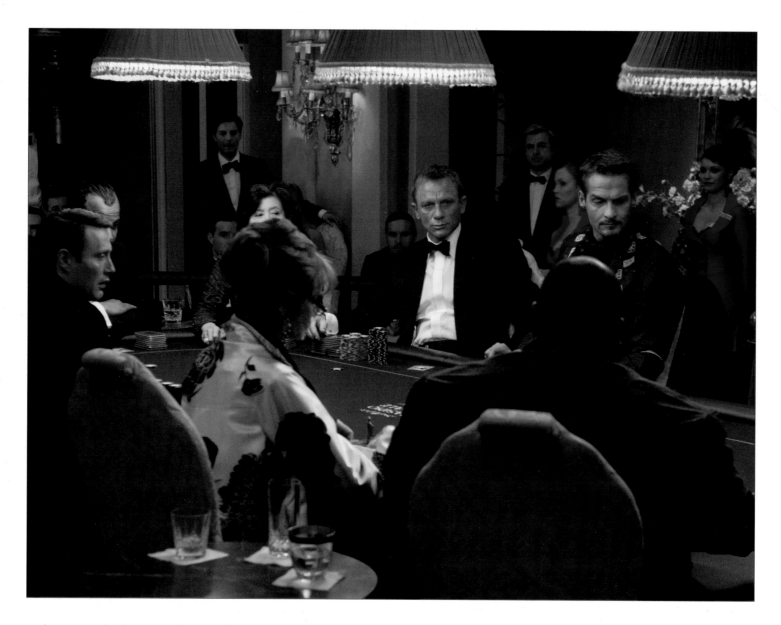

and cinematic landscape and spawn a host of imitators. Even Fleming, who initially doubted Connery's casting, was impressed, later reworking Bond's backstory in his 1964 novel *You Only Live Twice* to take into account the actor's Scottish ancestry. Eager to capitalise on *Dr. No*'s success, Eon Productions adapted four more Bond books – *From Russia With Love* (1963), *Goldfinger* (1964), *Thunderball* (1965) and *You Only Live Twice* (1967) – over the next five years. In the same year *You Only Live Twice* was released, Charles K. Feldman produced his own Bond adaptation for Columbia Pictures, a spy spoof that starred David Niven, Peter Sellers, Woody Allen, Orson Welles and Ursula Andress.

Two years later, Connery stepped down as Bond and was replaced by Australian actor George Lazenby for *On Her Majesty's Secret Service* (1969), which is now regarded by many as one of the strongest films in the franchise. Connery returned for 1971's *Diamonds Are Forever*, before passing on the mantle to Roger Moore in 1973. A huge TV star on both sides of the Atlantic thanks to *Maverick*, *The Saint* and *The Persuaders!*, Moore's 007 was synonymous with lightness and humour – striking the right balance for the times. After twelve years and seven very successful films, Moore passed his Walther PPK to Timothy Dalton in 1986. Dalton, who played to the darker side of Fleming's Bond, starred in *The Living Daylights* (1987) and *Licence to Kill* (1989) before Pierce Brosnan took over with 1995's *GoldenEye*, the first of his four Bonds, culminating in 2002's *Die Another Day*. Following the end of the Cold War, many had wondered if the Bond character was relevant any more. Brosnan proved them wrong with a bit of Connery, a touch of Moore and a big dose of himself.

ABOVE: The film's central poker game in progress.

RIGHT: Producer Michael G. Wilson instructs Craig on the finer points of poker.

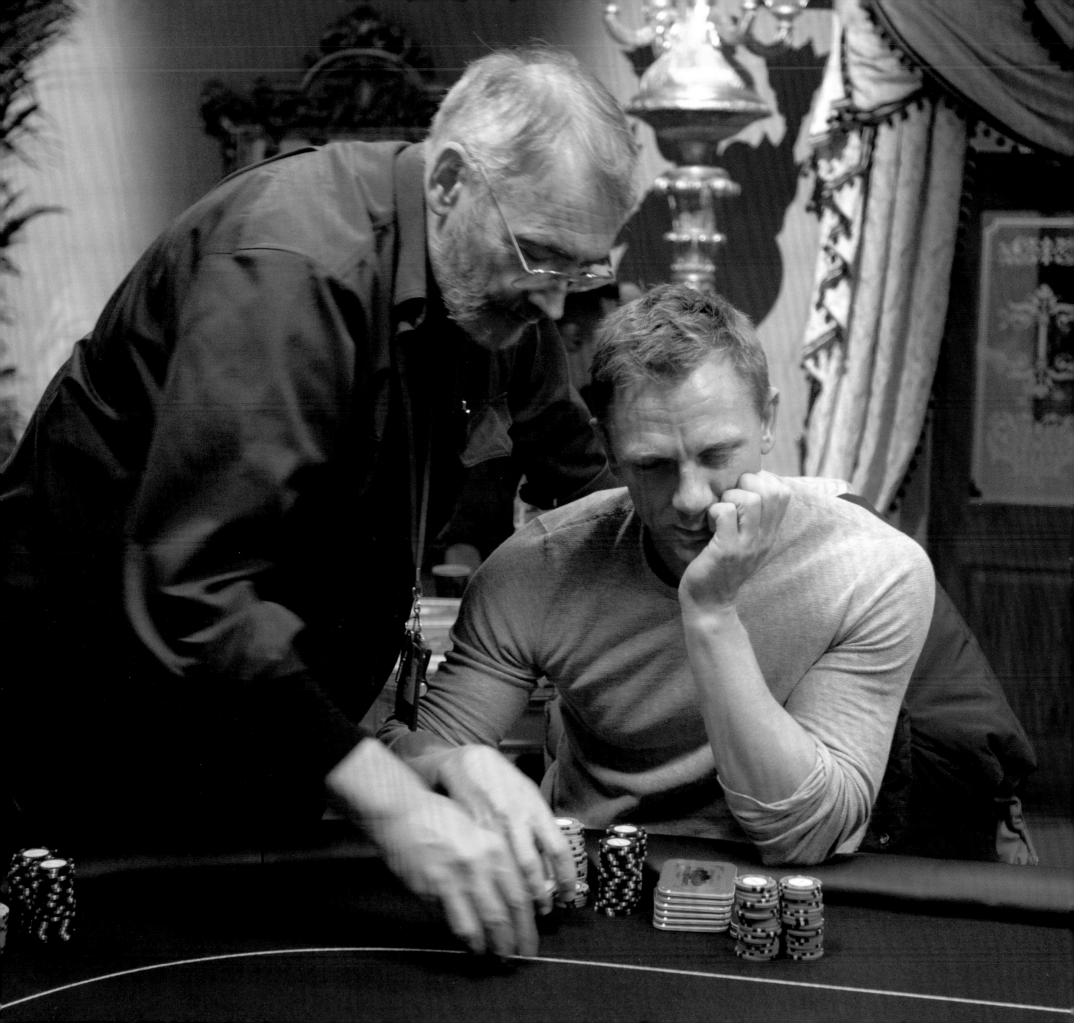

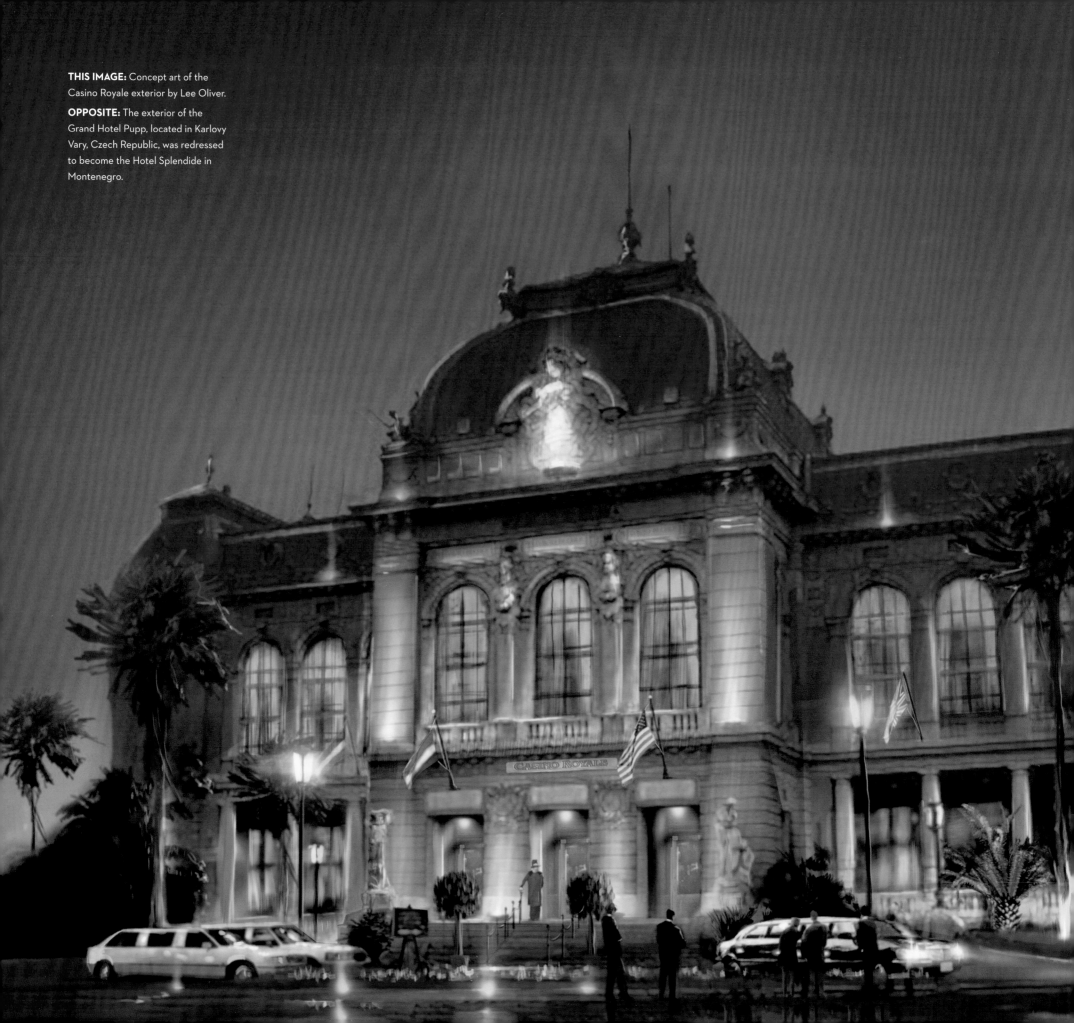

THIS IMAGE: Concept art of the Casino Royale exterior by Lee Oliver.

OPPOSITE: The exterior of the Grand Hotel Pupp, located in Karlovy Vary, Czech Republic, was redressed to become the Hotel Splendide in Montenegro.

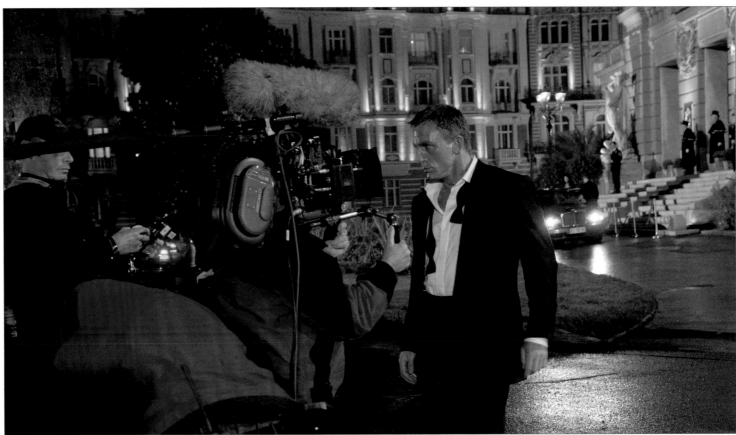

In 2004, Wilson and Broccoli were at the London office of Eon Productions discussing the future of the Bond franchise. Even though *Die Another Day* had proved incredibly successful at the box office, it was deemed too fantastical, and Wilson and Broccoli felt it was time to reconceive Bond.

"We were working on another script with Pierce in mind, but we were struggling," recalls Broccoli. "After a while it was very difficult to make a deal with Pierce. Then Michael said to me, 'Why don't we just do *Casino Royale*?' I said, 'Great. I'm in. Let's just do that.'"

It was a decision that, essentially, signalled the end of Brosnan's tenure as 007. "Barbara said, 'I'm getting on a plane,' and she did. She went to California and told MGM that's what we're going to do. It seemed to be the right decision. We both came to it at the same time," recalls Wilson.

Casino Royale was the holy grail, the book that not only introduced 007, but laid the emotional foundations for the character through his defining relationship with Vesper Lynd, a relationship that paved the way for Bond becoming the man (and the secret agent) that we all know and love. For Wilson and Broccoli, *Casino Royale* also represented the opportunity to realign more closely with Fleming's emotionally complex character

and redefine what a twenty-first-century Bond would be.

"We were trying to bring it back down to earth, to reconnect it to Fleming, to the books, so the origin story seemed to be the way to do that," notes Wilson, who has co-written five Bond films, beginning with 1981's *For Your Eyes Only*. "Here was a guy who wasn't quite Bond yet, but had to become Bond, and the trial was both a physical and mental challenge. He had to go through the experience of not being able to trust anybody, and that made him Bond. The story was fantastic, so we kept it pretty much as is, we just updated it."

British screenwriters Neal Purvis and Robert Wade had become Wilson and Broccoli's go-to guys, having written Brosnan's last two Bonds, *The World Is Not Enough* (1999) and *Die Another Day*, as well as the script for an unproduced spin-off centred on Halle Berry's NSA agent Jinx Johnson, a character who had been introduced in the latter film. "We were in a slight limbo, waiting on whether this movie was going to happen, and during that time Michael rang and said, 'Guys, I think it's time to read *Casino Royale*.' Or re-read. Which was the most amazing thing to just casually say!"

This time the pair were given an entire Fleming novel to adapt,

having previously used elements from Fleming's novels and short stories wherever possible in their prior Bond scripts. With *Casino Royale*, Purvis and Wade didn't just have a Fleming to work from, they had Bond's origin story, the rights to which Eon Productions and then-Bond distributor MGM had secured in 1999 as part of an agreement with Sony Pictures. However, upon re-reading the book, the pair realised "how small a story it is. It was effectively a radio play and you were going to have to open it up and add action that people expect," says Purvis. "But we had such a good foundation to do that."

At the centre of Fleming's *Casino Royale* is an extended high-stakes card game that takes place at the casino in fictional Royale-les-Eaux in northern France between Bond and bad guy Le Chiffre, the corrupt paymaster for a Soviet counterintelligence agency known as SMERSH. Bond's mission is to play and beat Le Chiffre, and M dispatches Vesper Lynd, personal assistant to the Head of Section S, to accompany him. The pair fall in love, only for Vesper to betray Bond and commit suicide. "Bond wins but is captured. He doesn't escape on his own. Then it turns out the girl who kills herself was a traitor," says Purvis. "That would be a hard pitch for a Bond movie, but because it's Fleming we were allowed to do it."

Wilson and Broccoli only had two directives as far as the script was concerned, two moments in the novel they insisted on keeping: the scene where Bond is tortured by a desperate Le Chiffre after he loses to Bond at cards, and the line, "The bitch

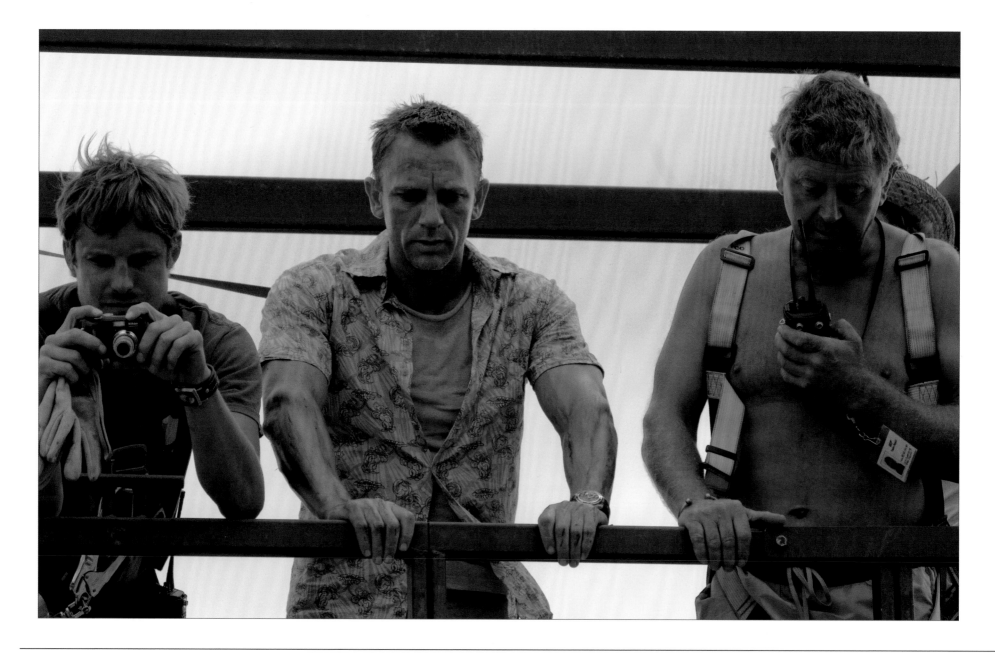

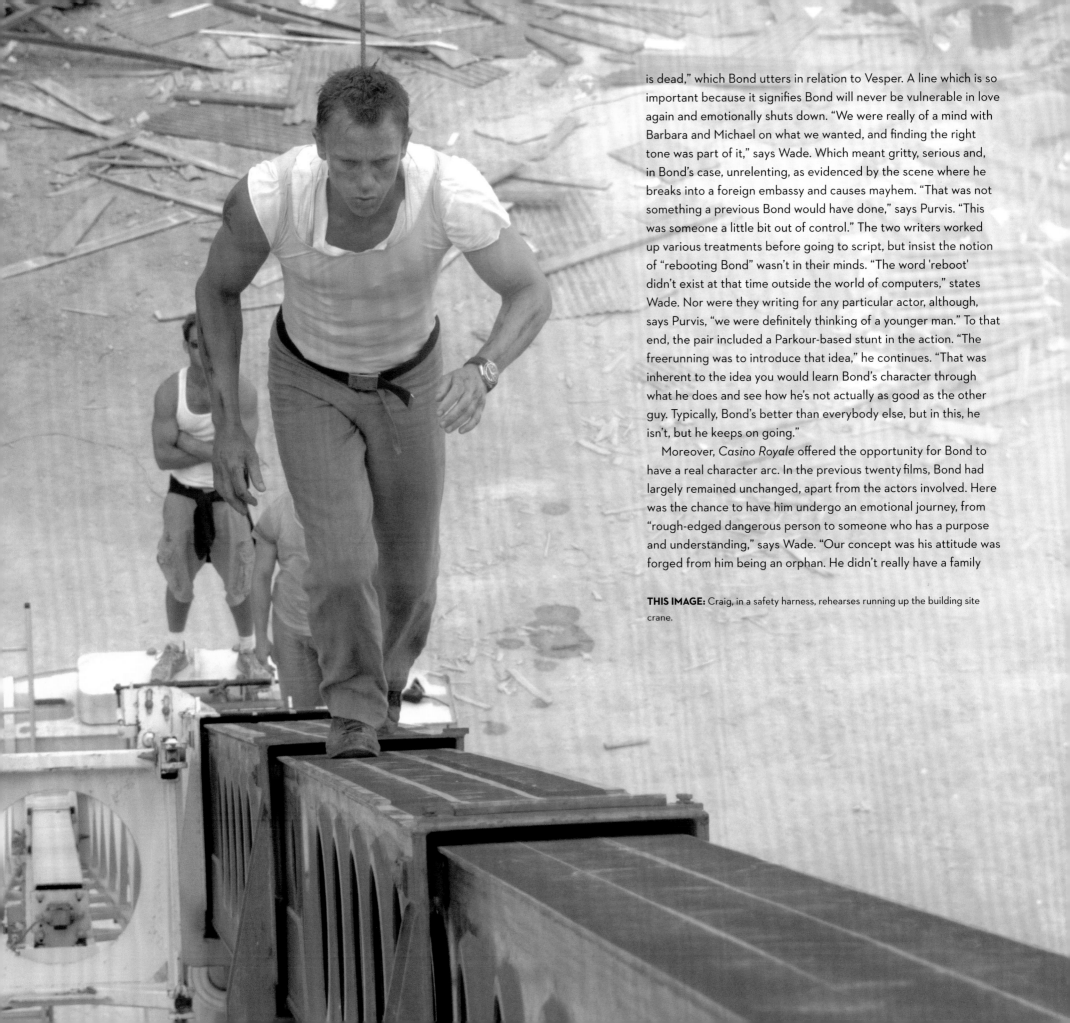

is dead," which Bond utters in relation to Vesper. A line which is so important because it signifies Bond will never be vulnerable in love again and emotionally shuts down. "We were really of a mind with Barbara and Michael on what we wanted, and finding the right tone was part of it," says Wade. Which meant gritty, serious and, in Bond's case, unrelenting, as evidenced by the scene where he breaks into a foreign embassy and causes mayhem. "That was not something a previous Bond would have done," says Purvis. "This was someone a little bit out of control." The two writers worked up various treatments before going to script, but insist the notion of "rebooting Bond" wasn't in their minds. "The word 'reboot' didn't exist at that time outside the world of computers," states Wade. Nor were they writing for any particular actor, although, says Purvis, "we were definitely thinking of a younger man." To that end, the pair included a Parkour-based stunt in the action. "The freerunning was to introduce that idea," he continues. "That was inherent to the idea you would learn Bond's character through what he does and see how he's not actually as good as the other guy. Typically, Bond's better than everybody else, but in this, he isn't, but he keeps on going."

Moreover, *Casino Royale* offered the opportunity for Bond to have a real character arc. In the previous twenty films, Bond had largely remained unchanged, apart from the actors involved. Here was the chance to have him undergo an emotional journey, from "rough-edged dangerous person to someone who has a purpose and understanding," says Wade. "Our concept was his attitude was forged from him being an orphan. He didn't really have a family

THIS IMAGE: Craig, in a safety harness, rehearses running up the building site crane.

background. He hadn't fallen in love before. Women were, as Vesper says on the train, 'a plaything' for him." So, when Bond falls for Vesper and she betrays him, he realises love can compromise him in his commitment to Queen and country.

To update the story, previously Communist agent Le Chiffre became the banker to the world's terrorists. "We'd read a book on the financial underpinnings of 9/11, and there was a big sell-off of airline stock the day before," explains Wade, "so we thought, *We're going to use that and make this card game about terrorism without dealing with physical terrorists so much*, and so Le Chiffre is the man who enables and profits from it." Purvis and Wade's other big idea was to make Vesper, as the Treasury liaison agent, be in charge of the money that Bond gambles with. "In the book, she's just René Mathis's assistant, so we gave her an important role with Bond, and that entrance: 'I'm the money,'" says Wade. "We were borrowing from *North by Northwest* for that scene on the train between her and Bond. Then it was all about: How do you add scale to it? Because that's what the film audience expects."

In addition to the inclusion of the aforementioned freerunning sequence as one of several large-scale action beats, Purvis and Wade's script climaxed in Venice with a palazzo sinking into the Grand Canal. "We had this idea that Venice would be an appropriate place for the death of their relationship," says Wade. Geographically, as well as thematically, Venice was perfect, since it was reasonably close to Montenegro, where they had decided to relocate the all-important card game. "They used to have a globe in the office upstairs at Eon," says Purvis, "and notionally we said Montenegro for the casino, because it sounded mysterious. Then we looked at where you could go from there, and Venice seemed like a very good place." The notion of the sinking palazzo came to Wade while he was in Pisa visiting the famous leaning tower. "Its leaning had been arrested by British engineers, who had put down a kind of girdle and pumped it full of concrete. That gave us the idea you could use air sacks to stop a palazzo from sinking. Then, as soon as there are bullets flying, they start to let air out..."

(Continues on page 25)

BELOW: Vesper Lynd (Eva Green) in the lift of the sinking palazzo.

RIGHT: Filming the sinking palazzo at Pinewood using a scale model.

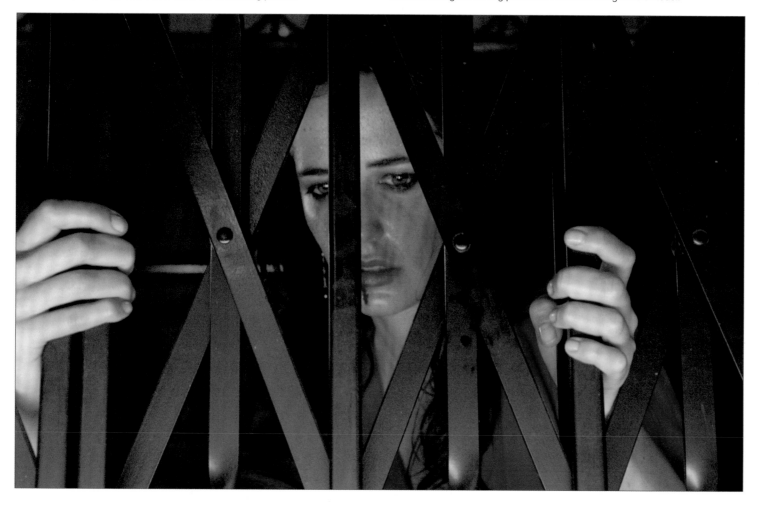

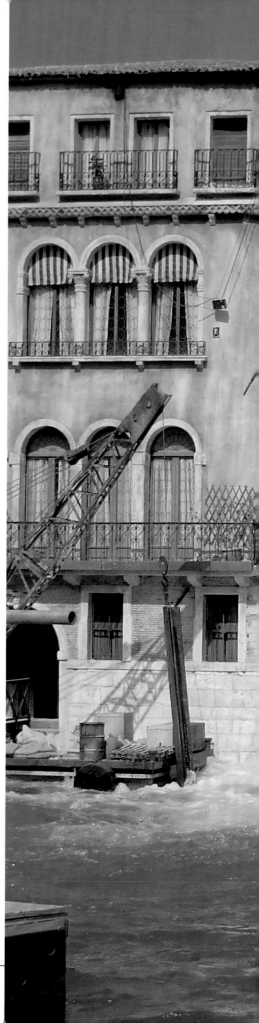

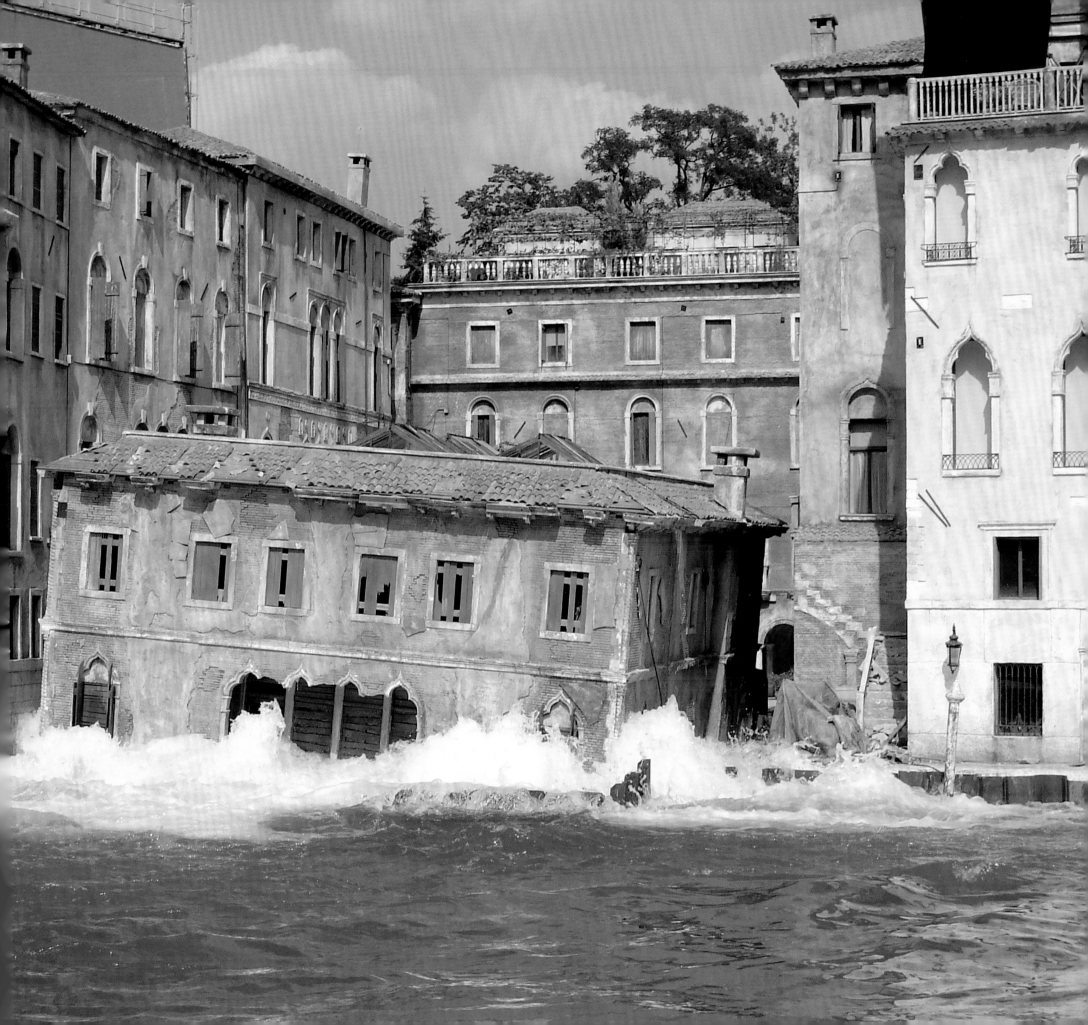

SINKING PALAZZO

For veteran Bond production designer Peter Lamont, the most difficult set to build in *Casino Royale* was the Venetian palazzo where, during the climactic third act, Bond follows Vesper and bad guy Gettler (Richard Sammel) inside and "literally brings the house down round about him" in an attempt to rescue her. "The whole thing became more complicated as the decision was taken that the house would not just sink vertically, but would need another axis to move the building from side to side as it sank," he recalled. Adds special effects and miniature supervisor Chris Corbould, "Martin wanted the villa to collapse like a block of flats."

While exteriors were filmed in Venice, where compression pipes were placed into the Grand Canal to simulate the water bubbling as it "sank", the palazzo was created on the 007 Stage at Pinewood Studios, where the stage's existing water tank was deepened to contain a four-storey villa mounted on computerised hydraulics, to allow it to sink halfway. "It was a massive rig made of around 120 tonnes of steel," explains Corbould, whose team was responsible for the sinking palazzo. A separate set, containing just the upper two floors, was also built and could be sunk completely.

"It was bloody tough," recalls Martin Campbell. "Also, they hadn't built the set before we went to Prague. I got back on a Friday, we all did, and were shooting that whole sequence on the Monday. I hadn't even seen the set. Chris Corbould, who is probably the best special effects man in the world, did a brilliant job, because that whole house was on a framework, so it could sink, it could go up, down, left, right, it could go on the diagonal. It was absolutely amazing what they did with that thing, and not once did it break down."

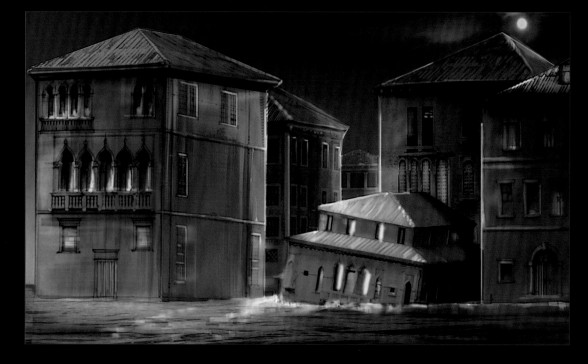
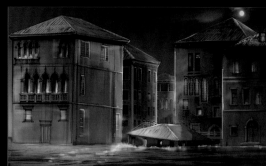
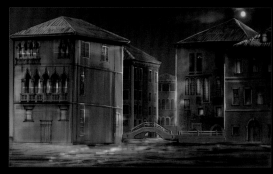

ABOVE: Concept art of the sinking palazzo sequence by Lee Oliver.

RIGHT: Model unit and visual effects supervisor Steve Begg (foreground, standing) supervises filming the large-scale miniature in the Paddock Tank at Pinewood in front of a blue screen.

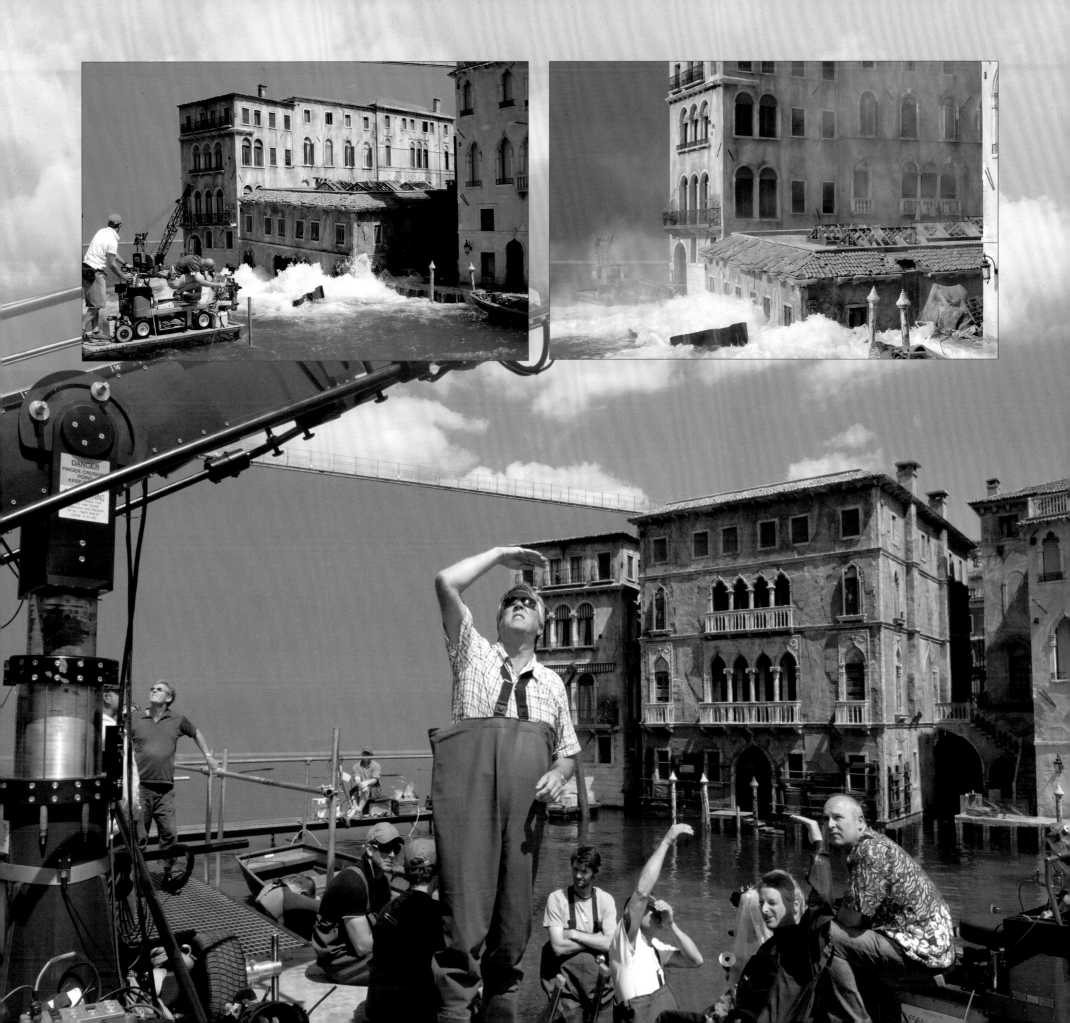

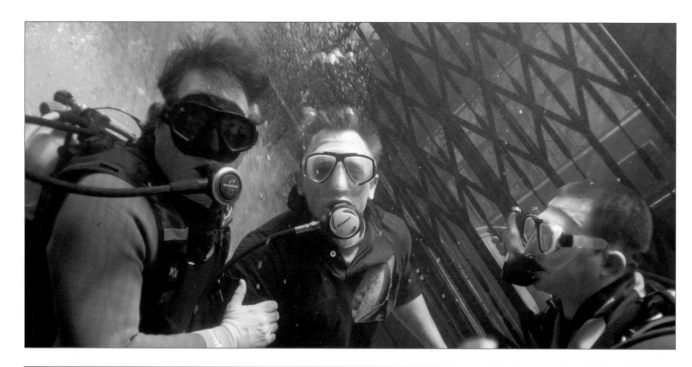

LEFT: Craig with 2 safety divers.

BELOW: The sinking palazzo set constructed on the 007 Stage at Pinewood Studios.

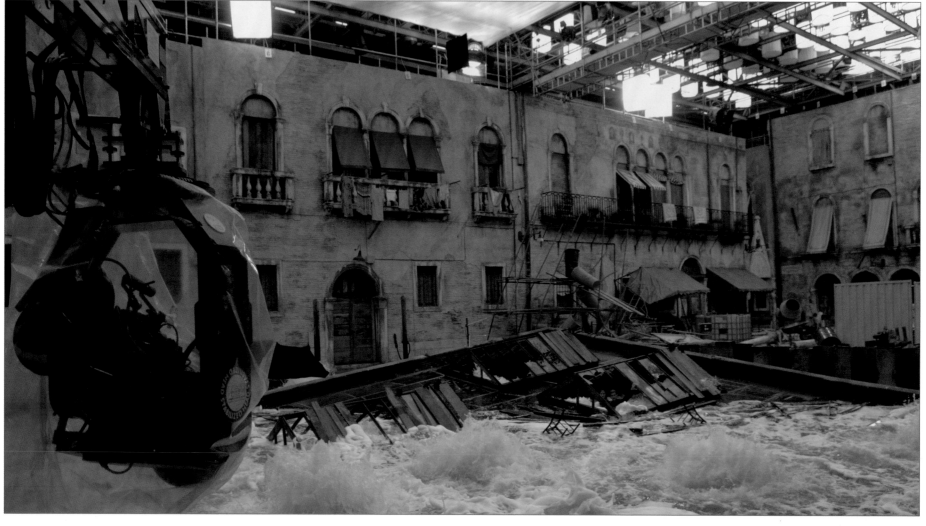

For Craig and Green, the sequence required working underwater, with safety divers positioned off camera with air tanks for between takes. "It was scary, even filming it," says executive producer Callum McDougall. "They were safe, of course, because we had the divers all around, but the set was complicated and you felt in jeopardy even walking around it."

A 26-foot-high model of the palazzo was also built by Corbould's team, who filmed it sinking in the Paddock Tank at Pinewood in front of a giant blue screen. As with the full-size villa, the large-scale miniature was operated by a computerised hydraulic system. The model was then digitally composited into the live-action canal footage that had been shot in Venice.

BELOW: Bond and the deceased Vesper.

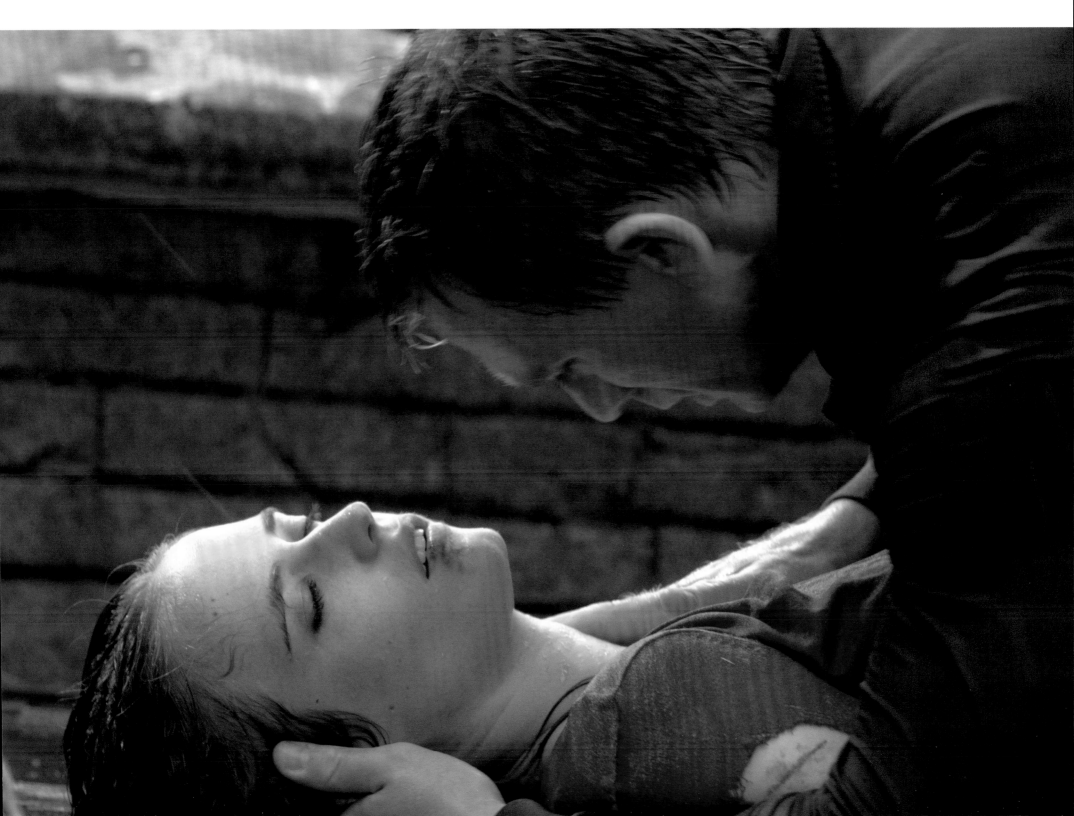

To direct *Casino Royale*, Wilson and Broccoli turned to New Zealand-born Martin Campbell, who made his name with the ground-breaking British miniseries *Edge of Darkness* and had successfully overseen Pierce Brosnan's Bond debut, *GoldenEye*. "We hired him the first time because of *Edge of Darkness*, which was a watershed event in British television," says Broccoli. "He's incredibly tenacious. There's no one who works more diligently than he does. He really understands action, he understands storytelling and is a terrific director. He gives it his all. He's meticulous in his preparation and is so incredibly enthusiastic about everything." Adds Wilson, "He comes on the set at five in the morning, by himself, and blocks everything ahead of time."

Campbell was intrigued by the notion of reinventing Bond a second time. "After the previous film, *Casino Royale* was a perfect book to go back to," he says. "We all agreed the whole thing should be much grittier, much tougher."

With a director in place, Purvis and Wade continued to work on the script, with Campbell insisting on the addition of a pre-credit sequence in which we see Bond carrying out the two kills he needs to attain "00" status. "The book talks about those kills, but doesn't start there, he's already an agent, so talking to Martin, we put those in," says Purvis. He and Wade spent more than a year working on dozens and dozens of drafts, before Campbell felt the script would benefit from a new perspective and suggested to Wilson and Broccoli that they bring on Paul Haggis, the Oscar®-winning screenwriter of *Million Dollar Baby* and *Crash*, to do a polish.

"I received a call from my agents at the time, who said, 'The Bond producers want you to write the next Bond movie,'" remembers Haggis. "I said, 'Have they seen my movies?' Because I was incredulous. 'Do they understand that if I do Bond I will ruin it for everyone forever?' They laughed and said, 'I think they know who they're talking to.'" Haggis was on a month-long holiday in Italy with his family, during which he'd promised not to work, but the Bond fan in him couldn't refuse. "So, I said, 'Okay, fine, I'd love to speak to them.'"

Once Haggis had a chance to read the current script, Wilson, Broccoli and Campbell flew out to hear his thoughts. Haggis felt that, as written, the third act was too faithful to Fleming, with Purvis and Wade, as in the book, having Vesper kill herself off-screen. In the script, Vesper left Bond a videotaped suicide note. He watches it, then tracks down and kills those responsible for blackmailing Vesper, in particular a character called Gettler and his henchmen. "We had big conflicts with Martin about that," says Wade. "Our thing was, it was the first time we had an Ian Fleming novel to deal with and wanted to stick to it as closely as we could. But Paul's idea was better." He suggested Vesper should remain alive until after Bond follows the bad guys into a palazzo. There, Gettler would trap Vesper inside an elevator and, once the house started to sink, Bond would be forced to watch her die.

"It was far more powerful to have Vesper in the elevator. It was much more emotional when Bond, having dealt with Gettler, tries to tear the door open and she locks the door and basically kills herself, because she's betrayed him," says Campbell. "Vesper had

to be in that sinking house," insists Haggis, "and since he's opened himself up to this woman, the only woman he's ever opened himself up to, he's going to feel rage, he's going to beat up the bad guys and he's going to be unable to save her, and he's going to be haunted by that forever."

Haggis was due to shoot the pilot for the TV show *The Black Donnellys* and only had a limited window in which to work, with not even enough time to re-read the book. "I had to deal with what was in front of me and trust Purvis and Wade had read it and had taken the best of it. I mean, they're very good writers."

When it came to Bond, Haggis says the producers "wanted a more rough-hewn character, somebody who lived in this world, rather than the guy with the clever lines and the good suits that never got wrinkled, never got blood on him," he explains. "I said I would approach Bond like any other character. He's not sacred, so I'm going to ask really hard questions of him before I write. What's with Bond and women? Why, as Fleming said, has he almost exclusively dated or slept with married women? I said to myself, 'He's a man who has serious scars. Someone who has built a lot of armour around his heart and his soul just to survive.' Then I said, 'What would it take to get under that armour?' Because that's the only way I'm going to make him vulnerable. Somebody has to get under his armour and that's going to be Vesper. To me, Vesper made Bond into the Bond we know. He needs to be a 'blunt instrument', as M calls him, in order to survive, to do what he does, to be an assassin. His humanity, if he lets it through, will destroy

BELOW: Vesper with a recuperating Bond.

RIGHT: Campbell behind the camera.

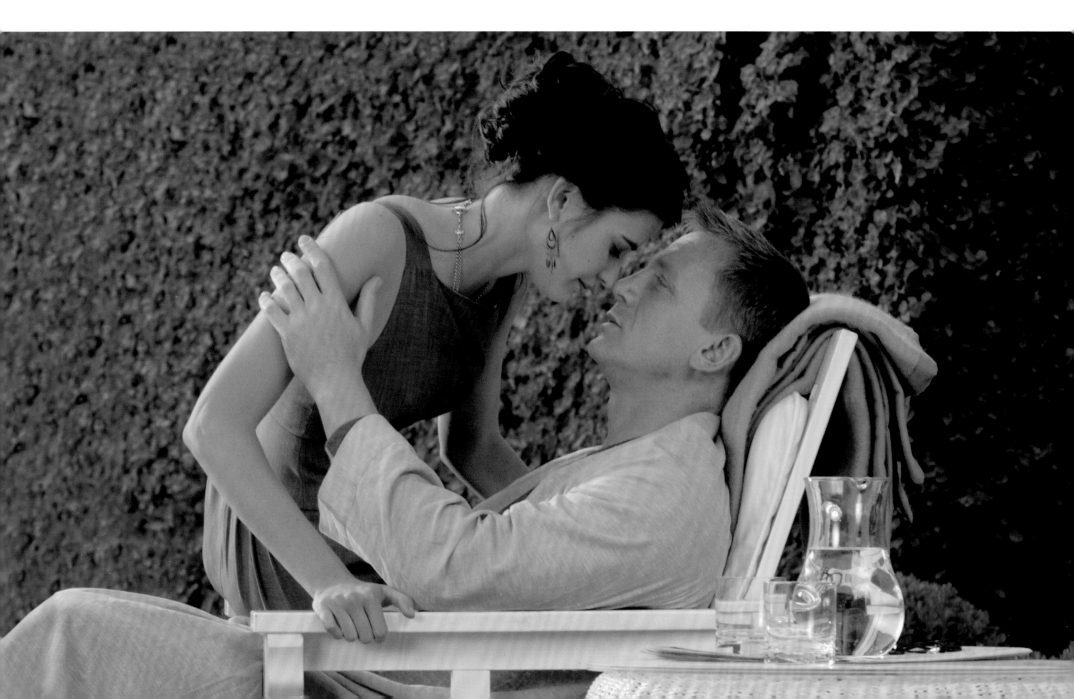

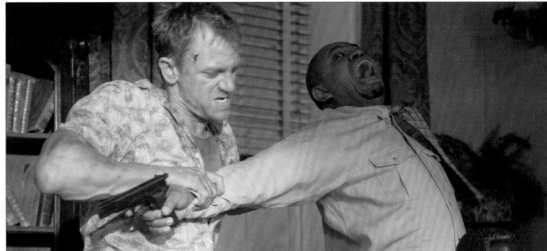

ABOVE: Craig's twenty-first-century Bond in action.

RIGHT: Craig and Caterina Murino filming a close-up.

him and it almost does in *Casino Royale*."

"The love story is very fundamental to Bond's formation,' says Eva Green, who played Vesper. "His heart is broken. His trust is lost. Later he's going to become the best secret agent ever, because he's so detached and can be like a robot and not be emotional."

Long before Haggis was drafted on board, Wilson, Broccoli and Campbell had already begun their hunt for an actor to play their modern twist on a "back-to-basics" 007. "We wanted to do a twenty-first-century Bond and redefine what a classic male hero should be," says Broccoli. "*Casino Royale* gave us the opportunity to get into Bond's inner life. It tells you why he became the man he became, so we wanted an actor who could be an iconic image of the twenty-first-century man and who had the acting chops to be able to deliver the emotional inner life without a lot of dialogue, because Bond is a very internal character. It was a very, very tall order, and there were hundreds of people being discussed."

Casting director Debbie McWilliams, whose association with the series dates back to the days of Roger Moore and who had been involved in the casting of Timothy Dalton and Pierce Brosnan, was given the herculean task of finding this new Bond. "The whole process was several months from me setting off with my backpack and passport going here, there and everywhere to when they actually chose him," she recalls. "There are always the usual suspects, but I like to find people who aren't well known or are slightly more unusual or a bit offbeat." Initially she was looking for "young actors, much younger than Daniel was at the time, because it was about him becoming James Bond. I went to all the English-speaking territories and I met lots of people, and a lot of them have become very famous." However, when it was decided

that Bond should be young, but not that young, "we went up a level age wise, and it brought in a different group of people."

One name had been on Broccoli's list from the very beginning: Daniel Craig. A graduate of the National Youth Theatre and Guildhall School of Music and Drama, the Cheshire-born Craig had originally broken through with the BBC drama serial *Our Friends in the North* in 1996, before going on to prove his versatility in a succession of acclaimed film and television roles, with his taste erring towards the arthouse rather than the overtly commercial, be it as George Dyer, alcoholic lover and muse of artist Francis Bacon, in *Love Is the Devil*, the pampered son of Paul Newman's mobster in Sam Mendes's *Road to Perdition*, philandering poet Ted Hughes in *Sylvia*, or as a Mossad agent hunting down Palestinian terrorists in Steven Spielberg's *Munich*.

Broccoli remembers first seeing Craig in *Our Friends in the North*. "Everything he did, he always became the character and disappeared into the role," she recalls, "but he also had an unbelievable amount of charisma. I always say, 'He's lit from within,' because whatever scene he's in, whether it's on the stage or on screen, he's completely captivating. He is a great character actor, but in the body of a movie star, and it's a very unique thing." While many critics saw Craig's 2004 role as the nameless drug dealer determined to go straight in Matthew Vaughn's *Layer Cake* as his "audition piece" for Bond, Broccoli insists it was his performance as Jesuit priest John Ballard in Shekhar Kapur's 1998 period drama *Elizabeth* that convinced her Craig was the one. "I remember thinking, 'Oh my God, he's the guy,' when he was in *Elizabeth*, walking down the corridor. I know that sounds crazy, but that was the moment I felt it in my gut. When your whole life is James Bond, some part of you is always looking for, *Who could play the*

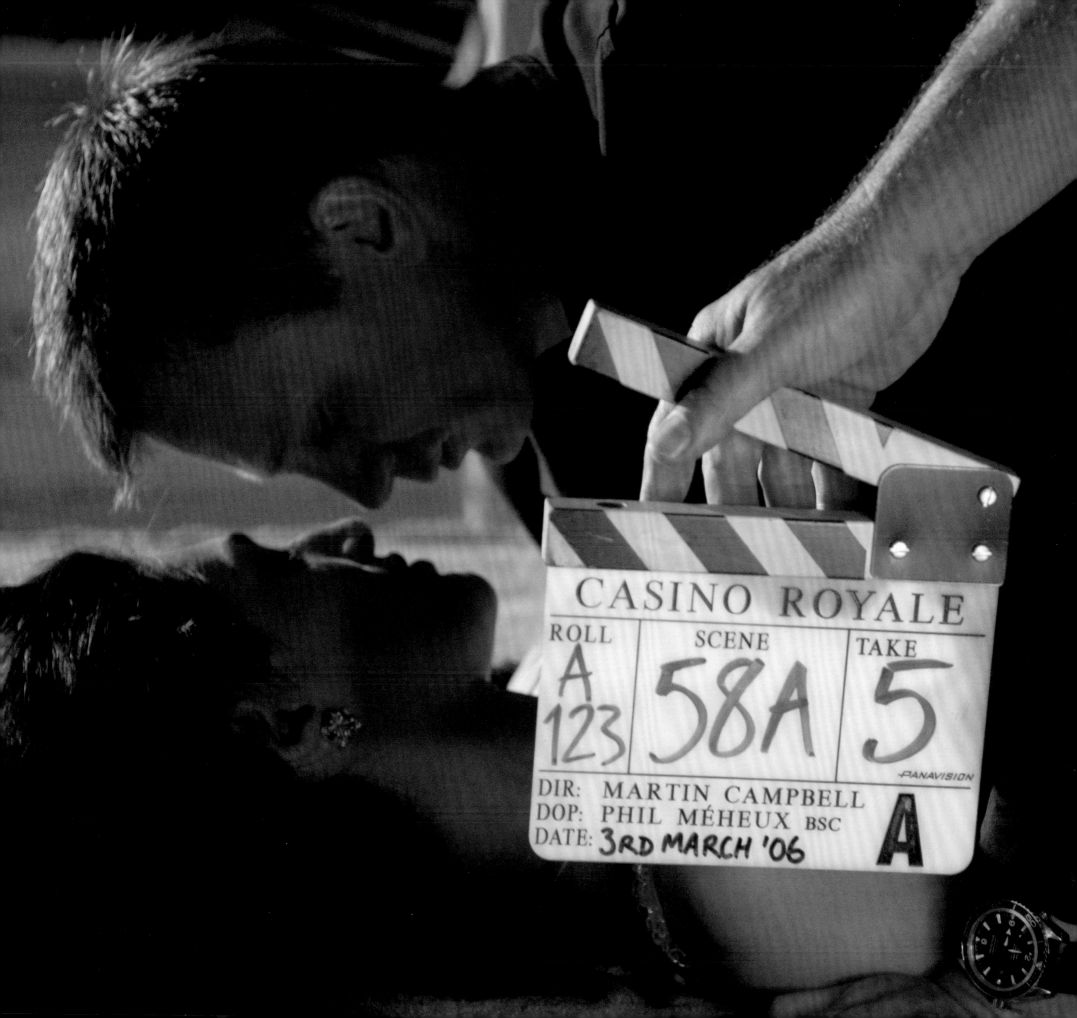

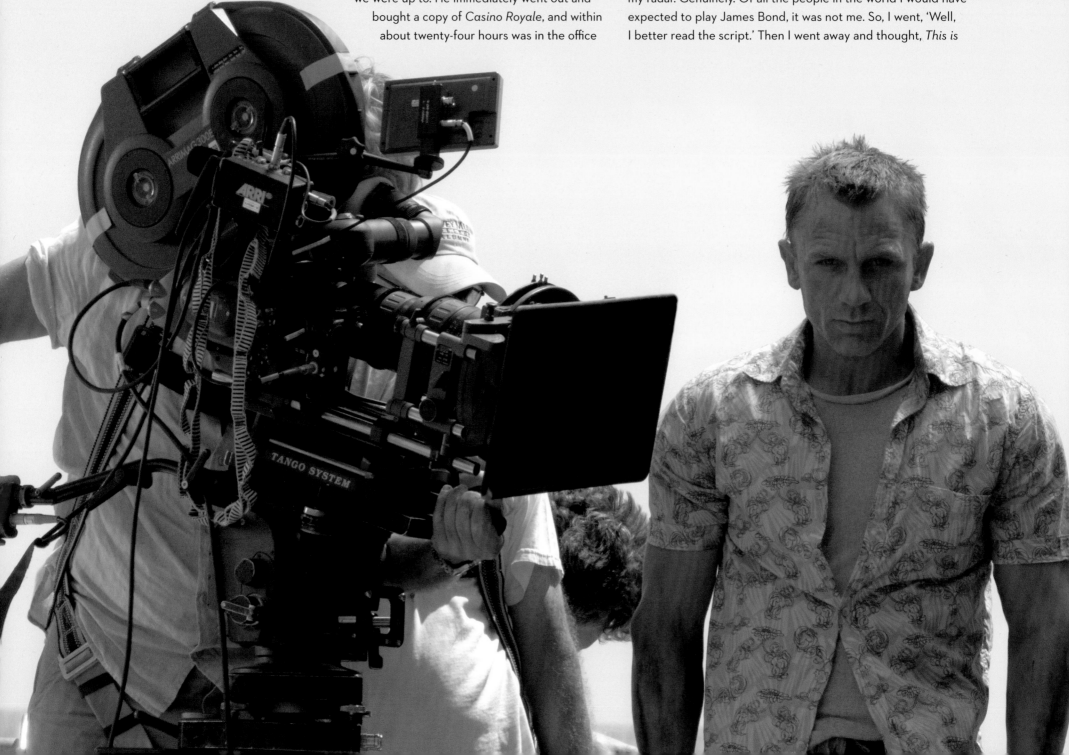

BELOW: Craig prepares for a take of the freerunning chase.

role? Daniel just eats up the screen. He's a truly remarkable actor."

McWilliams had her doubts. Not about Craig's ability, but rather about his desire to take on such a high-profile role as James Bond. "I thought he probably wouldn't be that interested, because he was a rather serious actor and did independent films and had never seemed to venture into the commercial side of things, apart from *Layer Cake*," she reveals. "He'd been classically trained and it was hard to categorise him, although the stuff he'd done showed how versatile he was. We got in touch with his agent and she was rather doubtful as well, but mentioned to him what we were up to. He immediately went out and bought a copy of *Casino Royale*, and within about twenty-four hours was in the office

at Eon, which confirmed his interest."

"I got a telephone call, 'Barbara would like to meet,'" recalls Craig, "and I thought, *She's probably seeing fifty people. I'm on a list. I'll go in, do the interview, say, 'Hello,' and that'll be it. I'd be that old bloke in the pub: 'Yeah, I was considered for Bond once.'* So, I wasn't excited or anything, didn't feel particularly nervous. I'd met Barbara, sadly, at someone's funeral long before and we had a couple of friends in common, and we just chatted. I don't know what happened in the first meeting, but they said, 'We want you to do this.' I was like, 'What are you talking about?' It was not on my radar. Genuinely. Of all the people in the world I would have expected to play James Bond, it was not me. So, I went, 'Well, I better read the script.' Then I went away and thought, *This is*

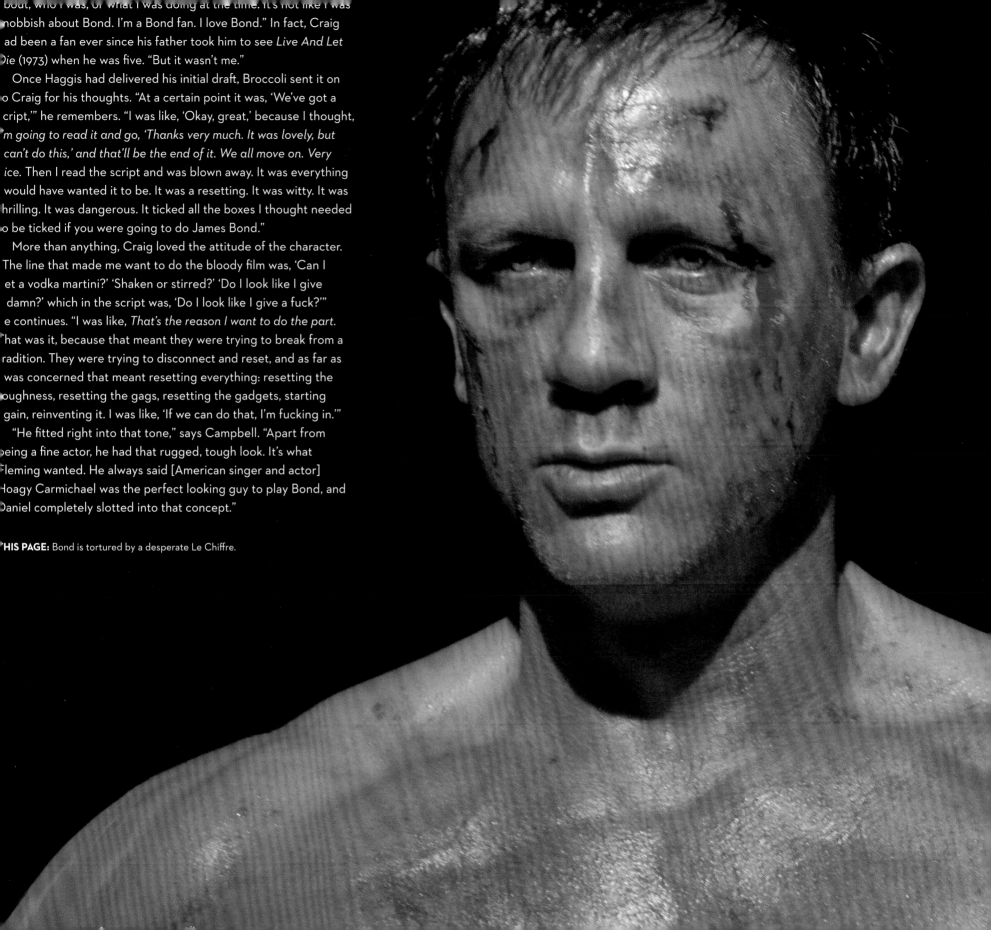

bout, who I was, or what I was doing at the time. It's not like I was snobbish about Bond. I'm a Bond fan. I love Bond." In fact, Craig had been a fan ever since his father took him to see *Live And Let Die* (1973) when he was five. "But it wasn't me."

Once Haggis had delivered his initial draft, Broccoli sent it on to Craig for his thoughts. "At a certain point it was, 'We've got a script,'" he remembers. "I was like, 'Okay, great,' because I thought, *I'm going to read it and go, 'Thanks very much. It was lovely, but I can't do this,' and that'll be the end of it. We all move on. Very nice.* Then I read the script and was blown away. It was everything I would have wanted it to be. It was a resetting. It was witty. It was thrilling. It was dangerous. It ticked all the boxes I thought needed to be ticked if you were going to do James Bond."

More than anything, Craig loved the attitude of the character. "The line that made me want to do the bloody film was, 'Can I get a vodka martini?' 'Shaken or stirred?' 'Do I look like I give a damn?' which in the script was, 'Do I look like I give a fuck?'" he continues. "I was like, *That's the reason I want to do the part.* That was it, because that meant they were trying to break from a tradition. They were trying to disconnect and reset, and as far as I was concerned that meant resetting everything: resetting the roughness, resetting the gags, resetting the gadgets, starting again, reinventing it. I was like, 'If we can do that, I'm fucking in.'"

"He fitted right into that tone," says Campbell. "Apart from being a fine actor, he had that rugged, tough look. It's what Fleming wanted. He always said [American singer and actor] Hoagy Carmichael was the perfect looking guy to play Bond, and Daniel completely slotted into that concept."

THIS PAGE: Bond is tortured by a desperate Le Chiffre.

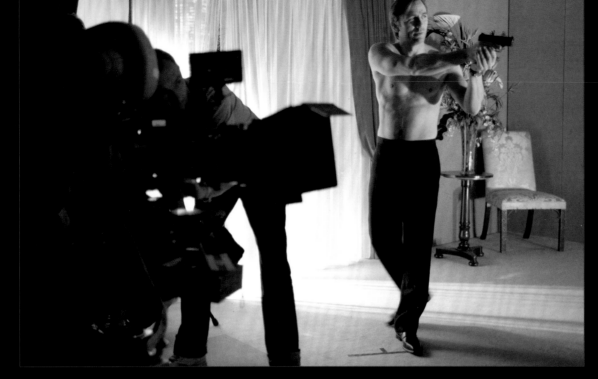

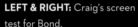

LEFT & RIGHT: Craig's screen test for Bond.

While Wilson, Broccoli, Campbell and McWilliams were in no doubt of Craig's acting credentials, other parties still needed to be convinced. "We got a lot of resistance [to Daniel], because people weren't as familiar with him as we were," admits Broccoli. So McWilliams was instructed to keep looking, "because, in America, nobody knew who he was, and I think the studio was keen to have somebody with more of a profile than he had back then. Time went on and I remember us all sitting round the large boardroom table at Eon going through every single person we'd seen, anyone who'd ever been considered, and Barbara said, 'For me, there is only one choice,'" recalls McWilliams. "I have to say, I was one of the few voices who supported her, because even then, at this late stage, people were unsure of him. Anyway, they took the plunge. You can never really imagine what they're going to be like, and neither can they, I don't think. It's a leap of faith on everybody's part, and luckily it paid off."

"It was Barbara who really pushed for Daniel and was determined to get him and she was quite right. It was a very good decision on her part," says Campbell. "Daniel, being the actor he is, was a little reticent, because you've got to think a bit about how it'll change your life, but they finally convinced him."

"I took a while to decide," reflects Craig, "but Barbara stuck it out, God bless her. She never lets go of something if she wants it. There were all sorts of things going on, and then they said, 'It's yours, but you have to do a screen test.' 'What? Why do I have to do a screen test if the job's mine?' The answer was, 'Because there's a studio involved and they need it.' 'Oh, okay.'"

A Bond screen test is an elaborate affair spread over several days at Pinewood Studios, involving full hair and makeup, a costume fitting and other actors. For *Casino Royale*, it also meant Campbell directing four potential Bonds – Henry Cavill, Sam Worthington, Goran Višnjić and Craig – in a *From Russia With Love* scene, where Bond meets Tatiana Romanova for the first time. "The reason for that scene is it covers everything," explains Campbell. "Bond comes into his hotel room, takes off his coat, takes off his gun, goes to the bathroom, runs the bath and suddenly senses there's somebody in the suite. There, of course, is the beautiful blonde in his bed, wanting to seduce Bond, because she's been sent up to get information, and there's a rather seductive conversation between them."

"I was supposed to do a whole day," recalls Craig. "Literally, morning till night, on set, fully costumed, with other actors, lit, on film. I did the morning, was supposed to take lunch and then come back in the afternoon and do a whole other session. I got

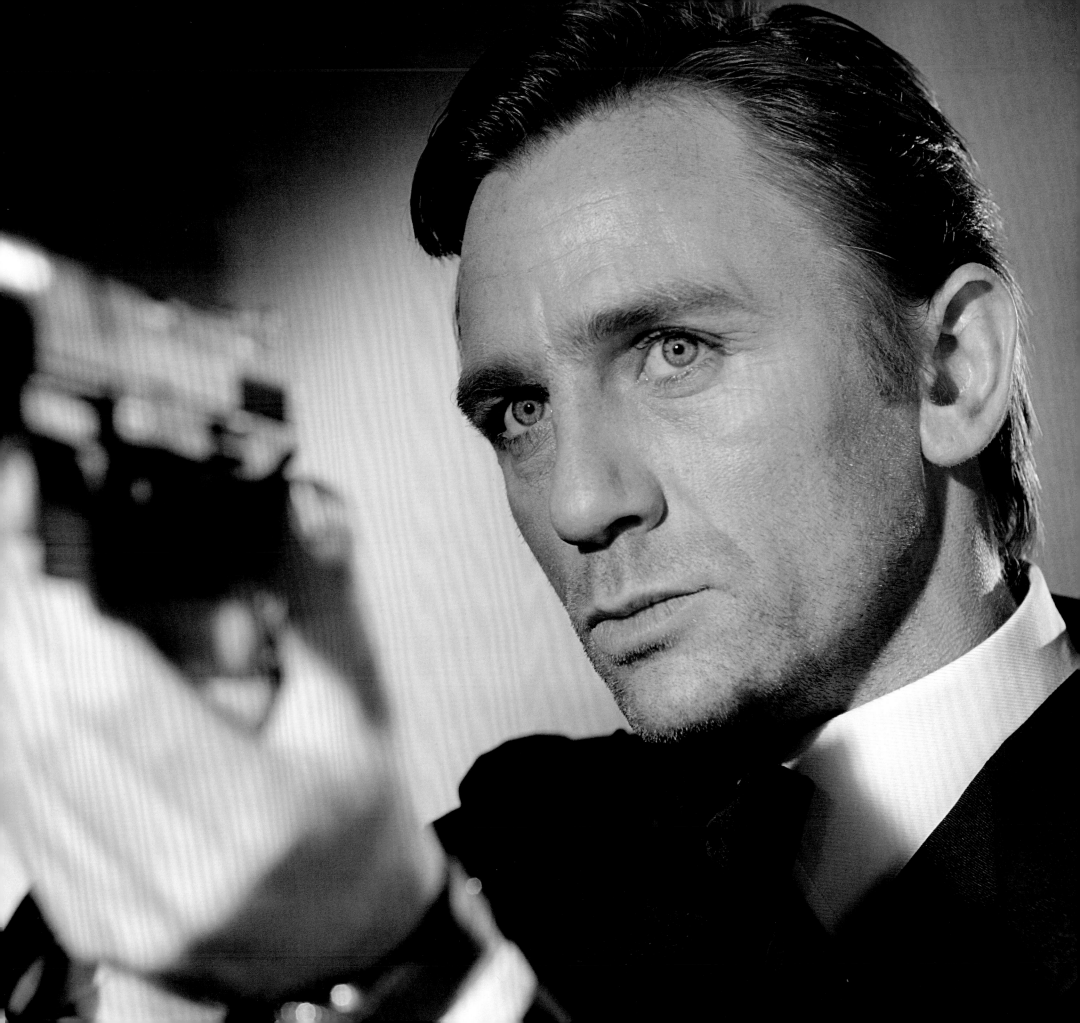

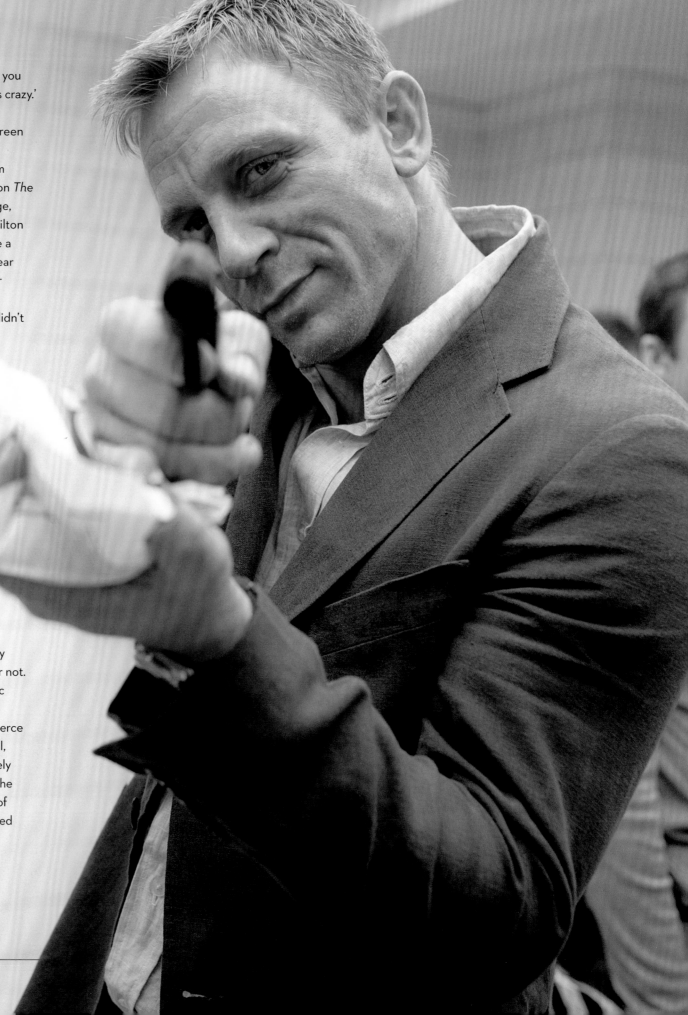

to lunchtime and I said, 'I'm out, guys. Bye,' and I left. I was, 'If you fucking don't know by now…'" laughs Craig. "I was like, 'This is crazy.' I started the way I meant to go on – being a pain in the arse."

Despite that, it was clear to everyone who saw Craig's screen test that he was the real deal. "All the actors were fantastic, but Daniel really stood out," says executive producer Callum McDougall, who started with Bond as an assistant director on *The Living Daylights*. "I remember seeing him walk onto the stage, thinking, *This guy looks like Bond.* [Bond director] Guy Hamilton once told Sean Connery to 'Own the suit. It needs to be like a second skin,' and out of the people we auditioned, it was clear Craig was going to be Bond, certainly for me, and I think for Barbara there was no question at all."

There was just one problem. Craig still wasn't sure. "He didn't want to do it," Broccoli recalls. "He realised how much his life would change, and he's a very down-to-earth person and he didn't really want the fame. He's not someone who's ever gone after fame."

Playing James Bond is more than a simple acting job, it's a lifetime commitment, even once you've retired from active service and handed over the baton to the next incumbent. As Pierce Brosnan famously said, "More men have walked on the moon than have played James Bond." "[Daniel] also didn't particularly want to be typecast," adds Broccoli, "because he's an actor who likes to take on different roles and he wanted to have flexibility."

"I was like, 'Shit, what do I do?'" admits Craig. "Life became really difficult then." To weigh the pros and cons, Craig took the "counsel of all my friends, my family, everybody I knew, to try and figure out whether or not I should do this or not. Because it was clearly going to be life-changing and traumatic and wonderful and fabulous and all of those things." Among those whose advice he sought out was the outgoing Bond, Pierce Brosnan, who told him to "Go for it." To help sweeten the deal, Wilson and Broccoli offered Craig a seat at the table, creatively speaking, meaning he would not only be actively involved in the development of scripts, but would be included in the choice of directors and key cast, a decision that would see Craig credited

RIGHT: Craig poses for the camera between takes on the bathroom set.

OPPOSITE: The brutal bathroom fight.

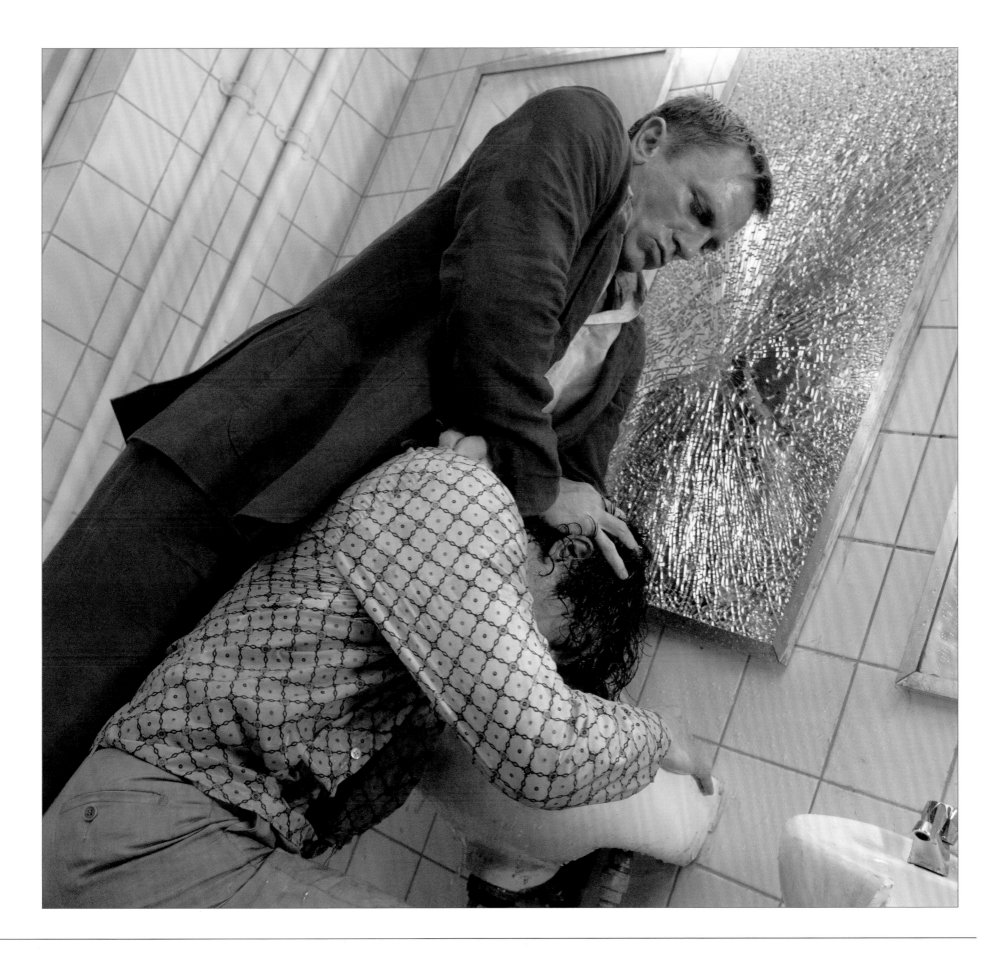

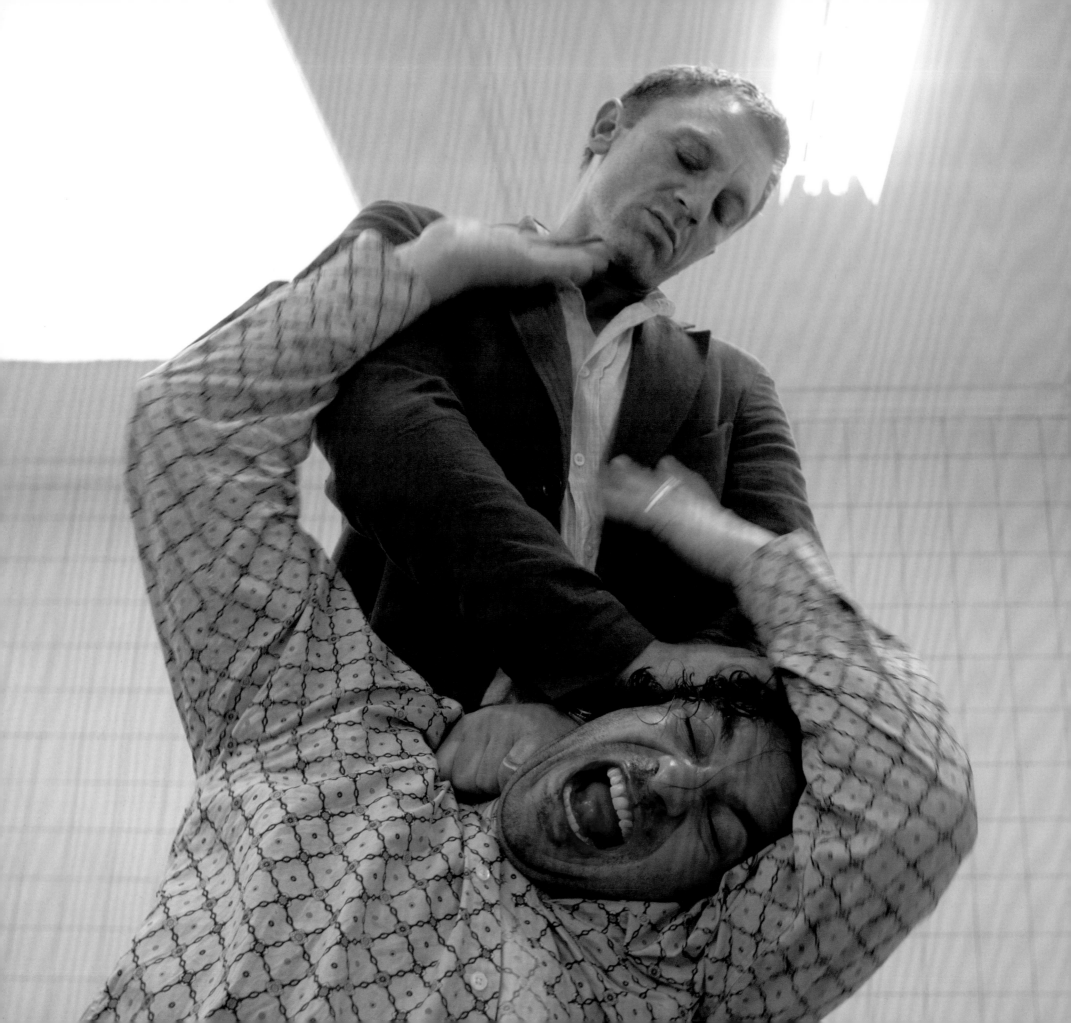

as co-producer on *Spectre* (2015) and *No Time To Die* (2021). "He recognised it would be a major commitment," says Broccoli, "and part of his agreeing to that was us agreeing he would be very much at the centre of everything we did."

"I said to Barbara and Michael, 'To feel like James Bond, I've got to feel like a part of this,'" explains Craig. "They were like, 'Good.' So they gave me a say, they gave me a voice, which I'm eternally grateful for. It's given me a voice in my whole career."

With that, Craig finally said yes. "It was a combination of him knowing he would be part of all those creative decisions and him accepting the parameters of the fame," notes Wilson. "And the script."

On Friday 14th October 2005, Daniel Craig was officially unveiled as the sixth James Bond with a press launch on HMS *President*, with the actor arriving via the Thames on a Rigid Raider speedboat, flanked by Royal Marines. The announcement, it's fair to say, was greeted with less enthusiasm than expected, with the media reaction to his casting ranging from muted to downright hostile. Craig was criticised for being too short – he's 5'11" – and too blond – Fleming described Bond as having "short black hair". He was even slated for wearing a life-jacket over his suit when travelling by motorboat to the event itself. "The press had it in for Daniel from the word go," says McWilliams. "He had so much negative stuff written about him. He was blond. He was this. He was that. He couldn't drive. It was all total nonsense. I don't know why people are so fixed on the idea that James Bond has to be dark-haired, because Roger Moore didn't have dark hair. I think it stirred him on to really do an incredibly good job, and that's what he did."

"It was all bullshit," scoffs Campbell, who was present at Craig's unveiling. "Even on *GoldenEye* there were these articles about how Pierce can't drive a stick shift. All this rubbish came out – goodness knows where they get it from. I said to Daniel at one point early on, 'Do you read this garbage they write about Bond?' And he said, 'Yes, I do, so when I come on the set and everybody has read it, at least I'm up to speed. But I ignore it.' Then you release the film and it shuts everybody's mouths."

In the meantime, the internet raged. Or rather, a small portion of it. A website appeared demanding the film be boycotted and Brosnan reinstated. "It was absurd," notes Broccoli. "Apparently, there were a couple of young kids in a remote part of the United States who were big fans of Pierce and didn't like the fact somebody else was taking over. It created this firestorm, which was pretty ridiculous. We were shooting in the Bahamas by this stage, and Daniel was killing it. From the second he started we all knew he was going to be amazing. It was all over the news every night, and we were thinking, *What's wrong with everyone? How can you pass judgment without having seen a foot of film?* Then, of course, the world changed. There was a paparazzi shot of him in his blue swimming shorts and suddenly the whole world saw what we had been seeing at the beginning, that he was phenomenal, and it all died down."

"Every new Bond has an enormous amount to prove, because it's such an iconic part and people have their own idea of who Bond is and what he should look like," says Judi Dench, who returned to play M for a fifth time with *Casino Royale*. "I was with Pierce on his first film, which was my first Bond, too, and taking the mantle over is really tricky. But both of them were wonderful. Daniel's a very, very good actor, and he seemed to take it entirely in his stride. He found his own place and made us accept an entirely different kind of, but nevertheless entirely believable Bond, and that's because he's such a good actor. But I'm sure if I'd looked closer I could have seen the whites of their eyes on both occasions, because taking that mantle over is unbelievably onerous and frightening."

As part of his homework Craig sat down and read all the Bond books. "Everything I brought to the character comes straight from Ian Fleming," he says. His Bond was serious, athletic and a departure from Pierce Brosnan's suave, silky smooth spy. Craig was the first Bond to look like he could actually kill you. "It was pretty much there in the script, but I had a very strong idea of how to play it and it was deliberately trying to be different," he admits. "The problem I had – and what I was terrified of – was what people expected. I suppose what they expect you to do is do an impression of the person that's been before, because the person that's been before is their Bond, and why the fuck would you come along and take away their Bond? You better come along and be something similar. I was like, 'I just can't do that. I can't be anything other than me. That's all I got. I don't do impressions.'"

As the script required Bond to chase down a bomb-maker skilled in Parkour, smash a bad guy's head through a bathroom sink, shattering the porcelain, and barrel his way into a foreign embassy, taking out guards with his bare hands as well as his trusty Walther, Craig set out to transform himself into the best possible shape. Simon Waterson, a former Royal Marine who had worked with Pierce Brosnan and Halle Berry on *Die Another Day*, was employed as his trainer and Craig underwent a rigorous physical regime for months prior to filming that continued throughout shooting. "Daniel saw it as a real challenge, in the sense he wanted to develop his body, so he would actually look the part," says Wilson.

(Continues on page 40)

SWIMMING TRUNKS

The moment the world woke up to Craig's Bond was when a paparazzi photograph of the pumped-up actor, wearing a pair of sky-blue tight-fitting swimming trunks and stepping out of the Caribbean surf onto a Bahamian beach, was published. The scene, which occurs early in the film, clearly pays homage to Ursula Andress' iconic appearance in a bikini in *Dr. No*, although screenwriters Purvis and Wade and director Martin Campbell claim they didn't have that in mind at script stage or while filming it. "No matter what anybody says, I needed a wide shot. That's it," insists Campbell of scene 47D. "There was no, 'Let's do a *Dr. No* shot.' It was only once the film was shown that that got picked up on, but it was entirely accidental in the sense we needed a wider shot of Daniel standing up, coming out of the sea."

"It wasn't meant to be a moment and yet it was a *huge* moment," says Robert Wade, who, along with Neal Purvis, had written the scene in *Die Another Day* where Halle Berry's Jinx steps from the sea in an orange bikini as a nod to Andress in *Dr. No*. "It's funny, we were writing what became *Quantum Of Solace* while they were shooting *Casino*, and we flew out to the Bahamas to talk about it," Wade continues. "On the plane, there was a British newspaper with a photograph of Daniel coming out of the water. Barbara had said, 'Don't bring any newspapers. We don't need newspapers with all this negativity.' But, in fact, it was the one that turned it all around. Suddenly people were excited about him. 'He's a hunk.'"

Broccoli didn't need the tabloids to tell her that. "I remember being with Lindy Hemming at my house in New York when Daniel was trying on forty pairs of shorts – which, let's face it, was not a hardship," she says. "They all looked great on him, but we loved the blue. Of course, when we were shooting it and he walked out of the sea, all the women were out of their minds. The men were, too. Like Ursula Andress, that image was something men and women could appreciate. Daniel exemplified the kind of man every man would like to be. Strong, powerful and beautiful."

Costume designer Hemming – who worked on *Die Another Day*, among many other Bonds – says Andress was in her thoughts from the get-go, as she amassed an array of trunks for Craig to try on. "I knew it was going to be an iconic shot. I had Ursula coming out of the sea in my head, but a man doing it," she reveals. "I got lots of different kinds for Daniel to look at himself and for us to see what we thought suited him best. By then he had become physically pretty magnificent and it was funny getting him to go behind a screen and come out with a different pair on and look at them and try to be serious and not laugh too much. I have a thing about Bond wearing blue anyway. When he's being Bond, blue is the colour he looks really great in."

"I'm scarred. I'm scarred to this day. I've had hours of therapy because of that," jokes Craig when reminded of that particular costume fitting. "I remember it distinctly. Lindy brought me a whole collection of trunks, which were basically lots of board shorts, because that's what everybody wore then, and then there was this small pair of blue things. I went, 'There's no contest. I don't even know why we're having this conversation. I'll have to stick those on.' I'd been working out for a year, prepping the movie, I was in great shape, and I was like, 'I'm not wearing board shorts. Get those on.' They were blue and I said, 'Ursula Andress.' I said, 'Fuck it, we're trying to subvert the genre, let's subvert the genre.'" He chortles. "It's a career."

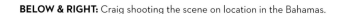

BELOW & RIGHT: Craig shooting the scene on location in the Bahamas.

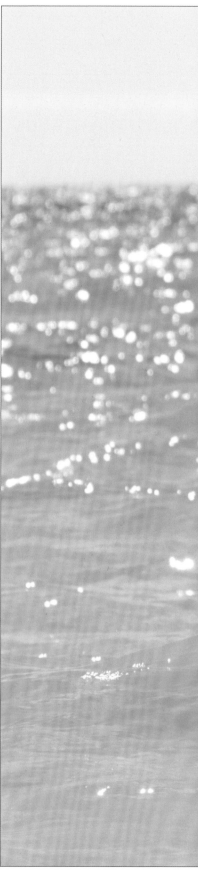

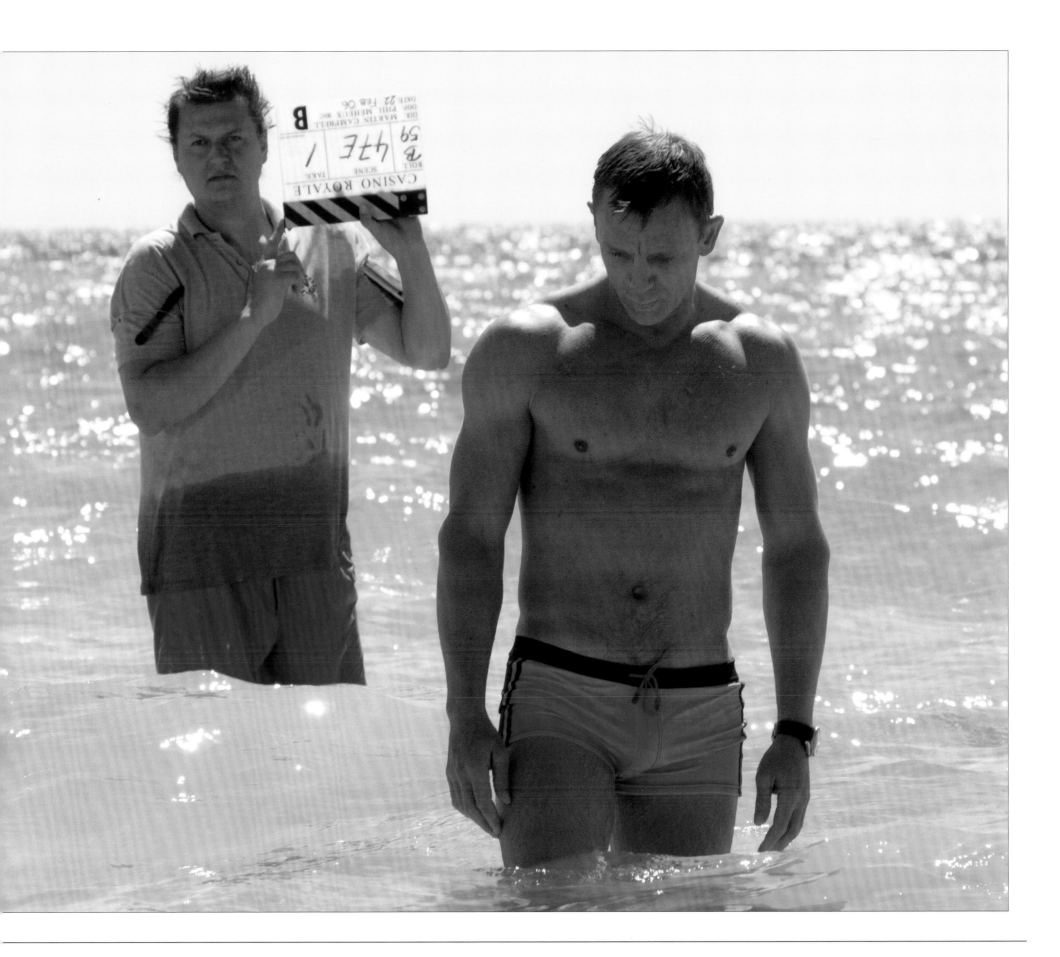

"His transformation was all part of him becoming the character, and he's obviously been extraordinary in that respect as well," adds Broccoli. "He basically became a gold standard athlete in order to achieve what he needed to achieve, and over these films he's been really extraordinary."

"He pumped himself up and brought exactly what you wanted – a rawness," notes Purvis.

"His level of commitment was something I hadn't really seen before from an actor and was so integral to the role, in all respects," says McDougall. "What he put into the stunt training, what he put into the pure physicality of it, he's such a methodical actor. From the minute we started setting up *Casino* and he was out in Prague, his commitment was inspiring to watch."

Filming began on 27th January 2006, with a pre-shoot at Barrandov Studios just outside Prague, and would last for 119 days and take in Italy, the Bahamas and the UK, with the production based out of the Czech Republic for financial reasons. "We scouted a lot of places," says McDougall. "We went to South Africa, went to Croatia, and then a decision was made that it was going to be too expensive to make the film in the UK because of the exchange rate, and so for the third time in Bond's history, it wasn't going to be a

completely UK-based production. It happened on *Moonraker* [1979], when they shot it in Paris, it happened on *Licence To Kill*, which was based out of Mexico City, and then on *Casino*. The Czech Republic worked out very well for us, although we did go back to Pinewood to shoot the sinking house."

Casino Royale sets out its stall from the very beginning, with Bond sent to kill Dryden (Malcolm Sinclair), a traitorous MI6 agent, in his office in Prague, a scene intercut with a fight in a bathroom between Bond and another man that's arguably more brutal than any in the preceding twenty Bonds. Campbell wanted the violence to be "ugly and quite vicious, which it is. In fact, we had to cut back a bit, because of the censors, on that scene," he explains of the fight in the bathroom. "Bond grabs the guy, they smash through the cubicle, he kicks him in the head, then he drags him across the floor and forces his head into the basin and drowns him. In the book, violence is not clean and efficient. Bond dislikes it intensely. So, if you look at Daniel's expression as he's drowning that guy, it's a very ugly, protracted killing. The guy won't go down and you can see it in Daniel's face. It affected him."

"Martin wanted to make it down-and-dirty," says Gary Powell, who worked as a stuntman on several Brosnan Bonds before his

BELOW: Campbell discussing the bathroom fight scene at The Cricket Club with Daud Shah (Fisher) between shots.

RIGHT: Stunt double Ben Cooke, Sebastien Foucan and Craig between takes on the embassy set.

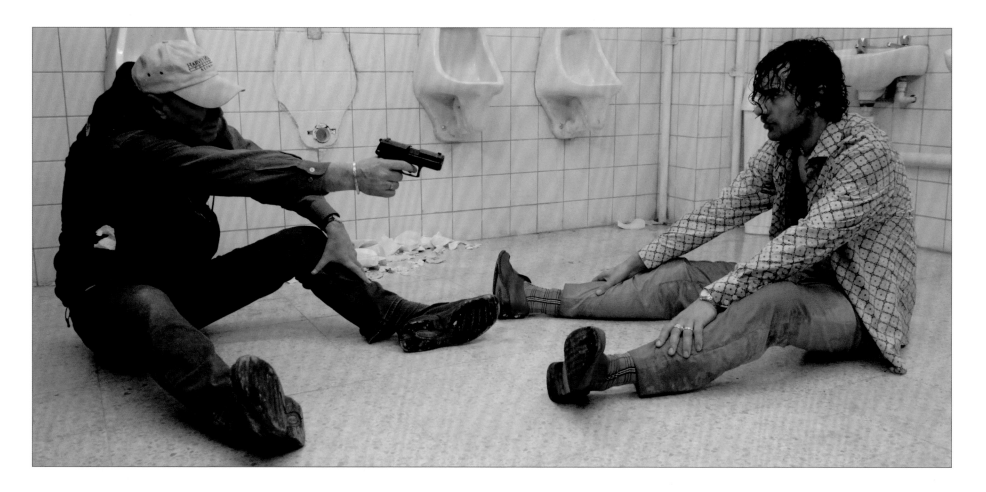

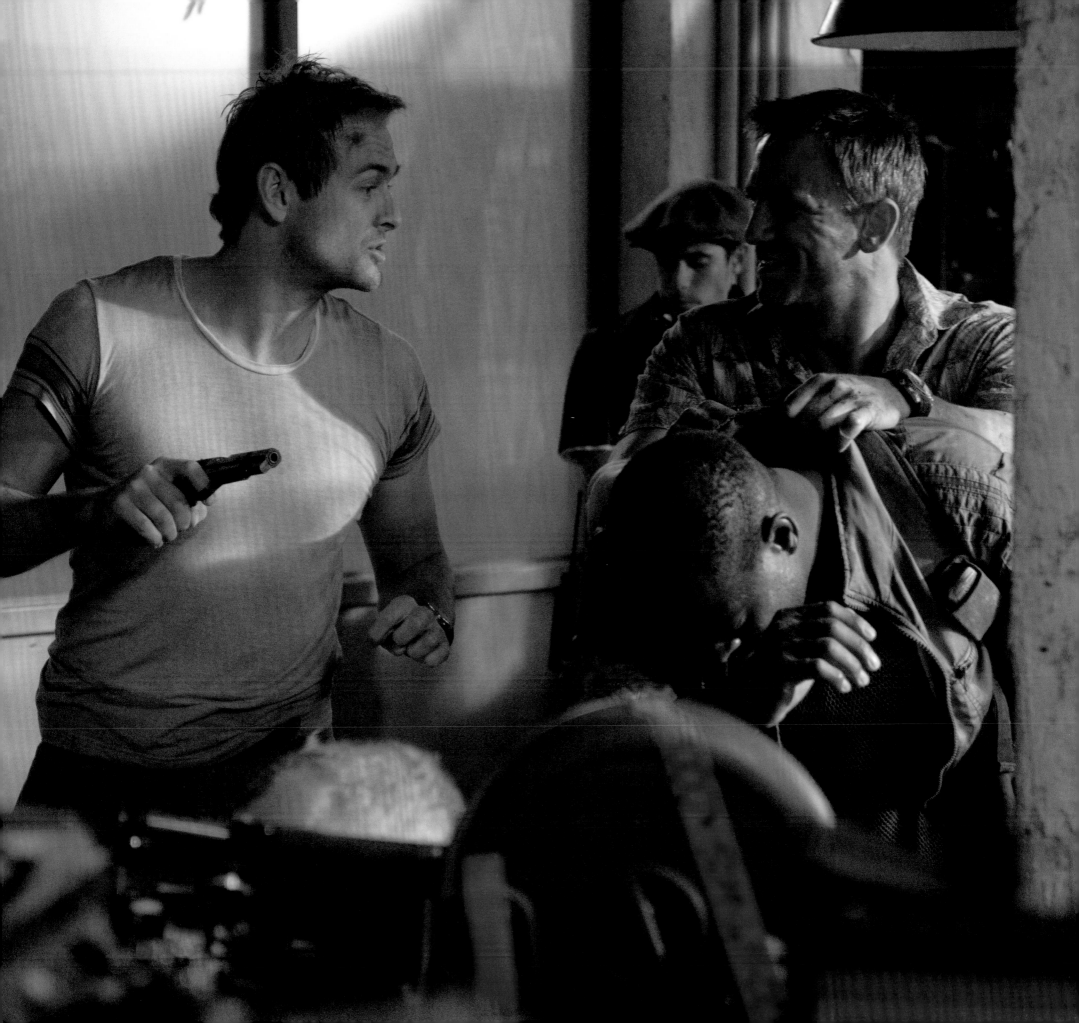

promotion to stunt coordinator on *Casino Royale*. "Roger Moore was tongue-in-cheek and could go into a massive fight and still come out with his hair in place. On this, Martin said, 'Bond has to bleed, he can't be invincible, he has to be vulnerable,' so from the action side of it we had instructions to make the fights short and sharp rather than long and drawn-out. Quality over quantity."

In the four years since *Die Another Day* had been released, action movies had been given a jolt of adrenaline thanks to, initially, Doug Liman's *The Bourne Identity* and then, to an even greater extent, its sequel, *The Bourne Supremacy*, directed by Paul Greengrass, with its kinetic car chases, visceral fight scenes and documentary-style cinematography. "Other franchises stepped up and that kicked us into touch. Hence, Bond took a completely different turn when Daniel came on board," acknowledges Powell. "*Bourne* completely reinvented the way we shot fights, and the energy of the film was completely different to anything that came before. So, when Bond was coming round, it had to step up, and Martin delivered the absolutely perfect version of that: it had to be gritty, it had to be sharp, but it still had to be James Bond."

The bathroom fight, the office killing and the subsequent sequence at the Nambutu Embassy, where Bond barrels inside after a would-be bomber, battling armed guards, before setting off a huge explosion, were the first scenes shot, with Campbell front-loading the schedule with action deliberately. "Martin was putting Daniel through his paces," explains McDougall. "It was relentless. Because Martin is so, so energised, he's like a hundred miles an hour and so action orientated. Just seeing Daniel do that, physically, on the set, you knew something was being created."

"Daniel wasn't that experienced with action and I had to get it right and he knew it," reveals Campbell. "Daniel, to his credit, listened. We had to do quite a few takes on that and he went for it. He had to look good. He knew he had to look good and it was a very tough one, but he got it, he stuck with it, he worked on it. He sometimes got very frustrated with it – not with me, but with himself. He stuck to it until he got it right. All credit to him, he was very determined, and it's a great sequence. He does it brilliantly."

"We started off with a sequence where I was basically kicking the shit out of people," recalls Craig. "It kind of broke the ice somewhat."

"This is where I give Daniel credit," says Powell, "because he

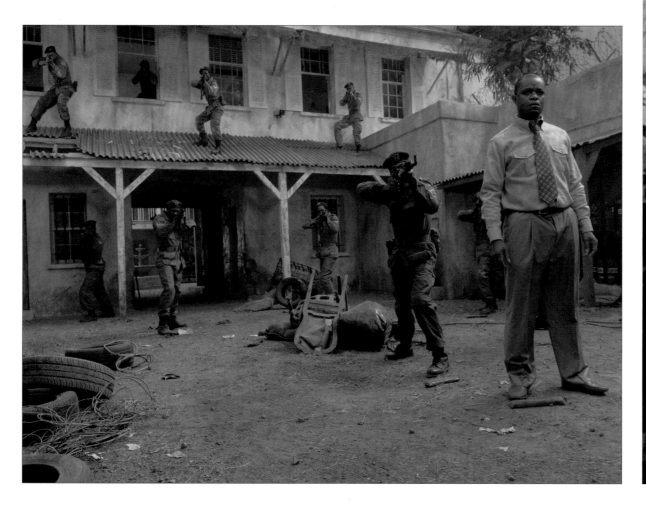

RIGHT: Bond sets off a huge explosion at the Nambutu Embassy,

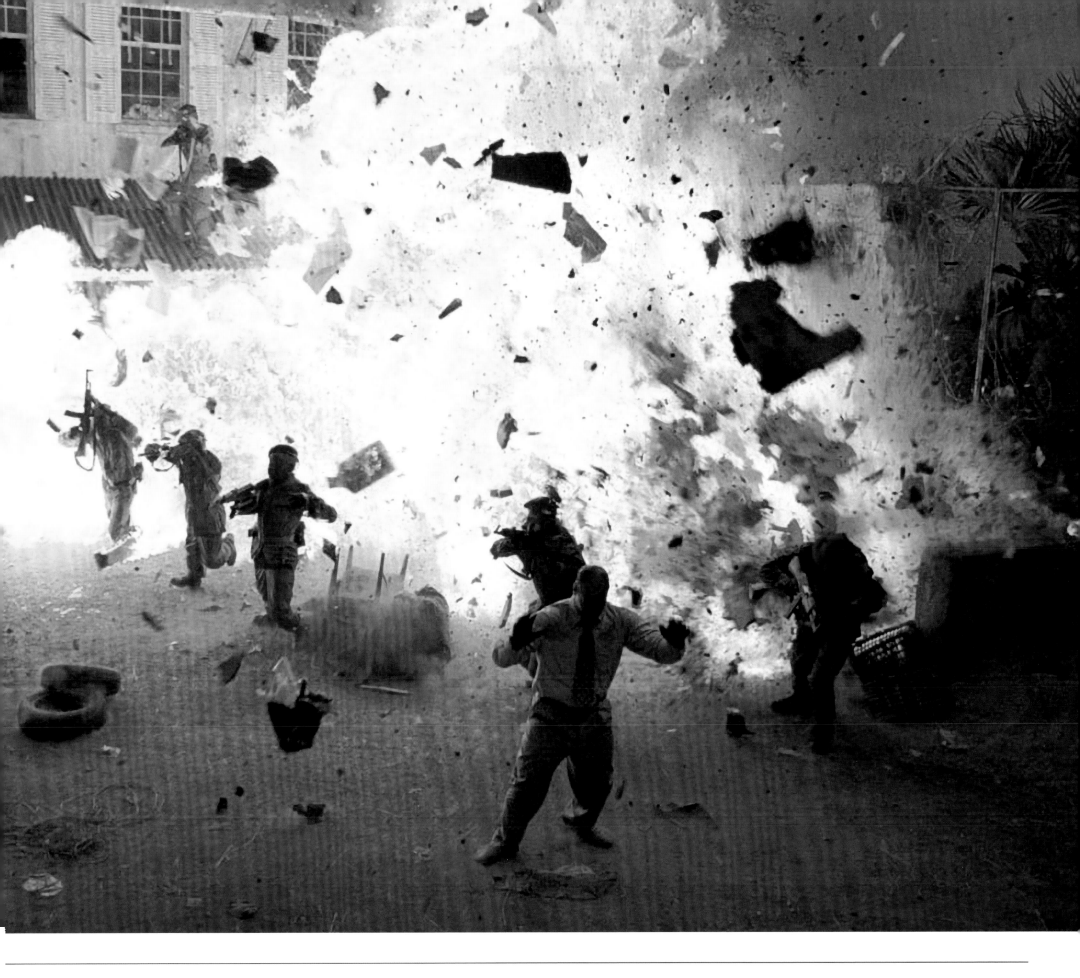

put himself into it a bit more than he probably needed to, and if you're going to put yourself into it that much, you are going to get knocked and bruised. He did, and he didn't moan about it. He wanted to deliver on camera, and it was a good thing to show to the studio, because they were encouraged by it. I will always remember Barbara coming up to me after we shot the bathroom fight and saying, 'That's amazing.' It set the tone for how the rest of the film played out, with it being full-on, one-hundred-and-ten percent, and nothing below that would be accepted."

More than just great action, the embassy fight was designed to show Bond's tenacity and character. Here is a man who is relentless, who will never give up, who will just keep on coming. "He's like a bulldog," says Powell. "Once he sinks his teeth in, he's not going to let go, he will get his man whatever the cost."

However, that fortitude goes hand-in-hand with a recklessness, an impetuousness that's reflective of an agent finding his feet. "At the end, he shoots the guy in the embassy, but if he'd thought about it, he should have waited," says Campbell. "The guy would have had to come out, and he could have followed him. Instead he jumps over the wall and creates mayhem, which makes for a great sequence, but it's not the brightest thing to do. The idea was not only to make an exciting sequence, but to portray Bond in his very early stages as a '00', having a lot of rough edges, thinking with his heart rather than his head, but having grit, determination and courage. He's like a bull in a china shop, an absolutely unstoppable force. That was early Bond, and by the end of the movie he's much more sophisticated, having been through that experience."

Both opening scenes – the Dryden kill and bathroom fight –

BELOW: Terrorist banker Le Chiffre and Mr White with the Lord's Resistance Army in Uganda.

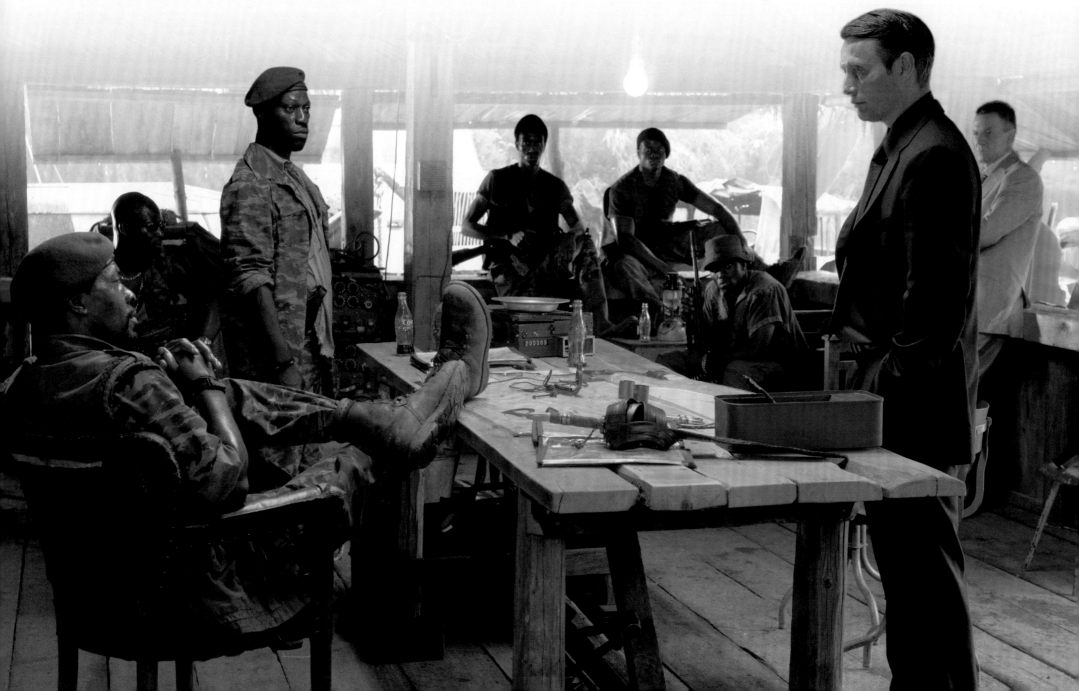

were shot in black-and-white by director of photography Phil Méheux, also returning from *GoldenEye*. "Black-and-white gives it a grittiness," says Campbell, who had Craig, as he shoots the bathroom bad guy, turn directly to camera, mimicking the famous Bond gun-barrel moment, with the colour red bleeding into the shot as the guy dies. "I wanted the red of the blood to be the first colour you see running through the barrel, and so make the famous shot where he turns and fires be when he shoots the guy in the bathroom – to be the derivation of all the other opening sequences – because, in a funny way, *Casino* is a prequel to the other Bond films. He's not James Bond until the last frame of the movie."

After the opening title sequence – which was directed by Daniel Kleinman – and a scene in which Mr. White (Jesper Christensen) introduces Mads Mikkelsen's terrorist banker Le Chiffre to the Lord's Resistance Army in Uganda, who charge Le Chiffre with investing a large sum on their behalf, *Casino Royale* finds Bond on a mission in Madagascar. He and another agent are trailing Mollaka, a scarred bomb-maker played by Sebastien Foucan, widely considered to be the founder of freerunning, and an early developer of Parkour, who had been hired to consult on the sequence and ended up starring in it, too. When Mollaka spots Bond's colleague, he takes off, with

Bond in hot pursuit, chasing him into a building site, up a crane, onto another, down again and, eventually, into the aforementioned embassy, where Bond kills Mollaka, his actions captured by CCTV and broadcast around the world, much to M's indignation. "We wanted to establish the new Bond as gadget-free, raw, slightly crazy, very physical and incredibly brave," reveals Purvis of the idea behind the sequence. "We were also aware there had never been a foot chase in a Bond movie before."

The chase was filmed in the Bahamas, subbing for Madagascar, on the site of an abandoned hotel at Coral Harbour, which had previously been used in *Thunderball* and *The Spy Who Loved Me* (1977). "There was a keenness to go back to the Bahamas," says McDougall. "It's very much related to Bond. They've been there many times, and I remember being on that recce when we came across this abandoned hotel and Peter Lamont, the most practical of production designers, saying, 'We can make this work. We can come up with a great sequence.'"

"We'd been there during *The Spy Who Loved Me* when it was a hotel, a pool and bar, and we often used to dine there, but now it was all overgrown, derelict," recalled the late and much-missed Oscar®-winning Lamont, who began his Bond journey as a draughtsman on *Goldfinger* in 1964. His team had to do

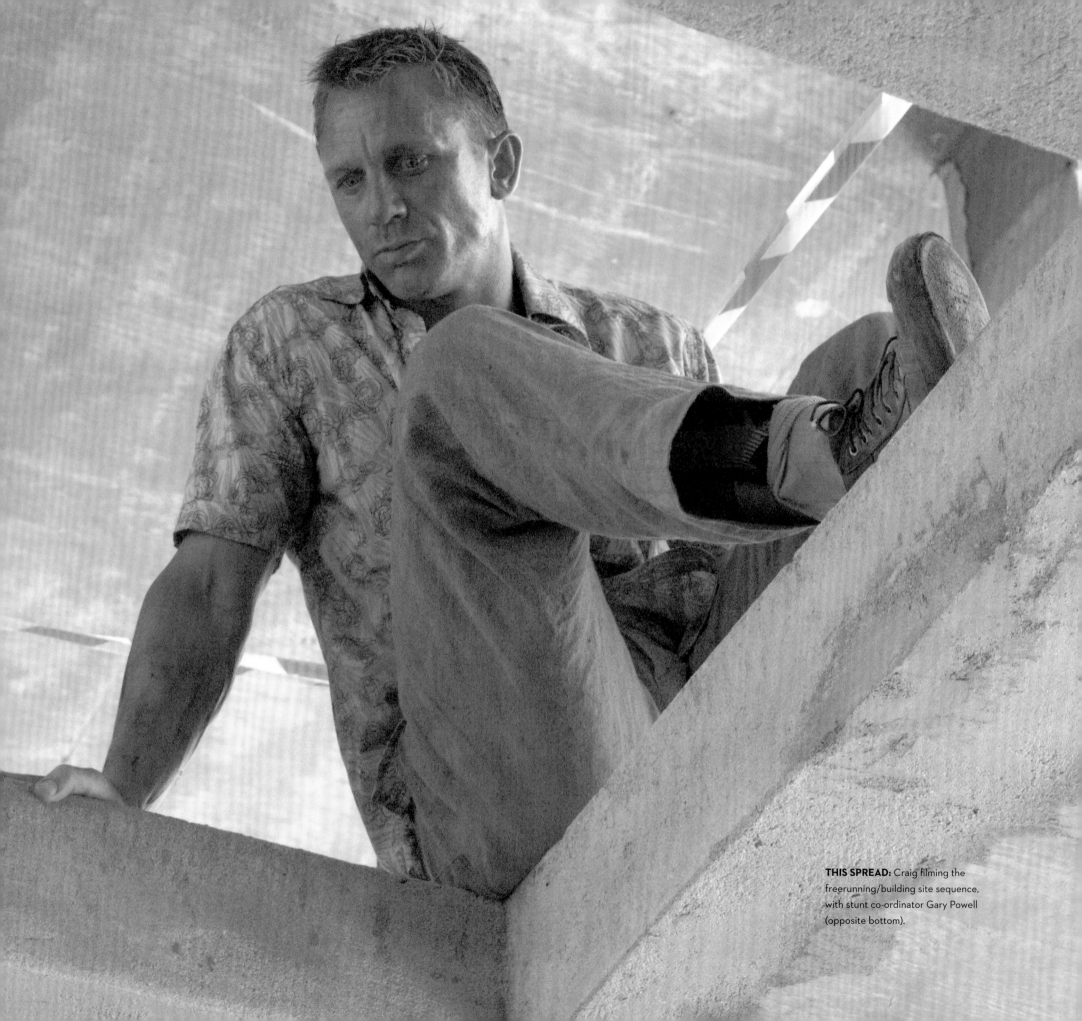

THIS SPREAD: Craig filming the freerunning/building site sequence, with stunt co-ordinator Gary Powell (opposite bottom).

very little to transform the site beyond importing steel girders and three cranes from the UK and dressing it with building equipment and material.

The freerunning/building site sequence was three months in the planning and the result of several departments – stunts, special effects and second unit director Alexander Witt and his team – working with Campbell and Craig to create the breathless, mind-blowing action one sees onscreen. "In the script it said, 'Bond sees a bad guy and what follows next is an amazing foot chase,'" laughs stunt coordinator Gary Powell, "so Martin and I sat down and talked about it. We had a model made of the building site, and Martin said, 'I want to go higher with this,' and the only way we could go higher was with cranes. We had one crane, two cranes, then more, before we came back down and settled on two. It was about finding the elements and giving the sequence a purpose, and a logic. It had to make sense."

The chase starts with Bond on foot, before he hijacks an eighteen-ton mechanical digger, destroying a hut, then slamming into a concrete plinth, the backhoe's bucket chewing into the concrete. "We built a model and put forward two or three ways that the digger could take out the concrete," says veteran special effects and miniature effects supervisor Chris Corbould, whose

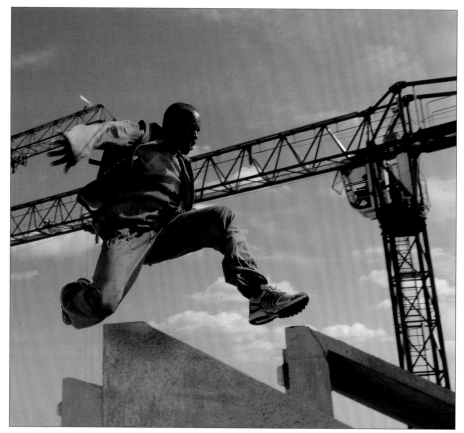

team were responsible for all the physical elements, among them the digger, scaffolding, a scissor-lift stunt, as well as all the breakaway props. "Martin preferred the direct way, with the bucket straight into concrete. The concrete curled round the bucket and came out like a wave."

Dismounting the digger, Bond then chases Mollaka up a steep steel girder. Powell began rehearsing with Craig while they were still in Prague, before the production moved to the Bahamas. "We turned up six weeks before we were due to shoot and started training, setting up all the rigs and the cables," he explains. "Then Daniel arrived and I walked him around the construction site, and as we were going up and up you could see the look on his face, like, *Shit, this is high!*"

When Craig runs up the girder, "he's on a cable," says Powell, "we've got a crane above him with a line. It is a bit of security. But again, you've still got to do the performance and switch off to everything around you, and he did and the end result is what you see on screen. He did an amazing job. I give anyone credit when they do something they're not comfortable with, whether that's riding horses, swimming or heights, if you're genuinely frightened

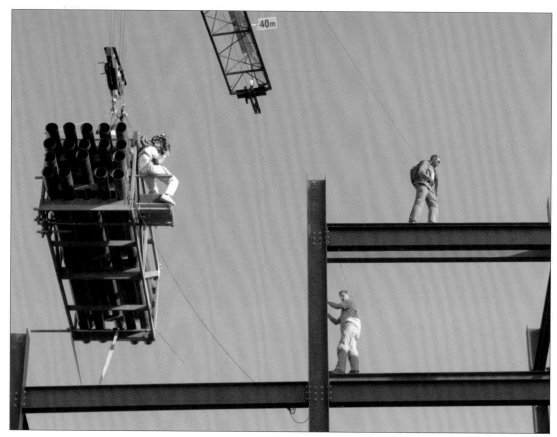

THIS SPREAD: Foucan and Craig filming the freerunning sequence.

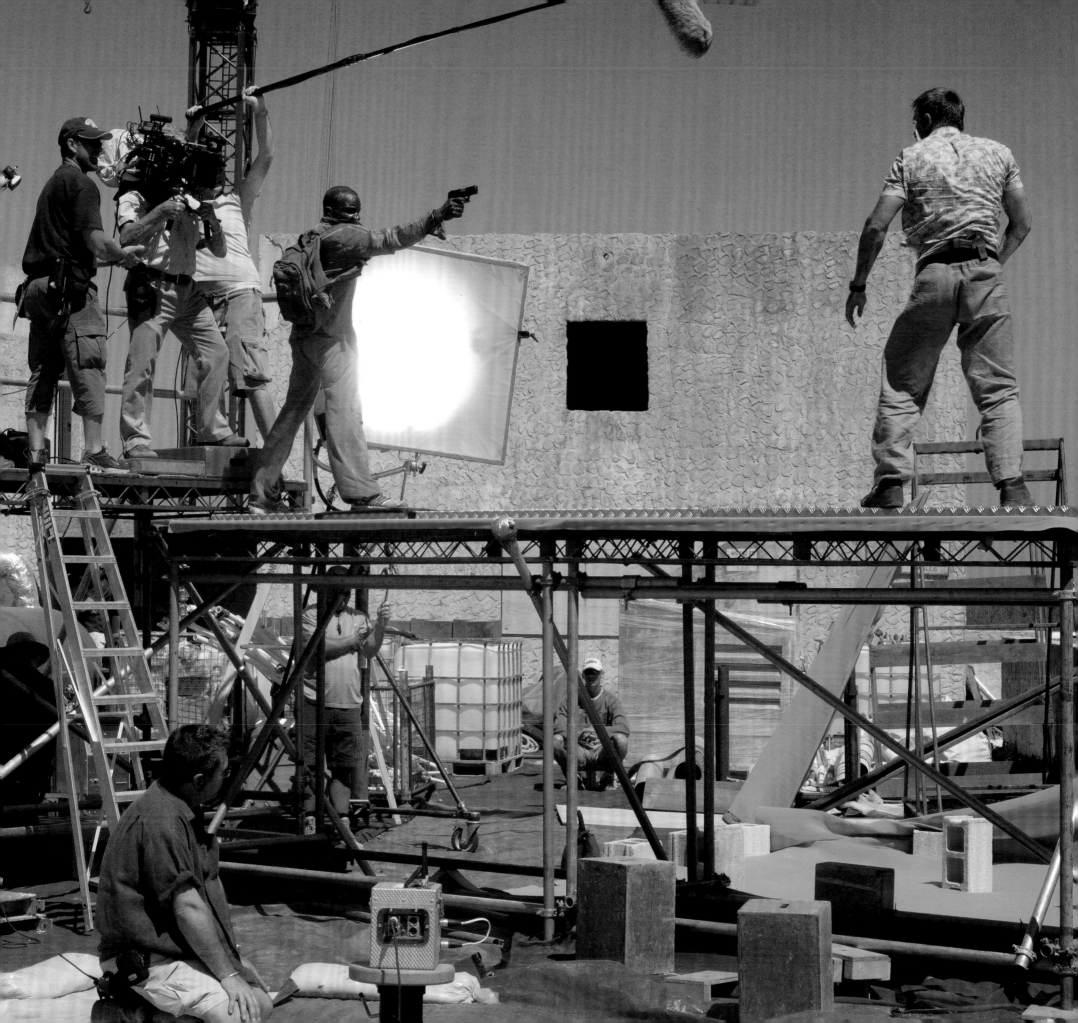

of it, and he was. Early on, we asked him, 'What will you do?' and he said, 'I'll do what I can. I want to do it.' He wants to be seen doing the stuff. There were times when we could have easily used a double, but he was like, 'The audience is going to pay their ten pounds or fifteen dollars to see me doing it,' so we used him as much as we could."

For wide shots of Bond and Mollaka clambering to the top of a full-size crane and fighting along its arm, Craig and Foucan were stood down while four stuntmen, Ben Cooke, Kai Martin, Curtis Small and Marvin Campbell, on wires, took their place, with second unit director Alexander Witt filming them either from the vantage point of a helicopter or else on the girder itself, shooting with a helmet cam. For medium and close-ups of Craig and Foucan atop the crane, a separate girder arm was balanced on the top of a low building, 110 feet in the air, with both actors attached to safety wires.

To escape Bond, Mollaka leaps from one crane to another and then onto the roof of the nearest building, which is still under construction. Stunt doubles Cooke and Adam Kirley jumped from one crane to another, before crashing onto the nearest rooftop. "That was all done for real," says Campbell. "There was no digital. It was all done with a wire, the whole thing. I wanted the guy to jump from one crane to another, but I wanted it all in one shot. I said, 'I don't want any jump [cut]s or cheats. What he's got to do is jump off one crane, land on the other, run along, and then jump off that crane.'"

"Everyone realised the previous film had embraced visual effects slightly too much, and we wanted to come back to what the Bonds were known for and create a stunt and make it feel real," says McDougall.

"I set the jumps up and pushed it to the limits of what a human being could do," reveals Powell. "There are people like Sebastien and [founder of Parkour] David Belle who can jump 25 feet to the ground, so I wanted to make sure what we were doing was achievable and not unbelievable."

"It took much rehearsal," says Campbell. "Then the second unit spent eight hours shooting it."

Even Craig took the plunge, jumping 110 feet off the girder onto an air bag below. "For any actor, it's intimidating," says Powell. "I give him full credit to switch off, do the performance, and do the action beats he did." In fact, Craig did a lot of the action himself. "He ran up the crane. He did the fight on the crane. He ran across the girders, all the rooftops, and the building inside. He came through the wall, which was a nice bit, and jumped onto the scissor lift that collapsed. The doubles did the jumps off the cranes, and bits of the fight, but that's only because Daniel was filming with the main unit. If he hadn't been filming with them, I'm sure he would have done a hell of a lot more." Not that Craig was ever reckless. "He's not someone whose ego gets the better of him," continues Powell. "He knows what his limitations are. He'd be like, 'Can I have a go at that?' If he said that to me, then I knew he could. There were times when he said, 'What do you think?' And I'm like, 'There's no need. We're never going to see your face.' He was very sensible, knowing what he could and couldn't do."

"Here's the deal, I didn't know I had a choice," quips Craig. "I didn't know I could have gone, 'I don't want to do this.' I was like, 'Oh, I have to do this, do I? Okay.' I was literally that naïve. That's why everybody, the team, were looking at me, like, *He's game.* Joking aside, maybe the pressure of all that backlash, maybe something got inside me, and that was what I was doing. *I'm going to do this, because I'm going to prove to everybody [I can], for them to go, 'Fucking hell, he can do it.'* Maybe that's where that came from. I don't know."

(Continues on page 58)

THIS SPREAD: Craig jumping 110 feet off a girder onto an air bag below.

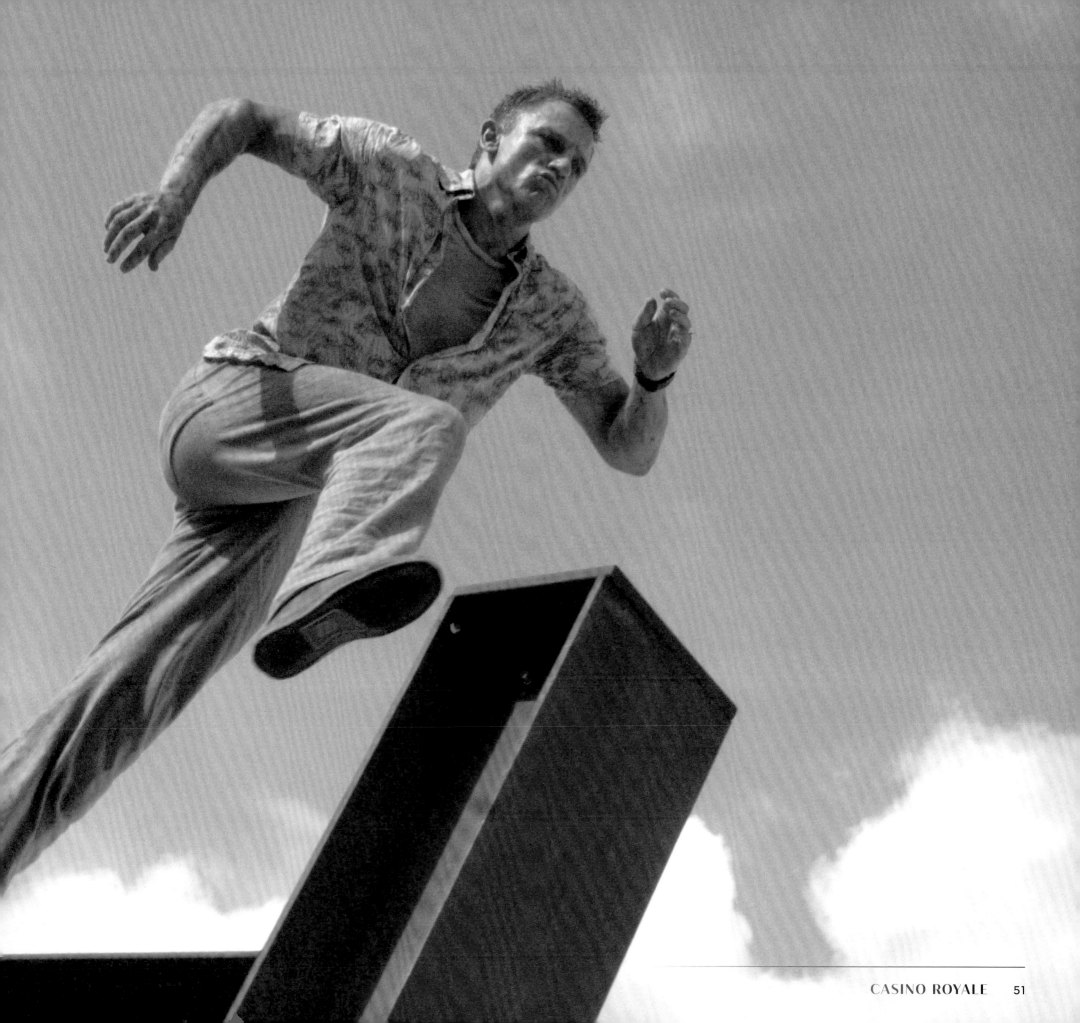

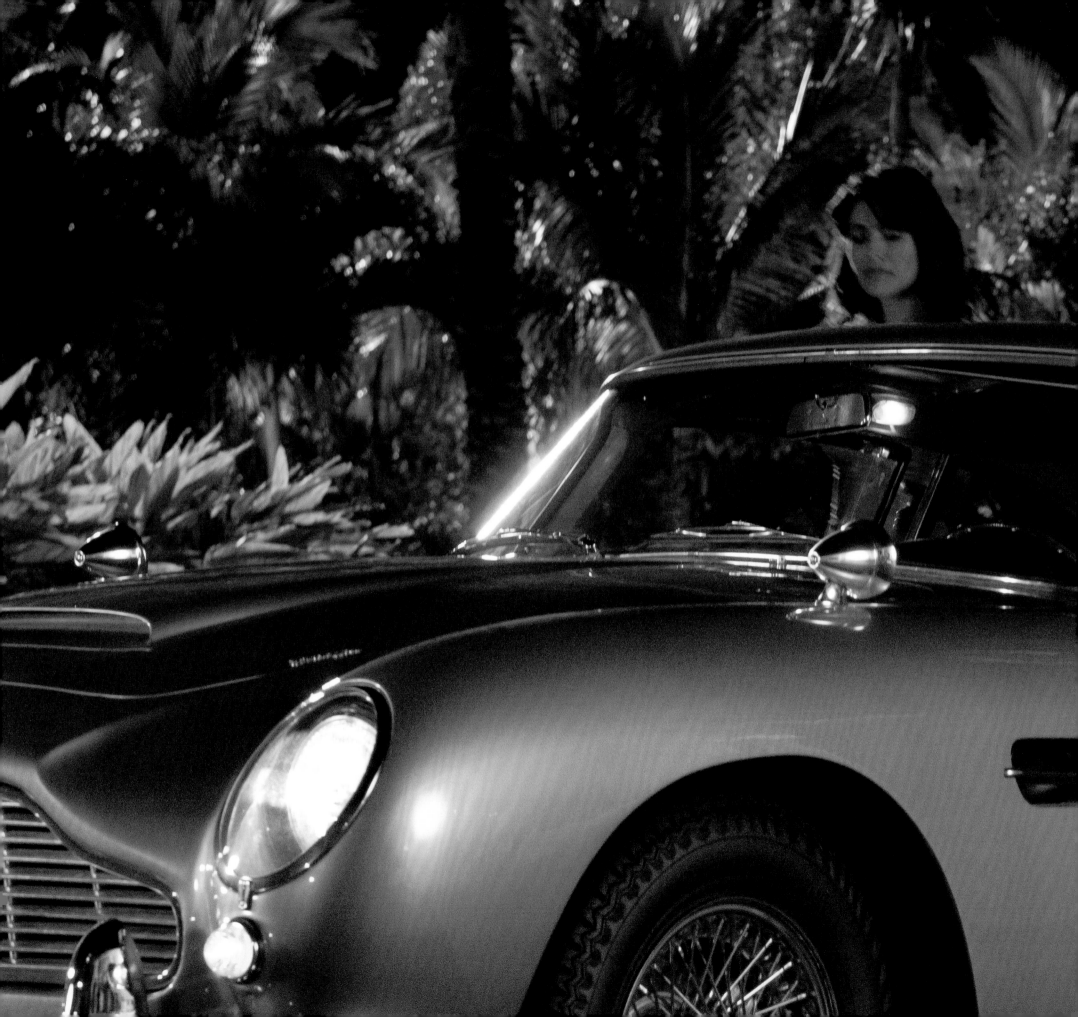

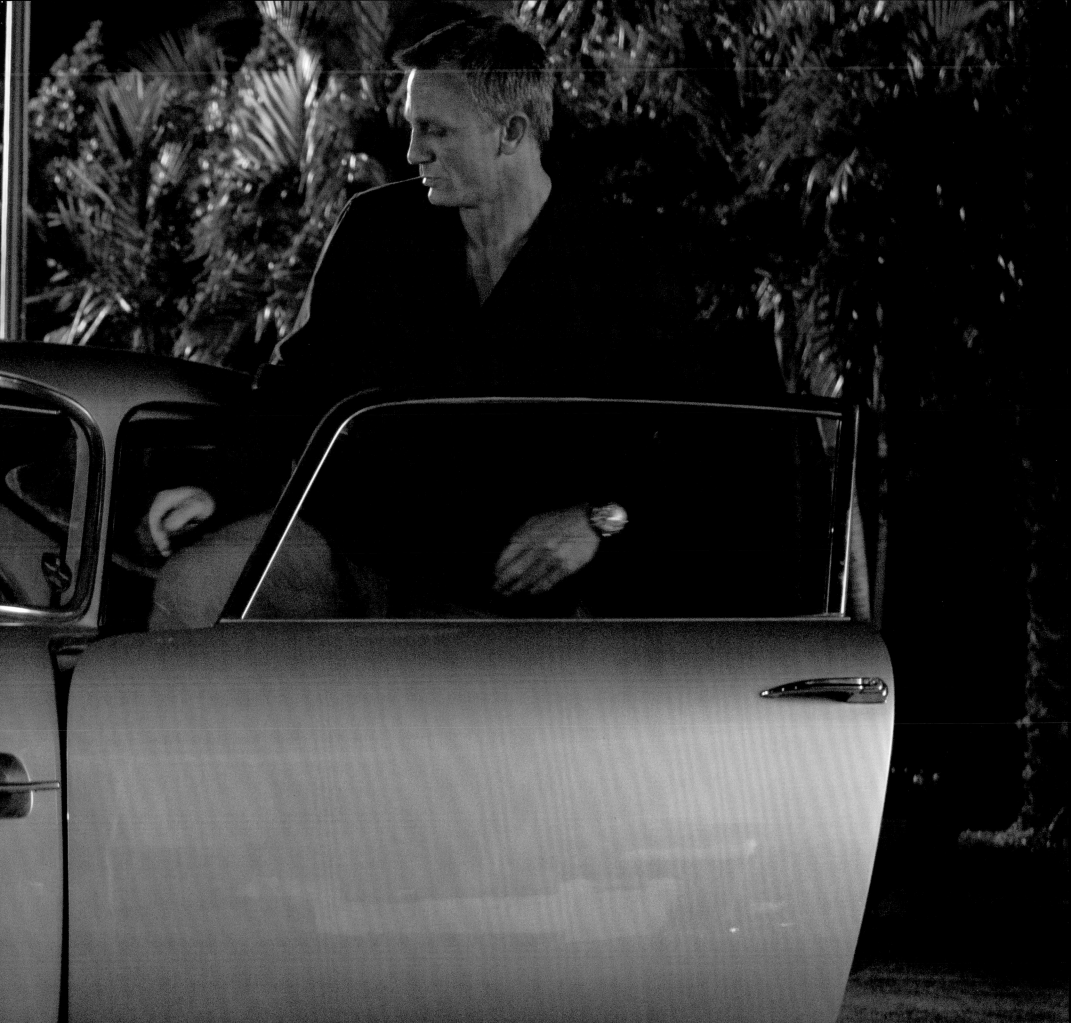

RUNWAY CHASE

After a trip to Nassau in which he wins an Aston Martin DBS in a hand of cards and beds Solange (Caterina Murino), the beautiful wife of the nefarious Dimitrios (Simon Abkarian), Bond hightails it to Miami to thwart a terrorist (Claudio Santamaria) intent on blowing up a prototype airliner on behalf of Le Chiffre, an action sequence which culminates in a runway chase involving planes, police vehicles and a fuel tanker. The chase was shot partially at Prague Airport, which stood in for the interior of Miami International as well as some of the airside shots, up until Bond hurls himself onto a tanker. From that point on, the sequence was filmed at night, for several weeks, on the tarmac at Dunsfold Aerodrome in Surrey, site of the *Top Gear* test track, by both Campbell and Alexander Witt's second unit, with visual effects adding all the landing lights, planes and terminal buildings in post.

"It took a long time," says Campbell. "I did all the close-up work of the fight in the cab between Bond and the terrorist, and that was intercut with Alex's work." Once again, Craig threw himself into the action, doing a lot of the work himself. "He was in the vehicle, fighting. He was hanging off the side of it. He was on top. He was driving it," says stunt coordinator Gary Powell.

PREVIOUS SPREAD: Solange, Bond and the Aston Martin DBS.

ABOVE: Art department design plan of the prototype airliner.

RIGHT: The runway chase.

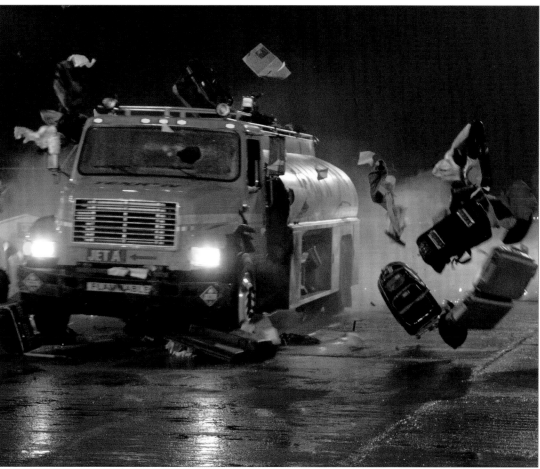

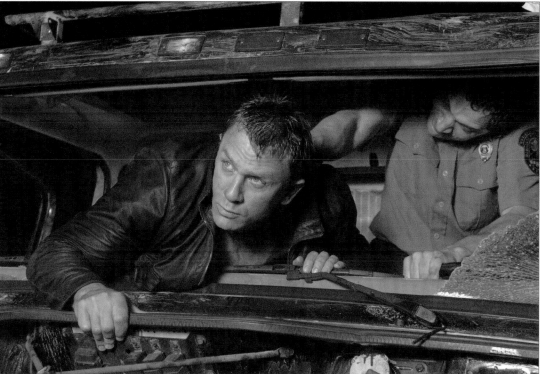

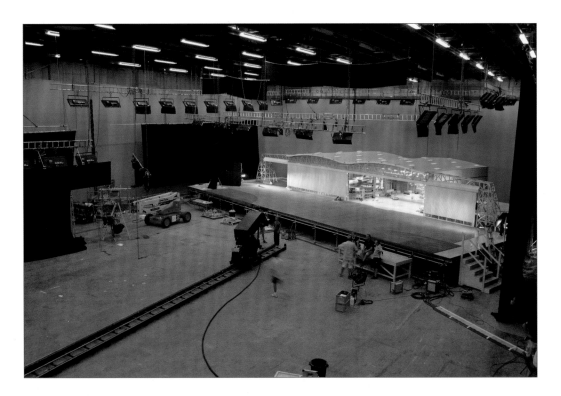

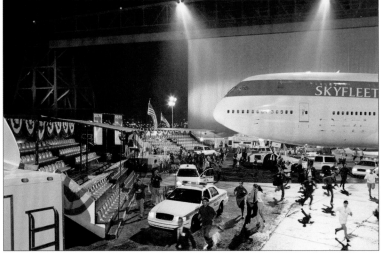

LEFT: FIlming a scale model of the hangar on set at Pinewood.

ABOVE: Crowds flee the unveiling of the prototype airliner

BELOW: Filming the fuel tanker sequence.

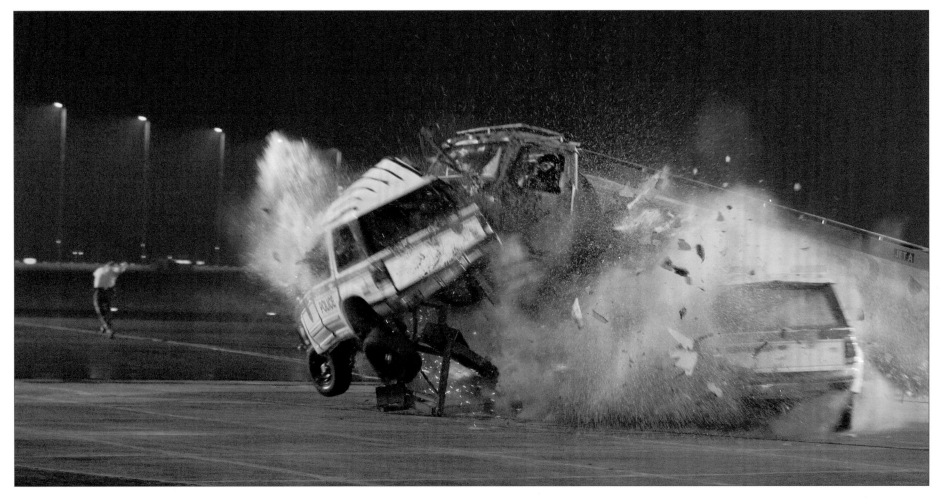

Craig was also crucial to how the sequence paid off. "We'd planned the scene so Bond pulls up and this terrorist confronts him with the gun," recalls Campbell. "It relied on all the old tropes of Bond knocking the gun out of his hand, slamming the truck door in the guy's face. Daniel said, 'No. It's not good enough. We can't do that. Bond has to be clever about this.'" This was a few days before the scene was to be shot. "I remember thinking, *He's right, but how do we solve it?*" Eventually, Campbell had the idea of Bond, when he's hanging out of the truck as it thunders towards the plane, seeing the detonator. "Then you cut away, and when you come back there's a moment where Bond grabs the bad guy's belt, but it's so fast you don't really register what he's done, which is attach the bomb to his belt. So when the bad guy presses the detonator he blows himself up. That was clever, and that came about because Daniel insisted he didn't do any of the old 'knocking the gun out of his hands, kicking him in the balls' stuff. 'Make it clever,' he said. That's a classic case of what Daniel contributes. He did that many times. He was very precise, and really had his head into Bond, insisting, 'No, we can't take the easy way out. We've got to come up with something better.' That's a perfect example of the way Daniel works."

BELOW: The prototype airliner is towed out of the hangar.

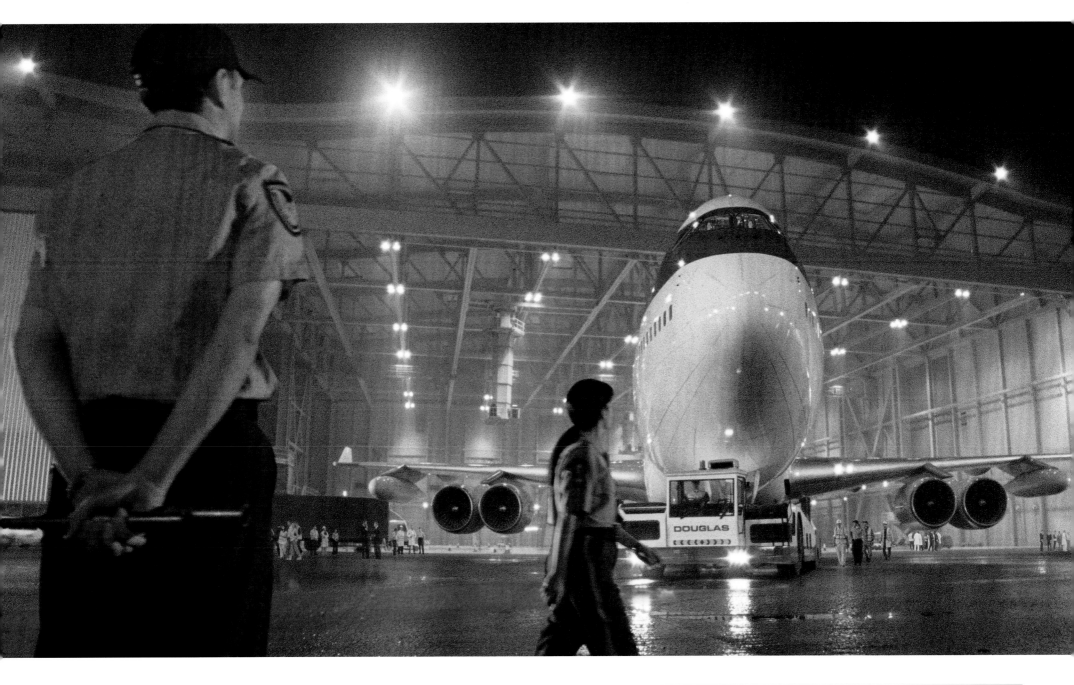

The emotional centre of *Casino Royale* is the relationship between Bond and Treasury official Vesper Lynd. Broccoli's first choice for Vesper was Parisian-born actress Eva Green, whose steamy screen debut in Bernardo Bertolucci's *The Dreamers* had brought her to Hollywood's attention, with Ridley Scott casting her in his Crusades epic *Kingdom of Heaven*. However, Green wasn't interested, and passed early on. "I was probably a bit stupid or naïve," she told *The Hollywood Reporter* in 2019. "I said, 'Ugh, a Bond girl? What kind of prissy girl is that?' They also kept the script secret. It wasn't until they gave me the script [nine months later] that I realised it was a meaty role. I didn't see her as a Bond girl. She's a strong character; she's got cracks."

THIS PAGE: Vesper "Lunch with Bond" costume design by Lindy Hemming (below) and Eva Green wearing the final costume.

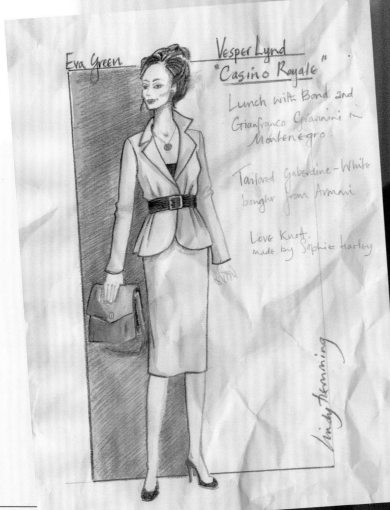

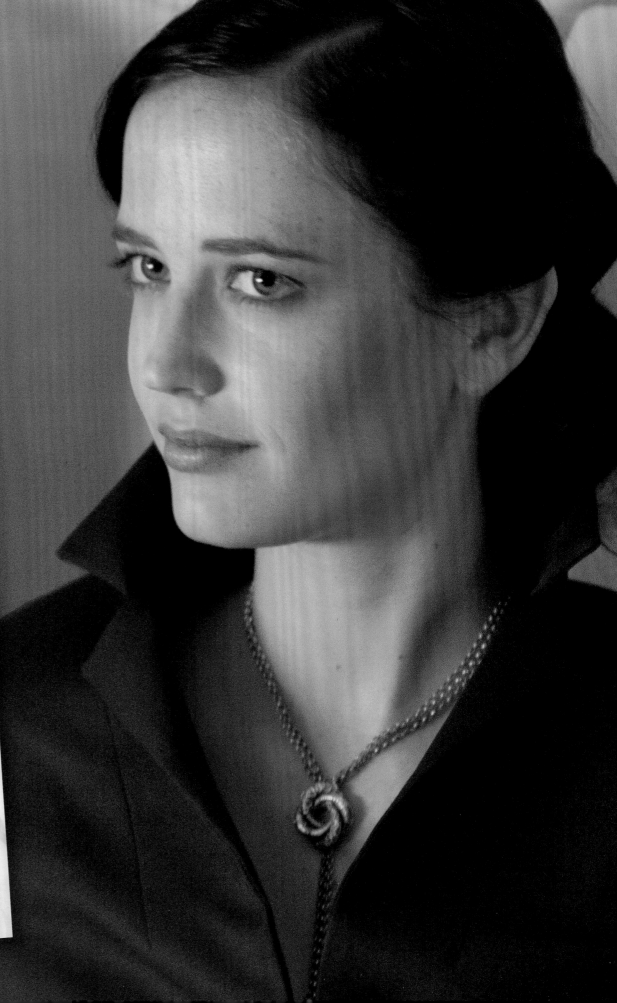

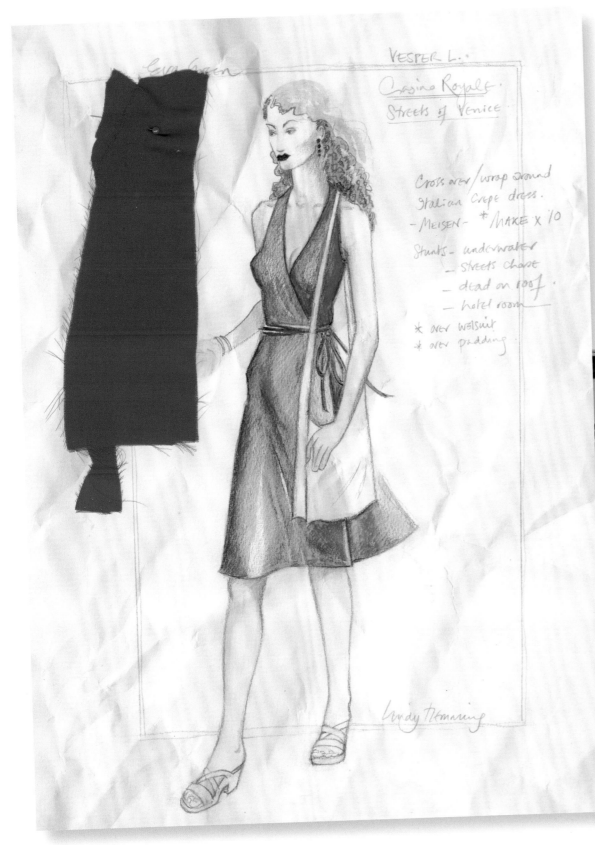

Eva Green

VESPER L.

Casino Royale.
Streets of Venice

Cross over / wrap around
Italian Crepe dress.
- MEISEN - *MAKE x 10

Stunts - underwater
 _ streets chase
 _ dead on roof.
 _ hotel room

* over wetsuit
* over padding

Lindy Hemming

With Green ruling herself out, the production was forced to look elsewhere. "We tested a lot of women for the role," says Campbell. "There were good actresses amongst them, but we didn't feel we were there yet." So much so that they started filming without a Vesper, "because, in our minds, we wanted Eva Green and we spent a lot of time trying to convince her to read the script and, eventually, she did," says Broccoli.

Two weeks into filming, Green agreed to a screen test, in Prague, with Craig. "It was one of the best scripts I've read in a long time," says Green. "Deep, with lots of twists and turns, and the love story moved me. Vesper is a complex person. She is full of secrets and I think that is why James Bond is attracted to her – because he can't really see through her. She has many layers – she's sharp, sassy, quick-witted, but also vulnerable. She and Bond spark off each other, they are always bantering and they understand each other on the surface."

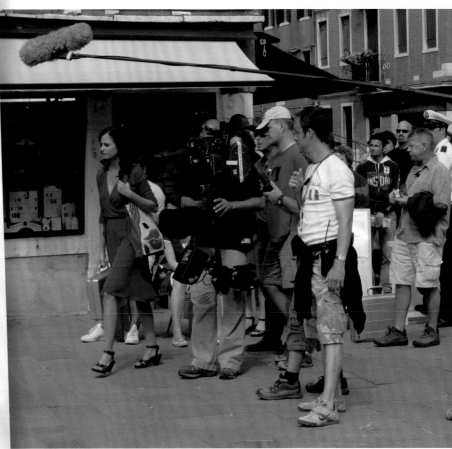

THIS PAGE: Vesper "Streets of Venice" costume design by Lindy Hemming (left) and Eva Green wearing the final costume on location.

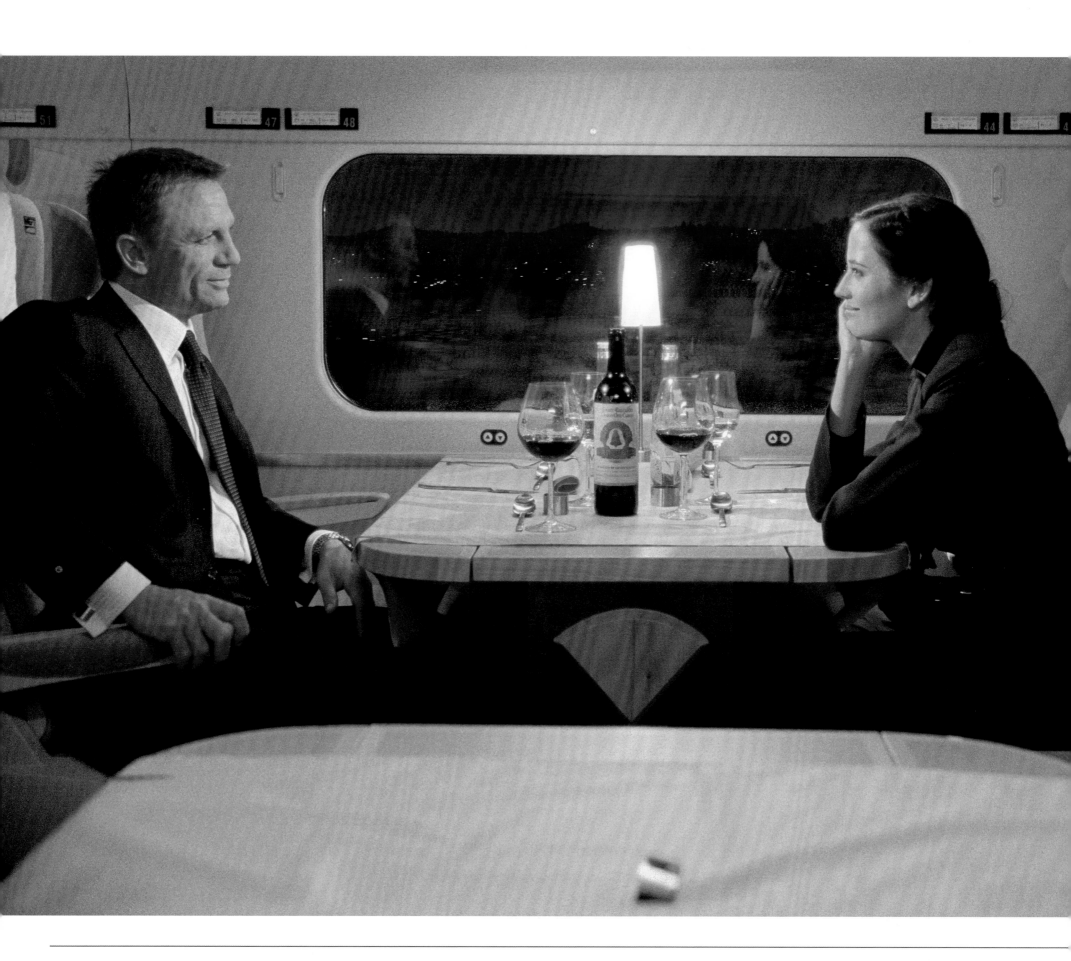

"Vesper had to be mysterious," says Broccoli. "There was a mystique about her and a withholding. That was the most important quality we wanted to get across. There's something she's withholding and it's very enticing to Bond. Eva is one of the most beautiful women on the planet and an amazing actress, and the repartee between the two of them, the chemistry between the two of them was really extraordinary."

"Eva was such inspired casting," agrees Craig. "That's what made that part. It was there on the page, but she was just brilliant in the role."

In the film, the pair meet in the dining car of a train bound for Montenegro when Vesper sits down opposite Bond and announces, "I'm the money." To which Bond replies, "Every penny of it." As introductions go, it was a fairly memorable one, and the subsequent scene, which, as critic Todd McCarthy put it, "crackles with a sexual undercurrent as they perceptively size one another up", was very reminiscent of Cary Grant and Eva Marie Saint meeting on the train in Alfred Hitchcock's *North by Northwest*. "All credit to Paul Haggis," says Campbell, who filmed the scene on stage at Modrany Studios in the Czech Republic. "I mean, they played it very well, but it's a brilliantly written scene. It's almost a masterclass in how you handle exposition, because it says so much about the characters."

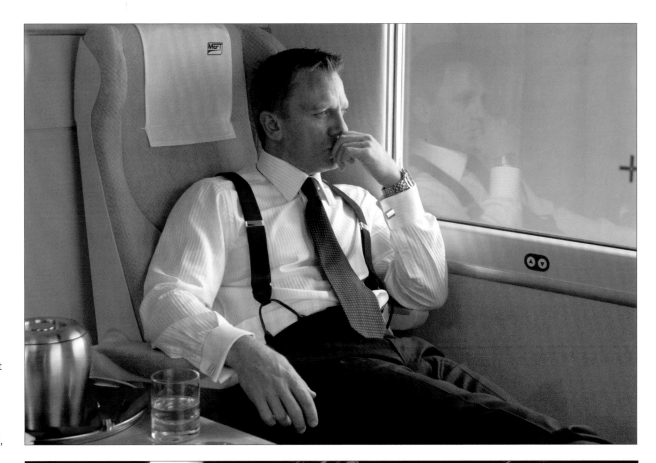

LEFT: Bond and Vesper meet in the dining car of a train bound for Montenegro.

RIGHT: Craig on the train set and the exterior of the set.

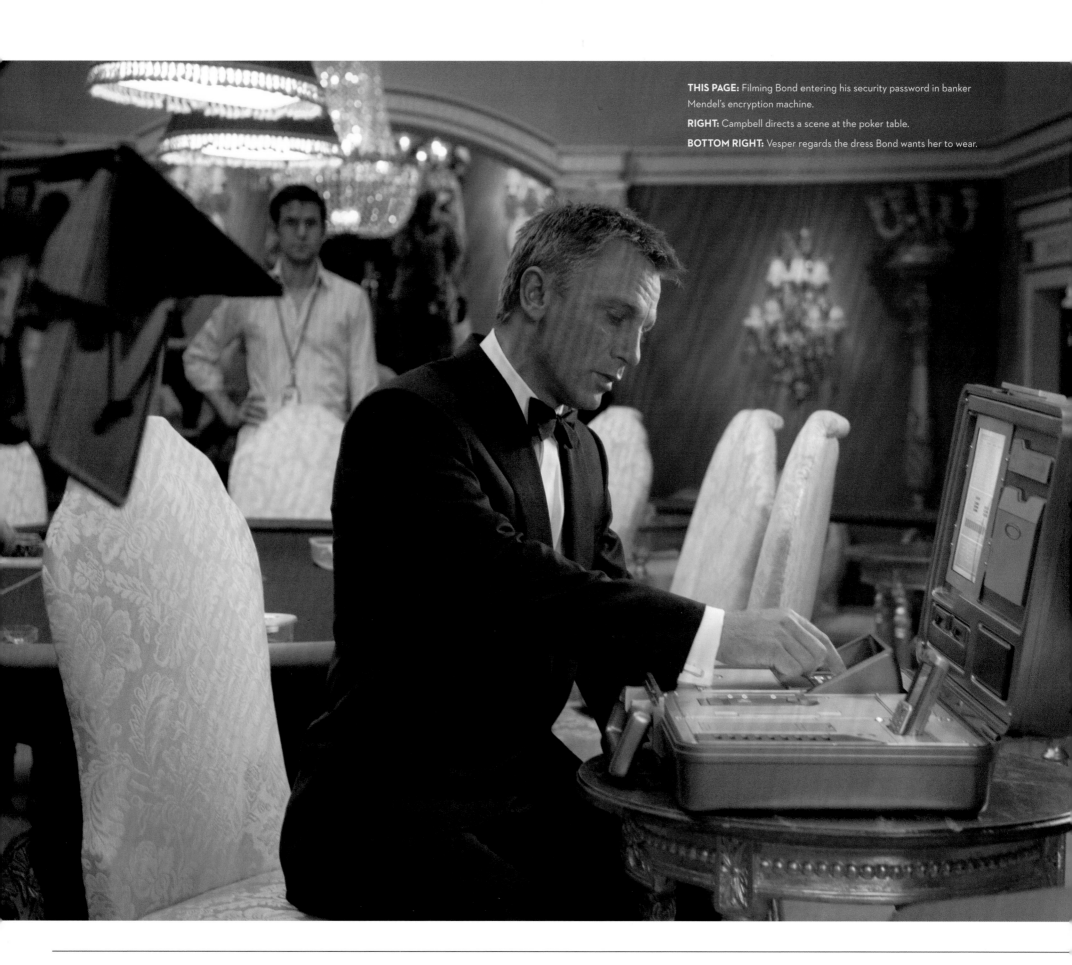

THIS PAGE: Filming Bond entering his security password in banker Mendel's encryption machine.

RIGHT: Campbell directs a scene at the poker table.

BOTTOM RIGHT: Vesper regards the dress Bond wants her to wear.

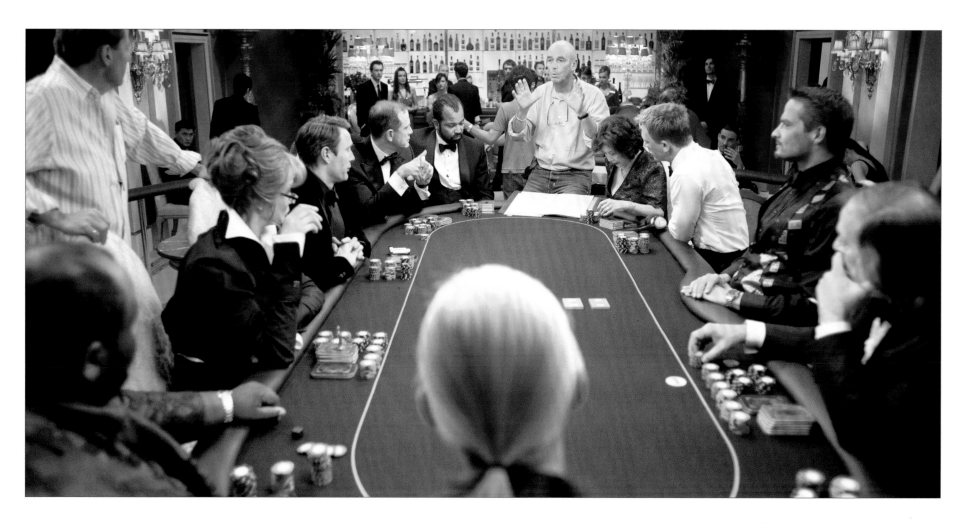

"The plot tells us Bond's going off to play poker, and in poker you never play your hand, you play the person across from you, so Bond has to be very good at reading people if he's very good at poker," says Haggis. "This woman's going to have no respect for this man at all, in fact, has complete disdain. That's a good place to start with a love story. She thinks he's going to screw it all up. He's quite amused. I thought, *Bond's going to read her*. He's going to tell her who she is, where she grew up, the way she speaks, what she's wearing, and he's going to feel very good about putting her in her place. Then she's going to turn around and do the exact same thing to him and he's going to be caught completely off guard, because no one's ever seen through him. Then I had that line at the end, 'How was the lamb?' 'Skewered.'"

Arriving at the Hotel Splendide (in reality, the Grandhotel Pupp in Karlovy Vary), Bond and Vesper connect with grizzled MI6 contact René Mathis, played by Oscar®-nominated Italian actor Giancarlo Giannini. Later, in their suite, getting ready to head out to the casino for the first time, Bond hands Vesper a slinky dress he wants her to wear to distract his fellow gamblers, and Vesper

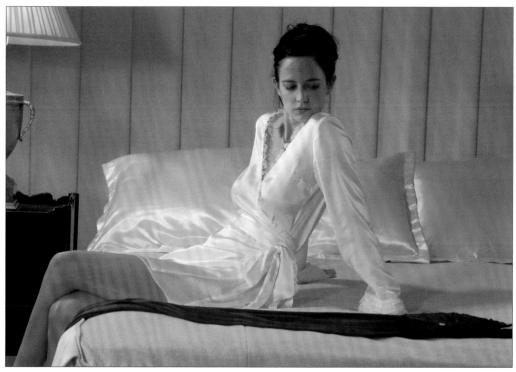

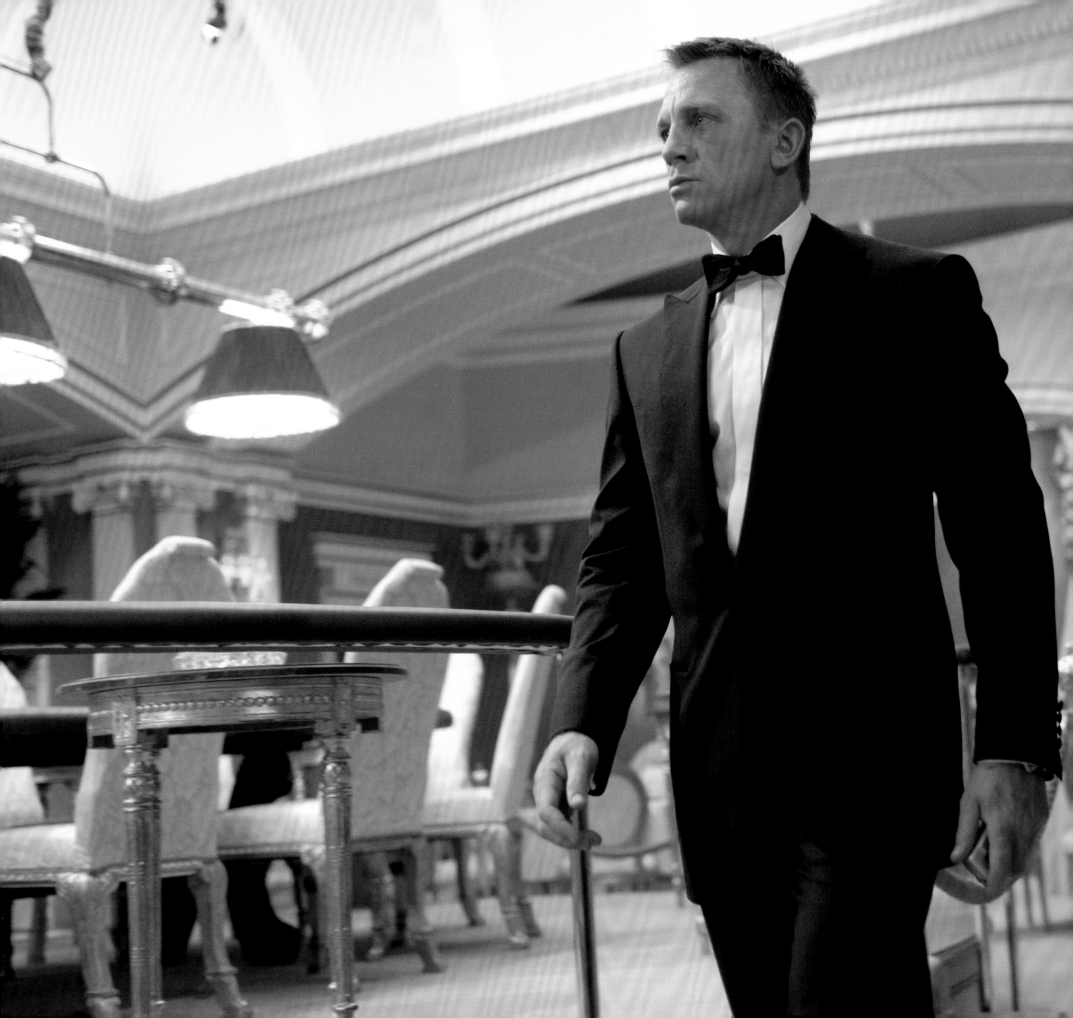

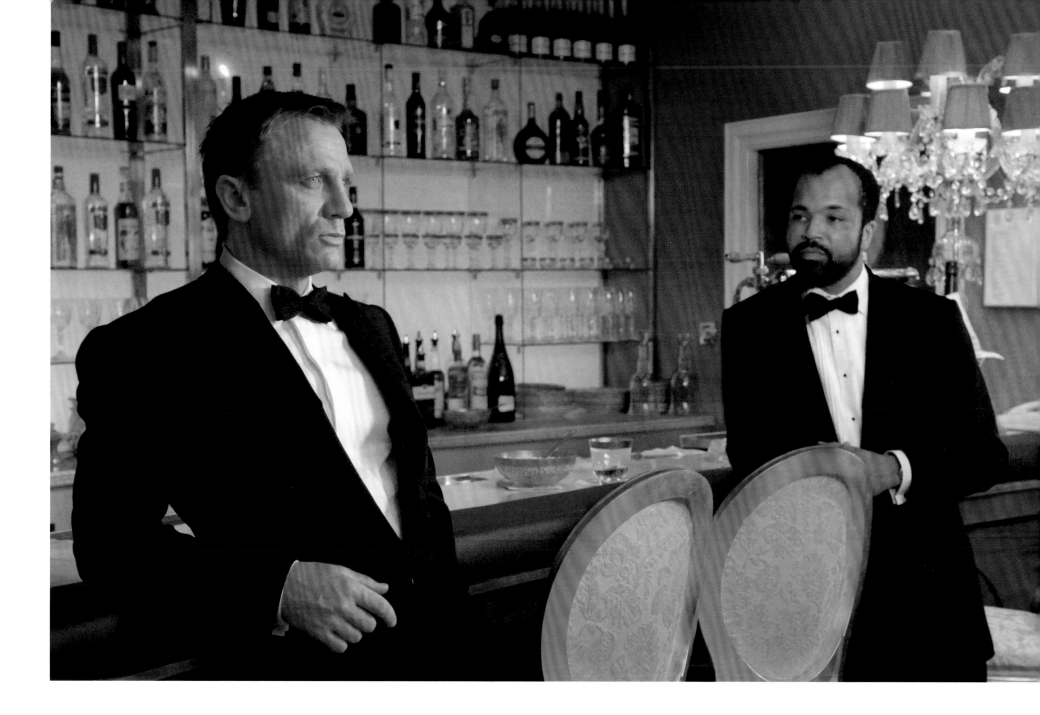

throws him off balance by presenting him with a tuxedo in return.

"She plays it beautifully," says Campbell. "Bond, with his very chauvinist attitude, 'I want you to wear this dress so their eyes will be looking at you, not on their cards,' and then he goes back and sees the tuxedo laid on the bed, which I thought was a really lovely moment."

"It's my favourite scene," reveals Purvis. "It's all so natural. It's not like a Bond movie. It's more like a drama. And when he looks at himself in the tux, we all know he's worn a tux before in the films, but, for him, it's like the first time."

Fleming had Bond and Le Chiffre play chemin de fer, a variation of baccarat. For the film, the game was updated to Texas hold 'em, "because poker is a game of bluff and strategy which offers more dramatic possibilities on screen," explains Wilson.

"Michael was very instrumental in the whole poker scene," says Broccoli of her brother and fellow producer. "He's a big poker player, so he taught everybody. The central card game is twenty minutes long, and even for people like me who don't understand poker at all, it was completely riveting. I felt as if I understood it, because it was so well presented, and Michael was at the centre of that, teaching everyone, having poker masterclasses."

"We rehearsed the cast on simple things," remembers Wilson.

OPPOSITE: Bond in the casino.

ABOVE: Bond and Felix Leiter (Jeffrey Wright).

"How to hold the cards, how to look at them, how to protect your cards, how to deal with the chips, to give them all different characteristics. We played a lot of games until we finally got to a point where they seemed to make sense dramatically and emotionally and had all the tension we needed."

The game took three weeks to film, with Campbell concerned it wouldn't be cinematic enough to keep audiences engaged. "I was terrified," he admits. "It was the most difficult thing I've ever had to shoot, ten players round a table, all looking at their cards and each other. Maintaining the tension was a nightmare. Between the games, we had Bond being poisoned, we had the fight on the stairs, that was all good, but what about the games themselves?" To prepare, Campbell studied as many movies as he could with card scenes. "I watched *The Cincinnati Kid*, *5 Card Stud*, *Maverick*, and I realised, it's not about the cards, it's about the players. When you've got actors as good as Daniel and Mads Mikkelsen, who are kind of eye-fucking each other across the table, that's what you're riveted to. Now I think they're some of the best sequences in the movie. They're tense, the acting between Daniel and Mads was absolutely great, mentally screwing with each other, which I thought was the key to it."

Le Chiffre was played by Danish actor Mads Mikkelsen, who casting director McWilliams first spotted in Susanne Blier's *Open Hearts* (*Elsker dig for evigt*) in 2002. "It was the most fantastic film, and I thought, *Wow, he's good*," she recalls. "Then, when I saw him in *Pusher*, I couldn't believe it was the same person. By this time, we'd set up camp in Prague and, as luck would have it, Mads was there shooting something, so I grabbed him and got him to come in. Then Barbara met him and said, 'Let's get him into costume. Get him into hair and makeup. Let's do the number on him.' So, we did all that, took him on set and Martin said, 'Great to meet you. See you on the day.'"

"He's another leading man and, for a villain who was more devious than powerful, he was still tough," says Wilson.

After the first break in play, Bond and Vesper are heading back to their suite when they're ambushed by a trio of Lord's Resistance Army soldiers, coming to get their money back from Le Chiffre, who lost it all on airline stock when Bond foiled the destruction of a prototype plane being unveiled in Miami. The sequence climaxes in a brutal fight between Bond and the bad guys in a hotel stairwell, with Vesper caught in the middle, forced to watch as Bond kills the men with his bare hands. Choreographed by Gary Powell, the fight was shot on a staircase set at Modrany that was, effectively, made of rubber, "so we could hit the walls harder," says the stunt coordinator. "We put rubber on all the walls, under the carpet, that way, no matter

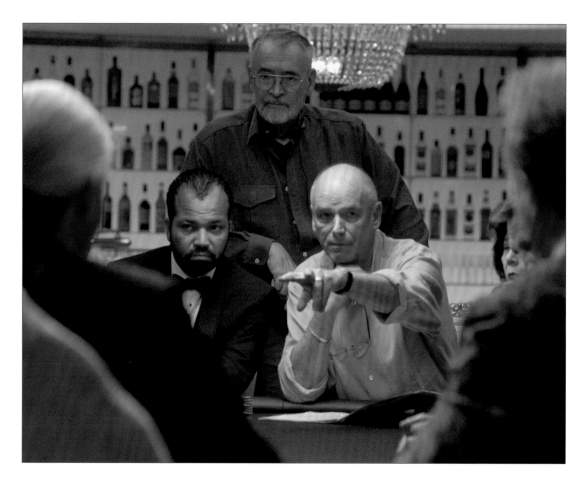

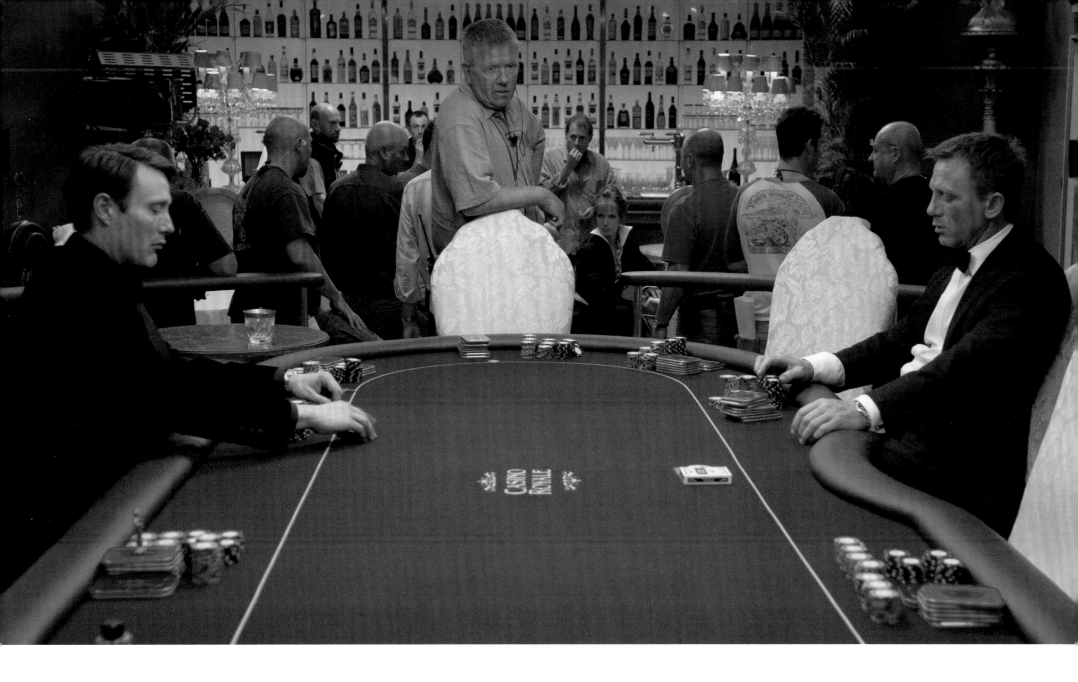

where we positioned the camera, it would be fine. Obviously, there was a cost involved and Michael and Barbara agreed to it. People still took knocks, but it made it easier for us to throw the actors around in there." It took several weeks of rehearsals and four days of solid shooting to get it in the can. "Daniel put a lot into it. He pretty much did the whole of that fight."

As with the opening fight in the bathroom, Campbell wanted it to be ugly and violent. "I had Bond strangling that guy at the end for about another minute in the original cut," he reveals. "Normally in movies, they strangle people and ten seconds later they're dead, but I didn't want this bugger to go down. Bond is trying to choke him to death, but he won't fucking die. He's still kicking and fighting. I got the idea from Hitchcock's *Torn Curtain*. There's a

great scene where they're trying to kill this guy in a room, but he won't go down. In the end, they try and stick his head in the oven. I lifted that concept. I wanted this guy to not die, and so it's horrible. Bond hates doing it, but he's got to, and it's protracted and really ugly." So much so, that the British Board of Film Classification and MPAA in the US asked for the sequence to be shortened. "In both cases, we had to reduce it."

"An assassin isn't somebody who shoots a laser beam from a long way. He kills you with a knife, up close," says Haggis. "There's blood, it's horrible, and you're participating in that ugly death. That shapes you as a human being and makes you into this 'blunt instrument'. So when Bond kills this fellow, not only does he get blood all over himself, he gets blood all over Vesper, and she can't

OPPOSITE TOP: Wright, Michael G. Wilson and Campbell.

OPPOSITE BOTTOM: Mikkelsen, director of photography Phil Méheux and Michael G. Wilson.

ABOVE: Mikkelsen, Hearn and Craig.

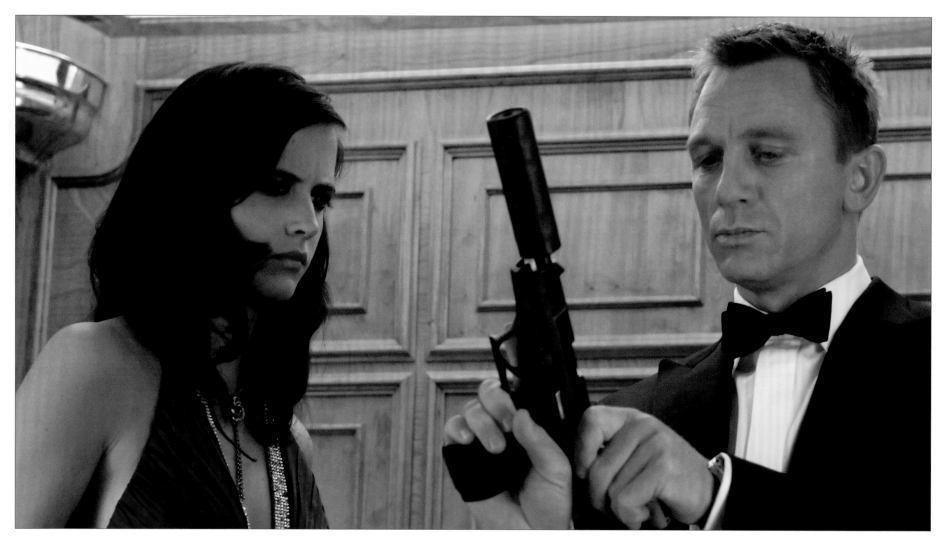

THIS SPREAD: Before (above), during (opposite) and after (right) the fight in the hotel stairwell.

help but see the stakes of what she's involved with. If you've got blood all over, what are you going to do? The shower scene came from that, of the need to create an action scene with emotional stakes, so you're caring not just about Bond, you're caring about her."

Bond ushers Vesper back to their room, before joining her a little later. He finds her sitting in the shower, fully clothed, traumatised by what she's just witnessed. Stepping into the shower, Bond sits down next to her and, without any words, consoles her. "There are moments in that film that are breathtaking," says Broccoli. "The scene in the shower is one of my favourite scenes ever. The moment when he gets in and he puts his arm around her, and the beautiful, beautiful music David Arnold wrote for that scene, I could cry thinking about it, it's so moving. That's the moment they fall in love."

It was Craig's idea that they both be fully clothed. "It all came off her performance. The way Eva played it was someone real, in shock," he explains. "At least two people had been killed in front of her and, like any normal person would be, she was freaked out. I've never been in terrible situations like that, but I've hurt

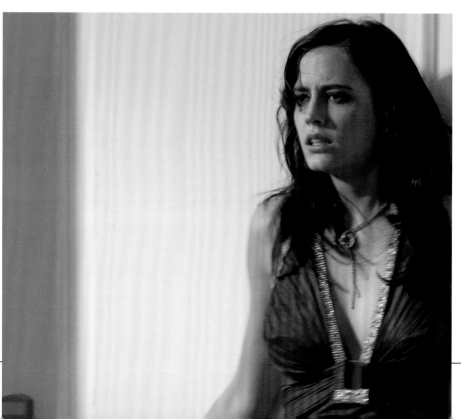

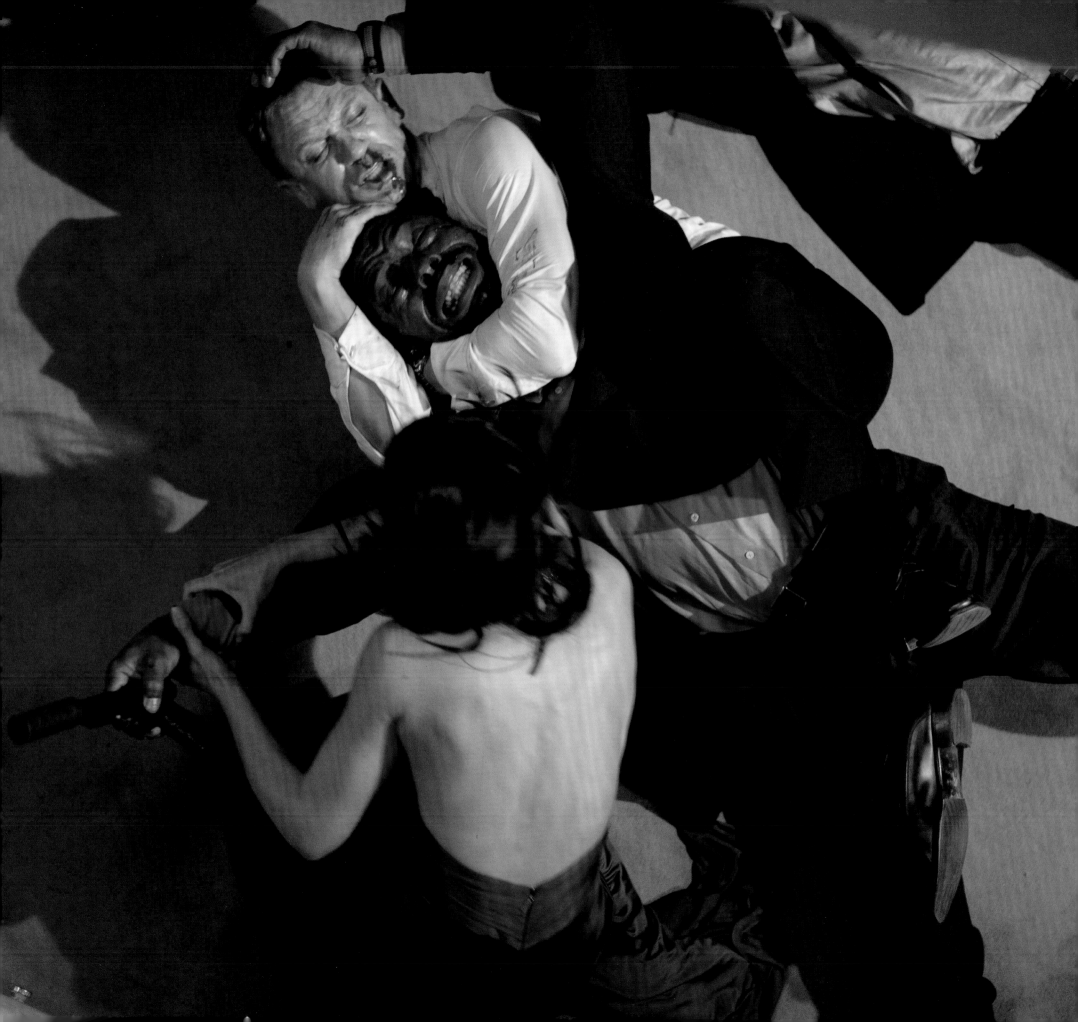

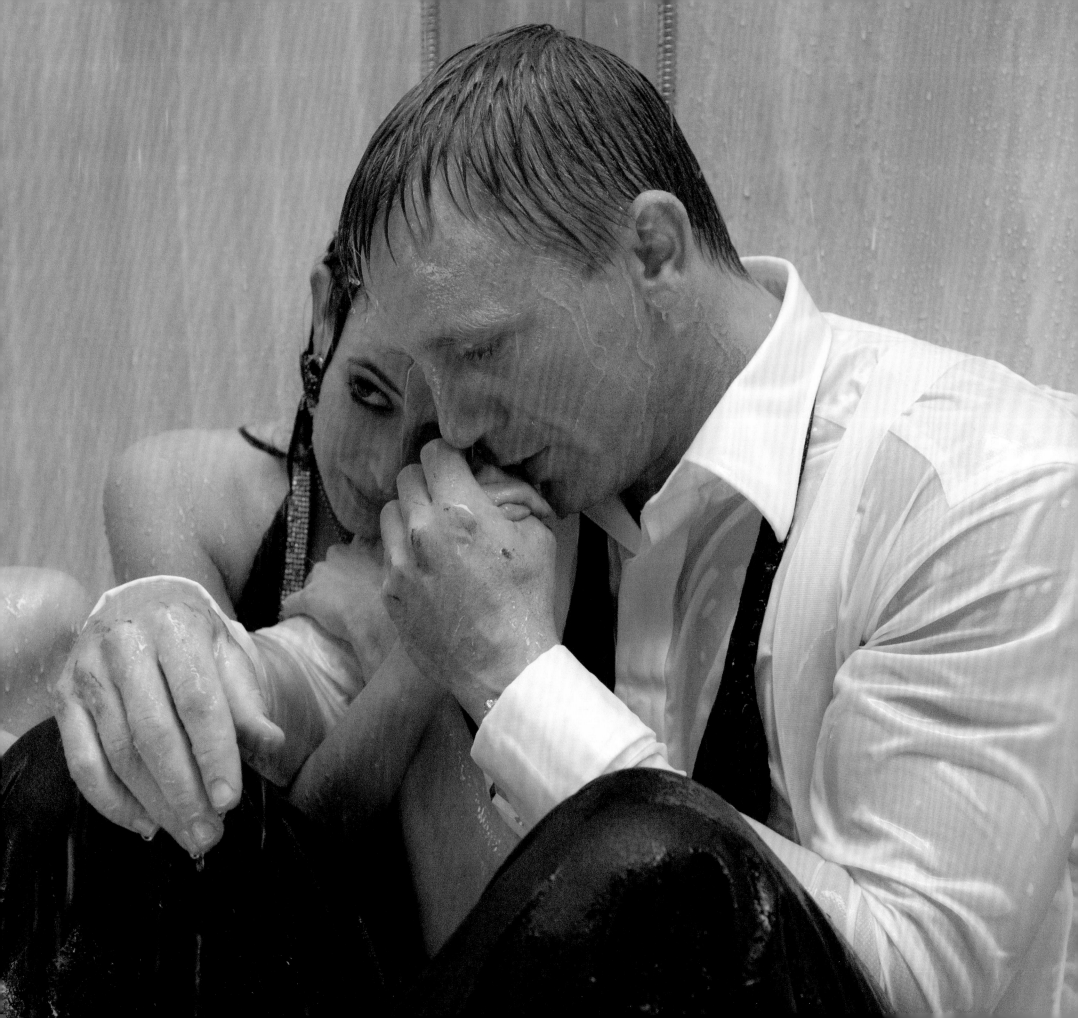

myself very badly, have been in shock and have done really odd things. I fell through a skylight once and really hurt myself, but as soon as I got up off the floor after being knocked out for a couple of minutes I finished watering the roof garden I was on. My friend came over and I was covered in blood. I remembered that very distinctly, and I thought, *That's what you do, you do something odd.* I was like, 'We don't need to see a naked girl at this point. We need to see bodies going through something.' As Barbara says, it's the moment they fall in love. It's the moment of connection, and it needed to be touching and real. I imagined her running around, shivering, having a drink, then going and standing in the hot shower, trying to heat up. I was thinking, *That's what I would do. Sit in the bath with my clothes on.*"

"It was a great idea to do it in their clothes," agrees Campbell. "Then I thought, *This all has to be one take. Let's not intercut. Let's keep it very simple. Daniel comes in, he sees her, he sits down, and the camera just tightens to a tighter two-shot, and at the end he puts on the hot water, slightly. I was very proud of that scene, I thought it was great, and the actors were marvellous in it too."

Casino Royale premiered on November 14, 2006 to almost universal acclaim, going on to score big with both audiences and critics alike, and earning a staggering $606 million worldwide, making it the most successful Bond film of all time (though that figure would be eclipsed by *Skyfall* six years later). "*Casino Royale* hits the jackpot," declared industry bible *Variety*, whose critic Todd McCarthy said the film "sees Bond recharged with fresh toughness and arrogance, along with balancing hints of sadism and humanity, just as the fabled series is reinvigorated by going back to basics." Craig, in particular, was singled out for his portrayal. "Daniel Craig is a fantastic Bond," wrote Peter Bradshaw in *The Guardian*. "And all those whingers and nay-sayers out there in the blogosphere should hang their heads in shame... Craig was inspired casting. He has effortless presence and lethal danger... he brings out the playfulness and the absurdity, yet never sends it up."

(Continues on page 77)

THIS SPREAD: Green and Craig filming the shower scene, with Campbell (below).

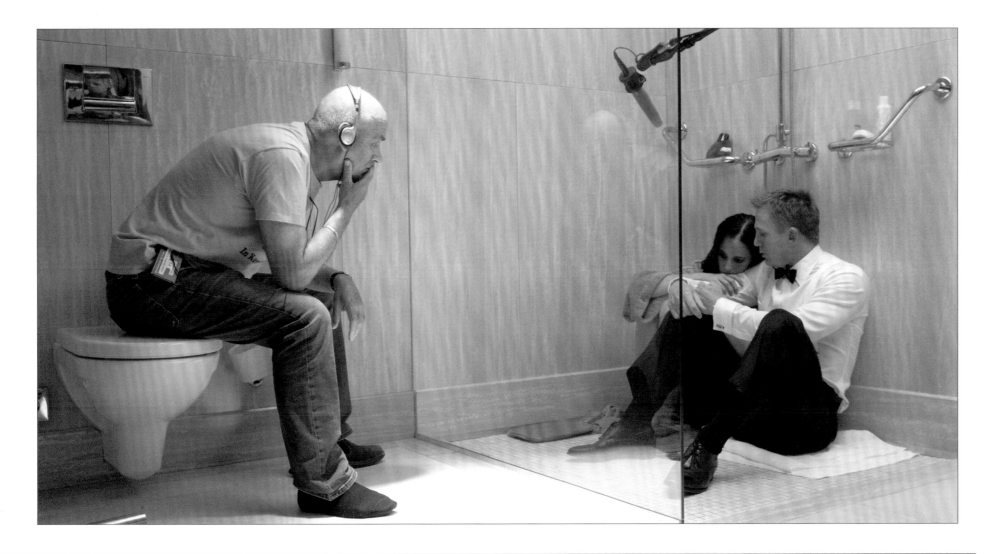

CAR CHASE

Following his withering defeat at Texas hold 'em, Le Chiffre kidnaps Vesper. Bond rushes outside to his Aston Martin DBS and sets off after them. As Bond rounds a dark bend, he sees Vesper tied up in the middle of the road and takes evasive action, his DBS spinning off and flipping over and over seven times before coming to rest in a crumpled heap and setting a new world record in the process. "Martin said, 'I want to see the best car crash I can and I want to shoot it all in one shot,'" recalls stunt coordinator Gary Powell. "Originally written it was a car chase, with both cars thundering on, then they went into some woods. I thought, *How boring is that? Yet another car chase. At night. Really? Come on,*" sighs Campbell. "Then I thought, *Why don't we just shock the audience?* Before it can even become a car chase, there is Vesper, in the middle of the road, and Bond slams on the brakes, the thing flips and crashes."

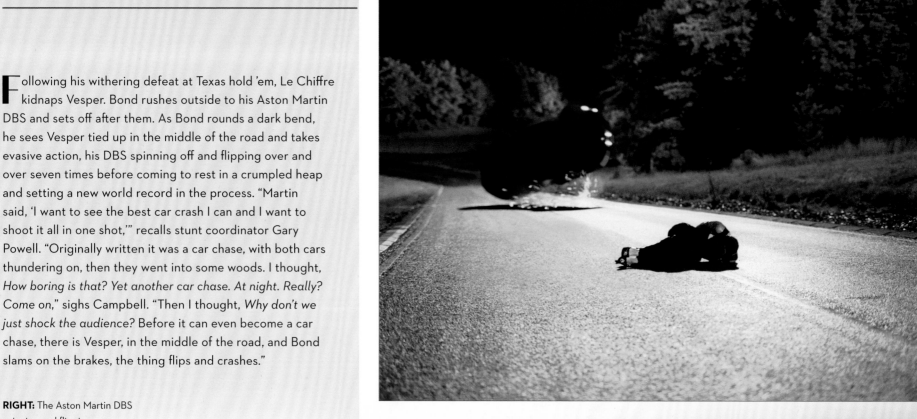

RIGHT: The Aston Martin DBS spinning and flipping.

BELOW: Filming the aftermath of the crash.

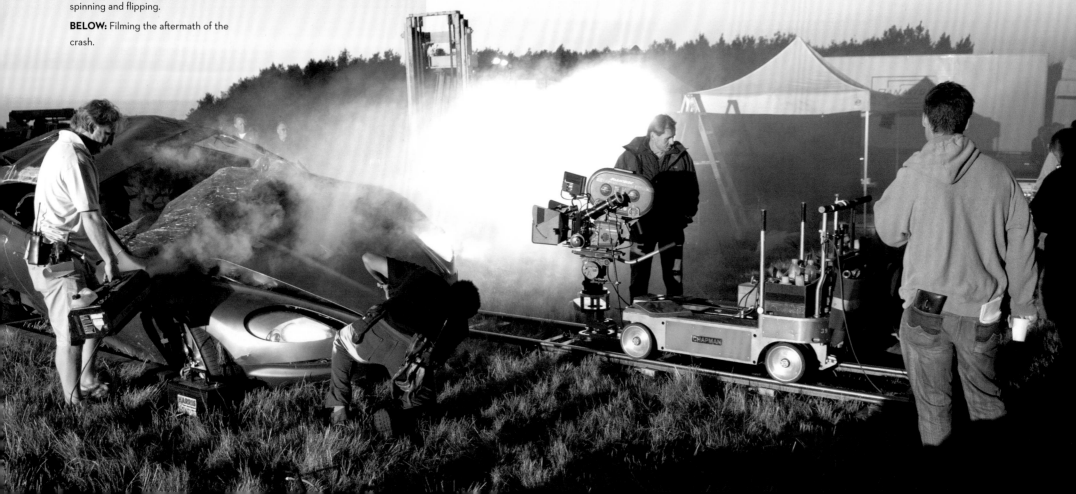

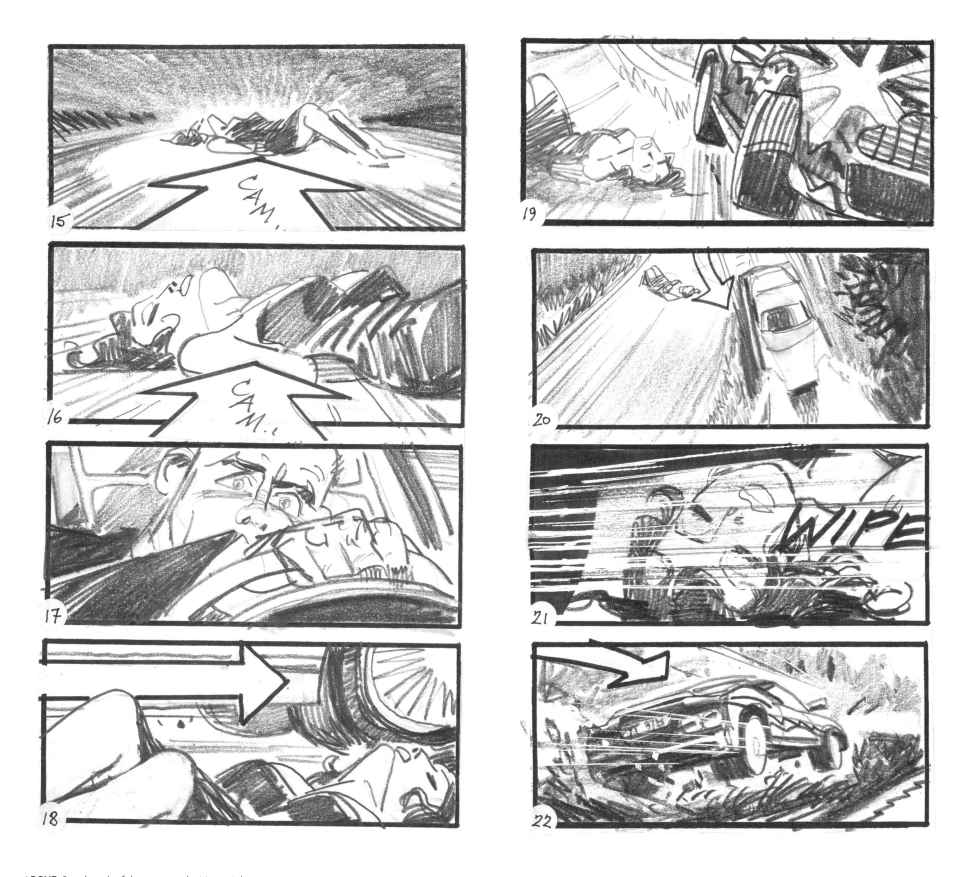

ABOVE: Storyboards of the sequence by Martin Asbury.

TORTURE SCENE

One of the two elements from Fleming's book that Wilson and Broccoli insisted be retained is the torture scene in which Le Chiffre strips Bond naked, ties him to a chair, then beats him with a length of rope (in the novel it was a carpet beater) to try and ascertain the whereabouts of his winnings. "It's a horrifying moment in the book and the fact we got it into the film, where he gets his balls bashed, is amazing," says Campbell. "It was pretty extreme."

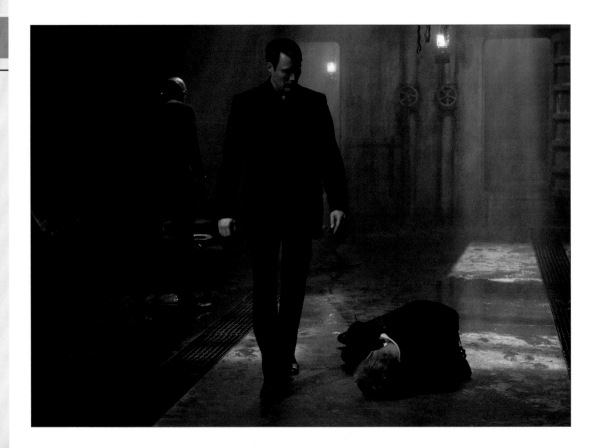

RIGHT: Bond is delivered to Le Chiffre for a brutal interrogation.

BELOW: Concept art of the torture scene.

OPPOSITE: Bond and Le Chiffre, between beatings.

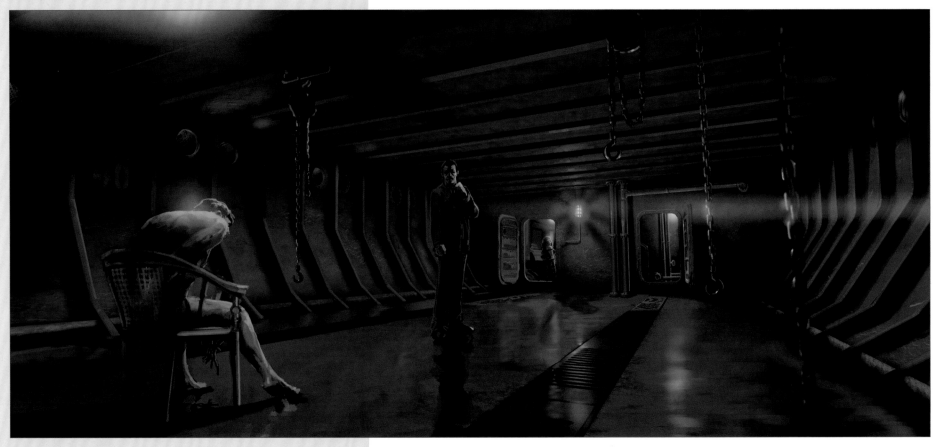

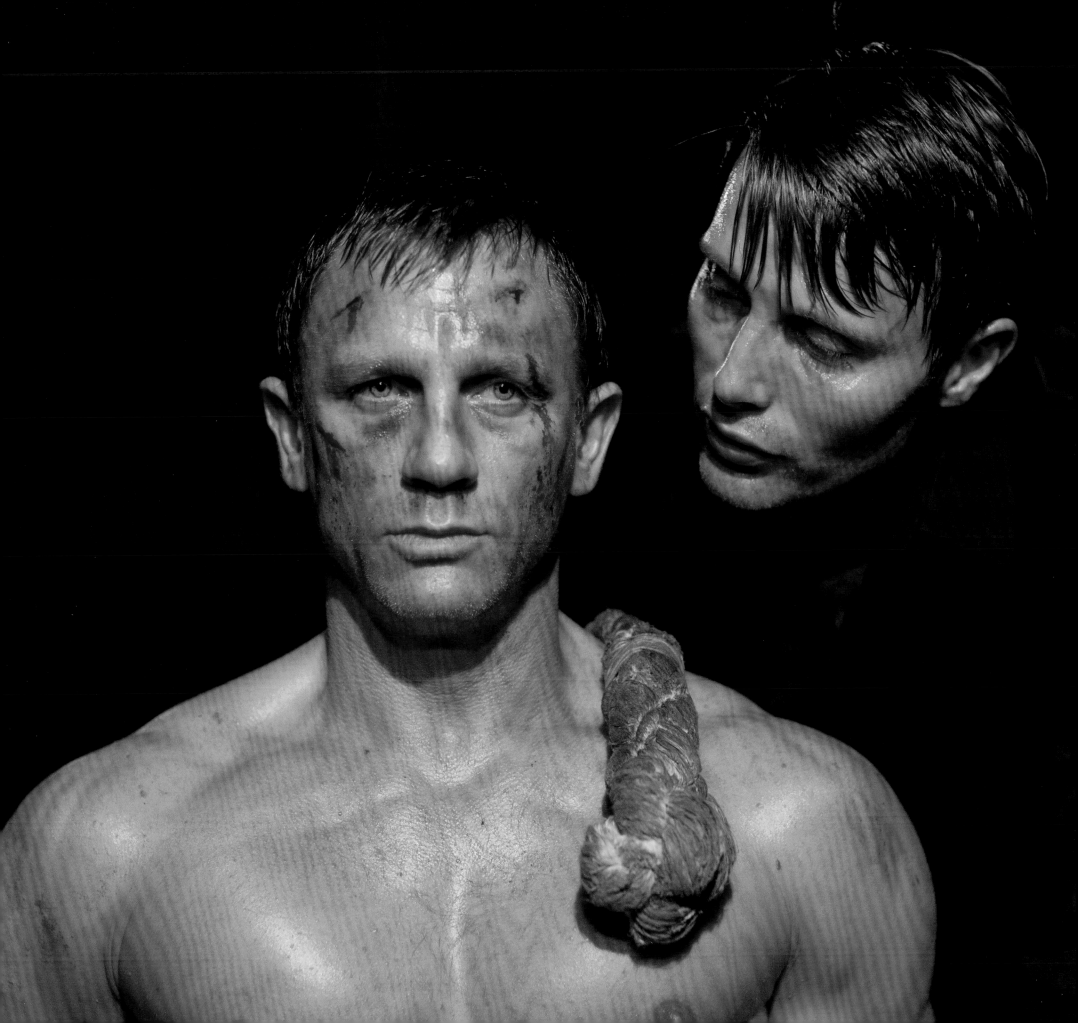

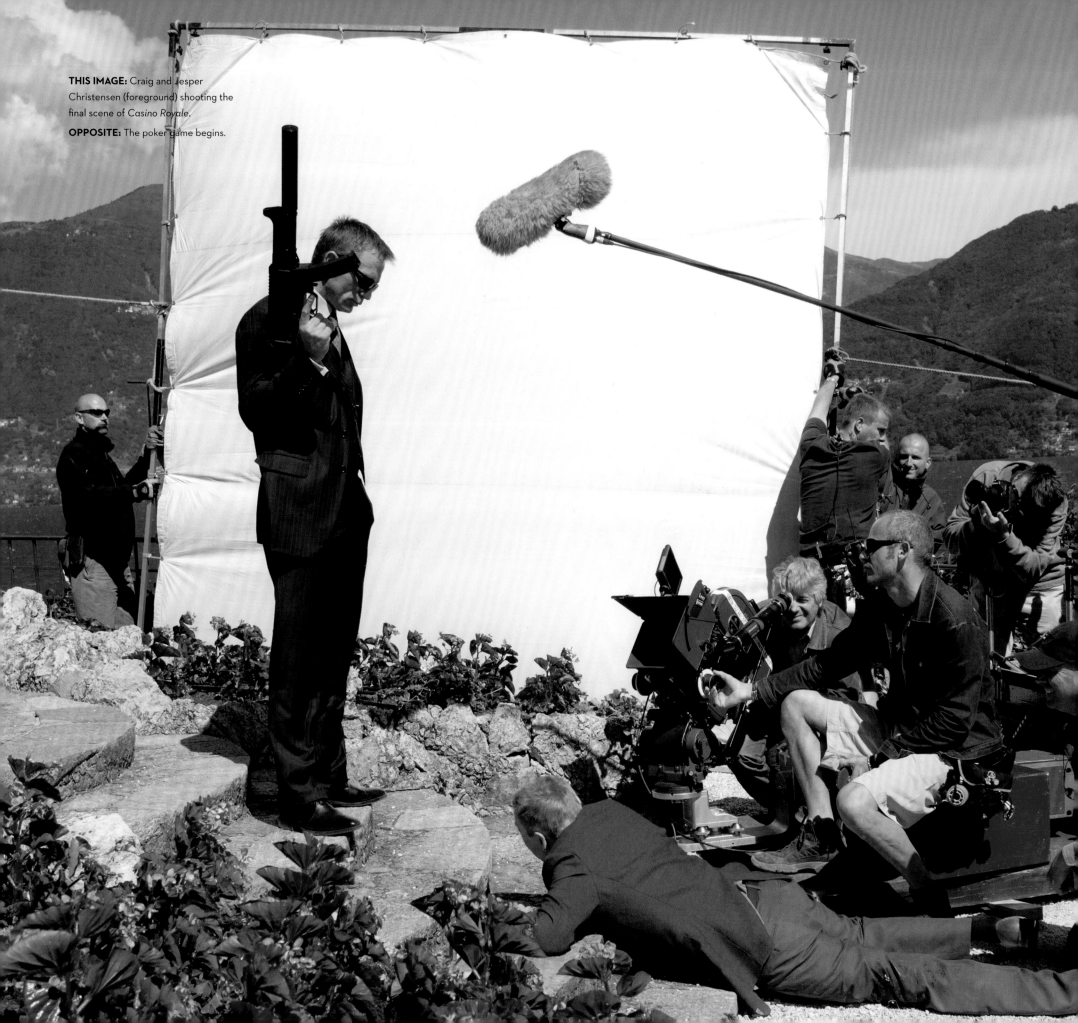

THIS IMAGE: Craig and Jesper Christensen (foreground) shooting the final scene of *Casino Royale*.
OPPOSITE: The poker game begins.

Almost overnight, Craig had become a global superstar and a household name. It was a far cry from the dark days of October 2005, following the film's press launch, when newspaper headlines openly mocked: "The Name's Bland, James Bland." Despite the tabloid turnaround, Craig says he never felt like gloating. "Never. A lot of people said that to me, especially after it came out. 'You must feel like telling them to go fuck themselves now? That must feel so good.' And I was like, 'I don't feel that at all, actually.' I knew we had a great script, I knew we had a great cast, I knew we had a great director. I knew we had the backing of EON Productions, MGM and Sony. They were putting their weight behind it, because they had faith in it. I was like, 'If you've got faith in it, I've got faith in it. That's all I need.'"

Craig recalls being in a hotel in Switzerland with Bond producer Barbara Broccoli and Sony studio chief Amy Pascal just after *Casino Royale* was released in America. "Barbara and Amy were in the bar. They were waiting up for the figures, because the figures were officially going to come out that evening. I didn't realise what they were doing, so I said, 'I'm off to bed. Okay. Bye-bye.'" A little while later, Craig's phone rang. "I was in bed, asleep, the lights were out, and Barbara said, 'Get down here now.' I went, 'What?' 'Get down here now!' I thought I was in trouble. Literally thought, *What's happened? It's all over. That's it. Swing and miss. Okay.*" But when Craig rejoined the two women in the bar, they had ordered him Bond's favourite tipple, a vodka martini, and pushed it across to him. "Barbara went, 'It's a hit.' That's the moment where I... It was difficult to take in. I was like, 'You mean it worked!?' She's like, 'It worked.' It was like, 'Oh, okay.' And my next line was, 'Does that mean I have to do another one?' The two women nodded. 'Fuck you.'"

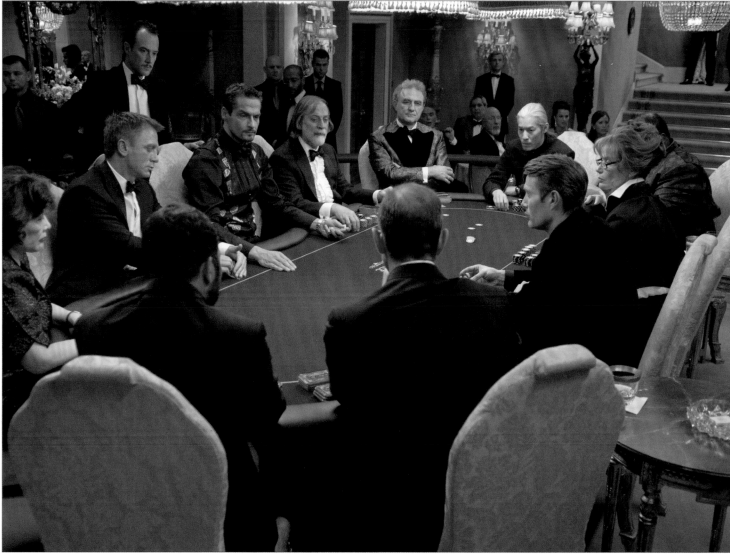

QUANTUM OF SOLACE

QUANTUM OF SOLACE

Before *Casino Royale* was released, producers Michael G. Wilson and Barbara Broccoli started work on a follow-up, bringing back Neal Purvis and Robert Wade to write the screenplay for *Bond 22*, a film they intended to be a direct sequel – a first for a Bond movie. Martin Campbell, however, had already ruled himself out of directing and so, Wilson and Broccoli approached *Notting Hill*'s Roger Michell, who had originally passed on *Casino Royale*. This time Michell, who had directed Daniel Craig in two low-budget British films, *The Mother* (2003) and *Enduring Love* (2004), said yes. Michell visited the *Casino Royale* set to pick Campbell's brains, working up his own ten-page treatment in collaboration with *Ocean's Eleven* screenwriter Ted Griffin, before, eventually, bowing out.

"Roger wasn't confident in doing a big action movie and wasn't confident about the script," recalls Purvis, who, together with Wade, accompanied Michell to the world-famous Palio di Siena horse race in August 2006 to scout for what would eventually form part of *Quantum Of Solace*'s

action-packed pre-credit sequence. "He wanted the script to be completely right before going into pre-production, and the nature of these films is there's a lot of catching up to do."

Wilson and Broccoli took their time finding a replacement, but in June 2007, Marc Forster was officially announced as director of the still untitled *Bond 22*. The Swiss-born Forster's second feature, *Monster's Ball*, had won former Bond girl Halle Berry a Best Actress Oscar® in 2002, and he had recently helmed the comedy-drama *Stranger Than Fiction* for Sony, the studio that had released *Casino Royale* and would be distributing the next Bond. "We wanted someone who could tell a story and who also had a unique visual style," says Wilson. "The minute we met Marc we decided he was the right guy, and it was just about convincing him."

"There is no point in doing these movies unless we're going to do something different, and Marc has incredible range," states Craig. "Look at his movies – *Monster's Ball*, *The Kite Runner*, *Finding Neverland* – they couldn't be more different, more individual. So when his name came up, I was excited about the idea of working with him, because I knew he'd look at Bond and go,

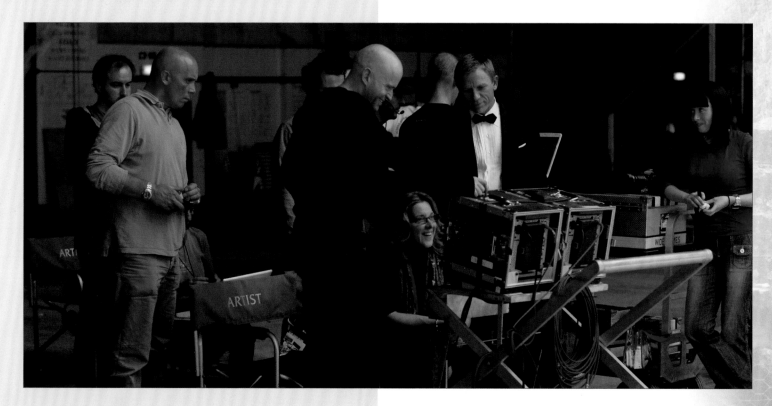

LEFT: Supervising armourer Joss Skottowe, director Marc Forster, producer Barbara Broccoli (seated) and Daniel Craig (James Bond) watch playback of a scene.

RIGHT: Bond pursues a double agent across the rooftops of Siena.

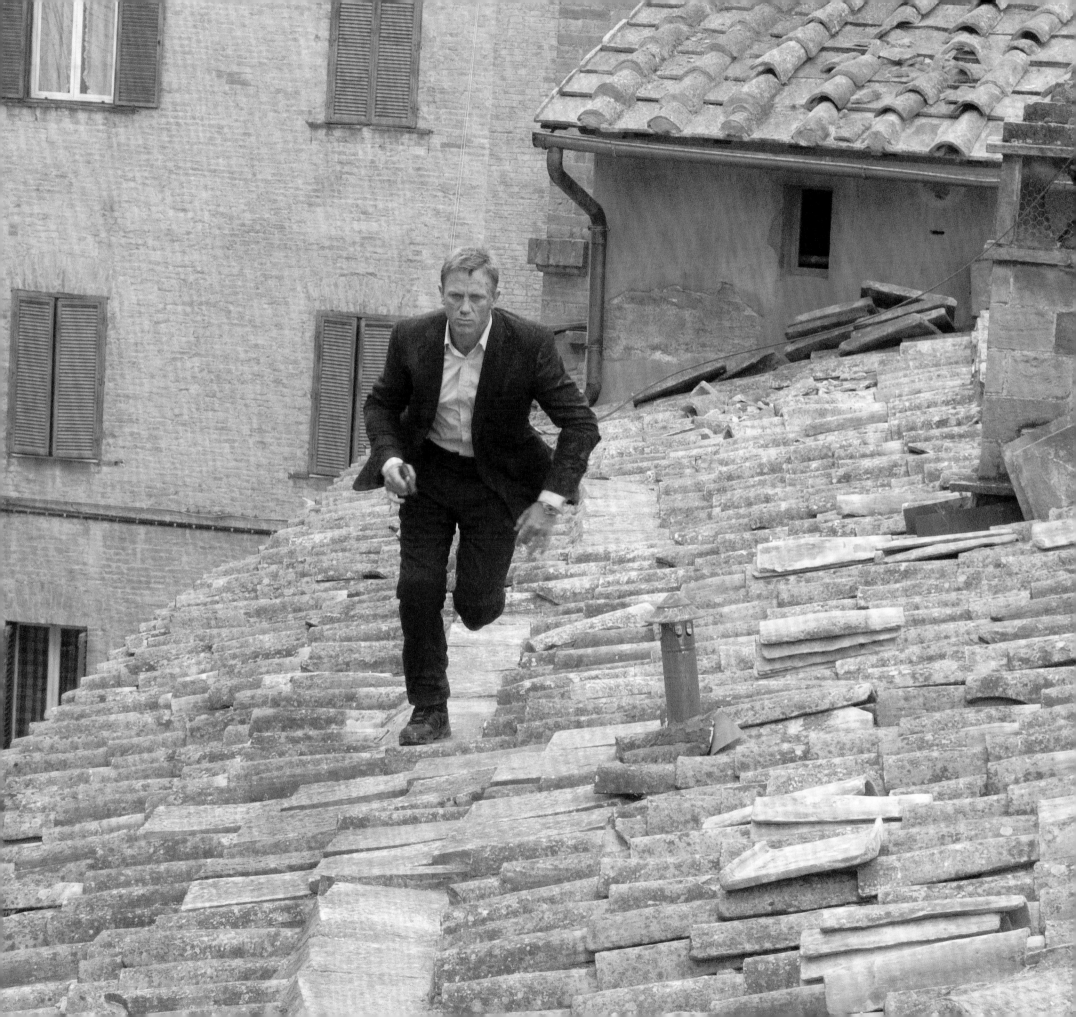

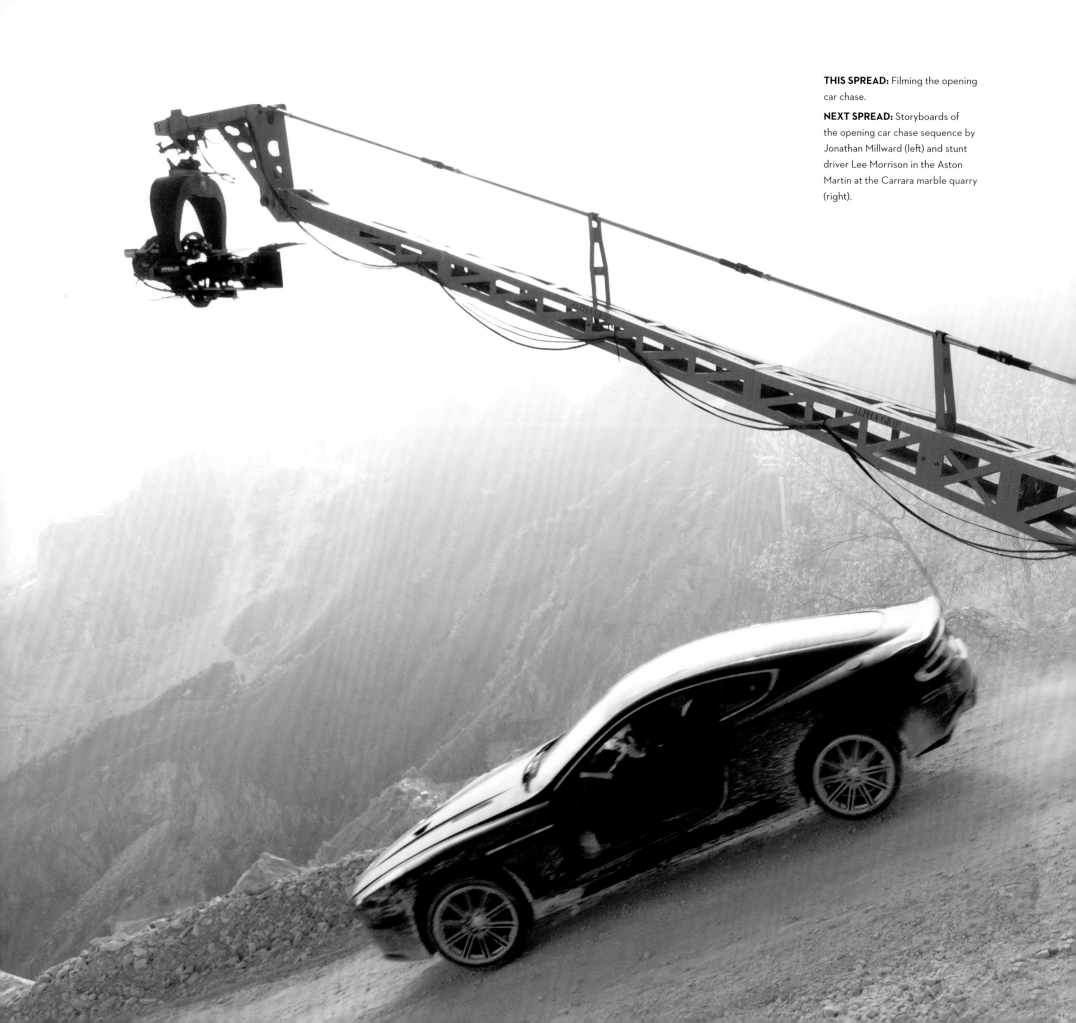

THIS SPREAD: Filming the opening car chase.

NEXT SPREAD: Storyboards of the opening car chase sequence by Jonathan Millward (left) and stunt driver Lee Morrison in the Aston Martin at the Carrara marble quarry (right).

'How do we make this into as good a movie as it can be, but also make it into something individual?'"

Known for being an actor's director, Forster was as surprised as anyone to be asked if he would be interested in directing a Bond film. "I was not an obsessive Bond fan. Like some people are Trekkies, I was not a 'Bondie'," he laughs. "But I always liked the [films] and they were something I grew up with. When I met with Michael and Barbara in their office in Santa Monica, I thought it was just going to be a meeting. Once I spoke to them, however, I realised how quickly the movie was going to happen, and when I jumped on this train it was not going to stop. At that point, I wasn't aware about the writers' strike, which, obviously, was the next hurdle. But I said I would read the script."

Purvis and Wade's script picked up roughly an hour after the events of *Casino Royale*, with Jesper Christensen's Mr White in the boot of Bond's Aston Martin as he drives from Lake Garda to an MI6 safe house in Siena, where Mr White is to be interrogated. "We had it that Bond was not happy about the way Mr White was being treated," reveals Wade. "Bond thinks he's not being pushed hard enough. So, without Mr White knowing, Bond helps him escape, then follows him. That leads him to the Palio. The film we were writing was all about Bond going after the guy who had been Vesper's lover, Yusef, who was living in Libya, doing another operation."

"There was a scene where Bond captures Yusef and tortures him," continues Purvis. "The CIA don't know Bond's got him. M doesn't know he's got him. Over a few days Bond tries to find out everything. We were taking cues from Lee Marvin in *Point Blank* and Nicolas Roeg's movies. We messed around with time a bit, because Bond was going berserk. It needed some work, but

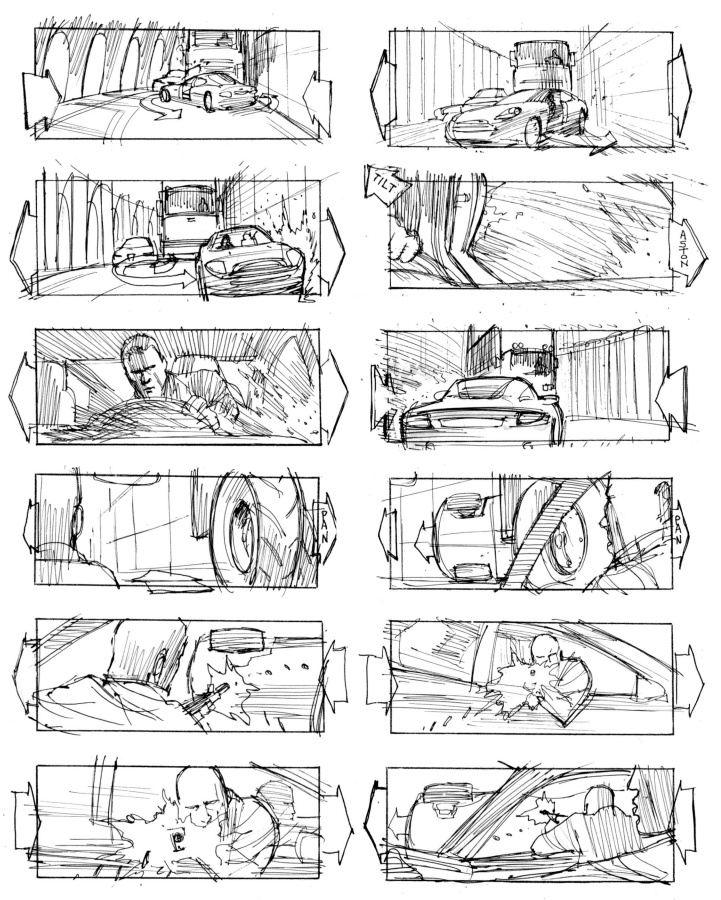

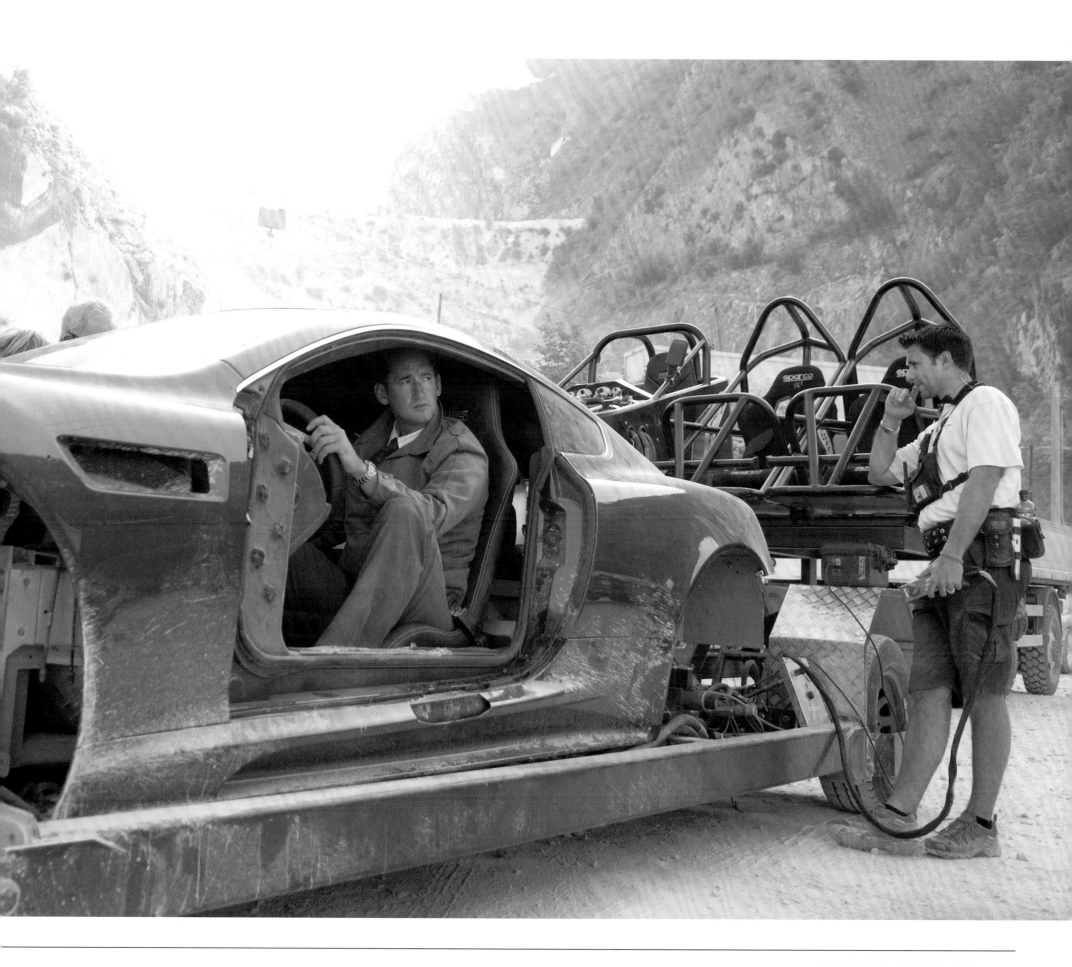

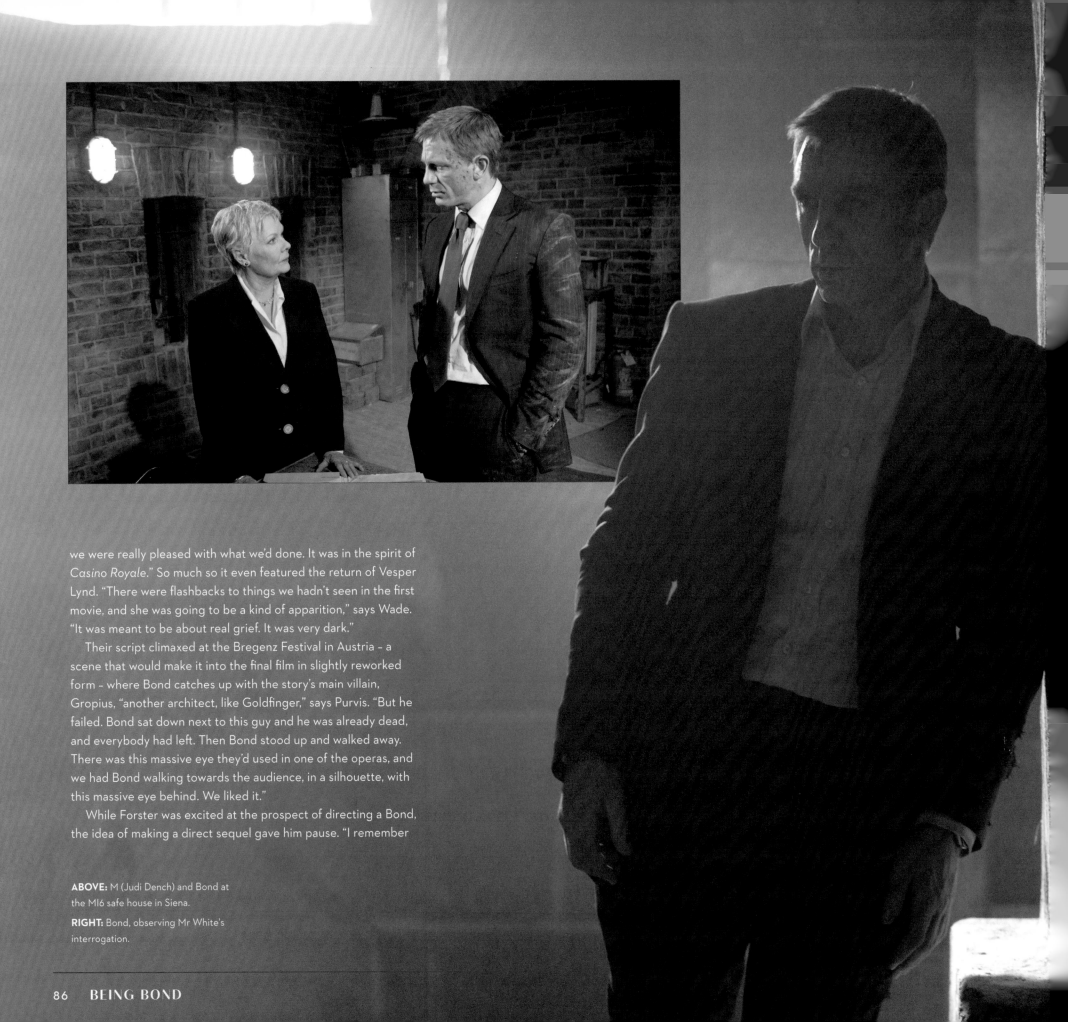

we were really pleased with what we'd done. It was in the spirit of *Casino Royale*." So much so it even featured the return of Vesper Lynd. "There were flashbacks to things we hadn't seen in the first movie, and she was going to be a kind of apparition," says Wade. "It was meant to be about real grief. It was very dark."

Their script climaxed at the Bregenz Festival in Austria – a scene that would make it into the final film in slightly reworked form – where Bond catches up with the story's main villain, Gropius, "another architect, like Goldfinger," says Purvis. "But he failed. Bond sat down next to this guy and he was already dead, and everybody had left. Then Bond stood up and walked away. There was this massive eye they'd used in one of the operas, and we had Bond walking towards the audience, in a silhouette, with this massive eye behind. We liked it."

While Forster was excited at the prospect of directing a Bond, the idea of making a direct sequel gave him pause. "I remember

ABOVE: M (Judi Dench) and Bond at the MI6 safe house in Siena.
RIGHT: Bond, observing Mr White's interrogation.

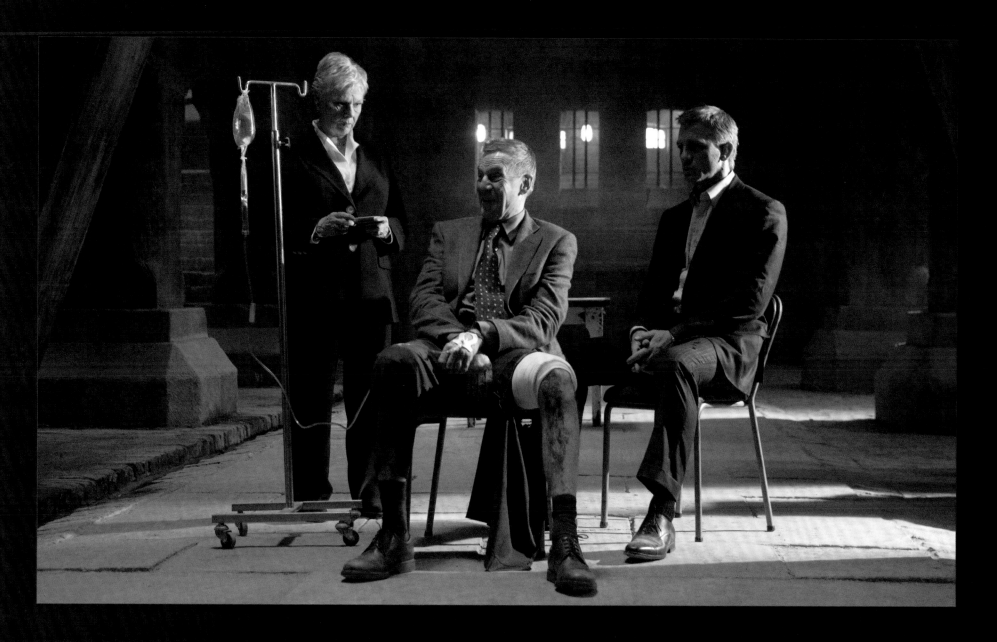

ABOVE: M questions an amused Mr White (Jesper Christensen).

seeing *Casino Royale*, thinking, *Wow!* Not just at how good Daniel was, but it made me feel nostalgic, it made me feel emotional. It hit so many buttons. At the same time, it intimidated me, because *Casino Royale* is based, in my opinion, on the best Ian Fleming book, and here we have two months to write a[n original] script." With the clock ticking, Forster recommended bringing in Paul Haggis, who had done such a stellar job on *Casino Royale*, once again. "I knew Paul, they'd just worked with him, and what I loved about *Casino Royale*, like everybody else, was the emotional part of the story, the love story between Bond and Vesper, which I thought was very moving, along with Vesper's death. I thought he would be the right guy to make that same adjustment to this current script." But Haggis wasn't interested. At least not at first.

"I didn't want to do it. I didn't think I could do a better script than *Casino Royale*," he admits. "Then they came to me again. I dearly love the franchise, I love the character, and I really loved working with Barbara and Michael. They had firm opinions, but were terrific collaborators. Michael is wonderful at landing locations for fabulous action scenes. He said, 'Wouldn't it be cool to do this in an opera?' And that adds so much to Bond. It's what Hitchcock did. So I said, 'Okay, I'll give it a shot.'"

Looming large over the entire development process, however, was the threat of a Writers Guild of America (WGA) strike that was due to begin on 5th November 2007, less than two months before the start of principal photography. The strike meant that all WGA writers, of which Haggis was one, would have to power down their

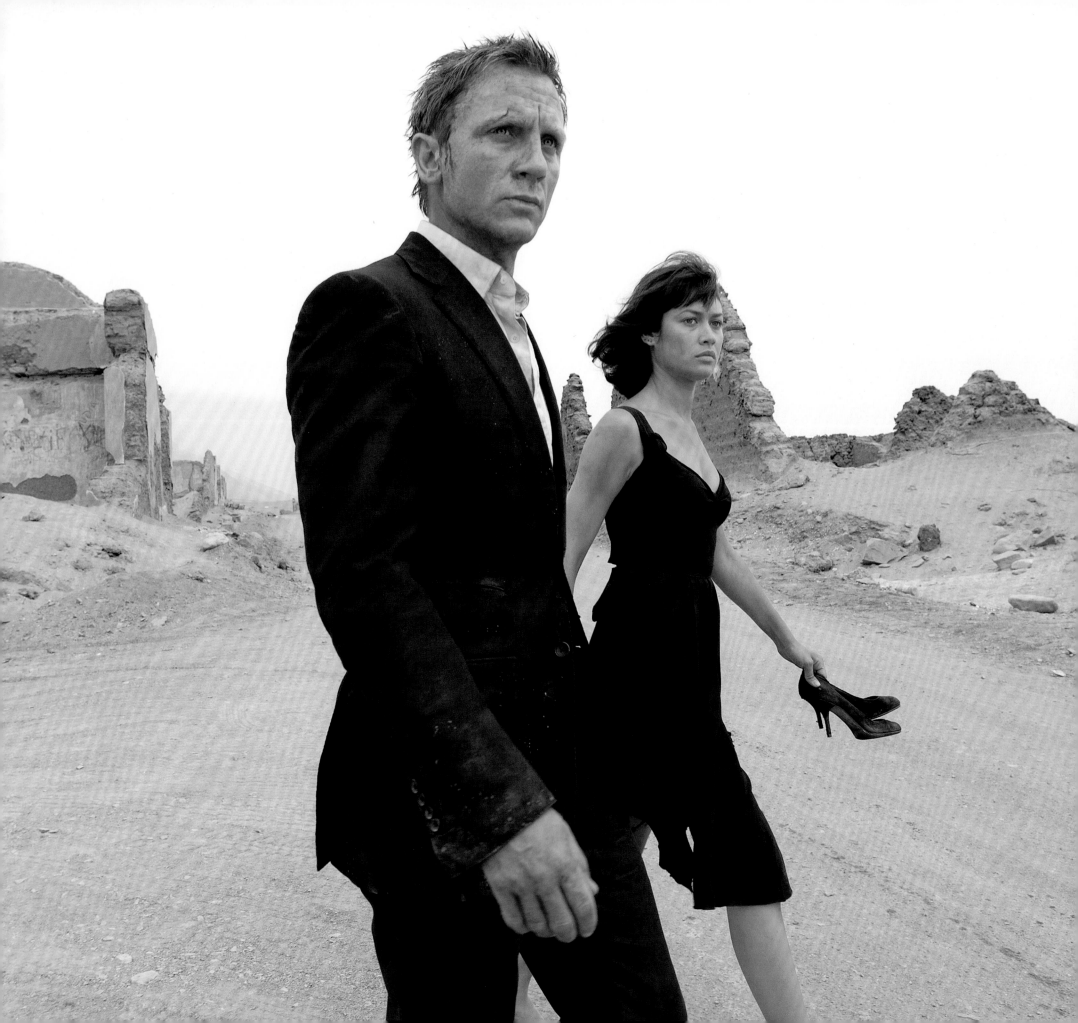

laptops and stop writing. So, whatever work the script required would have to be completed before then. "It was a race, like the last one was a race, because they had a deadline when they had to shoot and were building the sets, and they had to get the script done," recalls Haggis. "In this case, they had the strike coming up."

Along with Bond going all out to avenge Vesper's death, Purvis and Wade's *Bond 22* script featured the Quantum organisation, which monopolises the world's natural resources to manipulate governments across the globe. Instead, Forster suggested Haggis make it about water. "I felt, in the future, there will be a crisis and a shortage of water, and I thought it would be an interesting theme, so that was the jumping-off point," says Forster. "Marc liked the idea of water as this very modern MacGuffin," notes Haggis. Before Haggis began writing, he sat down with Wilson, Broccoli and Forster to outline the film's major beats. "There was a big board, we went through all the characters and scenes, and we all seemed to agree on certain things," recalls Forster. "Then Paul suddenly had another idea."

"I decided to take their script in an entirely different direction," says Haggis. "I had come up with this concept for a motivation for the entire film that was hidden until it was revealed at the end, which I loved and they didn't." Haggis decided Vesper had betrayed Bond because she'd had a baby with Yusef and the bad guys were holding that against her. "In the end, Bond finds the child, and the last scene is at an orphanage in Romania or someplace like that, this horrible place, where children are unattended. Bond gives a suitcase of money to the Mother Superior, then walks out, and that's where M meets him."

Forster hated it. "I said to Paul, 'Have you been to a Romanian orphanage? If Bond dropped off a baby at an orphanage, I don't know if [the audience] will ever forgive him for that.'" Broccoli and Wilson were in agreement.

With the strike almost upon them and script pages arriving in batches, Forster was beginning to have serious concerns. He met with Broccoli and Sony Pictures head Amy Pascal, but neither Eon nor Sony wanted to hit pause, leaving him with a difficult decision: stay and make it work or walk away. "I love Michael and Barbara, I really do. I said, 'I will stay on and make the movie.' The other reason was Daniel. I thought, *I have great producers, I have a fantastic actor, I have a fantastic crew backing me up. We can make this work.* I'm someone who loves an adventure and I thought I might never have this opportunity again. It was my first

LEFT: Bond and Camille Montes (Olga Kurylenko) in northern Chile's Atacama Desert.

RIGHT: Forster and Craig discuss a shot in the desert.

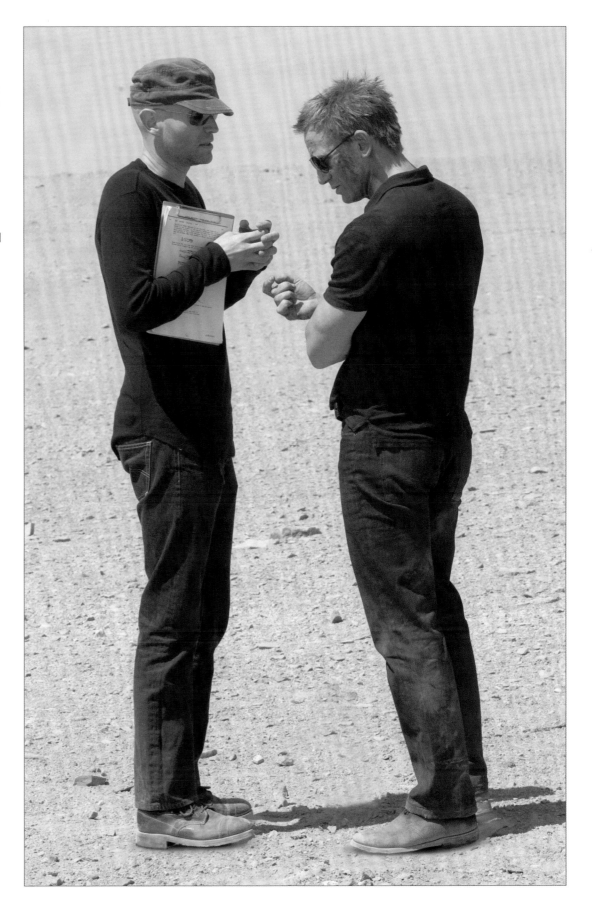

big-budget movie. I came from a place where you work two or three years on a script then look for the financing. Suddenly, I'm in a situation where I have all the whistles, bells and toys I want, but I don't have a foundation. Because I had that support system, because I had such an incredible actor and producers, I said, 'Let's roll the dice.'"

"Marc saw it as a challenge," says Broccoli. "He wanted to do a big movie and I think he felt he was in safe hands, because we had a team of people that had been through this before. He brought his key people to the party and we all worked together really well. The other motivating factor was working with Daniel, because Marc really wanted to do that."

Moreover, Forster had long wanted to make an action movie and finally, with Bond, he had his chance. "Suddenly, in that moment when I thought I would back out, I said, 'It has to feel like a throwback to seventies revenge thrillers, and be like a bullet, with lots of action,' because we couldn't compete with the emotional depth of *Casino Royale*. Now all Bond can think about is: *How can I get my revenge? How can I get over my pain?* That was my intention, because I knew we didn't have the time to really develop a more reflective, more meditative movie."

Key to that was finding locations that reminded Forster of sixties and seventies thrillers, such as *The Parallax View* and *All the President's Men*, "to achieve a slightly retro look, while at the same time trying to make it modern and cutting edge." To aid him in that regard, Forster drafted in cinematographer Roberto Schaefer, who had shot his previous six features, and production designer Dennis Gassner, who started as an assistant on *Apocalypse Now*. Gassner, whose credits include Barry Levinson's *Bugsy*, for which he won the Oscar®, Peter Weir's *The Truman Show* and future Bond director Sam Mendes' *Road to Perdition*, replaced Bond veteran Peter Lamont, who had been production designer on every Bond since *For Your Eyes Only*, with the exception of *Tomorrow Never Dies*. "Dennis and I have very similar aesthetics," says Forster. "I really enjoyed his work on *The Truman Show* and I thought his eye was very aligned with mine. When we met, we just hit it off."

"My agent called and said, 'They want you to do the Bond film,'" remembers Gassner. "I met Michael, Barbara and Marc, and as I walked in the room they said, 'You are going to do this movie,

aren't you?' I said, 'Sure,' and found myself the next day in Italy, running around, trying to find what the movie was going to be. After that a script came in and Marc said, 'I think we're in trouble.' I said, 'We're not in trouble. What do we have?' He said, 'We have nothing.' I said, 'No, we have one thing. One really, really important thing: Daniel. Look at that amazing face, with all those angles, and those blue eyes. So, we're going to do that. And water. That's how we're going to start the film.' You have to start with something, and we had Daniel. Because I knew him, and knew his strengths from what I had seen on *Road to Perdition* and *The Golden Compass*, I said, 'We're not going to screw this up. We can't stop. We're just going to keep moving forward.'"

Unable to bring on a writer, Forster "started reverse engineering" the script himself, determined to find a series of visually stunning locations on which to craft action sequences based around the four elements: earth, fire, air and water. "Locations are characters in Bond movies," he says. "You can't just shoot anywhere. You need to deliver some spectacular locations. It's an expectation people have. So we were scouting, trying to find locations that hadn't been shot before, to create something outside the box. As we were assembling all these pictures and locations, I was trying to connect them and find a path Bond could go through with different set pieces in different places." The film would, ultimately, across its six-month shoot, take in more locations than any other in the globetrotting franchise.

Bond 22 began principal photography on 3rd January 2008 with a script, though not "a script anybody was in love with," says Forster. "But the juggernaut had pulled out and we were ready to start shooting," notes executive producer Callum McDougall. "It was very difficult, because the script is the blueprint and you have to know where you're going," adds Broccoli. "We had the script, but it wasn't in shooting readiness. Normally, when that happens, you can work with the writers through the process. In that case, we couldn't." Forster started "with simple stuff, like when they jump out of the plane and tumble through the air. I took my time and I shot some of what usually would go to second unit, because we were still trying to figure out the pages. We finished in London at the end of January, then headed to Panama. The first week or two in Panama were the most hairy. Daniel and I spent a lot of time together."

(Continues on page 94)

MI6

Quantum Of Solace saw MI6 transformed into a state-of-the-art nerve centre, full of glass and light, the first of several revamps production designer Dennis Gassner would undertake during the Craig Bonds. "It was a little bit of an update for MI6, bringing it more into the twenty-first century," says Marc Forster. "I like the old-world feeling, but felt we could bring a little bit of technology into it as well and see that they're a bit ahead of the curve." I said, 'This is MI6, let's take it to a place that is really cool, that embraces the technologies of the day. Not futuristic, but reality-based. Let's look at all the reality-based items that are available in the military.' Because the military is always pushing technology and then that gets dumped back into the marketplace. Then I said, 'I want M to have a smart window.' I said, 'Judi Dench has one of the greatest voices in film history, let's use her voice, let everything be voice activated.' Everything spun off that and manifested into something I thought was quite interesting. Then I carried that into the next film, to a certain degree, with Q."

BELOW: Bond, Bill Tanner (Rory Kinnear) and M at the state-of-the-art MI6 headquarters.

RIGHT: M at her desk.

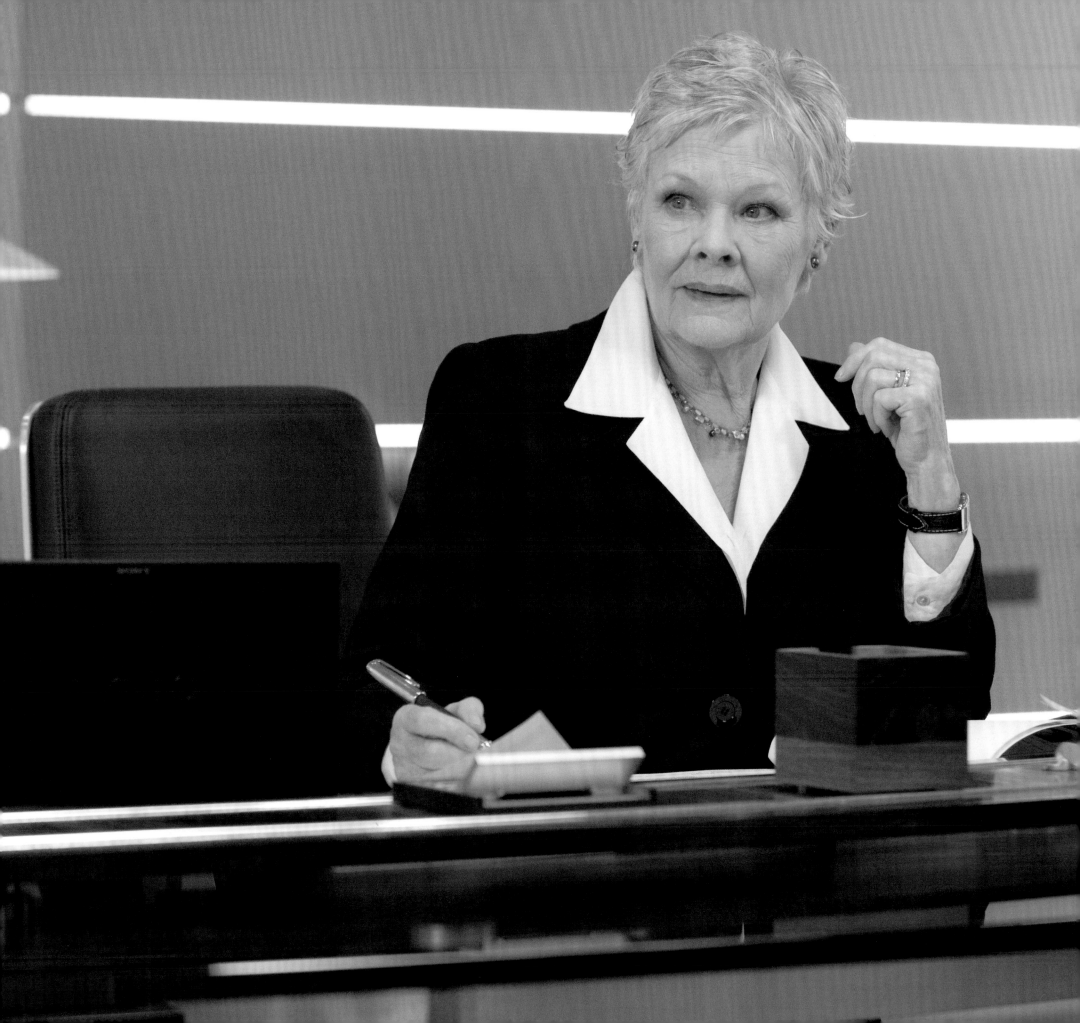

The two men would gather in Craig's trailer each morning to work out that day's scenes. "We went through ideas, looked at old pages," continues Forster. "We spent a lot of time discussing sequences, set pieces, scenes. I told him what I had in mind and then he said, 'Bond could say this or that,' then I walked out and said, 'This is what we're going to shoot.' He knew very clearly the Bond he wanted to portray, and he was very clear what he would say and what he would not. If you go through the movie, his dialogue is very limited and it's all very simple, very to the point.

He has one thing in mind: I'm going to avenge Vesper, the love of my life."

Fortunately, the Writers Guild strike ended on 12th February when the production was still in Panama. Forster flew in up-and-coming screenwriter Joshua Zetumer to work on the script, which was now officially titled *Quantum Of Solace* after a Fleming short story. "Josh had never rewritten or worked on a movie of that size before. He was in a hotel, writing a couple of pages a day, then would show them to Daniel and to me. We had come up with all

THIS PAGE: Filming the Palio di Siena chase on location.

OPPOSITE: Forster, Glenn Foster (foreground) and Craig prepare to shoot part of the sequence where Bond chases down Mitchell (left) and Mitchell and Bond fight (right).

the set pieces and planned them by then, so you couldn't change much. At the beginning, it was a bit of a shock for Josh. But he realised Daniel understood exactly what character he was playing and you just can't write something because it's cool or sounds good or you believe it is a Bond line. Daniel plays a specific Bond. His is not comparable to the other Bonds, because he made the character his own."

Despite the issues with the script, Panama proved a boon for the production, with locations in Panama City doubling for Bolivia and Colón subbing for Haiti. "We were filming on the Pacific Coast and the Caribbean/Atlantic Coast and dealing with the authorities about the Panama Canal, where if you delay a boat you get into huge penalty fees, and we were shooting all around the Canal," recalls McDougall. "We also went to Colón." A once thriving city and seaport on Panama's Caribbean coast, Colón had been beset by poverty and politically instigated riots since the 1960s. The location had been found by Gusmano Cesaretti, an Italian photographer and artist who worked as a visual consultant for director Michael Mann and who had been recommended by Forster. "Dennis was the first person to go there with Gusmano," says McDougall. "He phoned us and said, 'This place is amazing.' I don't think a film had been there before."

"There was so much history," says Gassner. "It was absolutely amazing, because you saw how beautiful it was at one point and how things had decayed. It was a gift. I see beauty in anything. It's just, where does it fit in the context of the narrative?"

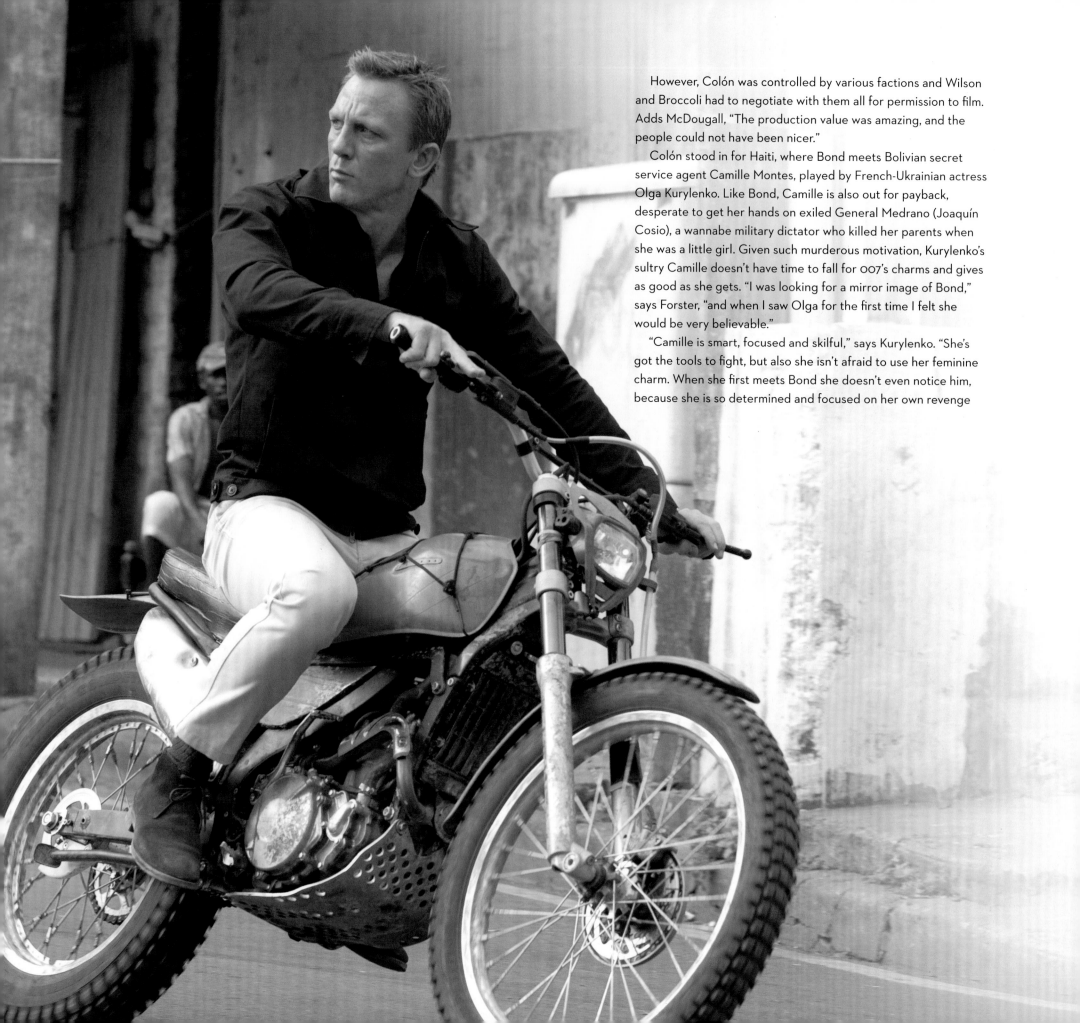

However, Colón was controlled by various factions and Wilson and Broccoli had to negotiate with them all for permission to film. Adds McDougall, "The production value was amazing, and the people could not have been nicer."

Colón stood in for Haiti, where Bond meets Bolivian secret service agent Camille Montes, played by French-Ukrainian actress Olga Kurylenko. Like Bond, Camille is also out for payback, desperate to get her hands on exiled General Medrano (Joaquín Cosio), a wannabe military dictator who killed her parents when she was a little girl. Given such murderous motivation, Kurylenko's sultry Camille doesn't have time to fall for 007's charms and gives as good as she gets. "I was looking for a mirror image of Bond," says Forster, "and when I saw Olga for the first time I felt she would be very believable."

"Camille is smart, focused and skilful," says Kurylenko. "She's got the tools to fight, but also she isn't afraid to use her feminine charm. When she first meets Bond she doesn't even notice him, because she is so determined and focused on her own revenge

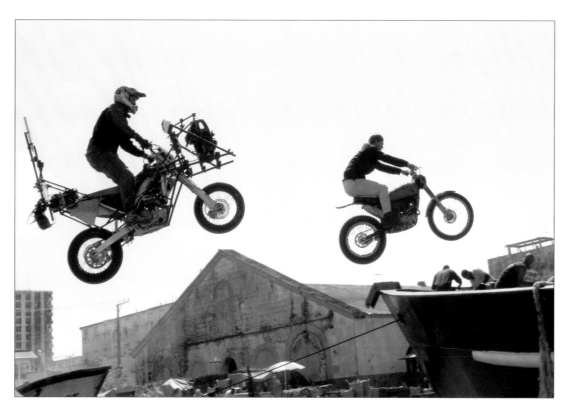

mission, but, little by little, she understands they are going in the same direction, even if their goals are not exactly the same."

"I had this concept that every time Bond tried to save her, she kicked his arse. No one was going to save her," adds Haggis. "My script went further than theirs in that direction. But they were tied together in order to get to this common goal. My title was *Sleep Of The Dead*, because neither Bond nor Camille could allow the dead to sleep. Their guilt couldn't allow it."

The pair team up to take down Dominic Greene, the film's sneering, leering villain, a fully paid-up member of the titular Quantum organisation and supposed environmentalist, whose altruistic ambitions are just a front for his Machiavellian schemes involving oil, water and great swaths of the Bolivian desert. Played by French actor Mathieu Amalric, Greene was designed to be a twenty-first-century baddie. "I wanted to create a villain who was more like a normal guy, because the villains today are not as

LEFT: Filming a bike stunt on location in Colón.

BELOW: Stunt coordinator Gary Powell, 2nd unit boat director Simon Crane (sunglasses), Kurylenko and Craig discuss a shot.

clear-cut as they used to be," says Forster. "During the Cold War, western cinema had a clear portrayal of good and bad. Today, the lines are blurred." One thing was certain, Forster wanted Greene to be devoid of any physical or facial deformity. "I asked Marc, 'Can I shave my hair or have a scar or something to help me?'" recalls Amalric. "He said, 'No, just your eyes, that's enough.' So that was scary, the responsibility of not being disappointing as a villain, and not being lost in the crowd."

Colón harbour also hosted the film's water-based action sequence, a boat chase in which Bond rescues Camille from Medrano's evil clutches. "We flipped a boat over end," says special effects supervisor Chris Corbould, who worked alongside stunt coordinator Gary Powell and second unit director (Panama) Simon Crane on the sequence. "It sounds easy, but it actually turned out to be quite difficult," continues Corbould. "We were ramming boats, blowing them up, it was a hardcore boat chase, really near the knuckle, doing serious damage. There were a lot of mechanics

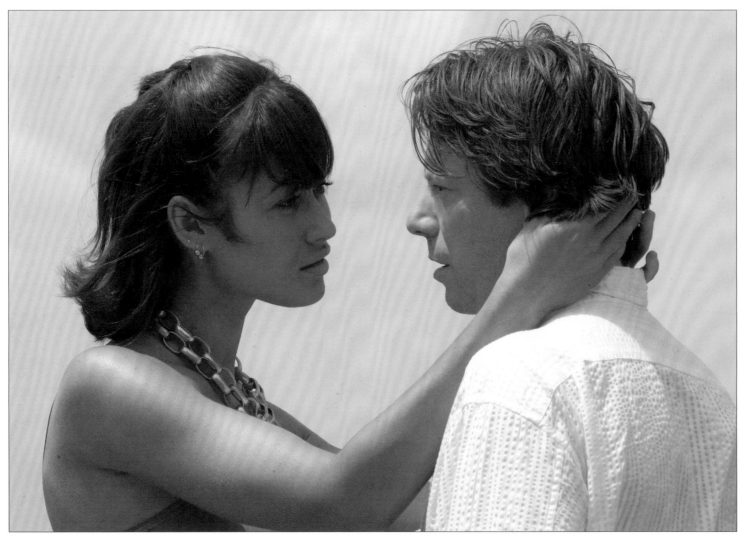

ABOVE: Preparing to film the boat stunt.

LEFT: Camille and Dominic Greene (Mathieu Amalric).

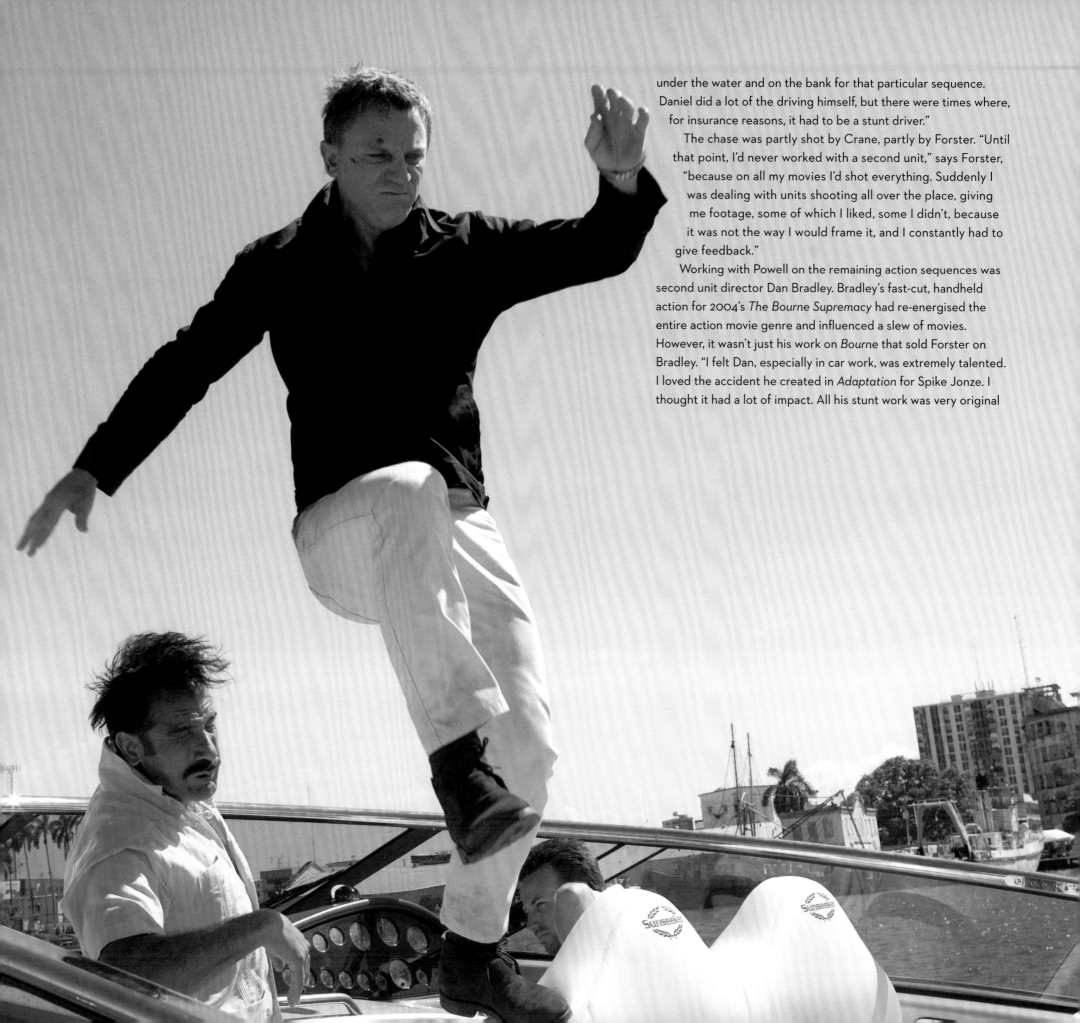

under the water and on the bank for that particular sequence. Daniel did a lot of the driving himself, but there were times where, for insurance reasons, it had to be a stunt driver."

The chase was partly shot by Crane, partly by Forster. "Until that point, I'd never worked with a second unit," says Forster, "because on all my movies I'd shot everything. Suddenly I was dealing with units shooting all over the place, giving me footage, some of which I liked, some I didn't, because it was not the way I would frame it, and I constantly had to give feedback."

Working with Powell on the remaining action sequences was second unit director Dan Bradley. Bradley's fast-cut, handheld action for 2004's *The Bourne Supremacy* had re-energised the entire action movie genre and influenced a slew of movies. However, it wasn't just his work on *Bourne* that sold Forster on Bradley. "I felt Dan, especially in car work, was extremely talented. I loved the accident he created in *Adaptation* for Spike Jonze. I thought it had a lot of impact. All his stunt work was very original

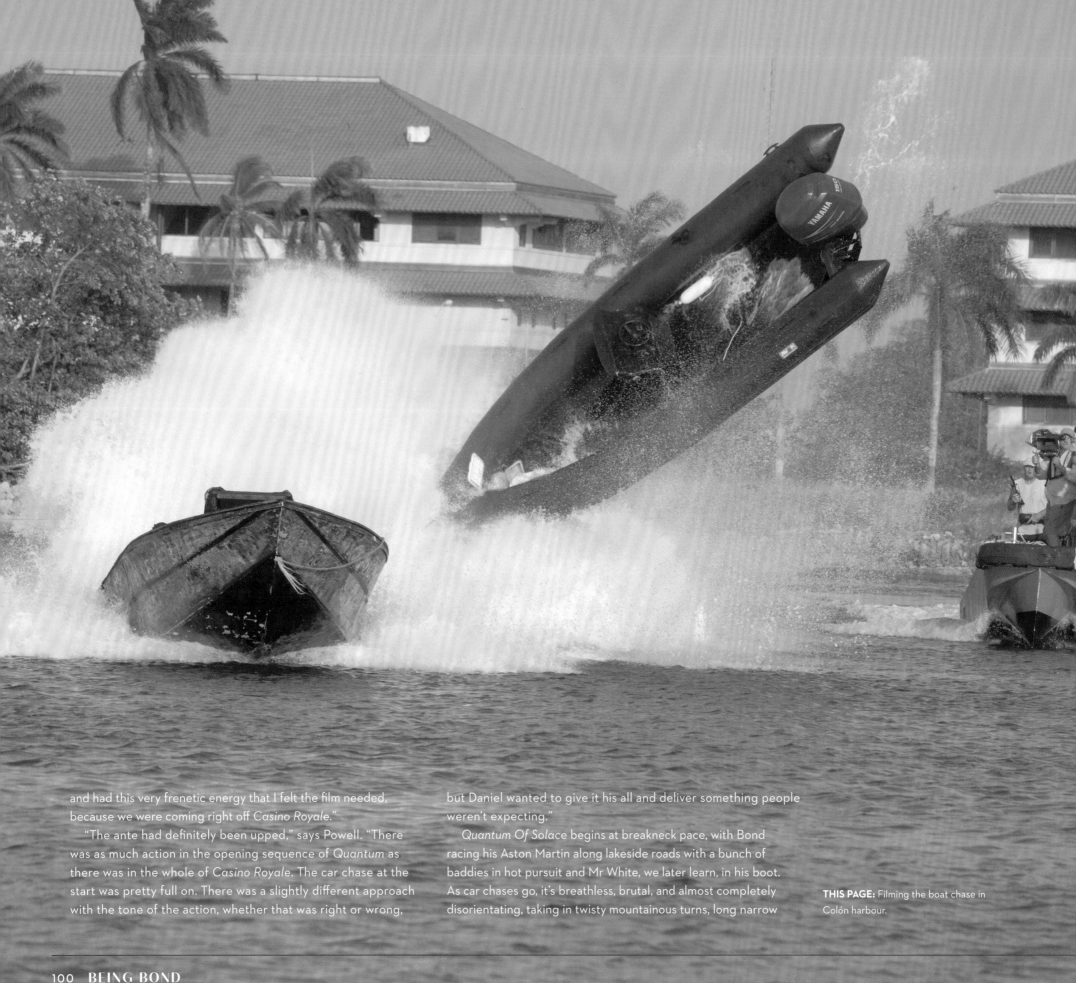

and had this very frenetic energy that I felt the film needed, because we were coming right off *Casino Royale*."

"The ante had definitely been upped," says Powell. "There was as much action in the opening sequence of *Quantum* as there was in the whole of *Casino Royale*. The car chase at the start was pretty full on. There was a slightly different approach with the tone of the action, whether that was right or wrong,

but Daniel wanted to give it his all and deliver something people weren't expecting."

Quantum Of Solace begins at breakneck pace, with Bond racing his Aston Martin along lakeside roads with a bunch of baddies in hot pursuit and Mr White, we later learn, in his boot. As car chases go, it's breathless, brutal, and almost completely disorientating, taking in twisty mountainous turns, long narrow

THIS PAGE: Filming the boat chase in Colón harbour.

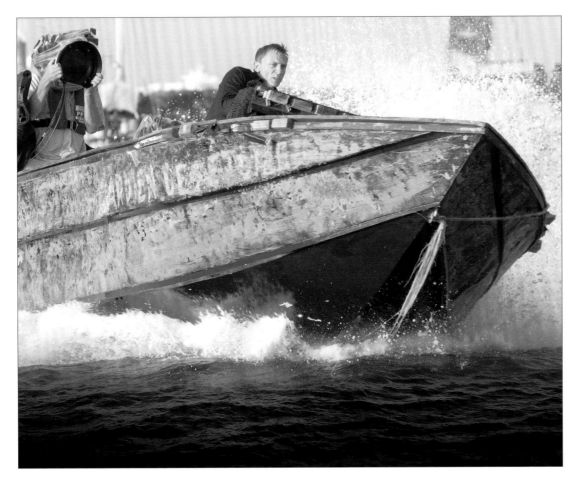

tunnels, with vehicles crashing into Bond and bullets ripping the Aston's bodywork, before ending up in the Carrara marble quarry. At one point, Bond's driver's side door is ripped off. "I felt it was very important for the chase to be very frenetic," says Forster. "We stayed away from a lot of wide shots and kept it pretty tight, the idea was to really aggressively take the car apart. I felt that aggressive camerawork and how we approached the car was a metaphor for the survival skills of Bond and who he is as a character. Originally, we had three Alfa Romeos chasing him, but ended up with two in the edit, because it got too long."

The chase took Bradley's second unit several weeks to shoot. "It was one of the most complicated car chases we've ever done," says McDougall. "We're always trying to push the boundaries to make it feel like you're absolutely in there with the action."

A somewhat dented Aston arrives at an MI6 safe house in Siena, where Bond dumps his prisoner, Mr White, just as the Palio di Siena – the city's world-famous biannual horse race in which ten horses are raced by riders dressed in the colours of ten of Siena's seventeen contrade (subdivisions) – begins. The race was something Wilson and Broccoli had long wanted to put on film.

"Dating back to medieval times, the Palio di Siena is the most exhilarating and extraordinary horse race in the world. It is also a symbol of pagentary, civic identity and pride, which makes it the perfect backdrop for a Bond action sequence," notes Wilson.

"Everybody knows what an incredible, beautiful city Siena is," says Forster, "but the race had its own difficulties, because almost every contrada in the city has a horse running, and all seventeen had to sign off on us filming. Initially only one or two would allow us to film the actual race, and I kept on pushing to shoot some B-roll when they did the training runs. In the end, thanks to Michael and Barbara's brilliant negotiation skills, they all agreed we could film it. Although they all had to approve the footage we wanted to use. They only had one or two very small notes, but it was still very tense, because they all had to sign off on the final cut."

During his first scout to Siena, Forster was shown around the city's underground tunnels, a warren of medieval aqueducts and subterranean cisterns, and decided to incorporate them into the Palio sequence, with the foot chase between Bond and double agent Mitchell (Glenn Foster) starting underground, before bursting out through a manhole into Siena's main square, Piazza del Campo, during the Palio. "We walked – crouched – through

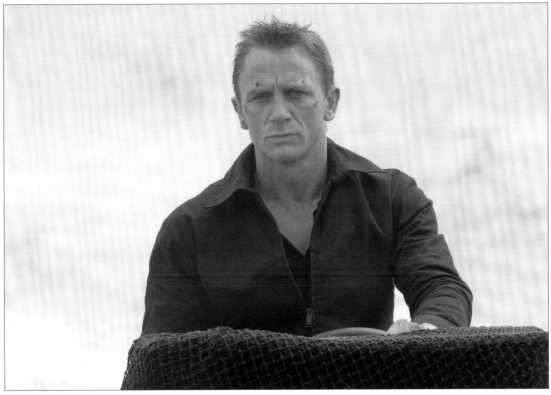

miles of cisterns, picking out each spot we liked emotionally, saying, 'This is great,' then moving onto the next," says Gassner, "until we had what we felt was a nice, interesting journey, then came back and had to squeeze all those elements onto the 007 Stage at Pinewood."

Forster filmed the actual Palio, which would form the film's earth-element-based action sequence, in the summer of 2007, six months before the start of principal photography, with sixteen cameras, before returning in May 2008 to re-stage the race with Craig chasing Foster through crowds of nearly a thousand extras. From the Piazza del Campo, Bond pursues Mitchell up onto, and across, the rooftops of Siena. "We discussed the option of building the rooftops in Pinewood," says Forster, "which would have been an enormous cost. So we spoke with our location manager about the city of Siena allowing us to use certain rooftops." The city said yes and the stunt team then had to test every rooftop on the proposed route to make sure they were safe.

To shoot the sequence, the actors and their stuntmen were attached to safety wires that were then attached to large overheard cranes, a challenge in itself given the historic city's narrow lanes. "It's a city that was built for carts and horses," notes Bradley, who shared directing with Forster on the Siena sequence, "and we were bringing eighty-tonne construction cranes just to hold up one end of a cable for a camera. We created probably the biggest 3D camera system ever deployed for film. There were four construction cranes bracketing our set, so we could fly the camera virtually anywhere and follow Daniel as he was running and jumping."

Once again, Craig did a lot of his own action, running across rooftops, jumping on top of a moving bus, leaping from building to building, as well as jumping across a street and landing on a balcony, as Bond pursues Mitchell. "It's about Bond's effort," says Bradley. "Bond is determined, he's relentless, he's just not going to let this go. As a director, I believe it's far more interesting looking at the actor's face doing these action sequences than watching slightly bigger stunts on the back of some guy's head. I was given the supreme pleasure of not actually having to sacrifice anything, because I got Daniel Craig to do it. He literally ran and did this twenty-foot leap across this street, dropped three stories and, in the foreground, I had Mitchell scrambling. Daniel's flying through the air firing his gun. It was a pretty great moment."

"Daniel ran across the roof, jumped from rooftop to gantry, jumped out of the building onto the roof of a bus," recalls Powell. "He did something like ninety-five percent of the rooftop sequence, and the only reason he didn't do the other five percent was because he was on main unit shooting. He did a hell

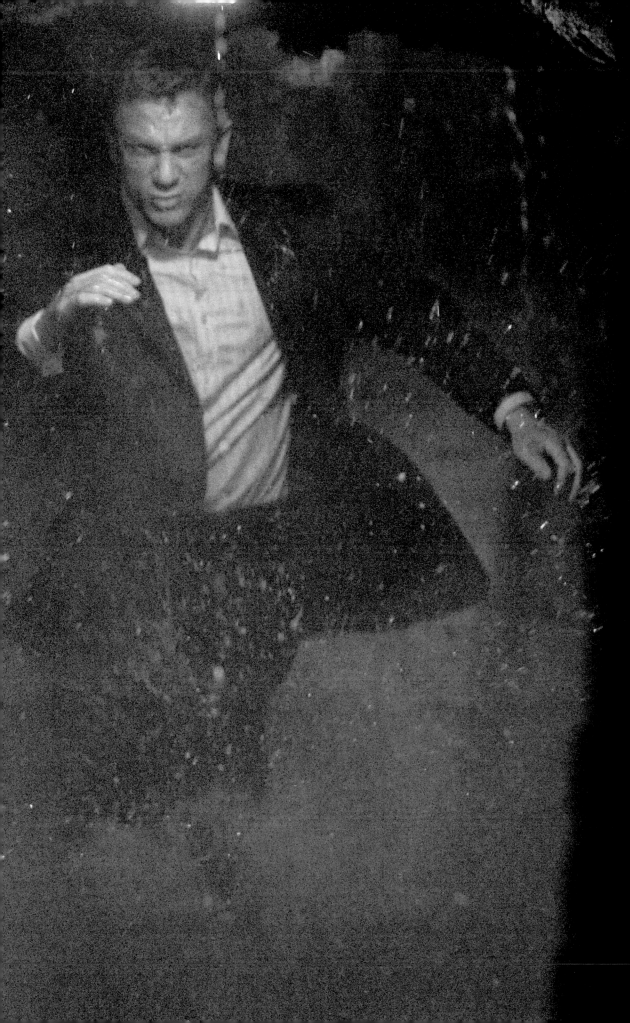

OPPOSITE TOP: Preparing to re-stage the Palio di Siena with nearly a thousand extras.

OPPOSITE BOTTOM: Siena's rooftops and the production's cranes.

LEFT & TOP: Filming the sequence where Bond chases Mitchell through Siena's medieval aqueducts and subterranean cisterns, recreated on the 007 Stage at Pinewood.

ABOVE: Craig, Foster and Forster prepare for the rooftop section of the chase.

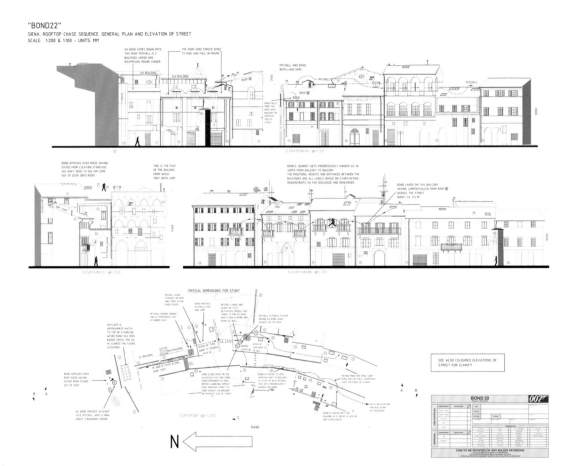

"BOND22"
SIENA, ROOFTOP CHASE SEQUENCE GENERAL PLAN AND ELEVATION OF STREET
SCALE: 1:200 & 1:100 - UNITS: MM

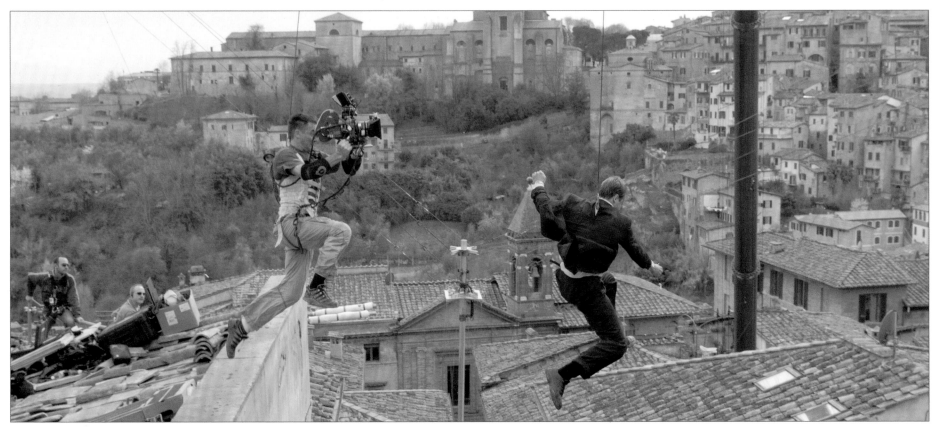

of a lot more than on *Casino Royale*, which was great for us and great for him."

When it came to the bus action sequence, Craig had to take a leap of faith, quite literally, by jumping out of a three-storey window. "I remember standing in this open window, with a harness on, and the basic idea is, when the bus comes around the corner, I leap out into its path," he recalls. "To this day, the words 'Three, two, one, action' make my eyes go up, because that's my signal to go. 'Three. Two. One. ACTION!' That's when I'm jumping from roof to roof. You're tied up [in a harness], of course. You're safe, but your brain says, 'No.'"

"He did the jump on the bus maybe twice," reveals Powell, "the jump across from the roof to the balcony once. He hurt his shoulder. We had the wall rubberised, but when he jumped across, he went for it one hundred percent. It was a narrow balcony, probably only two and half, three foot of landing space. He was on

a cable, but the cable's there to stop him falling, and we had a back cable to stop him going too far, but when he jumped, he rocketed across and, unfortunately, gave his shoulder quite a whack."

"I ended up doing way too much action," says Craig dryly. "The fact I'd done so much on *Casino* meant everybody thought, *He's the guy who does his own stunts*. I was like, 'I don't know if I am. I think you might be mistaking me for someone else.' I haven't done things as big as that since. I pretty much got rid of my fear of heights on that movie."

"He never mentioned to me he had a fear of heights," says Forster. "I thought at the time he was very gung-ho and very willing to do most of the action as it was the second film and he was in incredible shape. I thought he felt it was part of the character and it was important to him. He never complained. He was wanting to participate in the action, which I thought was extraordinary."

THIS SPREAD: Filming the rooftop chase with Craig and stunt double Bobby Holland Hanton followed by stuntman Diz Sharpe (opposite bottom).

OPPOSITE TOP RIGHT: Siena rooftop chase sequence digital schematic by Mark Stallion. Reinforced and connecting rooftops were constructed on location in the ancient Italian city of Siena for the Bond and Mitchell chase sequence.

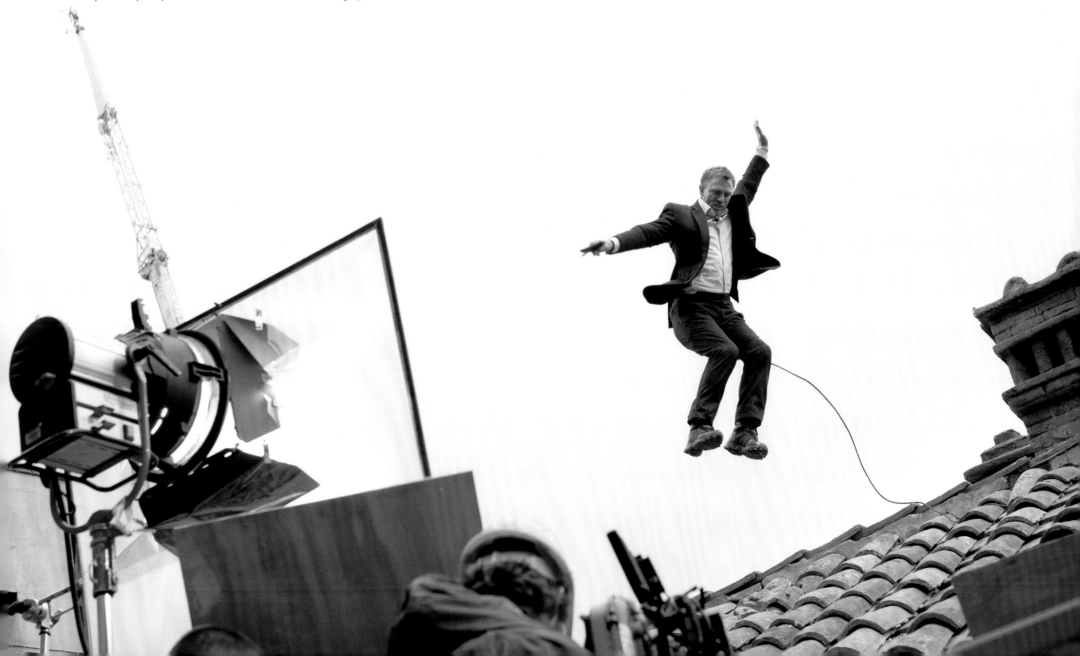

The chase ends in a cathedral bell tower with Bond and Mitchell upside down, tangled in bell ropes, an idea inspired by Forster's visit to a Cirque du Soleil acrobatic show. "Daniel was heavily involved in that," says Powell. "Again, it was a couple of weeks with him hanging upside down, crashing through all the girder work, fighting. We wanted to do it in a real cathedral originally, which would have been a huge challenge, because when you're working up that high things are hard. But we ended up building a set on the 007 Stage and maxed out the roof as much as we could. It took a lot of rehearsal but turned out great." The scene ends with an upside-down Bond finally snatching up his out-of-reach weapon, spinning to camera, and firing at Mitchell. "I thought it was a cheeky new way to do it," says Powell. "Then executing it becomes a whole other headache..."

Along with Siena, another location that featured in Purvis and Wade's original script was the Bregenz Festival on Lake Constance in Austria, which features the world's largest floating stage, and is where Bond tracks down Greene and his Quantum cronies at a performance of *Tosca*. The Seebühne staged their show over five nights as the backdrop for the scene's action. "I thought the opera was a great metaphor for the film and had this fantastic visual of a giant blue eye floating on stage," says Forster, who intercut Bond's adventures behind the scenes with the events on stage. "I had no second unit on that, it was just the main unit shooting. Looking back, I realised the more main unit I used, the more cohesive the film is in terms of the storytelling. With the Bregenz sequence, I had a clear vision of what I wanted to do and was able to bring that to life."

LEFT: Concept art of the cathedral bell tower interior by Paul McGill.

BELOW & RIGHT: Filming the end of the chase in the bell tower interior set on the 007 Stage.

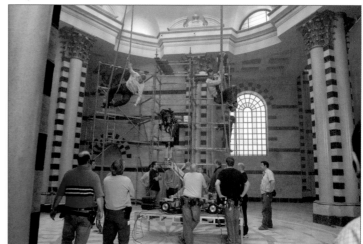

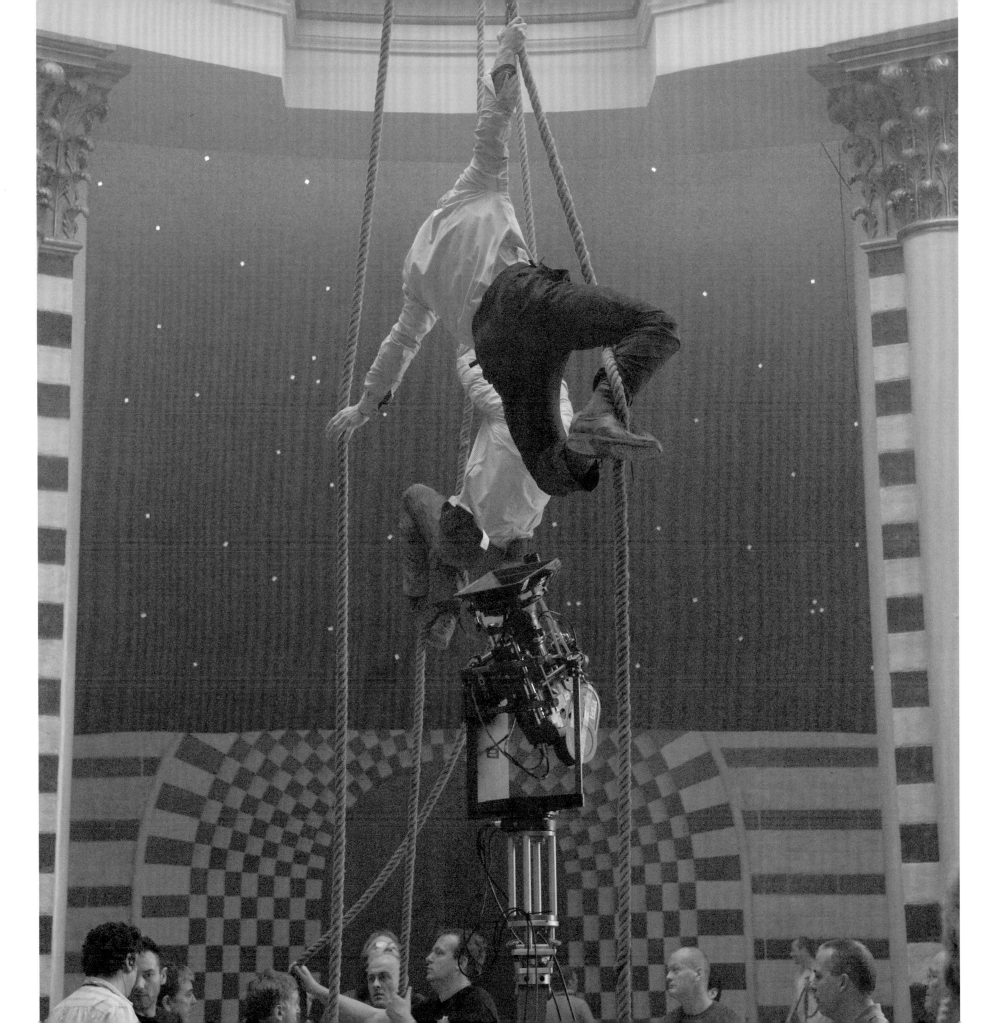

The sequence itself was partly inspired by the Royal Albert Hall concert scene in both the 1934 and 1956 versions of Alfred Hitchcock's *The Man Who Knew Too Much*. "I always loved Hitchcock's framing and the tension his framing created," says Forster. "I was a Hitchcock fanatic, especially during that time I made the movie. He was a master of creating negative spaces and tension between characters and the more we were battling with the script, the more I felt I needed to add tension through visual storytelling." During the scene, Forster drops the sound and uses only Puccini's music. "Throughout the movie, we had so many intense sound effects that it came to a point where dropping the sound made it much tenser. I mean, we tried some sound effects on the mixing stage and I didn't like them, so I just pulled them out and said, 'This works much better without them.'"

Another nod to Hitchcock was the attack on the Douglas DC-3, a propeller-driven plane from the 1930s, that Bond flies and

THIS PAGE: Bond tracks down Greene at a performance of *Tosca* at the Bregenz Festival on Lake Constance in Austria.

OPPOSITE TOP: The Douglas DC-3 interior set on a gimbal at Pinewood.

OPPOSITE BOTTOM: Filming the Douglas DC-3 exterior in Mexico.

that formed the film's air-based action sequence. The interior set was built on a gimbal at Pinewood by Corbould's special effects team and could move up, down and sideways. "It was fantastic and ultimately really made that sequence work," says Forster, who filmed with Craig and Kurylenko while second unit director Bradley shot the exterior and the flying stunts in Mexico. "[Bradley] was a bit frustrated, because they had wind and weather issues, so he wasn't able to get everything he wanted to get," says Forster, "but I think the scene works as a throwback to old-style action thriller/stunt movies that I enjoyed."

When the plane is shot down, Bond and Camille bail, skydiving to safety with just one parachute between them, although neither Craig nor Kurylenko were required to jump from an actual plane. "I don't think the insurance would allow us," says stunt coordinator Powell with a laugh. The sequence was shot at Bodyflight, a skydiving centre with a wind tunnel that simulates free-falling at 120 miles per hour. "We took all the windows out, put cameras and lights in and had weeks of rehearsals with Daniel and Olga," recalls Powell. "If Daniel was in there, he was with an Olga double and vice versa. You generally do it for a couple of minutes and when you come out you're tired, because it's such a pull on your shoulders and your body. So to go in, shoot for a minute or two, come out for a quick look, then back in again, for ten, eleven hours a day, was pretty full on."

(Continues on page 112)

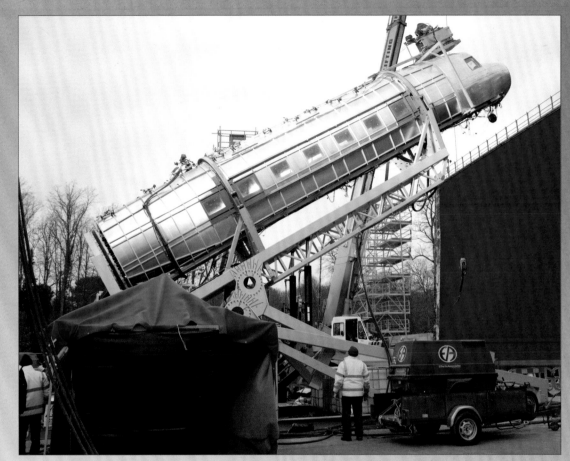

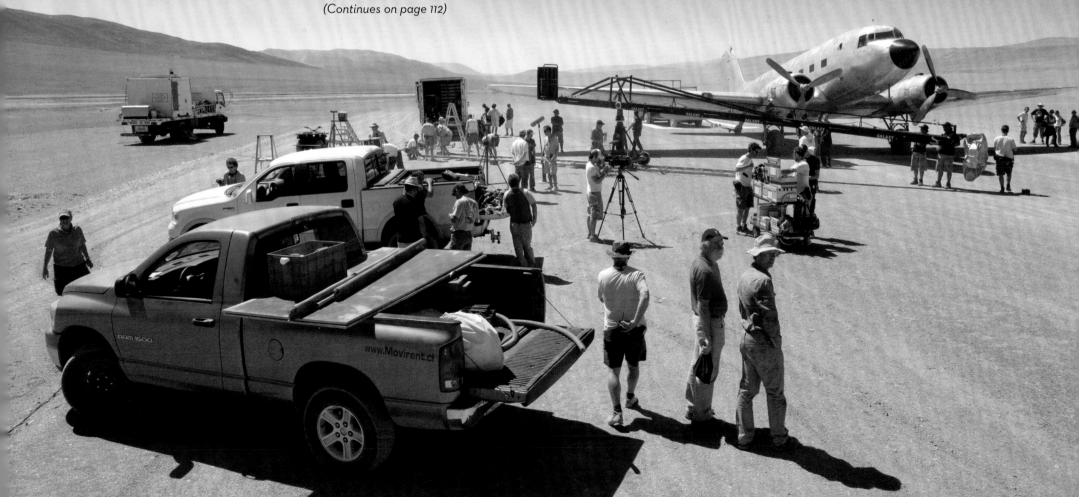

FIELDS' DEATH

When Bond arrives in Bolivia with the returning Rene Mathis (Giancarlo Giannini), they're met by novice MI6 agent Strawberry Fields, played by Gemma Arterton, making her screen debut. "I'd seen Gemma at drama school. She hadn't graduated," says casting director Debbie McWilliams. "You can't sit in a room with Gemma and not fall in love with her. She's gorgeous."

"To be honest, Gemma came in to audition and I thought she was so brilliant and her comedic timing was so good, I didn't want to see anybody else," says Marc Forster. Although Arterton remembers it differently. "When I did my screen test, I thought I had blown it, then a couple of weeks later, I was filming in the middle of the ocean in Gibraltar and I got a phone call from my agent singing the James Bond theme tune down the phone. I'll never forget it. Thinking about it now, on the way to my audition 'Nobody Does It Better' was playing on my car radio, so I think it was meant to be."

After sleeping with Bond, Fields turns up dead in his hotel room, face down on the bed, covered in oil, deliberately evoking Jill Masterson's demise in *Goldfinger*. "*Goldfinger* is one of the best Bond movies ever, a classic, and because this movie is about oil and water and resources, I thought it would be a fun thing to throw in," says Forster. "Ultimately, oil is the gold of today, and I thought having her lay there in oil would work for the story. It's also how it ends with Greene, in the desert, when Bond gives him the oil to drink. I used the same frame as in *Goldfinger*. I pulled up the frame on the day and framed the shot exactly the same."

THIS PAGE: Gemma Arterton and Craig filming the scene where Fields sleeps with Bond.

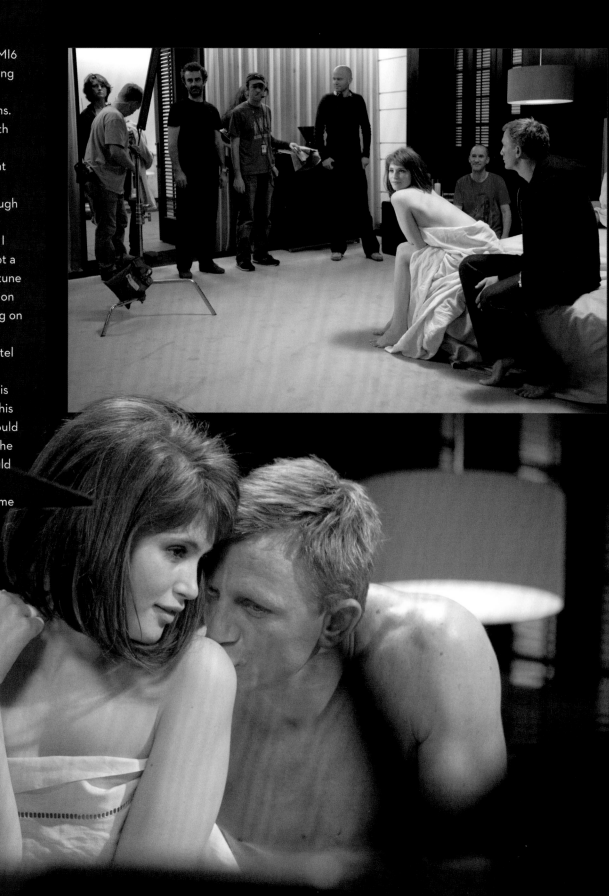

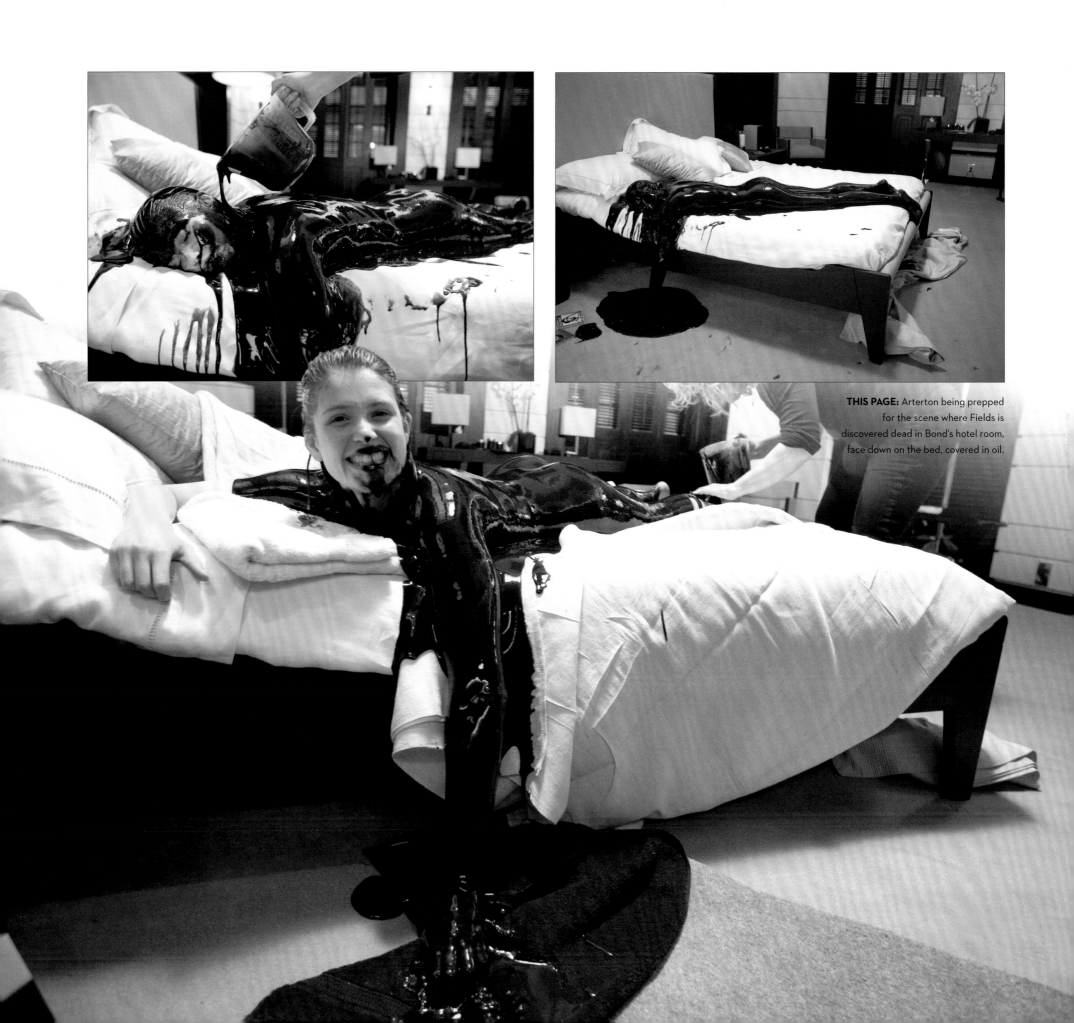

Quantum Of Solace climaxes at the extraordinary European Southern Observatory and hotel complex in northern Chile's Atacama Desert, three hours from the nearest town and at an altitude of six thousand feet. "The Atacama was amazing," says Gassner. "It's one of the driest places, if not the driest place on Earth, and so we had all this incredible landscape to deal with. My set decorator, Anna Pinnock, had been there and said it was so different to anything else she'd ever seen, so I went to my computer, looked up Atacama Desert, pressed 'images' and the third image was this German-built hotel in the desert. I sent it to my assistant and said, 'Copy that and send it to Marc.' Marc came back and said, 'This is going to be in the movie.'"

"I remember it very clearly. When Dennis showed me that location, I was in awe," says Forster. "I had never really seen anything like it. It's such a fascinating building, and even now, looking back to it, you felt like you're on a different planet. It doesn't feel completely Earthly, because outside you're in a desert and it's very, very dry and very low humidity, then you enter the

THS PAGE & OPPOSITE RIGHT: Camille and Bond discover Greene at his stronghold in the desert.

OPPOSITE LEFT: Forster, Amalric and Craig filming in the Atacama Desert.

building, and there's a very high humidity and jungle-like vegetation – which is very different to what we built on the 007 Stage. Being there and shooting there was a real treat and very special."

"When Dennis suggested it, I looked it up and said to him, 'That's in the middle of nowhere. Not only is it in the middle of nowhere, we want to blow it up!'" laughs McDougall. "Anyway, we approached them. I went to Germany to meet the people managing it, and they were incredibly enthusiastic. They said, 'We'd love to have a Bond there, but you can only arrive during daylight. We can't have any lights on at night,' because nothing could disturb what they were doing, which is observing the stars and the universe. I said, 'The bigger thing is, in the script we blow this place up,' and they went, 'Ah.' I said, 'It's fine. We'll build our own version of it.' And that's what we ended up doing. But we did shoot a lot of exteriors there. It was three hours from

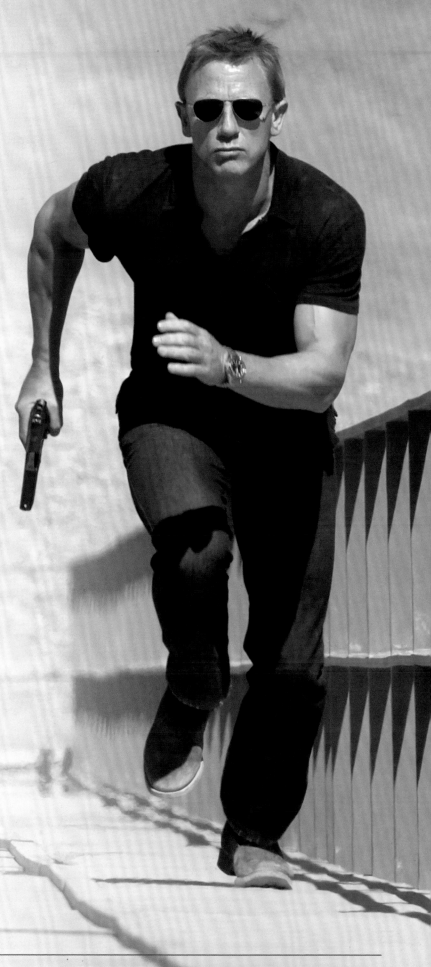

Antofagasta. They completely embraced us. We used to drive out every morning, taking two hundred people with us."

The hotel/observatory was to be the setting for the film's fire-based action sequence and the production recreated a portion of the exterior in the desert, which they set ablaze, while all the interiors were shot at Pinewood on the 007 Stage, on a massive set Gassner designed. "The interior we built was much starker, more minimalistic and cooler than the real hotel," says Forster. "That had much more warmth and humidity and plants and colour inside." Adds McDougall, "We'd loved to have done it there, because the interior of the place was unbelievable. It looked like a Bond set."

It's here that Bond finally gets his hands on the slippery Greene, slugging it out mano a mano as the entire complex goes up in flames around them, while Camille also gets her revenge on General Medrano. The sequence relied heavily on both the stunts and special effects departments, and was filmed in the final four weeks of shooting. With the Bond/Greene fight, Amalric wanted "to bring a certain style to it," says Powell. "He was like a wild animal, a crazy person who, when something went wrong, would explode into a rage. The actors talk to us about how they want to portray it, then we have a play, because the two of them have to gel. We would rehearse the fight with Mathieu and a double, with Daniel and a double, and at some point put them together

and build it up a bit at a time. You could be practising for weeks, because the actors are working, so you grab them when you can. Both of them put a lot into it." So much so that Craig was, again, injured. "He sliced his finger," continues Powell. "He slammed a fire hydrant door and, as he flicked it, there was a sharp piece of metal that should have been filed down. He also got a kick from one of the actors who had the wrong shoes on. He wore leather-sole shoes." Craig was also cut while filming the fight. "Mathieu hit Daniel above the eye and he had to have stitches," says Forster. "Fortunately, it wasn't too bad and we were able to carry on filming a few days later."

Then there were the fire effects themselves, which were mostly done for real. "That was a tricky sequence," Forster notes. "We enhanced it, obviously, with visual effects, but the way everything started to explode and burn was very impressive. It was also interior and [potentially] really dangerous, but Chris Corbould was able to make it safe, and make everybody feel safe, and we were able to complete the scene with a certain ease. Chris, in an incredible way, delivered that sequence. All the special effects were extraordinary."

"Normally you do a little bit of fire and a lot of CG [computer-generated effects]. We did a lot of fire and a little CG," says Powell. "So, kudos to Chris for building a set that we could constantly keep doing that to. The way his guys lit it up looked

OPPOSITE TOP: The hotel interior set on the 007 Stage at Pinewood, designed to incorporate the fire effects.

OPPOSITE BOTTOM: Amalric relaxes on set between takes.

ABOVE LEFT: Kurylenko filming on set.

ABOVE: Filming the real fire effects.

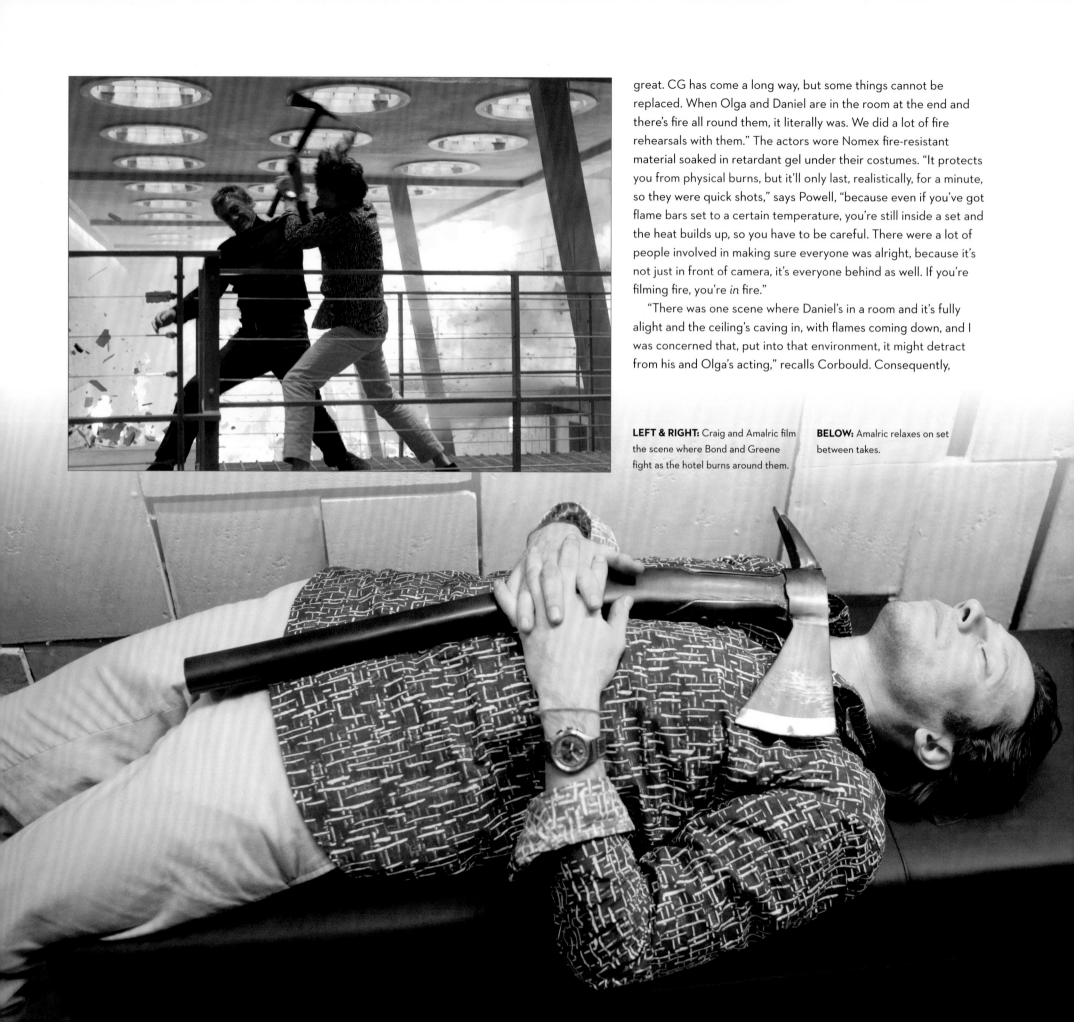

great. CG has come a long way, but some things cannot be replaced. When Olga and Daniel are in the room at the end and there's fire all round them, it literally was. We did a lot of fire rehearsals with them." The actors wore Nomex fire-resistant material soaked in retardant gel under their costumes. "It protects you from physical burns, but it'll only last, realistically, for a minute, so they were quick shots," says Powell, "because even if you've got flame bars set to a certain temperature, you're still inside a set and the heat builds up, so you have to be careful. There were a lot of people involved in making sure everyone was alright, because it's not just in front of camera, it's everyone behind as well. If you're filming fire, you're *in* fire."

"There was one scene where Daniel's in a room and it's fully alight and the ceiling's caving in, with flames coming down, and I was concerned that, put into that environment, it might detract from his and Olga's acting," recalls Corbould. Consequently,

LEFT & RIGHT: Craig and Amalric film the scene where Bond and Greene fight as the hotel burns around them.

BELOW: Amalric relaxes on set between takes.

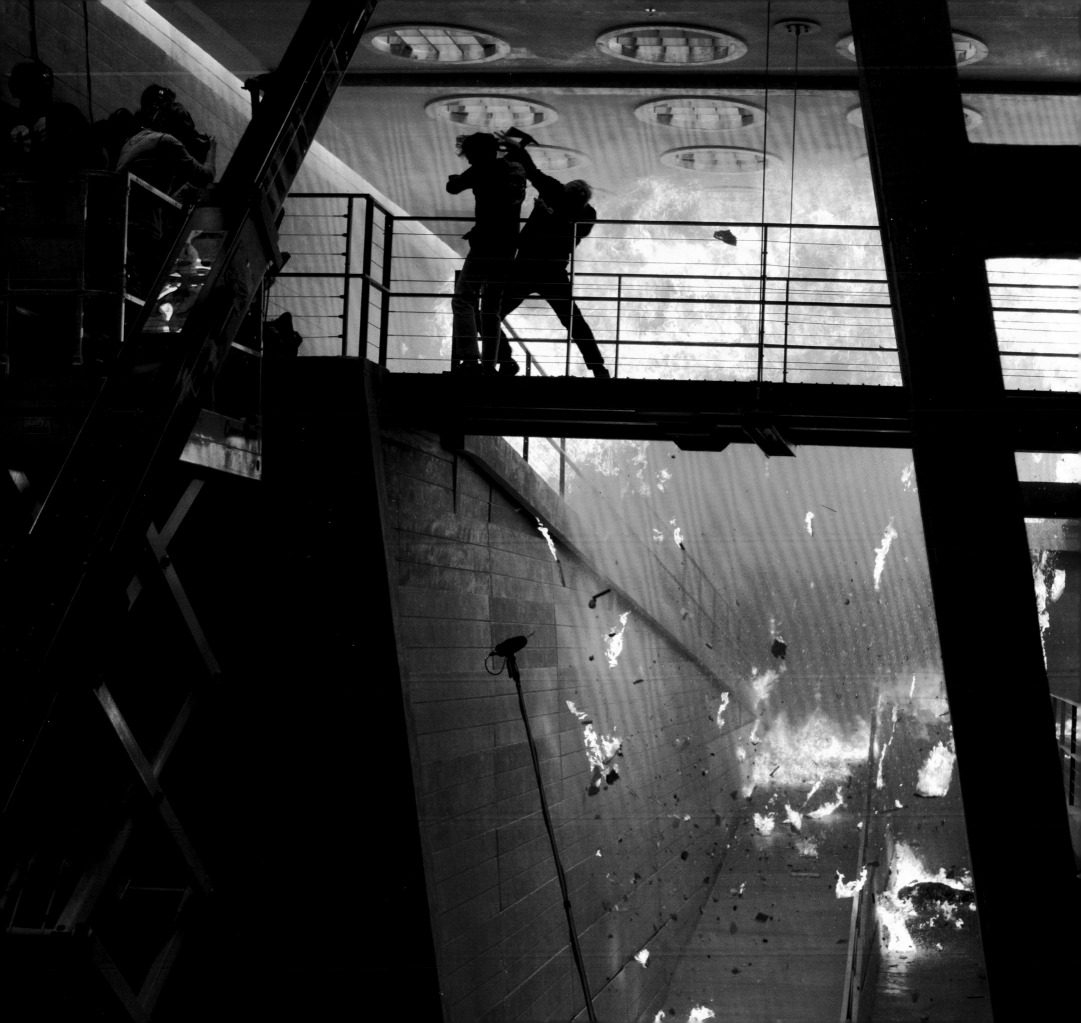

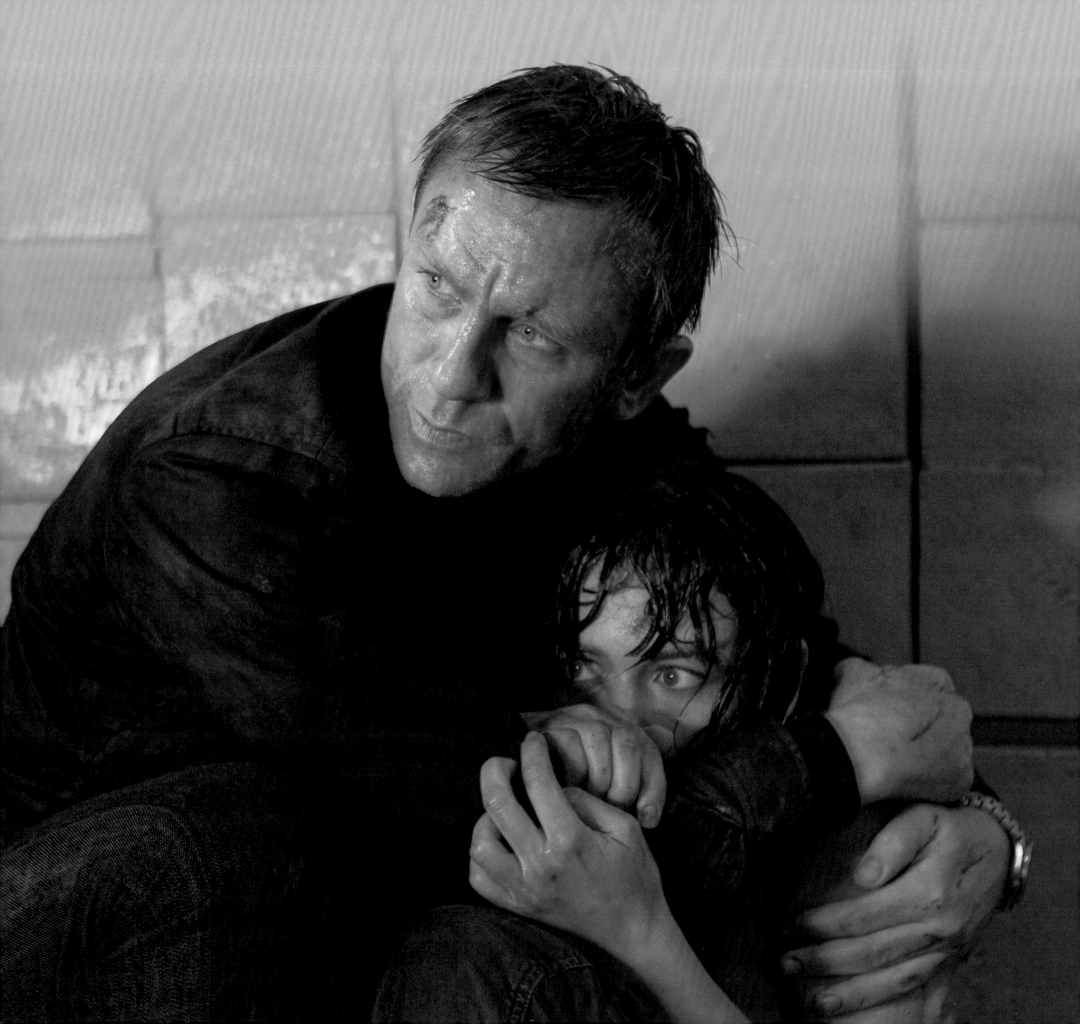

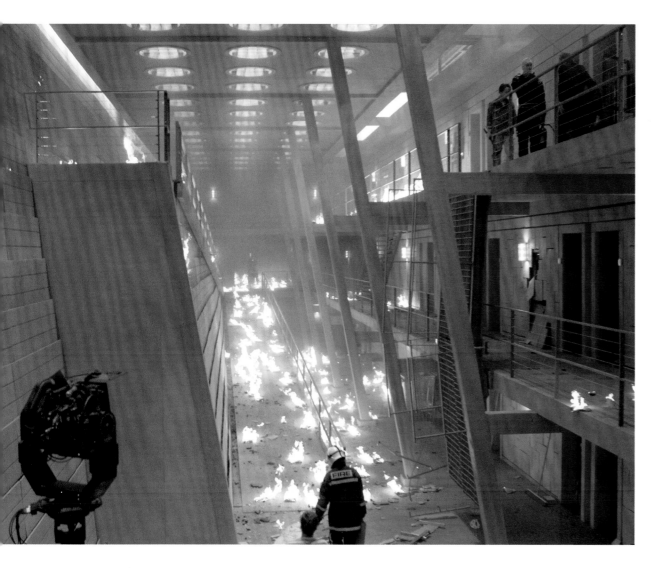

he suggested to Craig that he and Kurylenko might benefit from visiting his workshop, where he'd rigged up the entire set. "Probably more for Olga, so she felt she had confidence in it, because there was a fair bit of heat and a lot of flames," continues Corbould. "Daniel came in with Olga on a Saturday and we showed them that the fire switched off almost instantaneously, one minute it's there, five seconds later it's gone. I think it paid dividends, because it's quite an emotional scene and it allowed them to concentrate on their acting rather than be nervous. Obviously, they acted like they were nervous, but they weren't subconsciously thinking, *Am I going to get burnt? Is it going to get too hot?* That's one example of Daniel helping make these scenes look great. People say the action looks good, but he's part of that process, so I'm indebted to him."

Quantum Of Solace premiered on 31st October 2008 to somewhat mixed reviews, although, once again, Craig was singled out for his performance. "The man himself powers this movie; he carries the film: it's an indefinably difficult task for an actor. [And] Craig measures up," wrote Peter Bradshaw in *The Guardian*.

With a running time of less than two hours, *Quantum Of Solace* was the leanest Bond movie to date, a stripped-back approach that suited the character's state of mind following the events of *Casino Royale*, and went on to break opening weekend box office

OPPOSITE: Bond and Camille in the burning hotel.

LEFT: Every measure was taken to ensure the set was safe.

BELOW: The replica of part of the hotel exterior, constructed so it could be blown up.

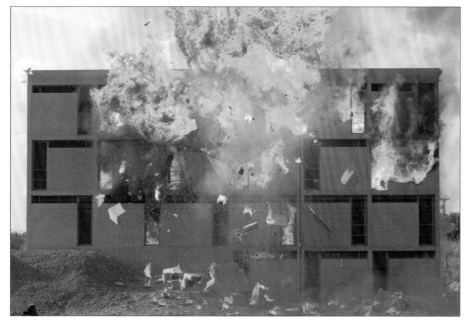

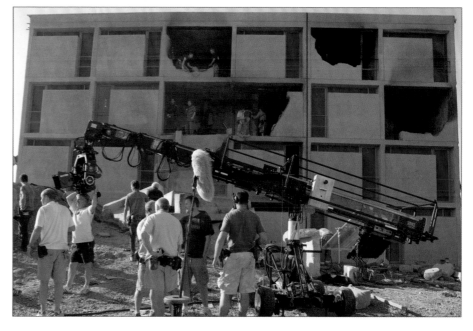

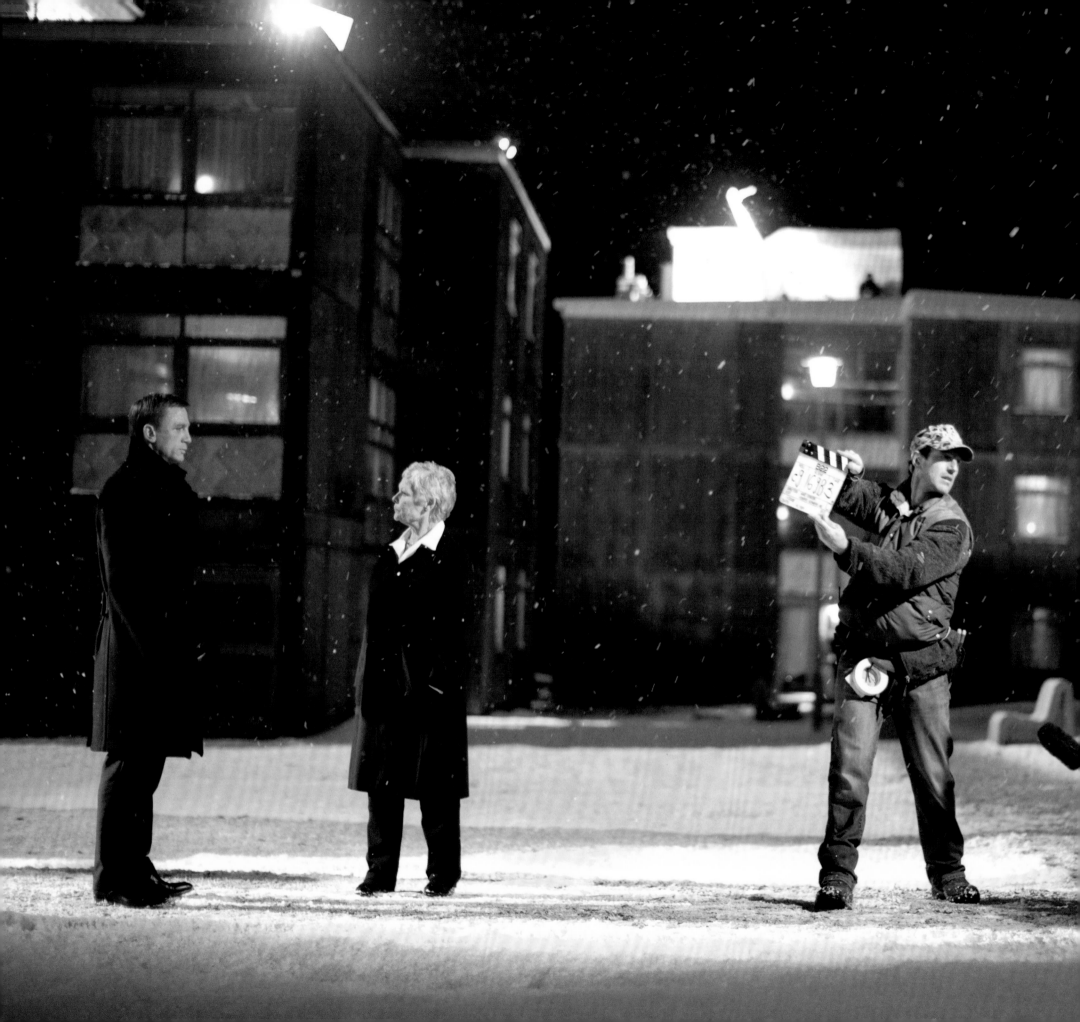

records across the globe, eventually grossing more than $576 million worldwide.

Over the years since, *Quantum Of Solace* has come to be seen in a far more positive light than on its initial release. "The film is really pretty good," says Broccoli. "Following *Casino Royale,* which was such a triumph, for some people it didn't live up [to their expectations]. If you just make the same movie again and again and again, I don't think we would be on film twenty-five. The great thing about the audiences is they take these films very personally, they all have an opinion, and you can't please everybody. But you've got to take risks and shake it up and make changes, and we tried that, and sometimes the changes, maybe, are not so good. Through all of this Daniel has been evolving the character, and when you look at the five films, I think *Quantum* is an important part of the whole development of Bond. He goes out for revenge and revenge doesn't really ever satisfy. There's also some really beautiful stuff in the film."

"I think *Quantum* is a greatly maligned movie that actually stands up rather well," Craig insists. "We were stuck. There was a writers' strike, then the potential of an actors' strike, so we were completely up against it. When you're in that situation it's difficult, obviously."

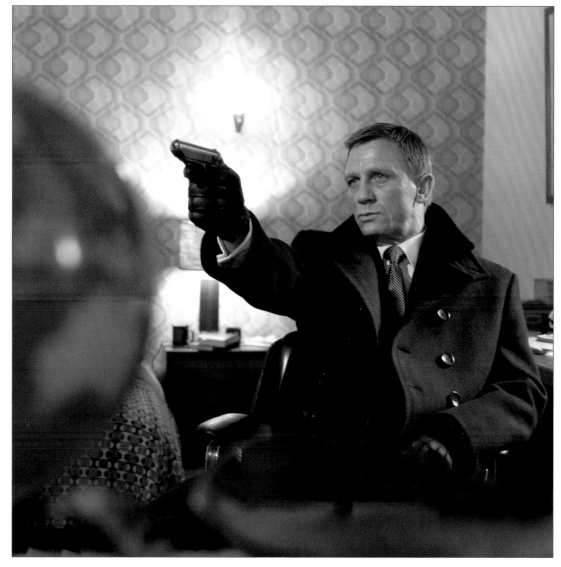

SKYFALL

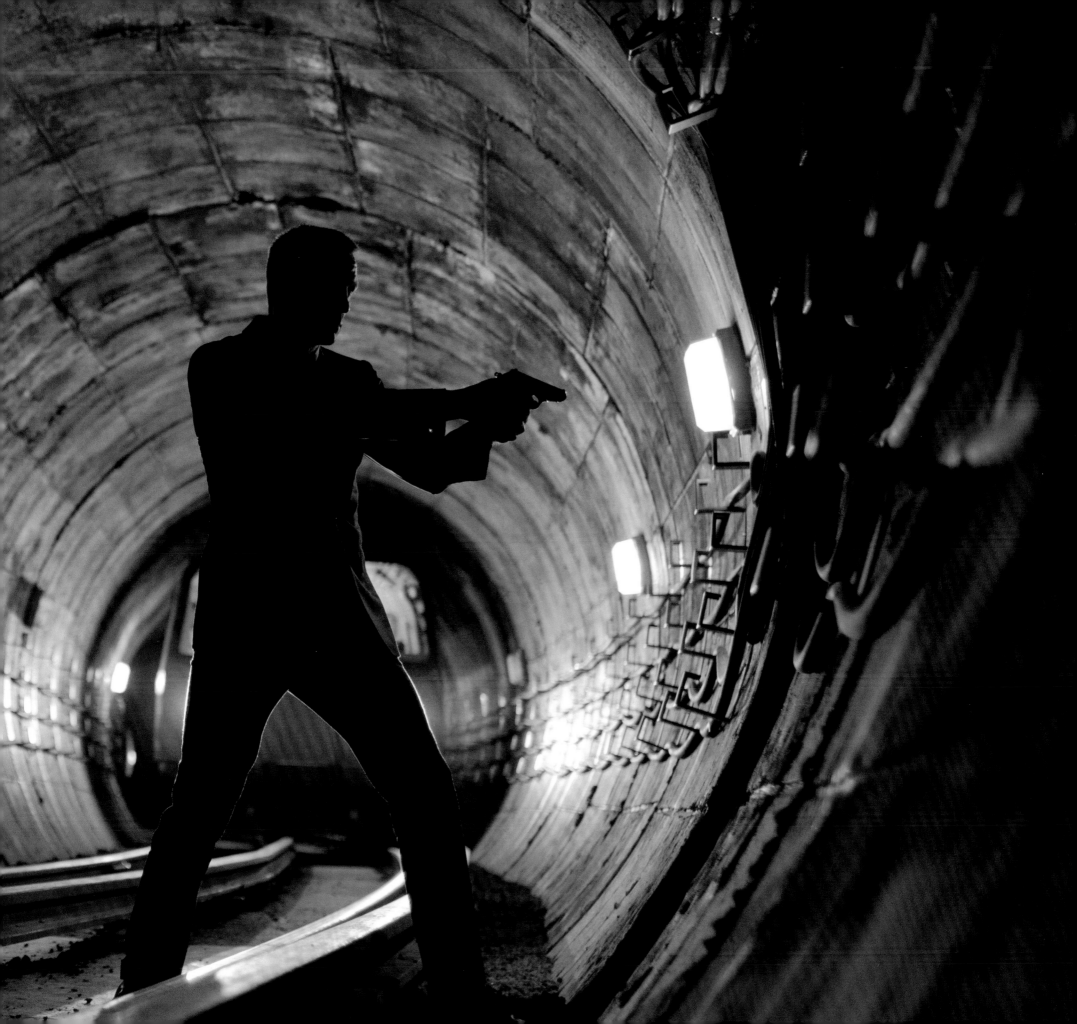

SKYFALL

For a time, following the release of *Quantum Of Solace*, it seemed that James Bond had finally met his match, not in the shape of a supervillain, but rather a financial foe when, at the end of 2009, MGM Studios found itself on the verge of bankruptcy, and its continued financial uncertainty throughout 2010 prevented *Bond 23* from going into production.

Prior to that, Bond scribes Neal Purvis and Robert Wade had been working on a treatment for a new movie with *The Crown* creator Peter Morgan, then best known for writing *The Last King of Scotland*, *The Queen* and *Frost/Nixon*.

One of Purvis and Wade's early *Quantum* scripts had featured a scene in which M is killed in a car bombing. "It happened quickly and Bond finds her two thirds of the way in," explains Purvis. "It was meant to be shocking, but it was a waste, a waste of a good death," says Wade, "and they didn't like that, understandably." By coincidence, Morgan had had the same idea of killing M off, although in his pitch Bond was the one to do it. "Daniel liked that," says Wade, "but we never thought it would really work." Nevertheless, the three writers came up with a treatment entitled *Once Upon A Spy*, which, according to Wade, was "very much a Cold War story. M had had a KGB lover when she'd been stationed in Berlin. His son was now an oligarch who was trying to blackmail her. The end was M asking Bond to kill her and he does."

In October 2009, Craig was in New York starring in *A Steady Rain* on Broadway. One evening, celebrating co-star Hugh Jackman's birthday, Craig bumped into Sam Mendes, the celebrated English theatre director who won the Best Director Oscar® for his debut feature *American Beauty* and directed Craig in 2002's *Road to Perdition*. Recalls Mendes, "He was talking about *Quantum* and I said, 'Who's going to direct the next one?' And he said, 'I don't know yet.' Then he looked at me and went, 'Why don't you do it?' That wasn't the reason why I asked him, but I thought, *Yeah, maybe*. Then, the more I thought about it, the better idea it seemed. But I never would have done it if it hadn't been for Daniel, in both senses: if he hadn't been there to ask me whether I was interested or if he hadn't been playing the part. That was the main draw for me, Daniel playing Bond."

"I've always felt Sam was a big movie director – he's

directed some big movies – but he hadn't directed something big and brash for a long time," reveals Craig. "I knew his skill with actors, and he elicits fantastic performances out of people, because people like working with him. I knew how much of a Bond fan he is, and how much it meant to him growing up, so I just asked if he was interested and he was. It seemed to me to be a perfect fit."

The following day, Craig telephoned Mendes to ask whether he had been serious about directing Bond. "I said, 'Yes,' and he said, 'You should meet Barbara and Michael, because it's not my job to offer, it's theirs,'" says Mendes. "I then had lunch with Barbara and Michael and they were delightful."

As well as being a much-lauded film and theatre director, Mendes is a massive Bond fan, of both books and films. His favourite being *From Russia With Love*. "For me, the movies divide into two around about *Moonraker*, when they become action-adventure spectaculars. I'd always wanted to do a thriller,

BELOW: Producer Michael G. Wilson, Daniel Craig (James Bond) and director Sam Mendes on the MI6 shooting range set.

RIGHT: Craig prepares to film part of the opening sequence.

and the Fleming novels were thrillers rather than action-packed adventures," Mendes notes. "But the big thing for me was having a Bond [actor] I believed in, who I thought was fantastic in the role, and felt, in his hands, the character could be taken to another level. If I didn't feel I could have made something that was part of the Bond story and at the same time personal to me, I wouldn't have attempted the movie."

"It was fresh territory for him," says Craig. "It was my third, but it was very fresh territory for him, so he was learning as he went."

There was, however, the small matter of the script. Mendes read the existing treatment. "I didn't love it," he admits. "But it had one very good idea, one very big idea in it, which was M would die at the end. I asked Barbara and Michael, 'Are you okay to retain that idea?' and they said, 'Provisionally.' I said, 'Okay, because I think we should construct a story that fundamentally leads to that moment. It's about something that M has done in her past, and the chickens have come home to roost.' That's where we started. I was living in New York at the time and Neal and Rob came over and we worked for a few weeks to put together a treatment, and they did sterling work, as they always do."

"I think it was William Goldman who wrote, 'Get the end of the movie and work back', and that was how it panned out with *Skyfall*," recalls Craig. "People were up for an emotional journey, and when you've got someone like Judi – we made her the protagonist of the movie – you're going to win."

With M's death to aim towards, Purvis and Wade began anew. As they had done with previous scripts, the pair delved back into the Fleming books for inspiration and hatched a plot that began with Bond "dying" on a mission – for his "obituary" they pulled directly from the final chapter of *You Only Live Twice* – before returning to Britain to find M being hounded by someone from her past. But who? "Daniel wanted a strong villain who was of similar age to him, his alter ego in some kind of way," says Purvis. Once again, the writers looked to Fleming, and *The Man With The Golden Gun* himself, Francisco "Pistols" Scaramanga, in creating the role of a former MI6 agent who seeks revenge on M. They called their character Javier Bardem, in tribute to the Oscar®-winning Spanish actor they hoped would play him, a character who would eventually be renamed Raoul Silva.

Meanwhile, MGM's troubles rumbled on, with the studio declaring itself bankrupt in November 2010. Nevertheless, Wilson and Broccoli were determined to keep the production on track and hired Purvis and Wade themselves to continue to work on the script with Mendes and Craig. "We weren't supposed to talk

ABOVE: Planning out the shooting schedule for *Skyfall*.

RIGHT: Javier Bardem and Mendes discuss a scene.

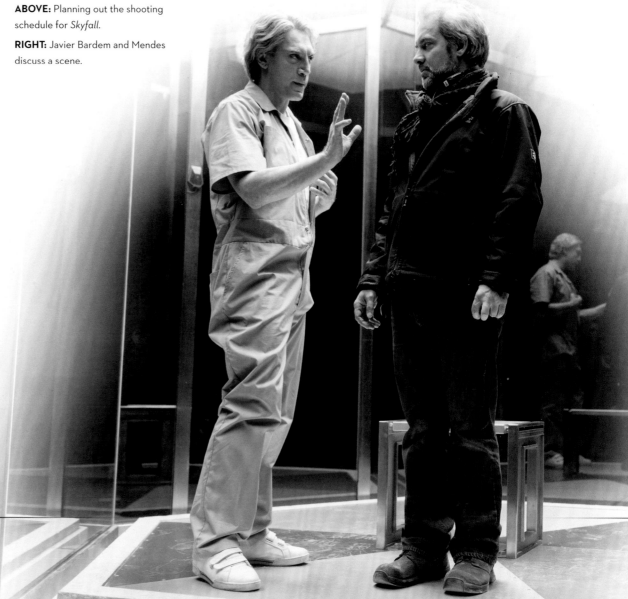

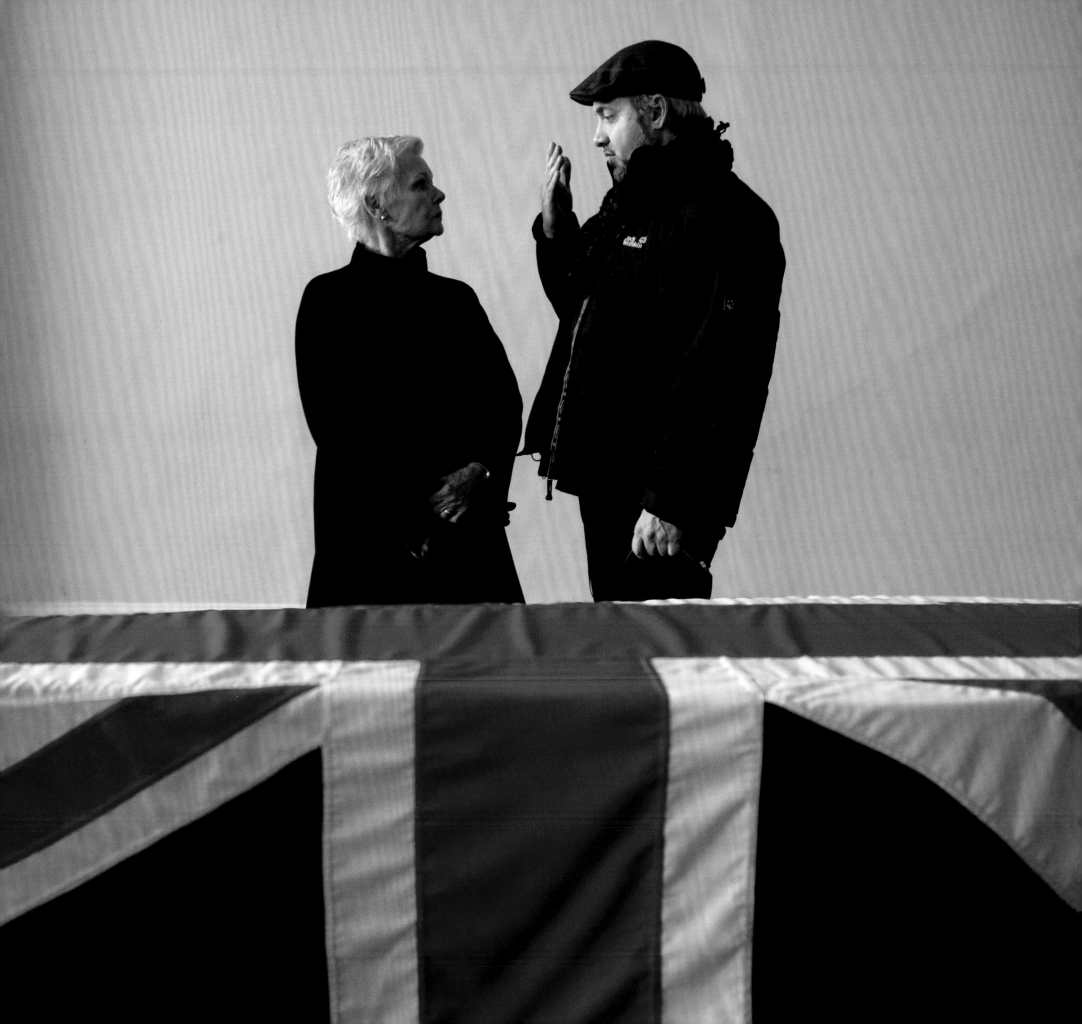

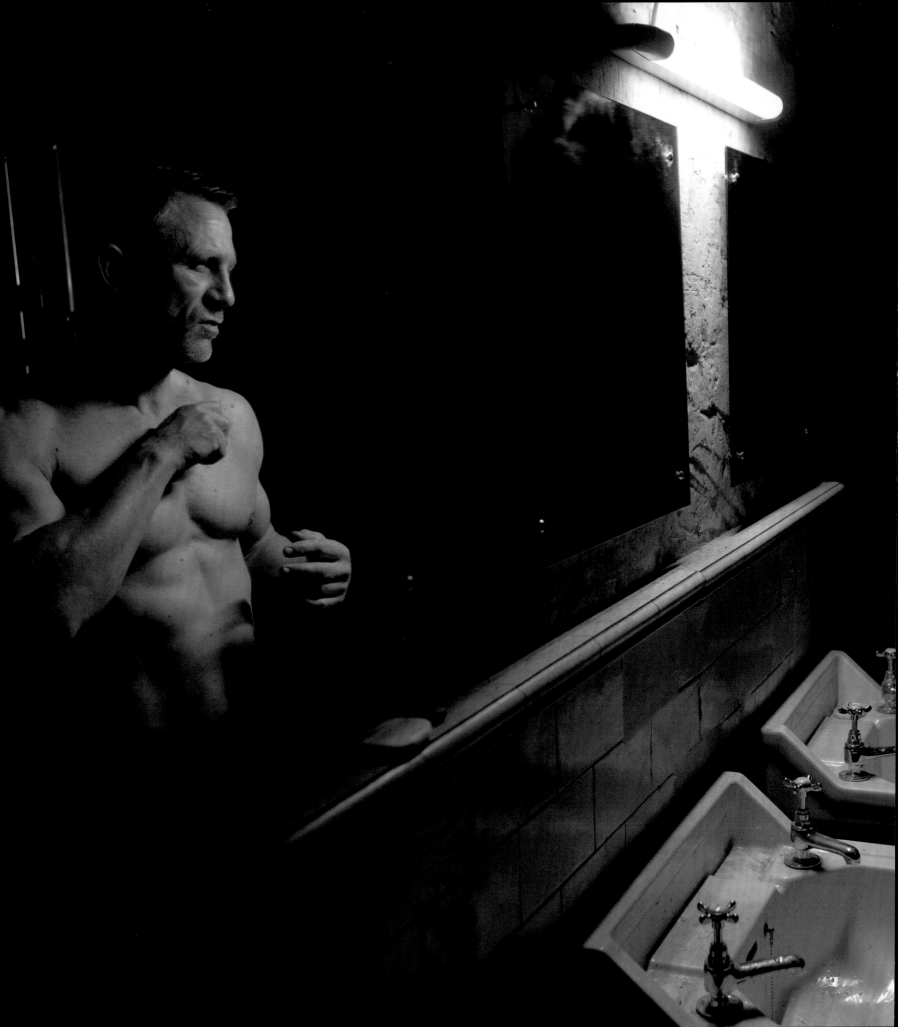

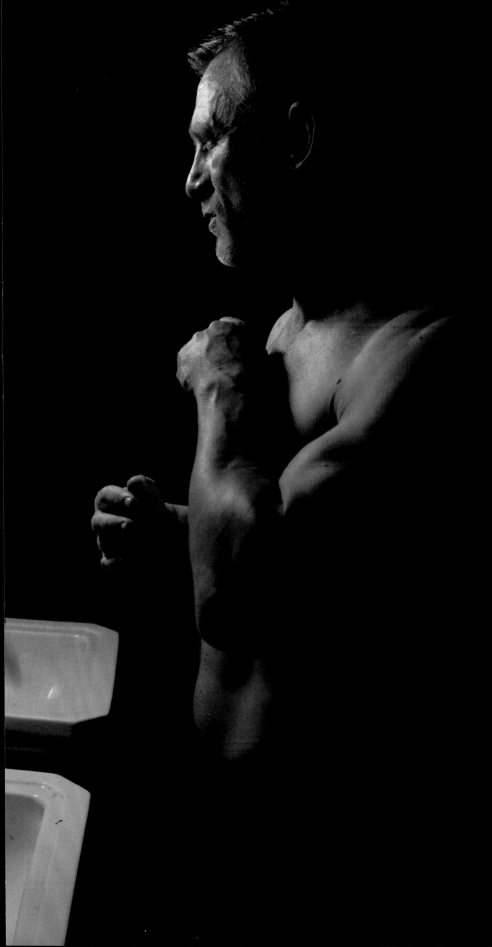

to each other, because MGM hadn't made the deal and we weren't supposed to be making the movie, [but] you couldn't shut us up," laughs Craig. "We were very excited about it. Sam and I sat down and re-read the books together and took out chapters and lines. I've read them all. I read them all when I did *Casino*. Then, when we're writing, we reference them. Someone will say, 'Isn't that a bit like...?' and you pull it off the shelf. We always look back on them in case we're missing anything."

As MGM emerged from bankruptcy in December 2010, *Bond 23* was officially back on track. "We'd been developing the whole time they'd been in this suspended animation," says Wade. "We'd been working on it for over a year with Sam, and it just wasn't coming together." More pressingly, MGM wanted a script to show to potential financial partners. "There were two, three weeks to go, and we were both unhappy with it, particularly the third act. Even though we knew we were going to kill her, it seemed like a series of events." Then the pair hit upon a solution. "We had the idea that Bond kidnaps M when this attack on her happens. He takes her to his lock up, you open the garage door and there's the Aston Martin, and now we're in business. He takes her to his family home that he hates, because he's trying to draw the villain into his world and gain an advantage."

"He's using M as bait," says Purvis. "It's not really about protecting her, it's about getting this guy, so he can kill him. That was an idea that came from nowhere, and it suddenly brought all these thematic resonances and enabled it to be about Bond's life, it gave us an end to the story." It did, however, mean ditching a large chunk of the current draft. "We told Michael, Barbara and Sam and they said, 'Go for it.' In two weeks we changed the structure and put what was at the end – we had a whole sequence with Bond diffusing a bomb at a train station in Barcelona – into the middle."

"It made it into a thing about the new and the old, the end of an era, and the fact M is going to pass," says Wade. "It's about death, it's about changing, and it's about recognising your own mortality as well."

While MGM was satisfied, Mendes still felt the script, then called *Silver Bullet*, needed some more work. Mendes drafted in Tony Award-winning playwright and three-time Oscar®-nominated screenwriter John Logan, who he'd known for many years. "I pressed on and brought in John, who was very positive about the work we'd done and retained a lot of what we both liked. Then Jez Butterworth did a pass at the end, a dialogue polish. Because there had been this delay, the script, by the time we went into pre-production, was pretty complete and in very good shape. The delay allowed us the time to think about the story more than might have otherwise been the case."

Like Mendes, Logan is a massive Bond fan and, coincidentally, had recently re-read all the Fleming books, "so it was at my fingertips in a nice bit of kismet." His task involved "everything from working out action sequences to writing dialogue to reinventing some of the characters in the process of discovering them," explains Logan. "But I had a fantastic spine that Rob and Neal had worked on so diligently. Their script was terrific and had many of the important elements that were in *Skyfall*. It had the Silva story, the M story. But things like Moneypenny, introducing a new Q, and figuring out the mechanics of everything, the entire third act when they get to Skyfall, was all the process you do with a director. It was Sam and me at first, then with Barbara and Michael, sitting around a table, really going into the nuts and bolts of structure, then dialogue."

A lot of the early discussions revolved around building "the perfect James Bond film," continues Logan. "It's a little like alchemy, because if you have too much grotesqueness or too much over-the-top action it can tilt the balance, so you don't believe the drama. Conversely, if you play it too hard and dark you lose the wit. The dialogue had to be eloquent when it needed to be, but also have flair and panache."

Mendes and Logan were keen to reintroduce a sense of fun that had been mostly absent from Craig's first two Bonds. "It was definitely something we talked about," says Logan, "that *Quantum Of Solace* and *Casino Royale* were very serious, hard films. Part of what Sam and I love about Fleming and the movies is the sense of wit and playfulness. Writing the scene in the casino or the shaving scene, to allow a playfulness and a raised eyebrow every now and then, was very important. We knew also it was going to end with a tragedy and a sort of rebirth for Bond, so we needed to sprinkle in real wit and joy. Even the sting of music when you see the Aston Martin for the first time has a lightness that helps balance the seriousness of tone and seriousness of the storytelling."

"Daniel established a Bond that was intense, real and human, so although we had our eye on trying to find moments of lightness, we were aware one of the reasons it had been successful was because of the truthfulness Daniel brought," says Mendes. In that regard, says Logan, Craig is the perfect Bond, implicitly understanding what works and what doesn't for the character. "He plays it hard, he plays it real, he plays it with consequence. Daniel also has a very sensitive ear for dialogue and so, in rehearsals, his response to the words Bond says, even the number of syllables in a line, is instinctively correct."

Mendes' main goal was "to make an audience feel Bond was vulnerable again," he says. "My issue with Bond was he was the one unchanging aspect in all the movies, and I wanted to make a movie about Bond's struggle. *Skyfall* is about him almost dying and coming back, injured and aging, feeling out of place, boozing too much and taking too many pills. I loved the fact Barbara and Michael allowed me to acknowledge that Bond was aging and that time passes in this franchise. The moment they said yes to that, it made it possible to tell a different kind of Bond story. You could acknowledge not only the aging of the character, but the aging of a nation, of an empire. That, to me, was the undertow of that movie. But within that, I was always looking for opportunities for lightness. Daniel also felt he couldn't continue that level of intensity he had explored in *Casino Royale*. There was a danger that if we repeated that tone, it would become too serious."

THIS PAGE: Craig (left), Mendes and director of photography Roger Deakins (below) filming on the MI6 agent training set where Bond is assessed.

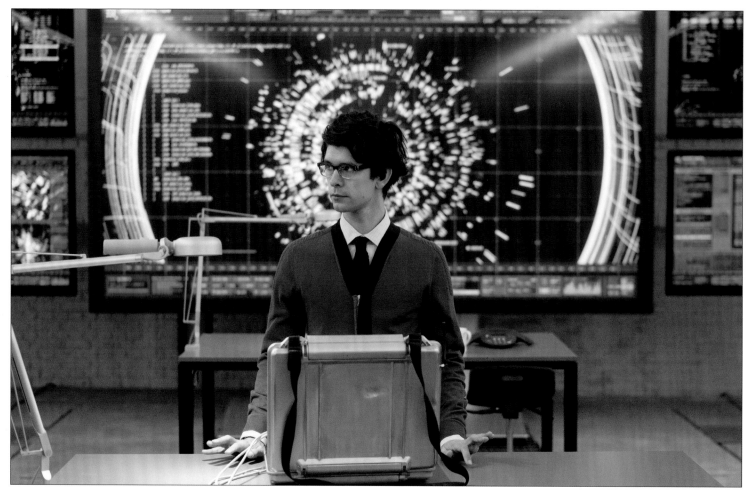

ABOVE: Q (Ben Whishaw), part of the MI6 new guard.

RIGHT: Whishaw, Mendes and Craig filming Bond's first meeting with Q on location at the National Gallery.

Part of that aging process meant introducing a new guard, a new – and younger – Q, Moneypenny and M, as played by Ben Whishaw, Naomie Harris and Ralph Fiennes respectively. "It was a conversation we'd been having. We had to reinvent. We were championing that idea that we needed a new Moneypenny and a new Q," says Craig, "and that's Sam's great skill, casting. You want actors to come in and claim those roles. You've got to find a way of doing it so people can re-fall in love with them. Nothing against the past – I'm a fan of every single Bond movie, every single book, and nearly every single performance – but we needed to say, 'This is our Moneypenny. This is our Q. This our MI6.' That's another thing we got to do: go back to the office, which, for me, was like, 'Yes! At last! That leather door.' Ben and Naomie and Ralph – it was a no brainer. 'These are three we're picking? Great. Thank you!'"

Purvis and Wade had reintroduced Moneypenny in their script for *Quantum Of Solace*, "the same way it was done in *Skyfall* – you don't know this girl is Moneypenny until it's revealed at the end,"

says Wade. "The idea was to bring back those familiar elements, because we deliberately got rid of all of the things, apart from Judi Dench's M, in *Casino Royale*." When it came to *Skyfall*, their Q was a much older man, more in keeping with the Desmond Llewelyn version, who first appeared in *From Russia With Love* and lasted until *The World Is Not Enough*, although it was eventually decided to make Q much younger. "It was a brilliant idea to cast Ben Whishaw as Q," says Mendes. "That wonderful moment in the National Gallery where they meet for the first time is one of my favourite scenes in either movie. Ben is a genius and played it with such a light touch. He's got so much charm and boyishness. It was very helpful to me that he and Daniel had worked together before and Daniel adores him. Also, because we were bringing Bond back to England for the second half of the movie, effectively, it was possible to keep Q very involved, which meant it was a much bigger role than normal. He wasn't just handing out gadgets."

The same thought process that led to Whishaw's Q was applied

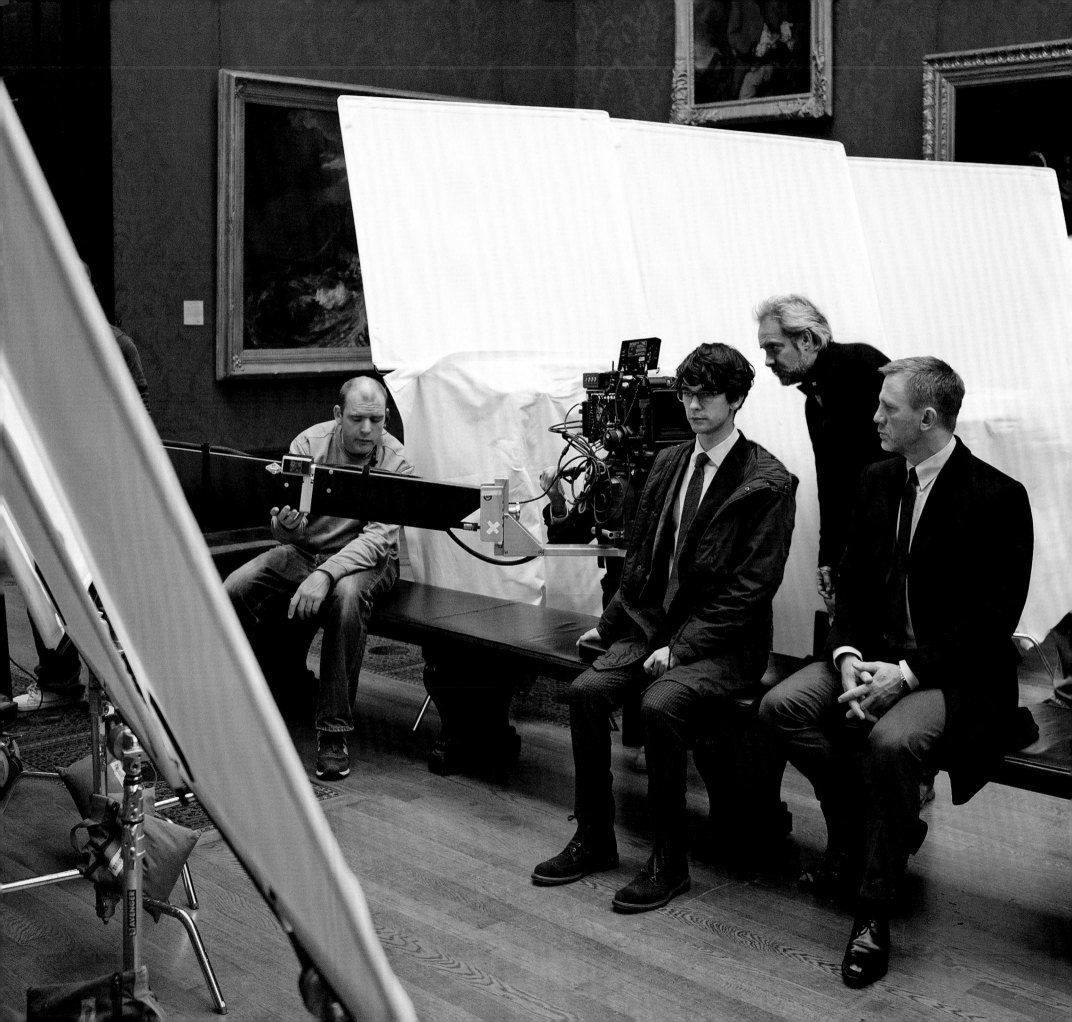

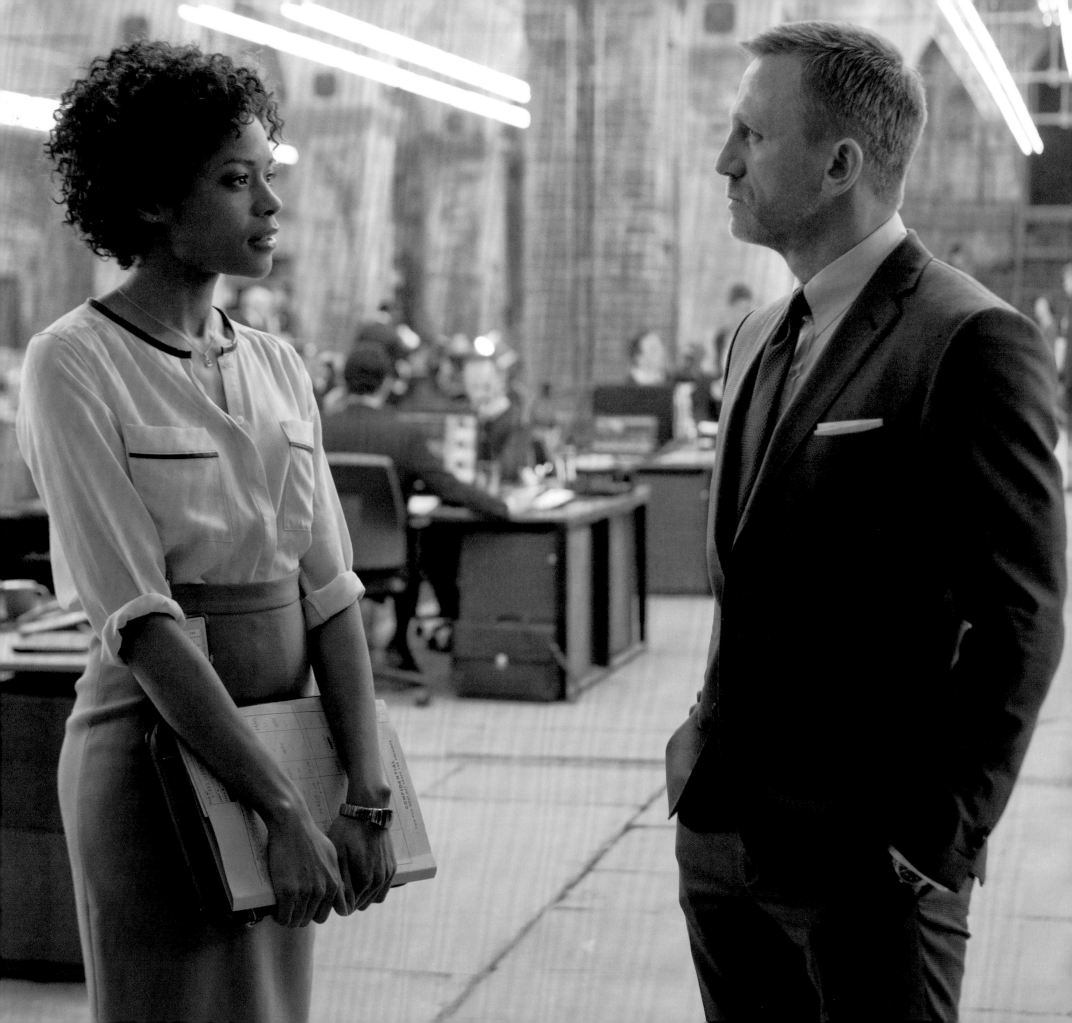

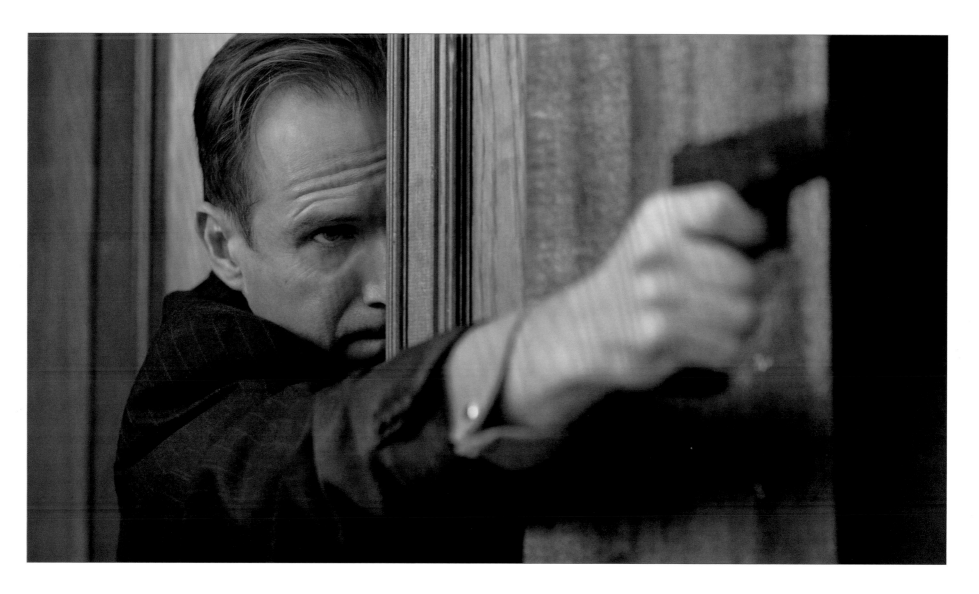

LEFT: Eve Moneypenny (Naomie Harris) and Bond at MI6.

ABOVE: Mallory (Ralph Fiennes).

to Moneypenny. "We needed to bring her back," explains Mendes, "but we needed to bring her back in a way that wasn't just an assistant to M. Somehow, I wanted her journey to sitting at that desk outside M's office to be almost accidental, and for us not to know her name until the end."

In *Skyfall*, Moneypenny is introduced, initially, as Eve, a resourceful MI6 field agent played by Naomie Harris, who, following M's orders, shoots Bond during the opening sequence in Istanbul, sending him tumbling hundreds of feet to his "death". "Sam is an absolutely phenomenal director," says Harris, who had to keep quiet about her character's true identity until the film's release. "He had such a vision for how Bond's character should develop. Also for Moneypenny, it was his decision that she should be out in the field and introduced as this kind of kick-ass character."

"Naomie has that wonderful combination of street

savvy and playfulness and that was the character we were creating," says Logan. "One who could hold a rifle and shoot a bullet, but also raise an eyebrow and deliver a nice double entendre. Michael and Barbara were committed to the idea of making Moneypenny an actress of colour and suggested the exceptionally talented Naomie Harris. Moneypenny came from almost a female empowerment idea, of trying to bring sexual equality and strong female roles to Bond that weren't the traditional *quote* Bond girl *unquote*."

Later, when Eve/Moneypenny joins Bond in Macao, the pair flirt in Bond's hotel room – she shaves him with a cutthroat razor – and possibly more before they venture out to the Floating Dragon Casino. "I wanted them to be very close together, but I wanted it to remain a mystery, a tease in a way," says Mendes. "In that respect, it does observe some of the old rules of the Bond/ Moneypenny relationship." Logan doesn't share Mendes' view and

is convinced the two slept together. "In my romantic heart I like to think, *Yes they did*, because when you go to *Spectre* you see sort of an occluded emotional moment with Bond and Moneypenny on the phone."

"It was not in the script as such," states Harris. "I think that one of the reasons their sort of love has endured so long is because they've never crossed that line. They play with the boundaries, but they never actually cross them. But who knows? It's up to each audience member to make up their own mind about what

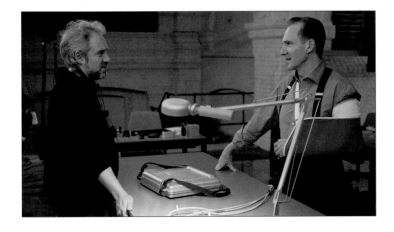

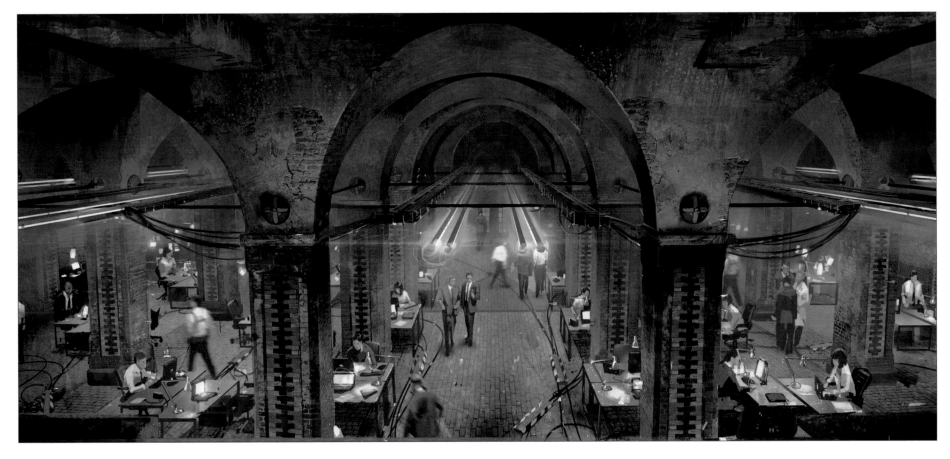

happened. I think Sam kept everyone guessing by having all those fireworks after, which seemed to be suggestive of something." Not that Craig is telling, either way. "It would be terrible if I let you know whether that's true or not," he says with mock indignation. "It would be awful. I don't think she would ever, ever, ever, ever forgive me. *If* it were true. The point is, it's ambiguous and that's the joy of it. I don't want to be the person to burst that bubble."

Only during the final beat of *Skyfall* is the now-deskbound Eve revealed to be Moneypenny, assistant to Fiennes' Mallory, who has replaced Judi Dench as the new M. "I felt we had a couple of real trump cards at the end," says Mendes. "We had M's death, the reveal of Moneypenny and the reveal of the new M. I felt we could Trojan horse Ralph into the movie, under the guise of someone who appears to be against Bond, and it turns out to be quite the reverse. He's there to oversee the move to the next generation. Ralph's a great actor. He was our first idea and, delightfully, he said

yes, and I loved carrying on with him into *Spectre*. Those three things coming one after another, I felt, gave us a great, flamboyant ending and a look into the future. A new beginning, in a way."

The return of the classic MI6 office, complete with its leather-panelled door that so delighted Craig, "was another trump card we played," says Mendes, who had production designer Dennis Gassner, returning for his second Bond, "find the original floor plans and recreate it. We actually made it a little bit larger, but gave it a real sense of old school again, taking it out of this kind of contemporary MI6 that emerged in the nineties, and bringing him back to Whitehall. Because we destroyed the MI6 building, it gave us the option to do it."

For *Skyfall*'s villain, Mendes wanted someone "more flamboyant, more frightening" than normal, casting Javier Bardem, who won the Best Supporting Actor Oscar® for his memorable turn as the sociopathic assassin in *No Country For Old Men*, and after who

OPPOSITE TOP: Mendes on the MI6 set with Fiennes (left) and Craig (right).

OPPOSITE BOTTOM: Concept art of the MI6 interior by Chris Rosewarne.

BELOW: Mallory is revealed as the new M, in the classic MI6 office.

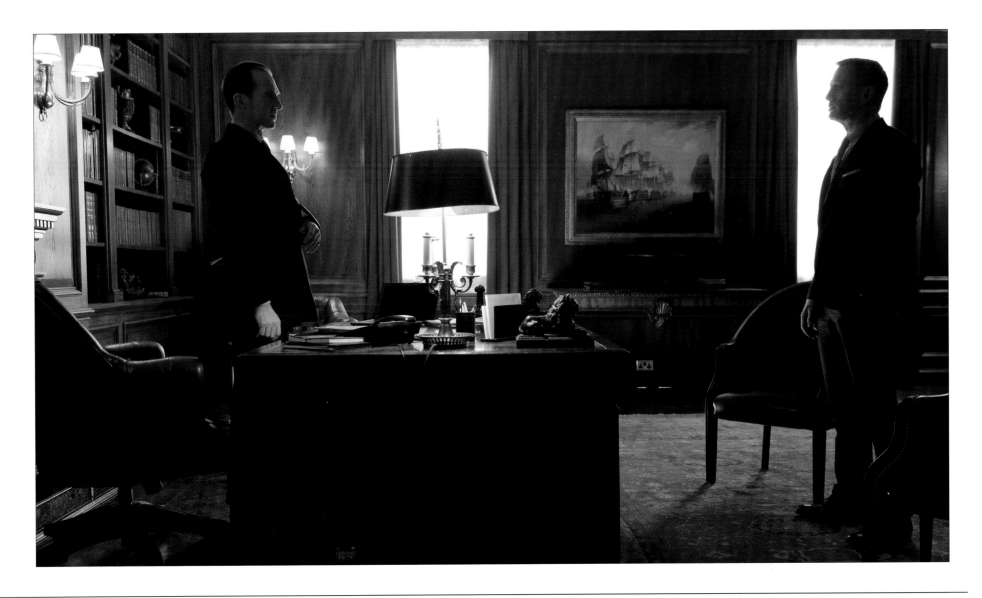

the character was initially named. "Javier was in my mind from the word go and I wanted to craft a character for him," says Mendes. "He was utterly delightful and incredibly collaborative. He read the script. He wasn't entirely convinced at first and we adjusted the part to what he felt he could bring to it."

Writing the deformed bleached-blond rogue agent Silva required holding a mirror up to Bond, according to Logan, "because protagonist and antagonist have to be almost mirror images of each other. It's a trope that runs through Fleming and many of the movies; Bond is most vulnerable and forced to be at his best when confronted with an equal. Silva's a very theatrical character. He likes to make an entrance, he likes to make an exit, the same way Dr. No did. So we gave Silva one of the great entrances. Sam shot it heroically, and Javier played it to perfection. He is a character who speaks in arias."

"The performance had to be real, but also have flamboyance," says Mendes. "The great Bond villains – the Dr. Nos, the Rosa Klebbs, the Goldfingers – are ever-so-slightly theatrical, yet all

THIS PAGE: Bardem, Craig and Mendes on the Dead City exterior courtyard set, constructed on a car park at Pinewood.

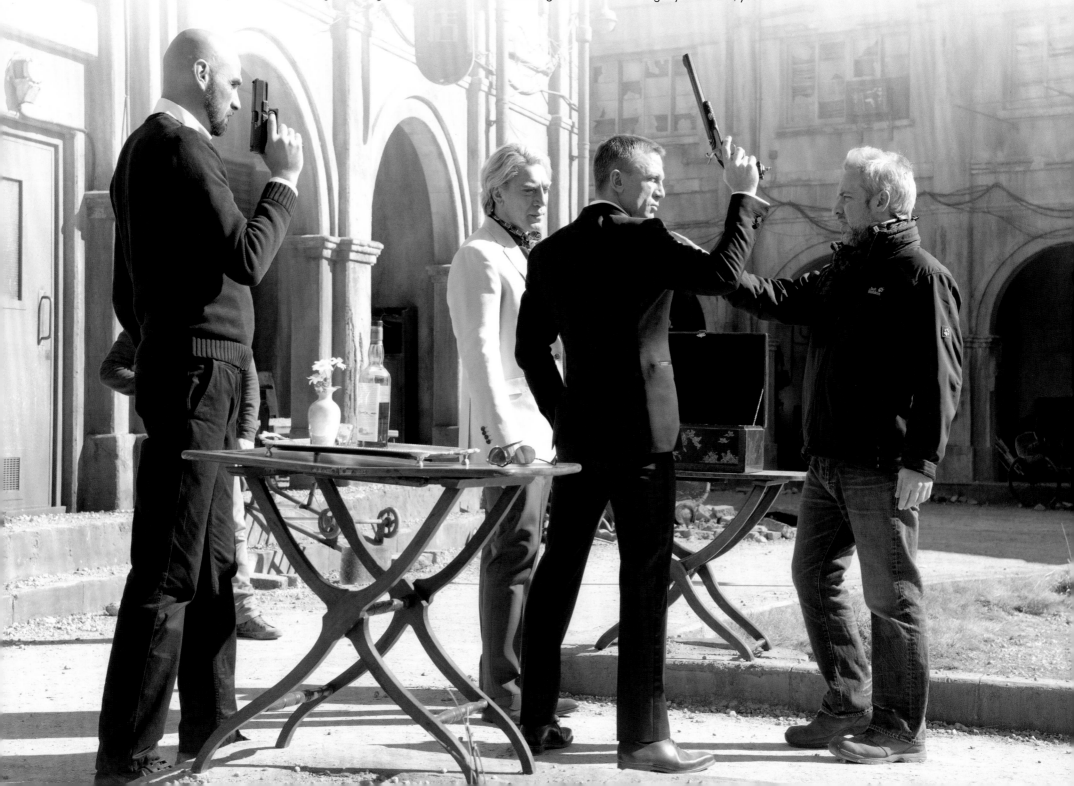

LEFT: Digital illustration of the Dead City exterior courtyard by Tim Browning.

BELOW LEFT: Silva delivers his metaphorical monologue.

BELOW: Mendes, Bardem and Bérénice Marlohe on the courtyard set.

the more frightening because of it. Javier allowed himself to be playful and mischievous, but never lost the danger, the mystery, the strangeness, the otherness." To Bardem, Silva was "an angel of death. A very clean-shaven person, who happens to be rotten on the inside."

The two men first meet in Silva's lair, an abandoned island off the coast of Macao referred to as Dead City, based on a former Japanese mining facility called Hashima Island. "We wanted to go there and film, but it was such a health and safety hazard," says executive producer Callum McDougall. Instead, Gassner built an exterior courtyard on a car park at Pinewood and an interior set, complete with working elevator, on Q Stage. The latter was designed to be long enough for Bardem to walk and talk from one end to the other, giving a speech about rats as he strides

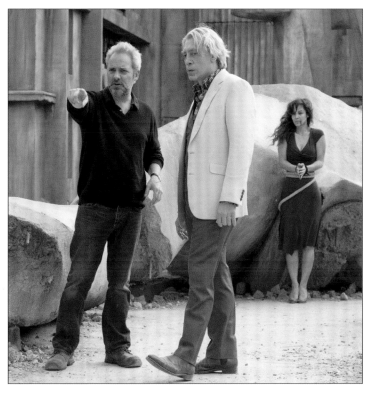

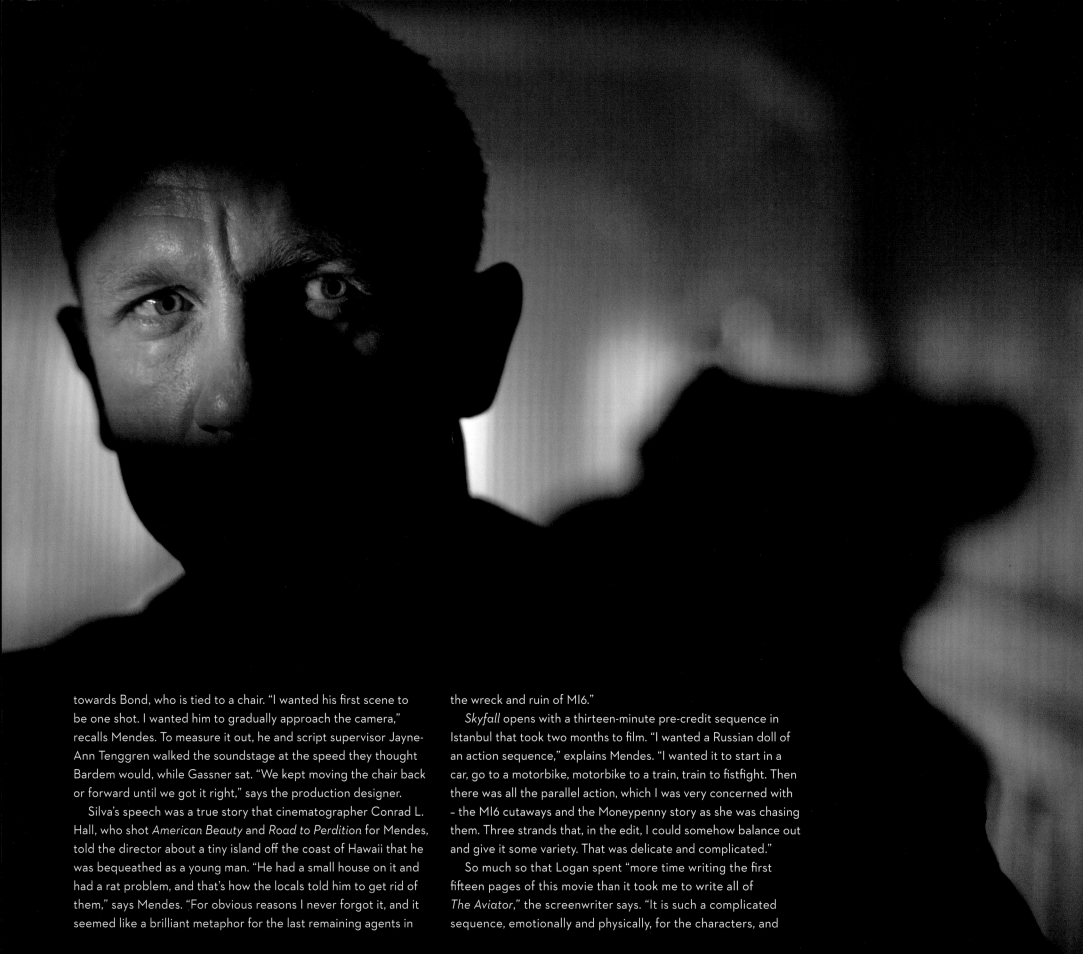

towards Bond, who is tied to a chair. "I wanted his first scene to be one shot. I wanted him to gradually approach the camera," recalls Mendes. To measure it out, he and script supervisor Jayne-Ann Tenggren walked the soundstage at the speed they thought Bardem would, while Gassner sat. "We kept moving the chair back or forward until we got it right," says the production designer.

Silva's speech was a true story that cinematographer Conrad L. Hall, who shot *American Beauty* and *Road to Perdition* for Mendes, told the director about a tiny island off the coast of Hawaii that he was bequeathed as a young man. "He had a small house on it and had a rat problem, and that's how the locals told him to get rid of them," says Mendes. "For obvious reasons I never forgot it, and it seemed like a brilliant metaphor for the last remaining agents in the wreck and ruin of MI6."

Skyfall opens with a thirteen-minute pre-credit sequence in Istanbul that took two months to film. "I wanted a Russian doll of an action sequence," explains Mendes. "I wanted it to start in a car, go to a motorbike, motorbike to a train, train to fistfight. Then there was all the parallel action, which I was very concerned with – the MI6 cutaways and the Moneypenny story as she was chasing them. Three strands that, in the edit, I could somehow balance out and give it some variety. That was delicate and complicated."

So much so that Logan spent "more time writing the first fifteen pages of this movie than it took me to write all of *The Aviator*," the screenwriter says. "It is such a complicated sequence, emotionally and physically, for the characters, and

BELOW: Harris and 2nd unit director Alexander Witt on location in Istanbul.

RIGHT: Bond hunts for Patrice and the stolen MI6 hard drive.

has to communicate something very specific about Bond and his relationship with M. It was also the trigger for the rest of the story. We worked on it endlessly, with location managers, with Dennis Gassner, and it evolved and evolved. That's what these action sequences are in big movies, a gradual building from an initial idea to what you see on the screen. It's like climbing a hill with lots of people joining the trek." Of paramount importance to Craig was making sure Bond was "not a superhero. He has no superpowers. Yes, he is heroic in his actions, but he's vulnerable and flawed," Logan continues. "Daniel was always very concerned with making sure it felt real, and that it felt doable for his character in those circumstances."

The opening was originally meant to take place in Mumbai, India, but, according to McDougall, "the safety element was too complicated to shoot there." The production scouted India, with Goa earmarked for the scene of Bond in the beach bar, but realised they wouldn't be able to do the train portion of the sequence. "Fortunately, our production manager had worked in Turkey and said, 'I think we can make this work in Istanbul. I think we can find a railway bridge,' which we did, near Adana."

Nestled on the banks of the Bosphorus strait, Istanbul was Ian Fleming's favourite city, although apart from a brief stopover in *The World Is Not Enough*, the last time Bond spent any proper time there on film was way back in *From Russia With Love*. "I loved Istanbul. I loved shooting there. I thought it was an incredible place," says Mendes. "It was a surfeit of ideas, really, and, if anything, we had too much in that opening. There's at least another four, five minutes of solid action on the cutting-room floor. There's a motorbike chase through the Grand Bazaar that went on for at least three minutes."

When it came to creating the action, Mendes worked alongside *Casino Royale* second unit director Alexander Witt, stunt coordinator Gary Powell and special effects and miniature effects supervisor Chris Corbould and their respective departments. "Each director comes with their own agenda for what they want to see. Sam is very character driven. Even though this was a huge opening sequence, it was all about character," says Powell. "I remember Sam saying he wanted to follow on from the tone of *Casino Royale*, he wanted the same team back who did *Casino Royale* and to carry on from there. He was very nervous that the action would look like stunts rather than story beats. When I do stunts, I don't do them for the sake of it. I always try to make sure that, as small as my storytelling parts are, they help enhance character and tell a story."

Skyfall begins not with the traditional gun barrel, but with Bond on foot, creeping along a darkened corridor, gun raised, into a ransacked apartment, where he discovers a critically injured MI6 agent and a laptop minus its hard drive, a hard drive containing classified information related to undercover NATO operatives. Ordered by M, via his comms device, to leave his dying colleague, Bond heads outside, onto the bustling streets of Istanbul, where he is picked up by Harris's Eve in a Land Rover Defender. The pair then chase an Audi, driven by Ola Rapace's Patrice, into Eminonu Square, one of Istanbul's oldest and most magnificent plazas. There, Gassner created his own Grand Bazaar with 196 dressed market stalls – "passionate" red being the dominant colour – and 500 extras.

The chase required twelve Defenders and sixteen Audis, modified and reinforced to the requirements of the stunt and camera teams. Two Defenders were fitted with driving pods on the roof. These allowed Harris to "drive" at fifty miles an hour through the packed streets of town, when, in reality, the car is being steered by a stunt driver sitting in the pod. "It was very tricky to film, because we were on the streets of Istanbul with lots of extras," Harris recalls. "Sometimes someone was driving above me, so it was all controlled, but sometimes

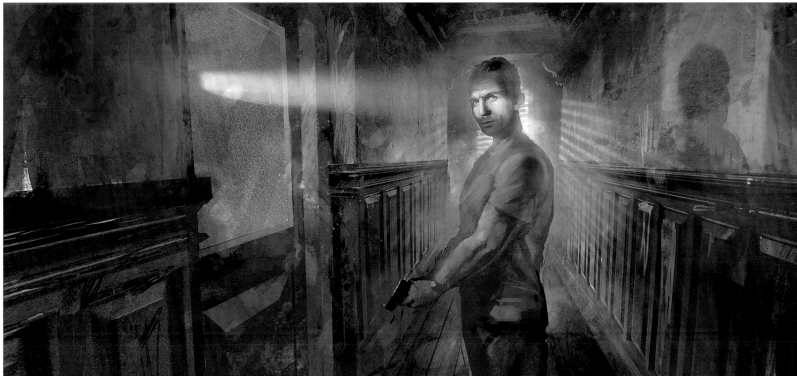

I did have to drive myself. It looks scary on screen and it was scary to film as well."

After Patrice crashes his Audi into a market stall, he commandeers a police motorcycle, opens fire, then peels out. Bond grabs another bike and sets off after him, the pair quickly taking to the rooftops of the ancient city. "If you're on the ground it's just a motorbike chase," says Powell, "so I said to Sam, 'Have we got any rooftops to work with?' And he went, 'Yeah.' This place was enormous. So we asked if we could use it and then we walked around, working out the plot, the route, the story points. It took quite a few weeks figuring it all out."

One idea was to build a three-to-four hundred feet long track on the existing rooftop paths for the motorcycles to ride on. "We were going to put Daniel on a motorbike on a track," says Corbould. "You'd only be able to see him from the waist up, but you would have had all of Istanbul in the background." Then Powell had another idea. "As we were looking at it, I said, 'I want to go across the roofs, the actual tiled roofs.' There was obviously a cost implication, because it meant reinforcing the rooftops. We had a meeting with Michael Wilson. He asked what was involved and then said, 'Do you think it's going to add to the motorbike chase?'

I said, 'One hundred percent,' and he said, 'Right. Do it.' I have to give credit to Michael, because it was a chunk of change, but it did add to the chase."

Before then, the rooftops and the two-and-a-half feet wide rooftop paths had to be properly prepared, with any satellite cables, air vents and sharp edges either removed or covered. The roofs themselves were reinforced with floating steel roof panels that both protected the historic structures and helped support the weight. Tiles were replaced with rubber ones, then swapped back after filming. Assistant stunt coordinator Lee Morrison and stunt rider Robbie Maddison stood in for Craig and Rapace during filming, with visual effects later digitally replacing their faces with those of the actors. "Daniel did some riding on the ground, but the rooftop was too risky," says Powell, who wanted to add a ramp to the sequence so Morrison and Maddison's bikes could jump sixty-to-seventy feet into the air then land on the downslope of one of the roofs, but Mendes felt it would look "too stunty" and nixed the idea. "Later, he did say to me, 'I should have let you do it,'" Powell notes.

"A bit like *Casino Royale*, I look at it now and go, 'How did we do that?'" laughs executive producer McDougall. "Well, we did it

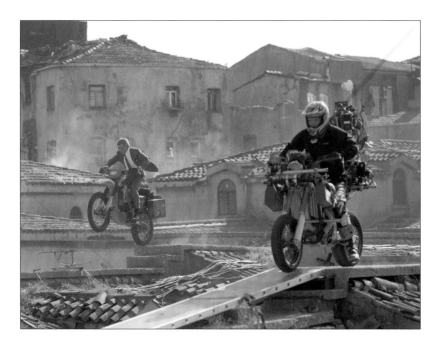

all for real." From the roofs, Bond and Patrice crash through a window into the Grand Bazaar itself, the pair travelling at speed through the covered market. Filming could only take place on a Sunday when the bazaar was shut, meaning the art department had to dress the set overnight Saturday ready for filming early the next morning.

To shoot the next stage of the chase, the production moved to Adana, a city close to Turkey's eastern border, where Alexander Witt's second unit filmed a bridge stunt featuring a hundred vehicles, as Moneypenny drives against the oncoming traffic, desperate to keep Bond in her sights. When Patrice jumps over the side, onto a train, Bond follows him, propelling his motorbike over the side of the bridge, and ending up hanging from the side of a carriage as Patrice takes pot shots at him.

The train sequence was even more complicated and dangerous than anything that preceded it in Istanbul, with Bond and Patrice set to battle each other in and on the carriages as they speed through the Turkish countryside. "We had to find railway tracks that had to have no cables above them and ideally sections with no bridges," says Powell, who was eager to design a fight that hadn't been seen before. A large Hornby model train had been set up in the production office to plot out the action on the train and one day Powell wondered, *What if there was a Caterpillar digger on the train that Bond could use to fend off the bad guy?*

TOP: Filming the motorbike chase across Istanbul's rooftops.

LEFT: Bond continues his pursuit of Patrice on a motorbike.

RIGHT: Craig filming the digger part of the train sequence.

"The idea was he used the bucket as a shield, because Patrice had this massive machine gun," he recalls. "It was also a 'Bond moment', because that's what Bond would do. He gets in a digger. He gets in a bus. Bond always does something in a vehicle that other people wouldn't, and I thought a digger driving along the back of a moving train would look cool. It was a throwback to Bond driving the Citroën 2CV in *For Your Eyes Only*, keeping up with a car he shouldn't be keeping up with, because he's doing things that anyone else wouldn't do. Also, if you've got the bad guy with a massive gun and you're both on a rooftop, he's going to shoot you. So it was making that scene believable. Bond's jumped onto this train and now he's face to face with this bad guy who's got a machine gun, and the digger's there."

Using the digger first as protection, then as a weapon, Bond sweeps aside a goods-car load of Volkswagen Beetles, before driving the digger along the train, then climbing across its arm to reach the next carriage. The CAT digger was "fairly monstrous and weighed something ridiculous like fifteen or twenty tonnes," says Chris Corbould, whose team pre-programmed all its movements in England before shipping it out to Turkey. "We computerised

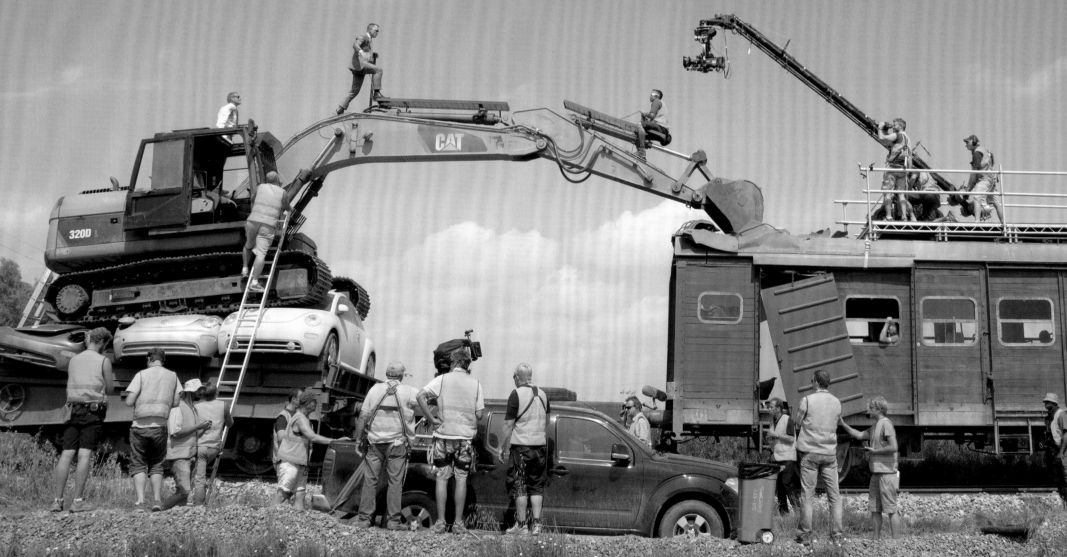

the digger arm going up, down, forwards, ripping the back off the carriage, and found all the materials that would look good when it ripped through the roof. Daniel sat in the cab, but we were controlling it so it wouldn't do anything erratic like skid sideways." To ensure the digger didn't slide off the train, a steel track was connected to its centre. "It was pretty nerve-wracking," continues Corbould, "especially when it bounced the Beetles off. You could feel the carriage rocking as the arm swung around." As debris caught beneath the carriage wheels could potentially derail the train, a small trailer was coupled between the two carriages to catch the torn-off back. The trailer was later removed digitally by visual effects. "There were little cheats we had to do for safety reasons, but they still did it on the train, going along the track, for real," Corbould says.

"The stuff on the train was, frankly, bonkers," recalls Mendes. "It was immensely technically complicated and, because I was determined – as I was in *Spectre* – to do these things [largely] in camera and not use visual effects, it took a long time."

Having dropped through the roof into a passenger carriage, Bond shakes himself down and adjusts his cuffs, a crowd-pleasing moment that was a Craig improvisation. "I didn't ask him to do that, he just did it when he landed," says Mendes. "I mean, he was incredibly adrenalized and Bond was doing it almost to calm himself down, to control his fear and refocus. It came from inside. It *was* scary. He was climbing across a digger arm on a train going at forty miles an hour. It was intense. That's a good

ABOVE: Craig prepares to adjust his cuffs.

BELOW: Craig and Ola Rapace filming the fight on top of the train.

example of why Daniel is so good in the role, because he did it with some level of reality and truth. That's Daniel making something work that in other people's hands might have been corny."

"It works because it's stress relief," says Craig. "I think by that point you're holding your breath. I just felt, we've got to do this, we've just got to go, 'It's all fine.' I suddenly realised why James Bond shoots his cuffs, because he's telling himself he's okay. It's like looking down at himself going, 'Two legs. Two arms. I'm still standing. Good.' I needed motivation to be able to shoot the cuffs at the right moment, and I never understood it until that moment. I'm not wearing a suit in the crane sequence in *Casino Royale*, but if I had been, I'm sure there would have been a moment."

"Daniel knows Bond inside out," says Harris. "He lives, eats, sleeps, breathes Bond. Obviously, we come on board once the script's ready, but Daniel's a huge part of developing those scripts and developing his character further and has such great insight into who Bond is. That's incredible to act opposite, because you're acting opposite someone who is so centred in what they're doing. I've never known anyone to be so passionate about a role they're playing."

The fight continues with Bond and Patrice atop the train, a sequence filmed by the actors themselves, as well as stunt doubles Ben Cooke and Andy Lister. Craig and Rapace were attached to cables that, in turn, were rigged to cables running alongside. "So you can fall over, but you can't fall off," says Powell. "They had kneepads on, all the sharp stuff was taken off the train, which had been rubber-topped, so if you did fall over it would have been relatively soft. But you're still on a moving train. It's intimidating regardless of who you are. But when you're 350 feet up on a bridge, wearing a suit, having to remember fight choreography... Daniel put himself out there. He didn't need to, we could have done it with a double."

(Continues on page 150)

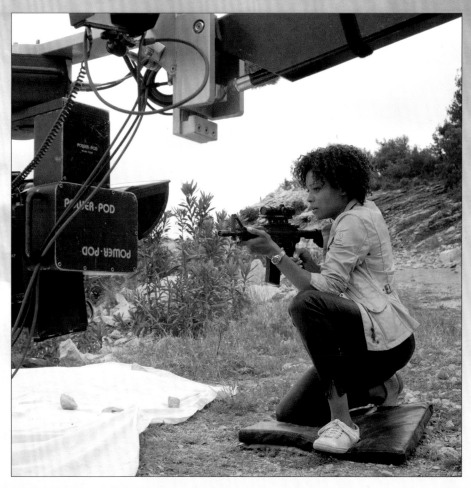

ABOVE: Harris as Moneypenny, about to take the shot.

BELOW: The train on the Varda Viaduct.

PRE-CREDIT SEQUENCE SUIT

The tight-fitting suit Bond wears in Istanbul was designed to duplicate the "iconic blue-grey one Cary Grant wears in *North by Northwest* [1959]. I wanted that particular colour and we studied it," says Mendes, "because to me, Grant's Roger Thornhill in *North by Northwest* is the first Bond figure. That's the first Bond movie in a way and was certainly an influence on all the early Bond movies and on me and is a masterpiece."

Throughout *Skyfall*, costume designer Jany Temime opted for a tighter cut when it came to Bond's suits. "Tom Ford suits are made mostly for an American public and Bond is a European character, a European hero, and that was giving the suit a European touch." Moreover, making them tighter meant "you feel the body running and moving. It's much more *active*. You see the suit, but you also see the body in the suit. I wanted a trouser that was quite tight, so when Daniel was running you could feel his muscles moving. That's why I chose very thin fabric. I wanted constantly to see that body ready to kill. This is the glory of good tailoring. When the suit is made for you, you can roll, you can stand, you can run, because it's a second skin. And the silhouette was good. Daniel liked it, Sam loved it, because it was like a new Bond. There was something very young and dynamic about it."

THIS PAGE: Craig, wearing ripped trousers, and Rapace filming the train fight.

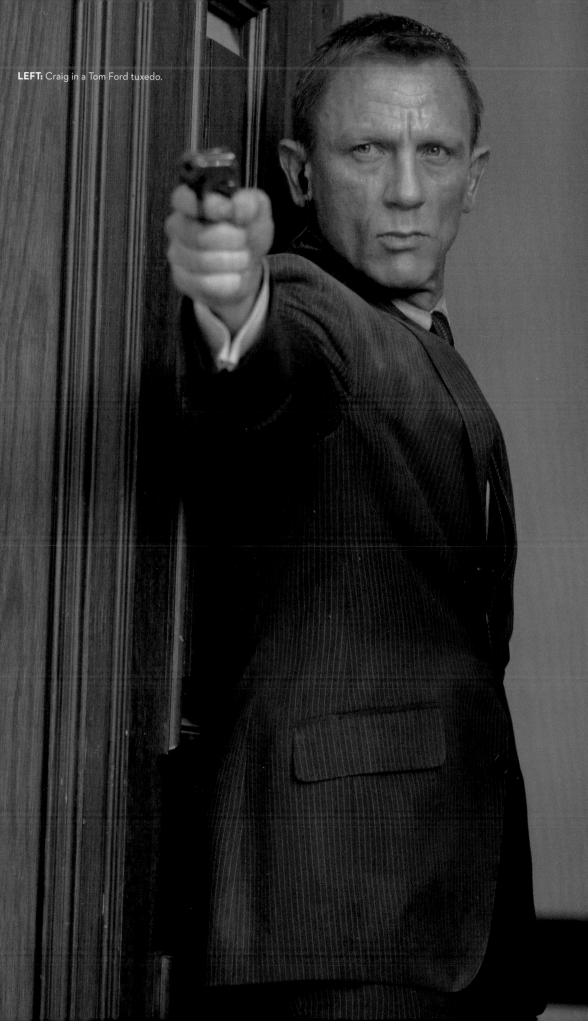

However, the tight-fitting suits did have their drawbacks. "Every time he bent over they ripped," laughs Mendes. "We had a van full of one suit. There were probably eighty in this one van that travelled all the way to Istanbul, because we needed suits in different stages of disarray. He gets shot in the shoulder, so there were those with wounds in them and blood, post-fight and pre-fight. He got through two or three a day on the top of the train, because every time he moved and punched Ola his suit would rip. But they were great suits. Jany is very skilful, and she kept saying, 'Bond is a legend to me. He is not a human, he is a *legend.*' Okay!"

"Standing on top of a train travelling at 40 miles per hour, fighting with Ola Rapace, going over a 300-foot drop was probably a standout moment for me," recalls Craig. "I had my heart in my mouth the whole time they were on the roof," insists Broccoli. "They had safety wires, obviously, but the things they were doing were heart-stopping. Daniel's the reason why the action works as well as it does, because he sells it. He's up there, and audiences know that."

The sequence climaxes at the breathtaking Varda Viaduct, an hour outside Adana. As the train crosses over the 570-foot expanse, with Bond and Patrice still wrestling on the top, heading for a tunnel (added by visual effects in post) on the other side, Moneypenny is instructed by M to "take the shot." Moneypenny inadvertently hits Bond, who plummets 300 feet into the river below. Lister performed the stunt, his safety line attached to a crane arm fixed on another carriage, falling 80 to 90 feet out of shot. "What was really tricky about that was it was a working train line, so we couldn't build anything on the side of the bridge," says Powell. "We came up with a system which could be packed down quickly and we could be off the track

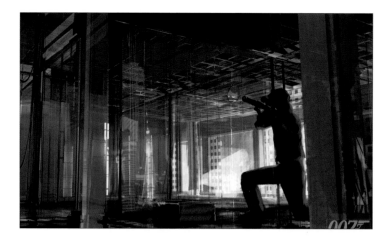

TOP: Concept art of Patrice on the 67th floor of a Shanghai office building by Kim Frederiksen.

BELOW: Preparing to film the Shanghai fight scene on set on the 007 Stage at Pinewood.

RIGHT & OPPOSITE: Bond finds Patrice and they fight.

in 30 minutes if the train was coming. It was a lot of work." A full-size dummy was used to simulate Bond hitting the water, his limp body washing along the river before sinking. At which point Daniel Kleinman's title sequence kicks in, accompanied by Adele's Oscar®-winning theme song.

Missing presumed dead, Bond is drowning his sorrows in the coastal town of Fethiye in southern Turkey when he sees news of an attack on MI6. Returning to London an unshaven, psychologically damaged, pill-popping wreck straight out of

Fleming, Bond manages to trail Patrice to the sixty-seventh floor of an office building in Shanghai, where he is readying to take out someone in a neighbouring building with a sniper rifle. The pair fight and Patrice falls to his death. While the plan had been to shoot the sequence in China, after a location scout it was decided it would be more controllable to film at Pinewood, where Gassner created a Shanghai skyscraper and the building opposite on the 007 Stage. A second unit was sent to Shanghai to shoot establishing shots, with an aerial unit granted rare

THIS PAGE: Bond arrives at the Floating Dragon Casino in Macao

access to the skies above the city. "For me, Dennis's finest hour design-wise was the Shanghai office tower, which I thought was an incredible set with all the LED screens and [director of photography] Roger Deakins' lighting," notes Mendes. "It felt like we were floating in the clouds somewhere, when we were only twenty feet above the ground. The way Dennis and Roger used LED screens, neon and reflections to create this maze of light and darkness within was remarkable. Both Roger and [director of photography] Hoyte [van Hoytema], who worked with me on *Spectre*, are exceptional and elevated the look of the movies. The confidence they had using darkness and their lighting and level of sophistication in terms of the look of the movies was really a big part of why they were liked."

Following his exploits in Shanghai, Bond tracks a lead to the Floating Dragon Casino in Macao, where he meets Bérénice Marlohe's mysterious Severine. Initially, the production hoped to use a pre-existing casino set they found in Shanghai. "Sam, the producers and I walked around and thought, *This is really good*," recalls McDougall. Three weeks later, they returned for a technical recce and the set's floors had collapsed. "There had been a shoot on it two or three days before we arrived, with a hundred extras. That was a really good indication we should build our own. We brought everything from China and shipped it in."

The set was constructed on D Stage at Pinewood, while its

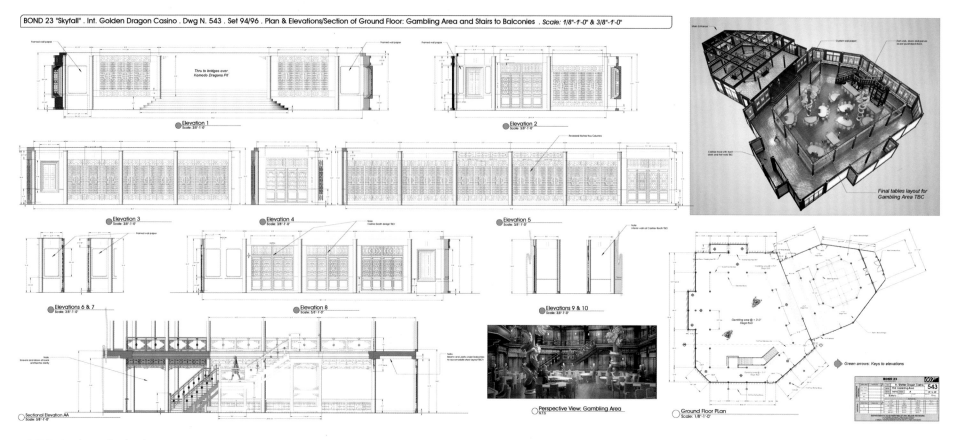

BOND 23 "Skyfall" . Int. Golden Dragon Casino . Dwg N. 543 . Set 94/96 . Plan & Elevations/Section of Ground Floor: Gambling Area and Stairs to Balconies . *Scale: 1/8"-1'-0" & 3/8"-1'-0"*

ABOVE: Set design for the Floating Dragon Casino interior by Greg Fangeaux.

BELOW: Marlohe prepares to film a scene on the set, constructed on D Stage at Pinewood.

BELOW: Mendes and Craig on set.

ABOVE: Storyboards of the casino interior sequence by Jim Cornish.

waterfront exterior, where Bond arrives by boat, was built on the Paddock Tank and featured three hundred floating lanterns and two thirty-foot-high dragon heads. They were made by twelve Chinese artisans flown in especially to create authentic structures made from wound steel cables and silk fabric, which were lit from within by four hundred light bulbs. "It gave us complete control and gave us what we wanted," says McDougall. "That's the great thing about studios, you can really create what you want, as long as you sell the illusion to the audience that you're somewhere else."

"You can see the influence of those sets in other movies," says Mendes. "Dennis understood the flair and flamboyance required for Bond, yet he's done enough real-world design to understand how to make sure one foot is always in that world as well. He was an amazing part of the whole experience for me. Of course, he

started with *Quantum*, but I had already worked with him on two movies."

When Bond arrives at the Floating Dragon he's dressed in a blue Tom Ford tuxedo that became all the rage as a result. "The blue tux was my idea," says costume designer Jany Temime, "because, in the thirties, when the tux was invented, they were dark blue, so you wouldn't mix people up with the waiters. I said that to Tom Ford, who wasn't sure. Then it became such a success he was really happy. Daniel was also very happy about it, because, in a way, it was innovative, it was new, but it was not that different. In the beginning, we had a waistcoat, too, but it was too much, so just a cummerbund. It was perfect. When they were shooting at Pinewood on that lake and I saw Daniel, I was crying. I thought, *He. Is. Perfect.* I was so high I drove home and I got three points on my license."

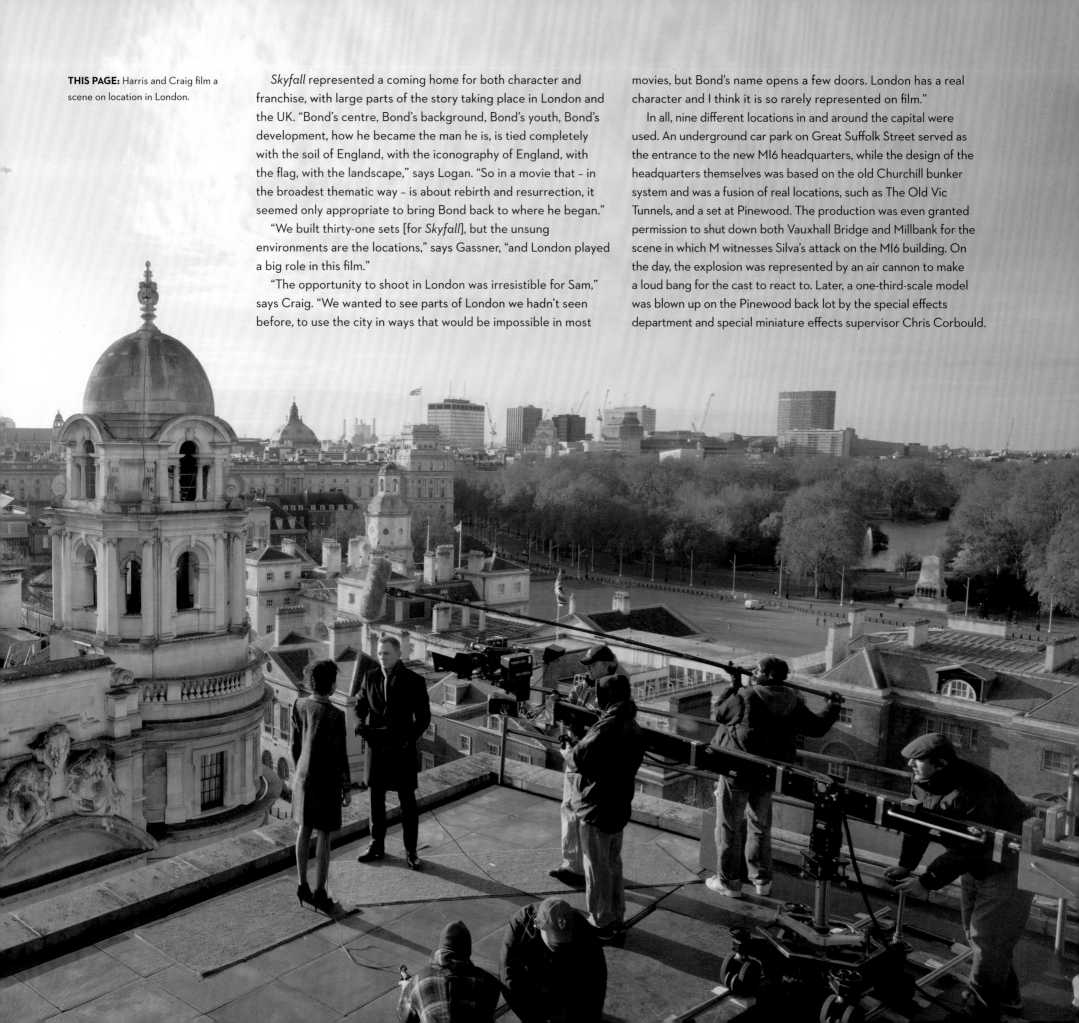

THIS PAGE: Harris and Craig film a scene on location in London.

Skyfall represented a coming home for both character and franchise, with large parts of the story taking place in London and the UK. "Bond's centre, Bond's background, Bond's youth, Bond's development, how he became the man he is, is tied completely with the soil of England, with the iconography of England, with the flag, with the landscape," says Logan. "So in a movie that – in the broadest thematic way – is about rebirth and resurrection, it seemed only appropriate to bring Bond back to where he began."

"We built thirty-one sets [for *Skyfall*], but the unsung environments are the locations," says Gassner, "and London played a big role in this film."

"The opportunity to shoot in London was irresistible for Sam," says Craig. "We wanted to see parts of London we hadn't seen before, to use the city in ways that would be impossible in most movies, but Bond's name opens a few doors. London has a real character and I think it is so rarely represented on film."

In all, nine different locations in and around the capital were used. An underground car park on Great Suffolk Street served as the entrance to the new MI6 headquarters, while the design of the headquarters themselves was based on the old Churchill bunker system and was a fusion of real locations, such as The Old Vic Tunnels, and a set at Pinewood. The production was even granted permission to shut down both Vauxhall Bridge and Millbank for the scene in which M witnesses Silva's attack on the MI6 building. On the day, the explosion was represented by an air cannon to make a loud bang for the cast to react to. Later, a one-third-scale model was blown up on the Pinewood back lot by the special effects department and special miniature effects supervisor Chris Corbould.

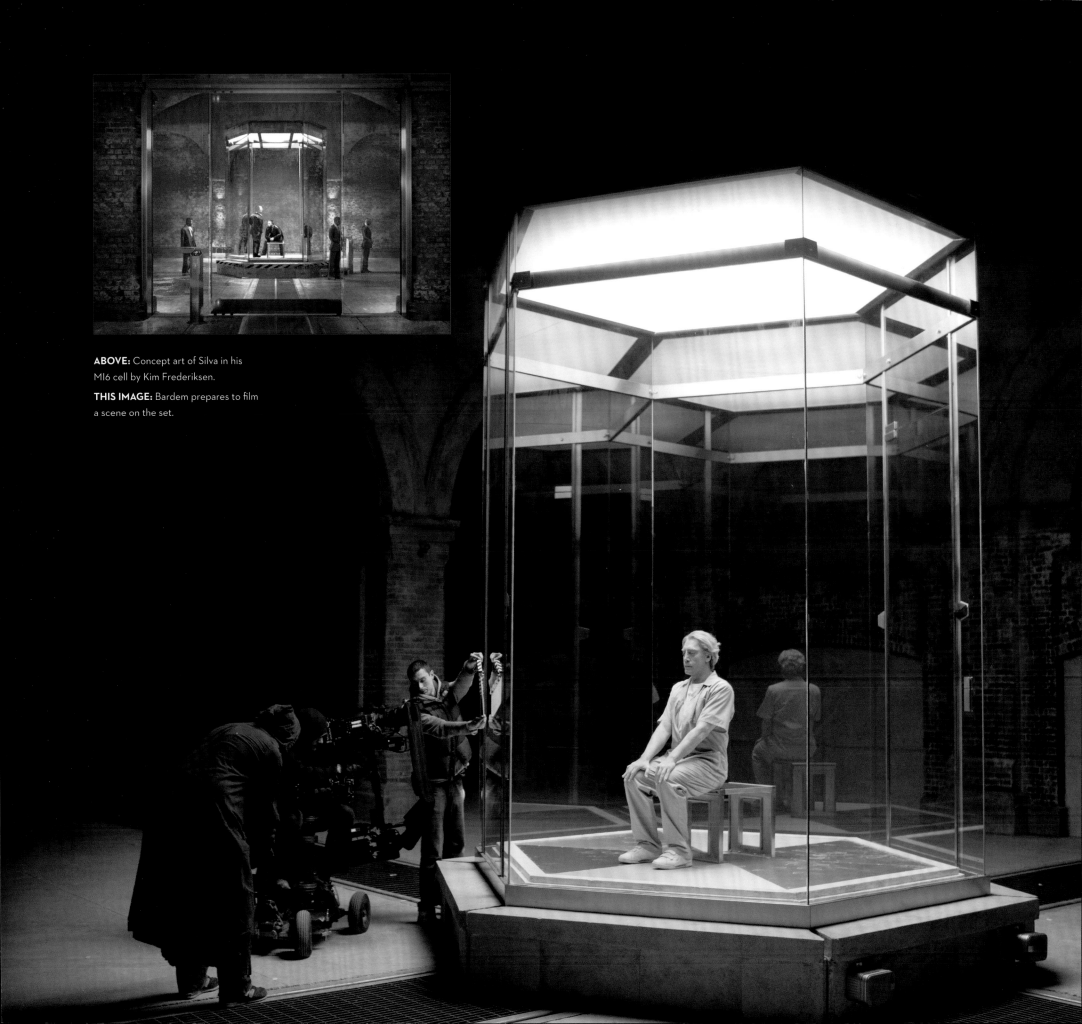

ABOVE: Concept art of Silva in his MI6 cell by Kim Frederiksen.

THIS IMAGE: Bardem prepares to film a scene on the set.

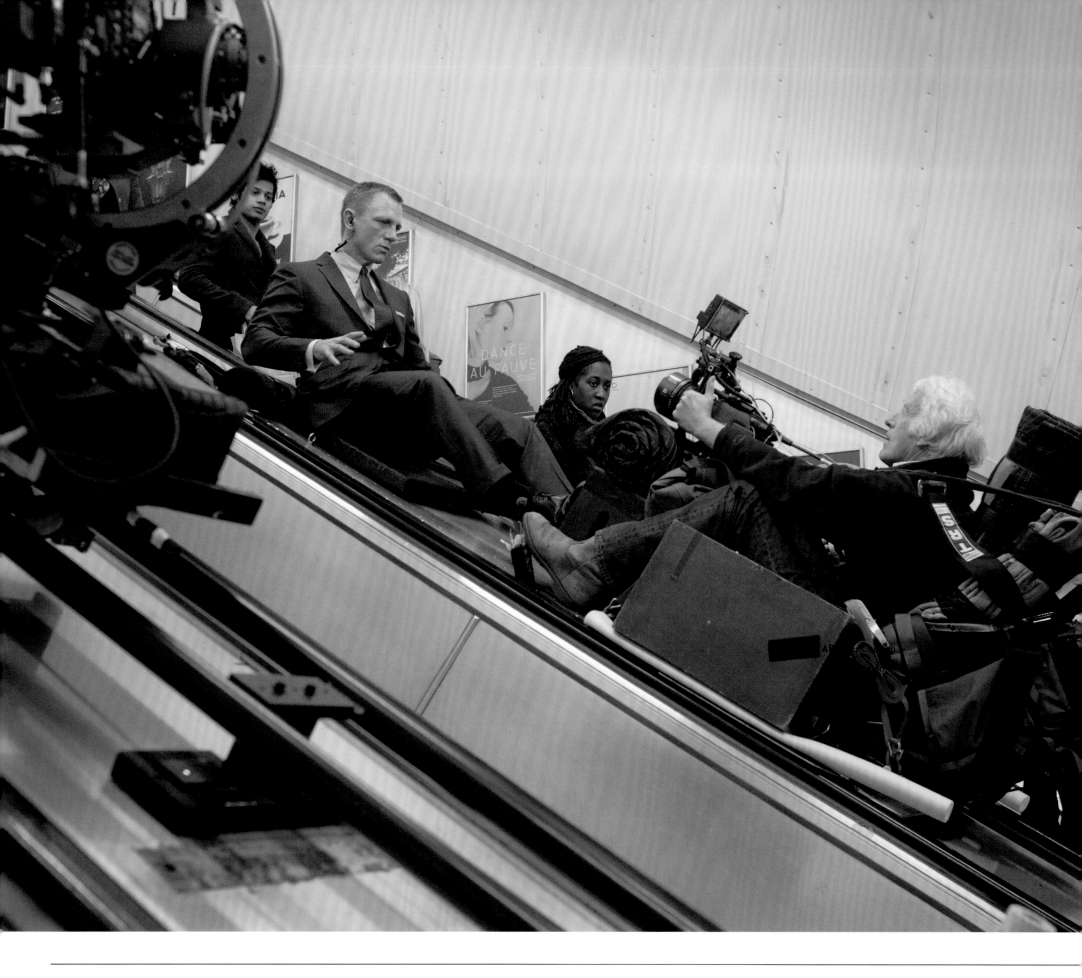

The Bond/Silva chase through the London Underground was filmed over four weekends at Charing Cross Station. "We had to go in at night and be out by six o'clock in the morning, because it became a live station then," recalls McDougall. "This is before they had the Night Tube. It would be harder to do now." To shoot the scene of the pair sliding down the escalator, production had to remove all the upright signs that are there precisely to prevent people sliding. Although, says stunt co-ordinator Gary Powell, "It was so old and dirty you couldn't slide anyway. The first time we jumped on it, nothing happened! We spent a day cleaning it and going up and down, and the more we went up and down, the more polished it became and the quicker it got." While Bond and Silva's stunt doubles slid down unaided, for shots of Craig and Bardem, a rig was built to control the actors' descent, with the camera on a winch.

(Continues on page 163)

OPPOSITE: Craig slides down the escalator on location at Charing Cross Station.

LEFT: Craig films a scene on a London Underground train.

BELOW LEFT: Silva, disguised as a Metropolitan Police officer, escapes on a train.

BELOW: Mendes and Bardem on location on a Charing Cross London Underground platform.

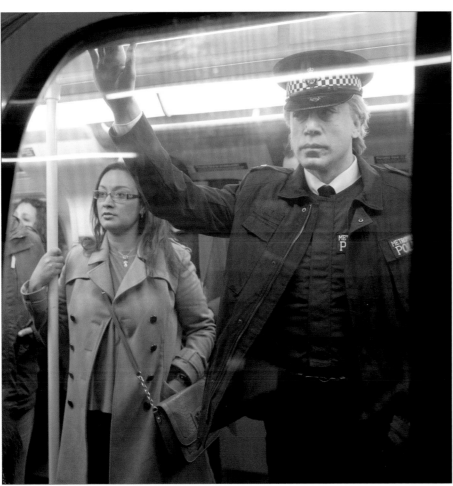

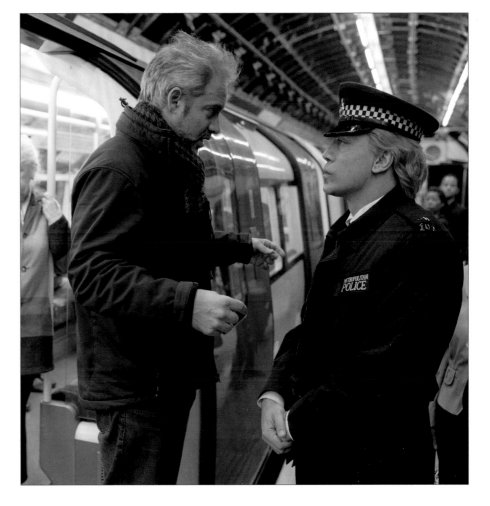

TUBE TRAIN

Part of the Underground chase involved a hugely complex set piece, with a tube train crashing into the catacombs, that took five months from concept to completion. The idea came from special effects and miniature effects supervisor Chris Corbould, who was finishing up on Christopher Nolan's *Inception* when Mendes called him up one night and said, "'I've got this chase through the London Underground and I want one jaw-dropping moment,'" recalls Corbould. "I stayed awake, came up with the idea, then fired it through to him the next morning and he loved it, the producers loved it."

"What I wanted, when I joined the franchise, was to get those guys who had been working on it for years, the Gary Powells and the Chris Corboulds, and say, 'What do you want to do with it? What do you think is missing?' And listen to them," says Mendes. "It would have been absolutely inappropriate for me to come, never having done a big action movie, and say, 'This is how I'm going to do it.' I wanted to know what they wanted and, in both cases, I discovered real passion and real opinions about what works well and what doesn't. They were throwing ideas in all the time and one of Chris's was to contrive a situation where a tube could crash through the roof – it seems bonkers now – of the catacombs under the tube station."

"When I came back from *Inception*, my crew had already started the initial prep," continues Corbould, who would later win an Oscar® for Nolan's movie. "I've got six or eight key guys who are my think tank and I said, 'Let's talk about the tube train.' One of my guys asked, 'What planet were you on when you dreamt that up?' I said, 'What do you mean?' And he said, 'You know each carriage is sixty feet long?' I said, 'That's fine. We'll just get a couple of carriages.' Then, 'Do you know each one weighs about thirty tonnes?' Then reality hit." In the end, Corbould's team made two sixty-foot carriages, which still weighed a whopping five tonnes each, that were mounted to a monorail system that ran diagonally from one top corner of the 007 Stage, through the set and out the other side. "We linked it to a tractor unit outside the stage with pulleys and

that enabled us to get the train up to speed by the time it entered the set," explains Corbould. "Then it dropped down into the set. We built a false floor, so when it hit the ground it would plough through. It was a massive build, with great big steel goalposts to hold the monorail. Essentially, we built a rollercoaster ride in five months. We had three or four different stopping systems, with the final brake being a wall of sandbags at the end of the set."

The stunt was a one-time deal, with nine remote cameras set up to capture it and the crew outside in vans. "With the amount of damage – ploughing through stone columns, chewing the floor up – it was better to get one good take, rather than compromise to get extra," says Corbould. "We could have done it again, but it would have been two weeks to get it back to that stage."

"It was so dangerous, and pretty bloody exciting," reveals Mendes. "We used every inch of the stage. In fact, right at the end of the shot, you can see the front of the tube banging the wall of the 007 Stage and the whole thing juddering – the actual wall. There was so much momentum, it practically went through. It's one of Chris's finest moments. He's an engineering genius, but he's also a man who's full of great ideas, and that was one of them."

"Chris Corbould is a genius at creating these [stunt set pieces], the best there is," concurs Craig. "He built a tube train that comes crashing through the ceiling. Clearly, it's not a real tube train, but it does weigh a few tonnes and it is moving pretty fast. I'm not next to it when it's happening – I can't be, for safety reasons – but we make it look like I'm next to it, running. Chris makes these things work."

To cap it off, Corbould even makes a cameo appearance as the tube driver. "I did a lot of second unit directing for Sam on that, and he said, 'I need a shot of the driver,'" recalls Corbould. "I went down to the greenscreen, shot the driver, sent the footage to Sam, and he said, 'It's not quite right. Do something different. You're going to have to be the driver.' I thought, *Here we go. This is for the joke reel.* So the first couple of times I didn't take it seriously. Then I thought, *I'd better do one sensibly, in case it isn't a wind-up.* And it wasn't. You only see me for about an eighth of a second, but I am in that shot."

RIGHT: The tube train catacombs crash set on the 007 Stage at Pinewood.

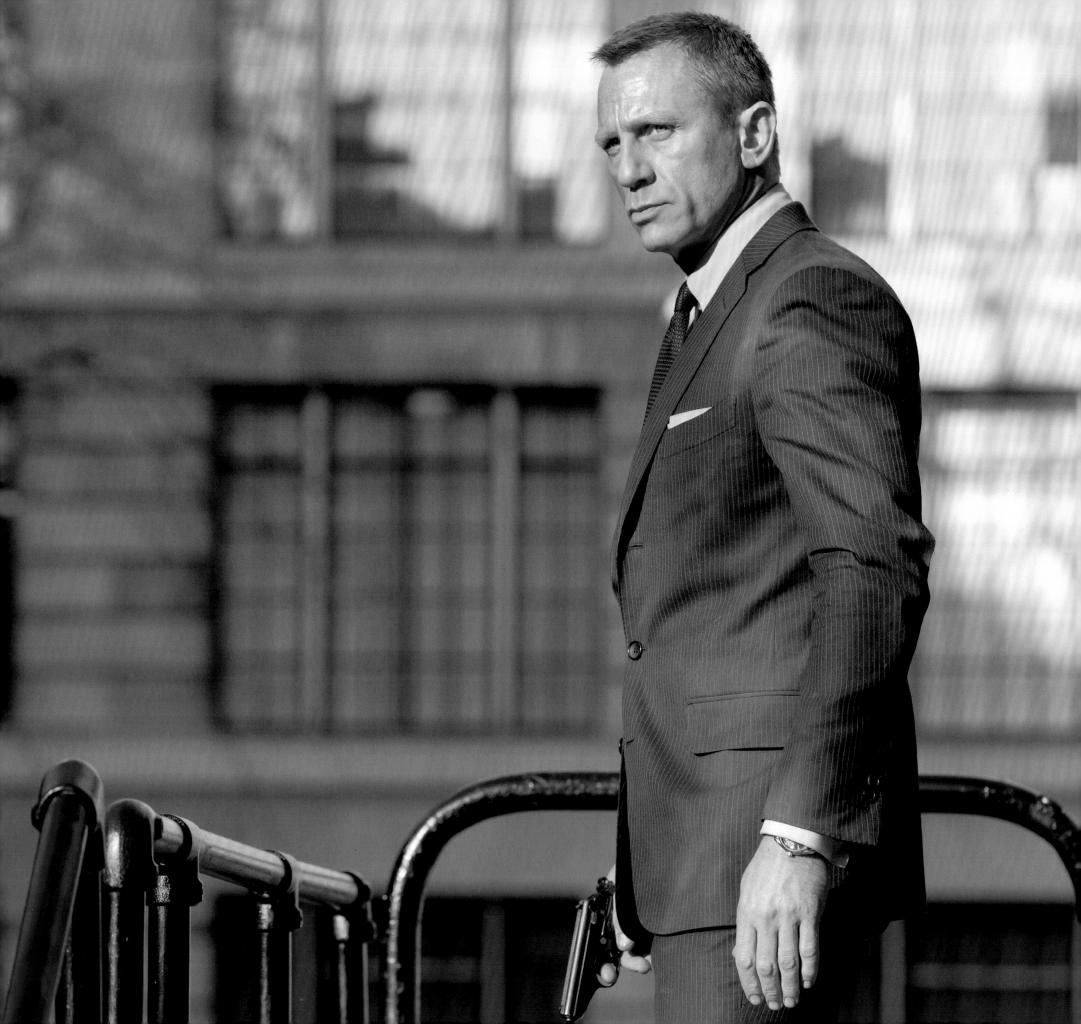

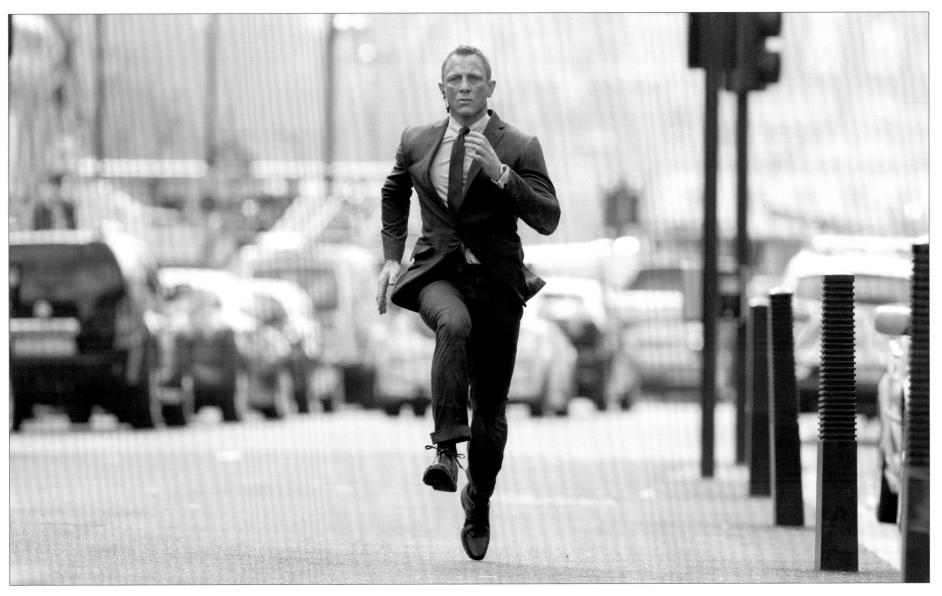

The sequence continues into Whitehall, which production closed off one Sunday morning to film Bond running down it. "You have that moment when he's racing to get to the inquiry, running down Whitehall, with M quoting Tennyson, and you have that feeling he is a symbol of what is great about the country," says Mendes. "It felt like a really interesting story to be told about coming back to Britain and understanding how it's changed. Also, by inference, answering: What's the point of MI6? What's the point of Bond? In a kind of meta way, what's the point of Bond movies? That's where we were headed."

THIS SPREAD: Bond chases Silva down Whitehall.

Bond arrives in the nick of time to stop Silva killing M, shepherding her out of harm's way with a little help from both Eve and Mallory. The shootout was choreographed by stunt coordinator Gary Powell, who initially had Bond running in through the side door before shooting at the fire extinguishers to provide cover for M. Craig had another idea. "Daniel said, 'No, I'm going to come in and *walk* across.' When you see it, it looks frickin' cool – Bond calmly walking across, firing into the smoke," says Powell. "It's my favourite scene in the whole film. And Judi Dench did all her own stunts."

LEFT: Judi Dench (M), Rory Kinnear (Tanner) and Craig during a break in filming.

BELOW LEFT: Filming the moment when Bond shepherds M out of harm's way.

BELOW: Dench prepares to film a scene.

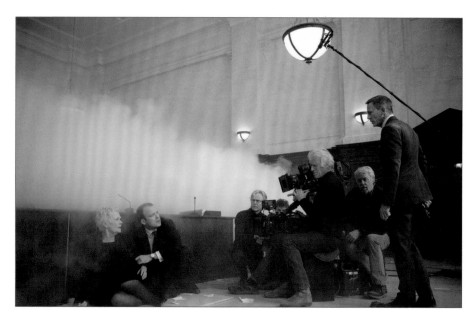

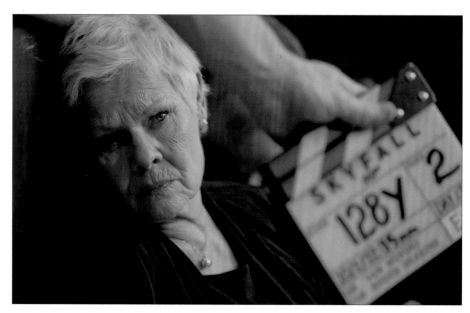

In Bond's obituary, published in the *You Only Live Twice* novel, it was revealed that his father, Andrew, was Scottish and his mother, Monique Delacroix, Swiss. Both died when he was young, an event from which Bond has, somewhat understandably, never fully recovered. It was this backstory that Purvis and Wade mined when creating Bond's ancestral home, Skyfall, in the highlands of Scotland, to which he retreats with M. A foreboding stone lodge set in a bleak landscape, it provided a fitting setting for the climactic showdown with Silva. "When we talked about Skyfall, we talked about the loneliness of the character," recalls Logan. "In the books, he's constantly grappling with anxiety, depression, the loneliness of what being a secret agent really is, the anonymity, all of those things, so the idea of a bleak landscape he sprang from seemed to be appropriate, and what a grim, depressing place it is. It was always intended to be tonally sad and bleak, in terms of creating that sad, bleak, magnificent character that we all love."

At a press conference in London on 3rd November 2011, exactly fifty years to the day since Connery was first announced as 007, *Skyfall* was officially unveiled as title of *Bond 23*. "It's such a beautiful word and thematically it makes sense," says Logan. "It's a lovely thing," adds Mendes, "because it's buried in the movie and is part of the fabric of the film, which is what you want with a title, rather than it be imposed on the top."

(Continues on page 168)

ABOVE: The headstone for Bond's parents at Skyfall, set dressing prop.

BELOW: Concept art of the entrance to the Skyfall estate in the highlands of Scotland by Kim Frederiksen.

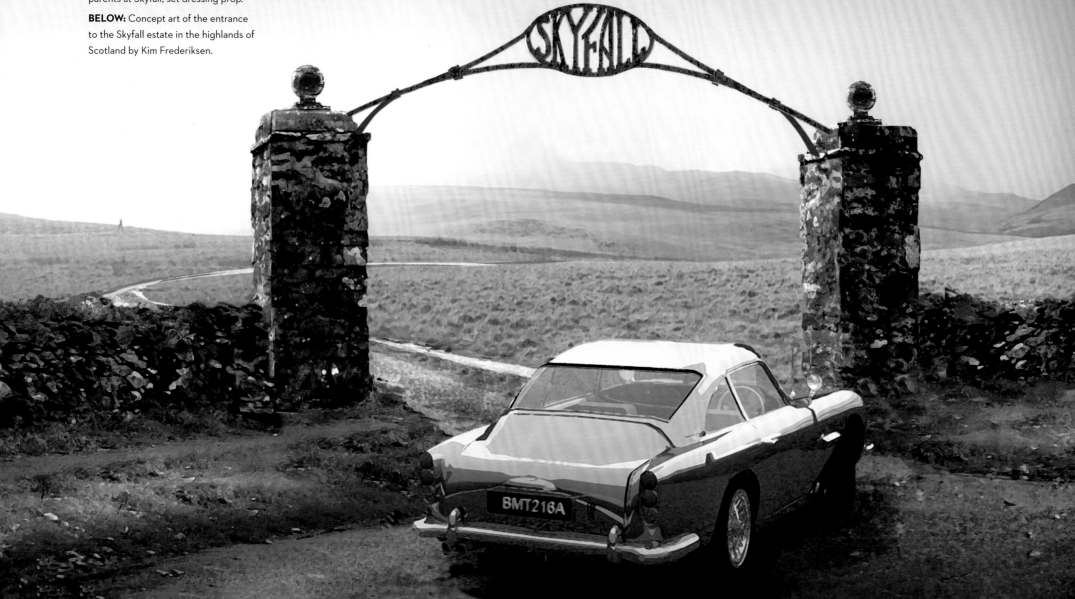

ASTON MARTIN DB5

When Bond "kidnaps" M and spirits her off to his ancestral home in Scotland, he uses the same iconic 1964 Aston Martin DB5 that Sean Connery drove in *Goldfinger*, one of many subtle and not-so-subtle Easter eggs and in-jokes Mendes and his writers threw in for fans, including Bond stepping on the Komodo dragons in Macao – a nod to Moore's alligator evasion in *Live And Let Die* – fifty-year-old whisky or gags about exploding pens. "The car was our idea," says Wade. "Sam then wanted it to be the one from *Goldfinger*, so he could do the machine guns, but

for us it was the one he won in the card game [in *Casino Royale*], then had to convert from left-hand drive to right-hand drive."

While *Skyfall* only features a few brief shots of Bond driving M through London, they filmed much more. "We had a long, long scene where we were driving through London, about three o'clock in the morning," recalls Judi Dench. "It was the day before my birthday, and the police let us go through lights. It was wonderful. Glorious evening. That was thrilling."

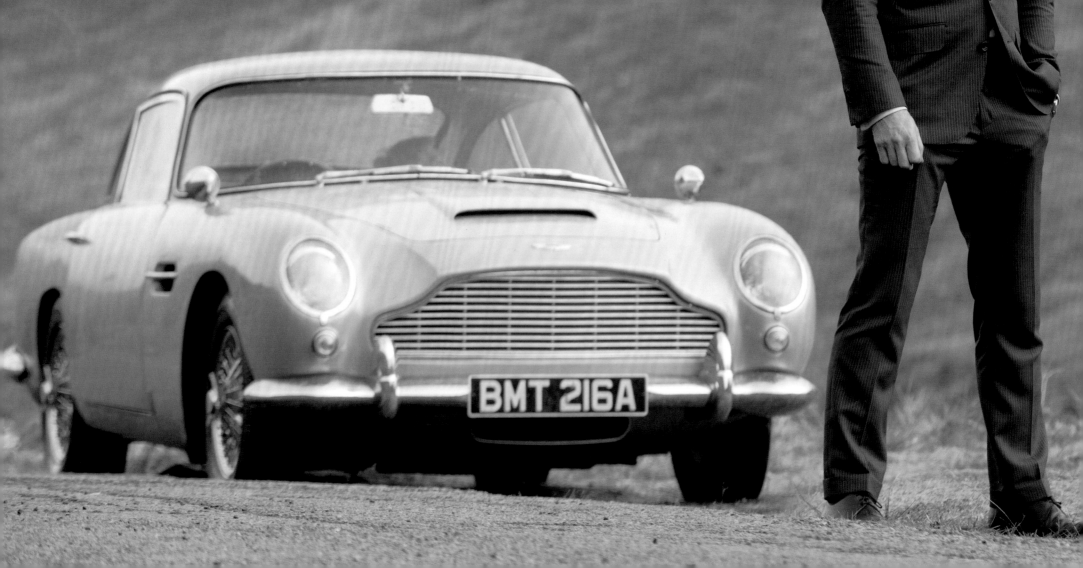

BMT 216A

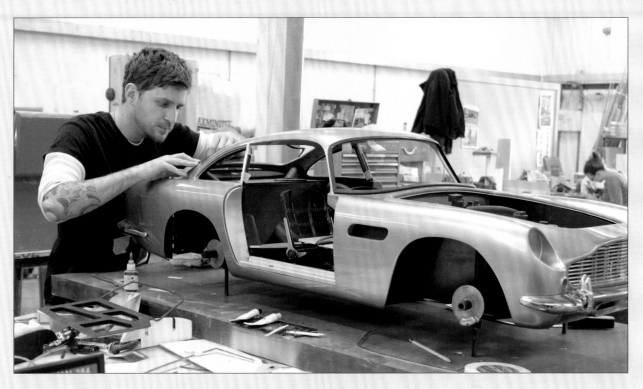

OPPOSITE: Bond, and his Aston Martin DB5, arrive in the highlands.

LEFT & ABOVE: A scale miniature of the Aston Martin DB5 was constructed for the car's destruction in the film.

BELOW: Storyboards of the Aston Martin DB5 in action during Silva's assault on the Skyfall house by Jim Cornish.

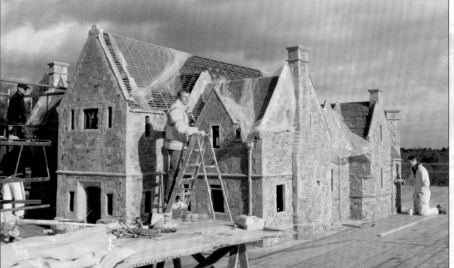

ABOVE LEFT: Albert Finney and Mendes on location on Hankley Common.

LEFT: Dench between breaks in filming in the highlands.

ABOVE: The Skyfall scale model under construction.

Once Bond and M arrive at Skyfall, they encounter a shotgun-toting gamekeeper named Kincade who, we soon discover, looked after the young James for a short while following his parents' deaths. In the film, he's played by the legendary Albert Finney. "It was a real coup to cast Finney. He was a fantastic actor and Cubby had always wanted to work with him, so we were very blessed to get the opporunity to work with him," says Wilson. *Skyfall* was to be Finney's final on-screen performance.

While a handful of scenes were shot in Scotland – notably the picturesque moment where Bond and M stand discussing his childhood, which was filmed in Glencoe – Skyfall was built on Hankley Common, part of a military testing site in Elstead, Surrey, while the interiors were constructed on stage at Pinewood. "There was a lot of debate about where we should shoot it," remembers McDougall. "We looked at Dartmoor. We did extensive recces up in Scotland. We looked at real castles and found an amazing one, but because we were going to blow it up, it didn't work out. My family heritage is Scottish and there was a house I knew there that absolutely looked like Skyfall but was so derelict we'd never have been able to do what we needed. The landscape has mountains behind it, and Dennis said if we put in CG mountains and a bit of snow, Hankley Common could work [as a substitute]. I defy anyone to say it wasn't Scotland we went to. A bit like Shanghai, as long as you establish the look of somewhere, people don't question it."

Bond, M and Kincade prepare for battle as best they can, before Silva arrives by helicopter with a phalanx of armed men and proceeds to lay waste to the place. The scenes utilised the full-size

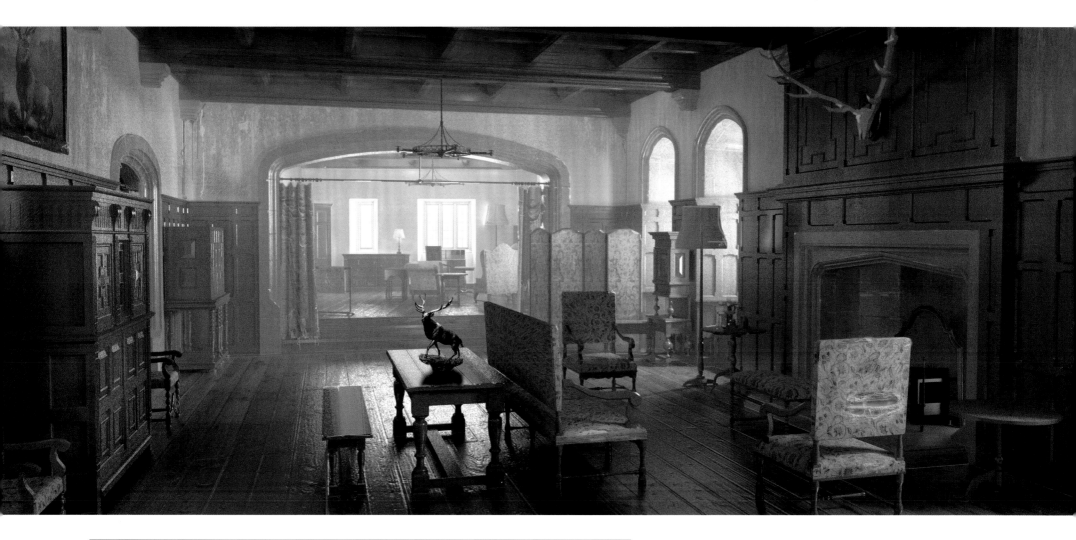

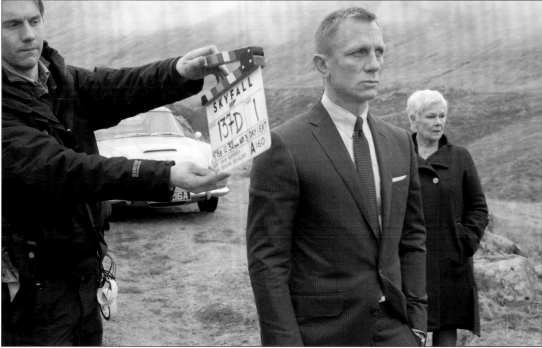

set as well as one-third-scale models of Skyfall, the helicopter and DB5, with Chris Corbould overseeing a splinter unit to film all the explosions and destruction. "We put the helicopter on a hydraulic rig to give us a lifelike movement as it crashed into the house," he recalls. "We used 150 sticks of dynamite and a couple of hundred gallons of fuel."

The familial relationship between Bond and Dench's M, a relationship that really came to the fore when Craig stepped into 007's shoes, reaches its tragic conclusion in *Skyfall*, when the grand dame of MI6 dies of injuries sustained in Silva's attack. "There's an autumnal tone to *Skyfall*," says Logan. "People are wearing heavy coats, it's elegiac, so the idea of taking that mother figure from Bond so he can start with a clean slate seemed very appropriate."

ABOVE: Concept art of the Skyfall house interior by Tim Browning.

LEFT: Craig and Dench filming in the highlands.

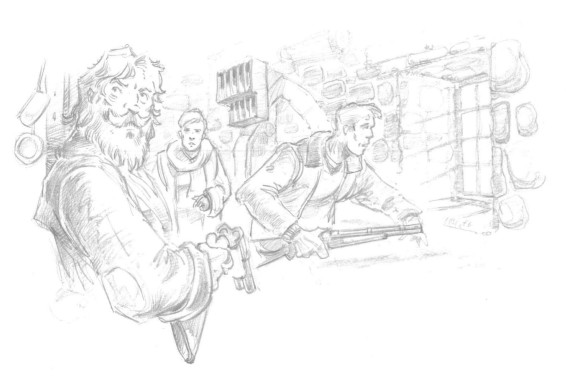

ABOVE & OPPOSITE TOP:
Storyboards of the helicopter
sequence during Silva's assault on the
Skyfall house by Jim Cornish.

LEFT: Dench filming in the interiors set
constructed on stage at Pinewood.

"Daniel and I struck up a good relationship the first time we worked
together, and the relationship developed as each script required
something a little bit more from us," says Dench, who insists the story
that she burst into tears after being informed they were killing off M is
"ridiculous. I didn't burst into tears at all. They told me at The Wolseley,
Barbara and Daniel. I thought, *Okay. Fine. Eighteen years is actually
quite enough.*"

"I took no great pleasure in the fact she was leaving the franchise,
but I felt it gave us an unbelievable story to tell," says Mendes.
"Because we knew that's where we were heading, that sense she's
beginning to make mistakes – one of which is ordering the shot to
be taken at the beginning – her tussle with that and her refusal to go
quietly, was part of the mainspring of the movie. As was the fact one

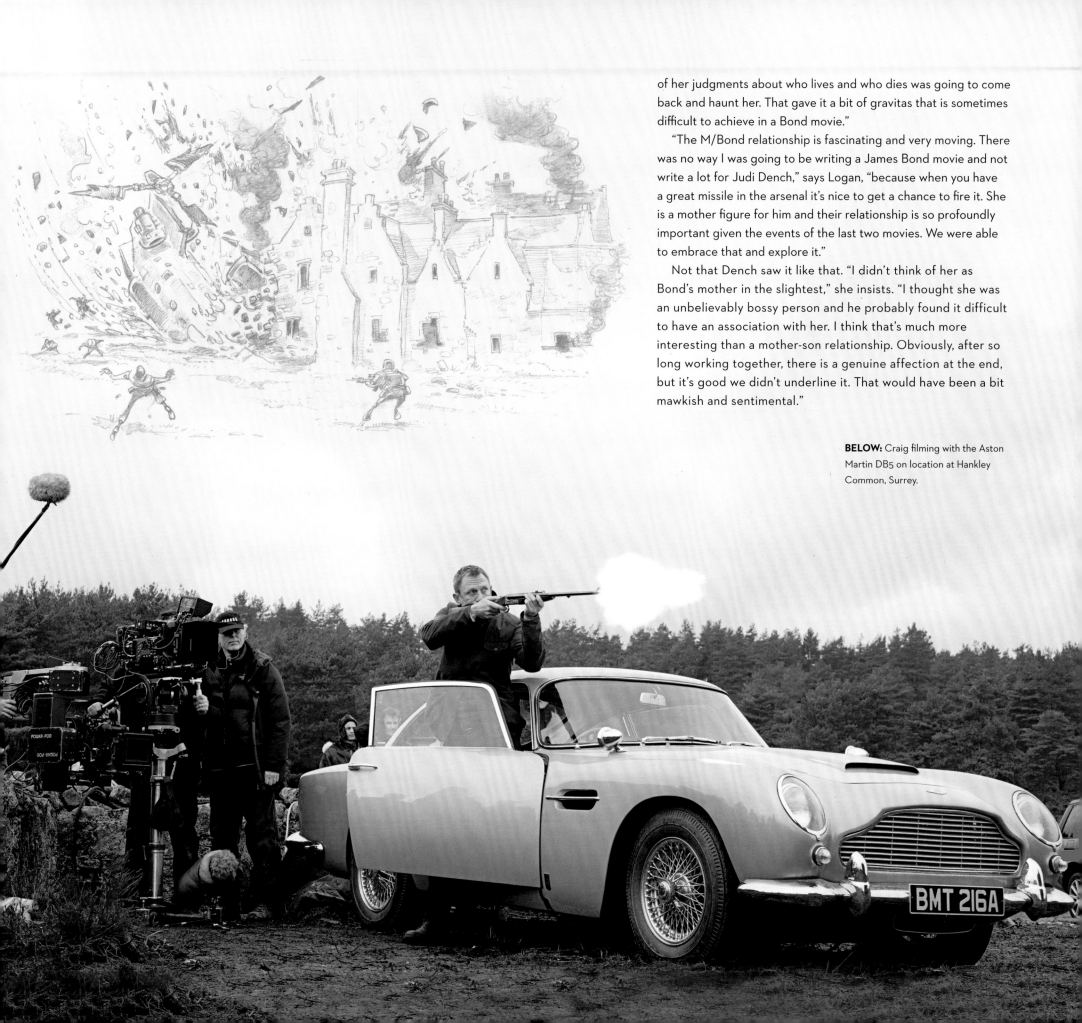

of her judgments about who lives and who dies was going to come back and haunt her. That gave it a bit of gravitas that is sometimes difficult to achieve in a Bond movie."

"The M/Bond relationship is fascinating and very moving. There was no way I was going to be writing a James Bond movie and not write a lot for Judi Dench," says Logan, "because when you have a great missile in the arsenal it's nice to get a chance to fire it. She is a mother figure for him and their relationship is so profoundly important given the events of the last two movies. We were able to embrace that and explore it."

Not that Dench saw it like that. "I didn't think of her as Bond's mother in the slightest," she insists. "I thought she was an unbelievably bossy person and he probably found it difficult to have an association with her. I think that's much more interesting than a mother-son relationship. Obviously, after so long working together, there is a genuine affection at the end, but it's good we didn't underline it. That would have been a bit mawkish and sentimental."

BELOW: Craig filming with the Aston Martin DB5 on location at Hankley Common, Surrey.

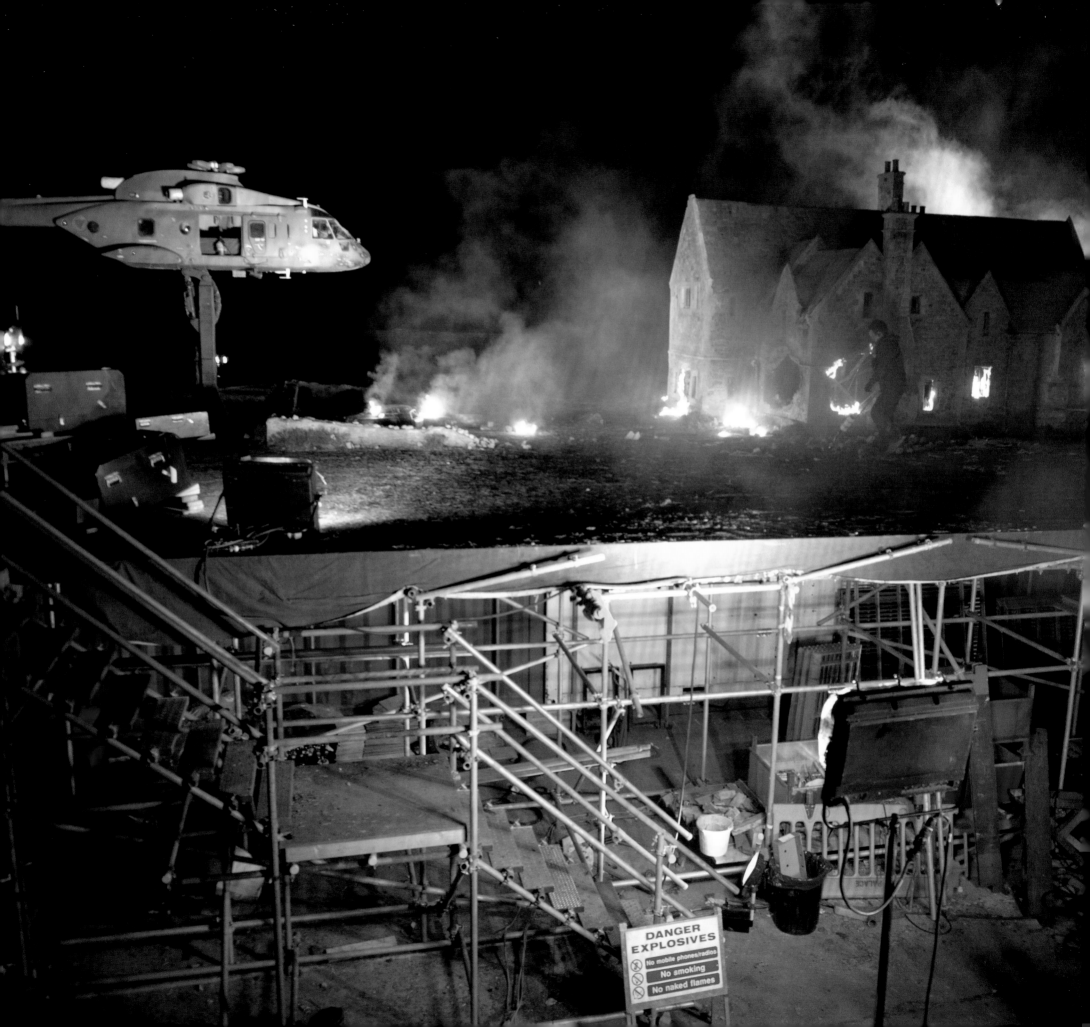

DANGER
EXPLOSIVES
No mobile phones/radios
No smoking
No naked flames

LEFT: Filming the helicopter sequence using scale models.

RIGHT: Schematic showing the blast layout for filming the interior stunts by Dean Clegg.

BELOW: Bardem filming on location at Hankley Common, Surrey.

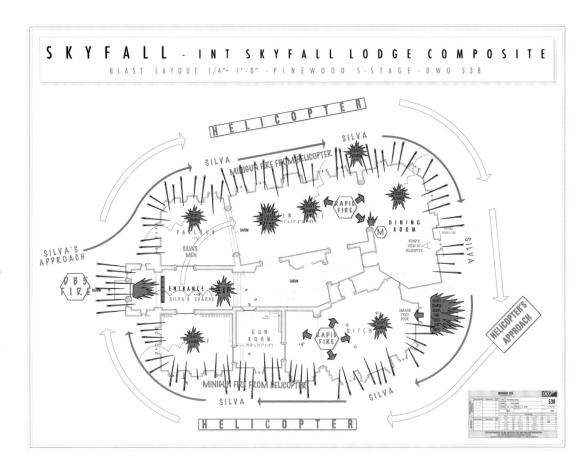

SKYFALL - INT SKYFALL LODGE COMPOSITE
BLAST LAYOUT 1/4"= 1'-0" · PINEWOOD S-STAGE · DWG 538

"We wanted to make the most human Bond film we could, in terms of treating the characters seriously and taking them outside their job assignments," continues Logan. "So when Bond kidnaps M and takes her into his past, an environment she's not used to, it creates a vulnerability in her that's very interesting and allows them to build a different relationship in that last part of the movie. I was not in London when they were about to shoot the scene, so Sam called me up and we worked on it over the phone to reduce it to the most 'haiku' version, because you don't need to say a lot when you have Daniel Craig and Judi Dench and those eyes looking at each other. That speaks volumes."

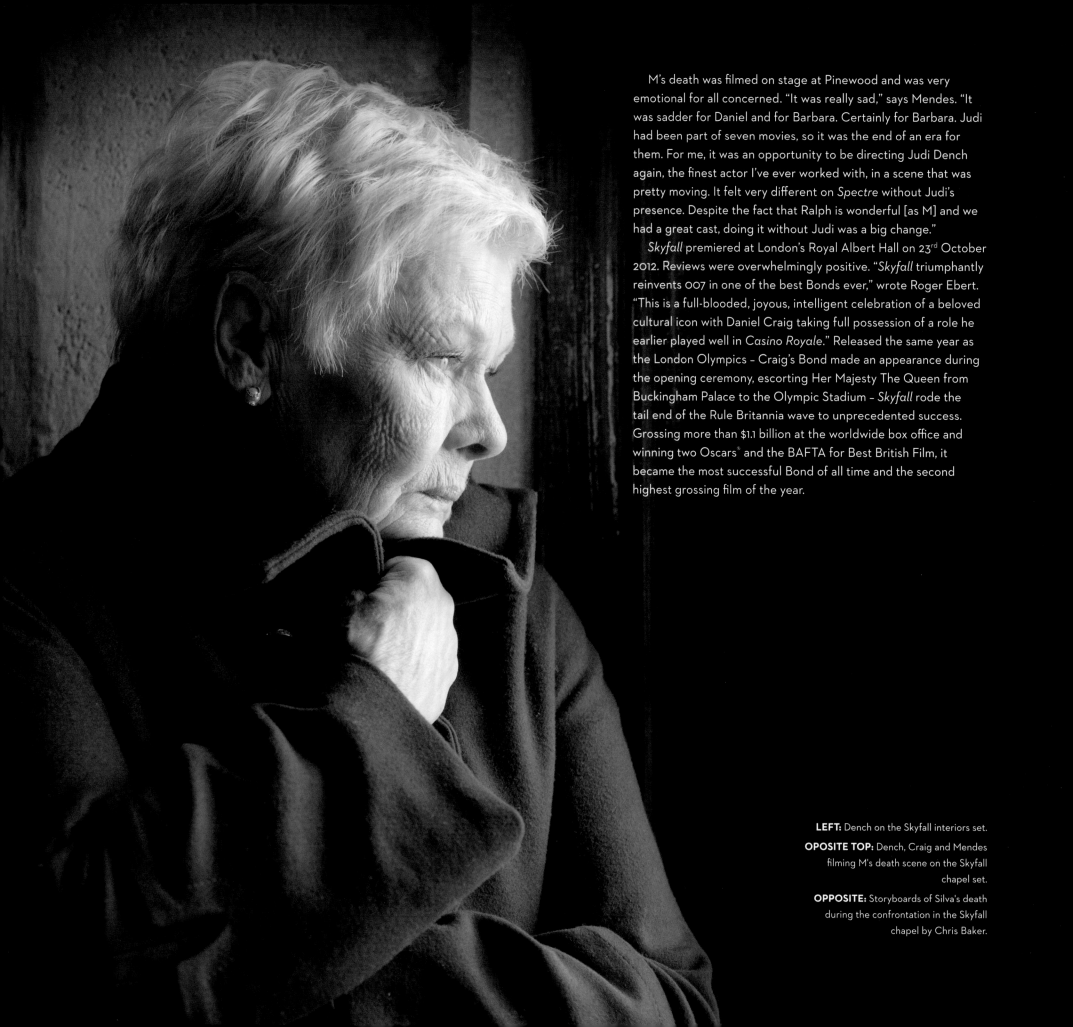

M's death was filmed on stage at Pinewood and was very emotional for all concerned. "It was really sad," says Mendes. "It was sadder for Daniel and for Barbara. Certainly for Barbara. Judi had been part of seven movies, so it was the end of an era for them. For me, it was an opportunity to be directing Judi Dench again, the finest actor I've ever worked with, in a scene that was pretty moving. It felt very different on *Spectre* without Judi's presence. Despite the fact that Ralph is wonderful [as M] and we had a great cast, doing it without Judi was a big change."

Skyfall premiered at London's Royal Albert Hall on 23rd October 2012. Reviews were overwhelmingly positive. "*Skyfall* triumphantly reinvents 007 in one of the best Bonds ever," wrote Roger Ebert. "This is a full-blooded, joyous, intelligent celebration of a beloved cultural icon with Daniel Craig taking full possession of a role he earlier played well in *Casino Royale*." Released the same year as the London Olympics – Craig's Bond made an appearance during the opening ceremony, escorting Her Majesty The Queen from Buckingham Palace to the Olympic Stadium – *Skyfall* rode the tail end of the Rule Britannia wave to unprecedented success. Grossing more than $1.1 billion at the worldwide box office and winning two Oscars® and the BAFTA for Best British Film, it became the most successful Bond of all time and the second highest grossing film of the year.

LEFT: Dench on the Skyfall interiors set.

OPOSITE TOP: Dench, Craig and Mendes filming M's death scene on the Skyfall chapel set.

OPPOSITE: Storyboards of Silva's death during the confrontation in the Skyfall chapel by Chris Baker.

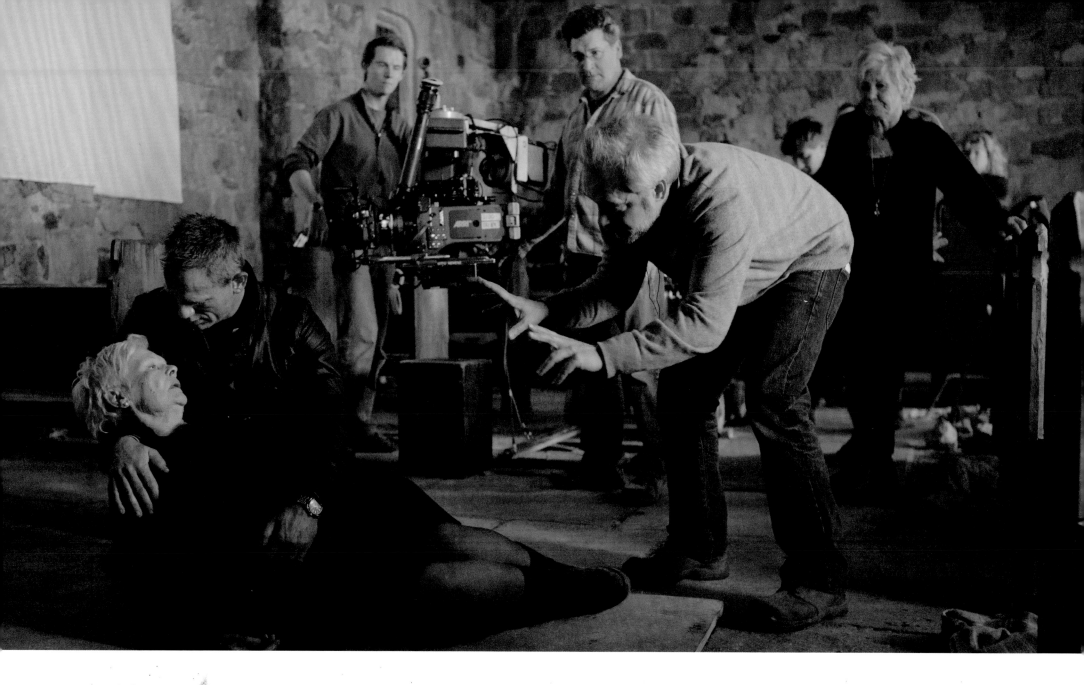

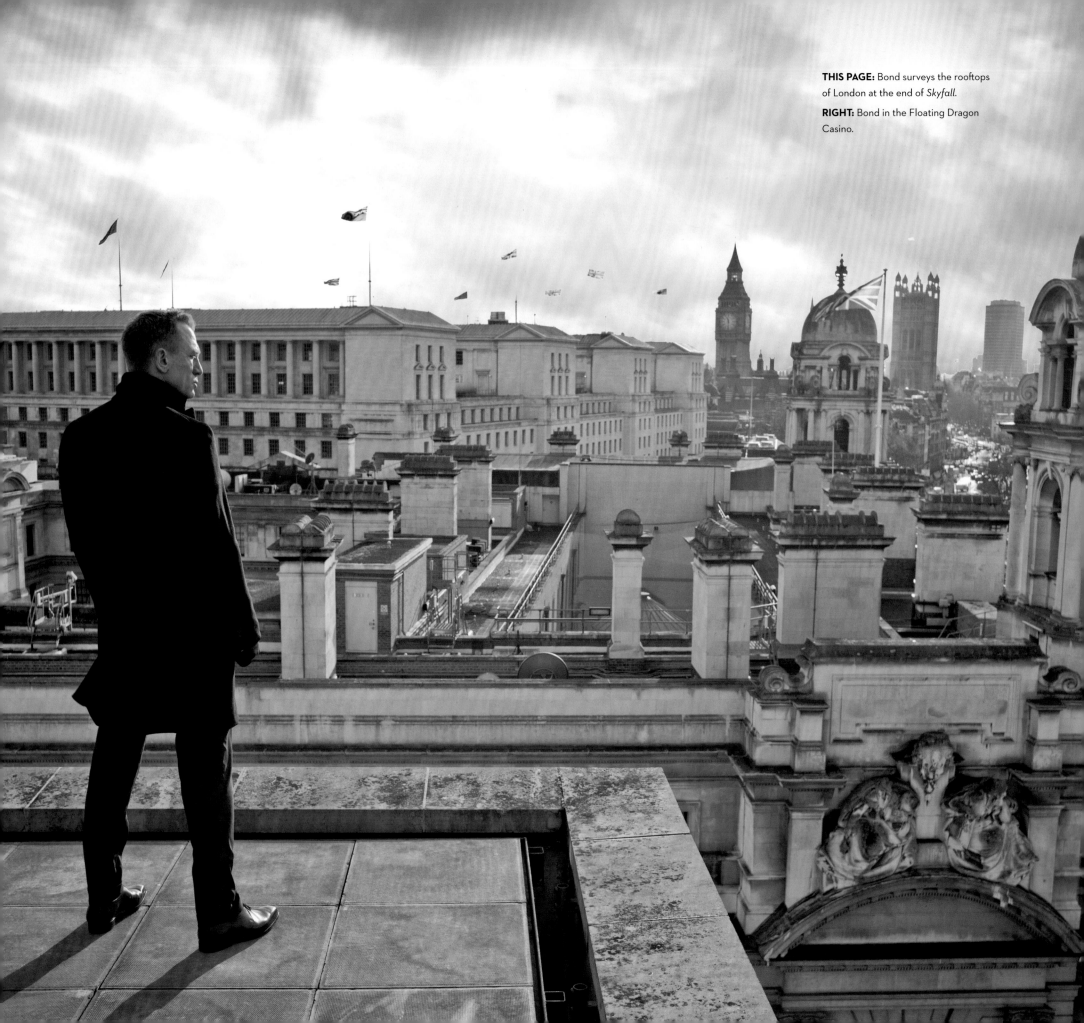

THIS PAGE: Bond surveys the rooftops of London at the end of *Skyfall*.

RIGHT: Bond in the Floating Dragon Casino.

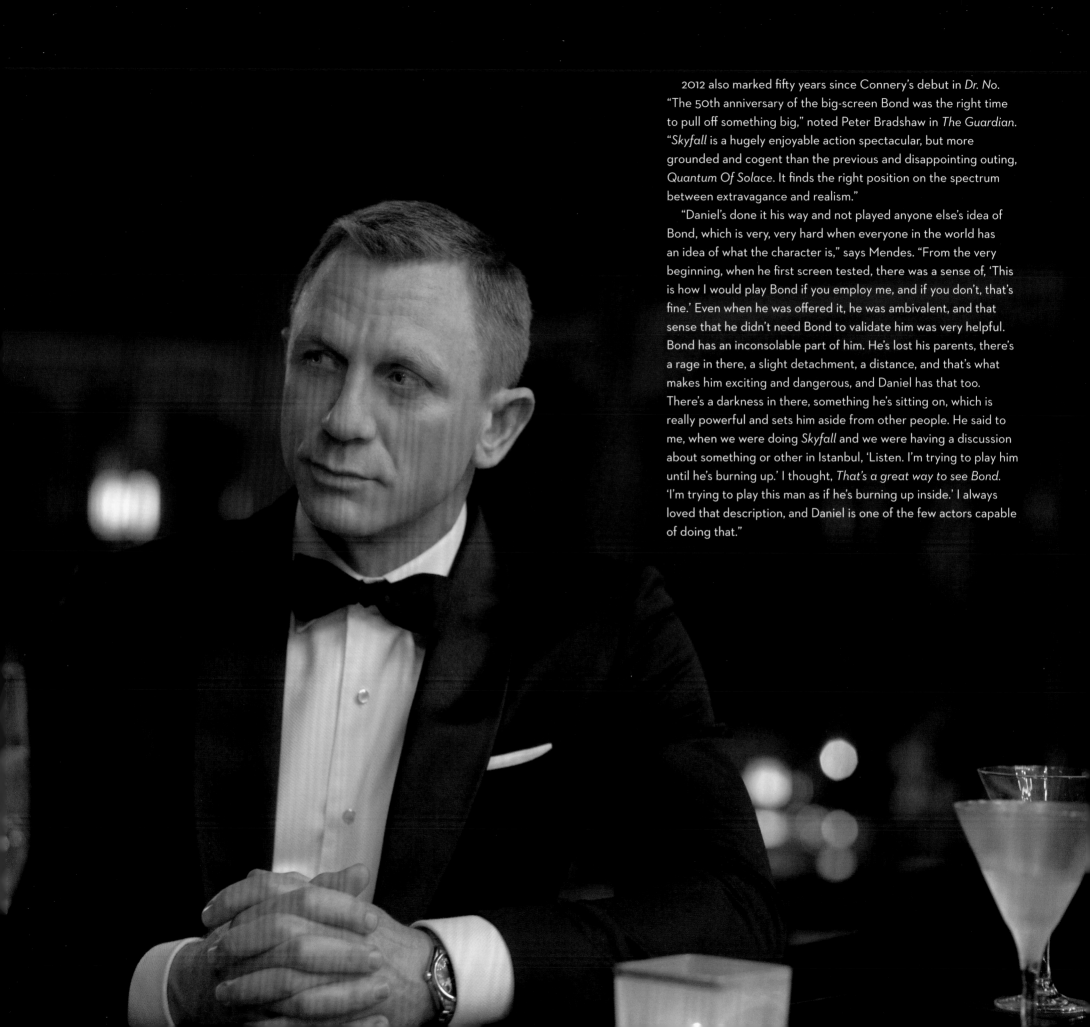

2012 also marked fifty years since Connery's debut in *Dr. No.* "The 50th anniversary of the big-screen Bond was the right time to pull off something big," noted Peter Bradshaw in *The Guardian.* "*Skyfall* is a hugely enjoyable action spectacular, but more grounded and cogent than the previous and disappointing outing, *Quantum Of Solace.* It finds the right position on the spectrum between extravagance and realism."

"Daniel's done it his way and not played anyone else's idea of Bond, which is very, very hard when everyone in the world has an idea of what the character is," says Mendes. "From the very beginning, when he first screen tested, there was a sense of, 'This is how I would play Bond if you employ me, and if you don't, that's fine.' Even when he was offered it, he was ambivalent, and that sense that he didn't need Bond to validate him was very helpful. Bond has an inconsolable part of him. He's lost his parents, there's a rage in there, a slight detachment, a distance, and that's what makes him exciting and dangerous, and Daniel has that too. There's a darkness in there, something he's sitting on, which is really powerful and sets him aside from other people. He said to me, when we were doing *Skyfall* and we were having a discussion about something or other in Istanbul, 'Listen. I'm trying to play him until he's burning up.' I thought, *That's a great way to see Bond.* 'I'm trying to play this man as if he's burning up inside.' I always loved that description, and Daniel is one of the few actors capable of doing that."

SPECTRE

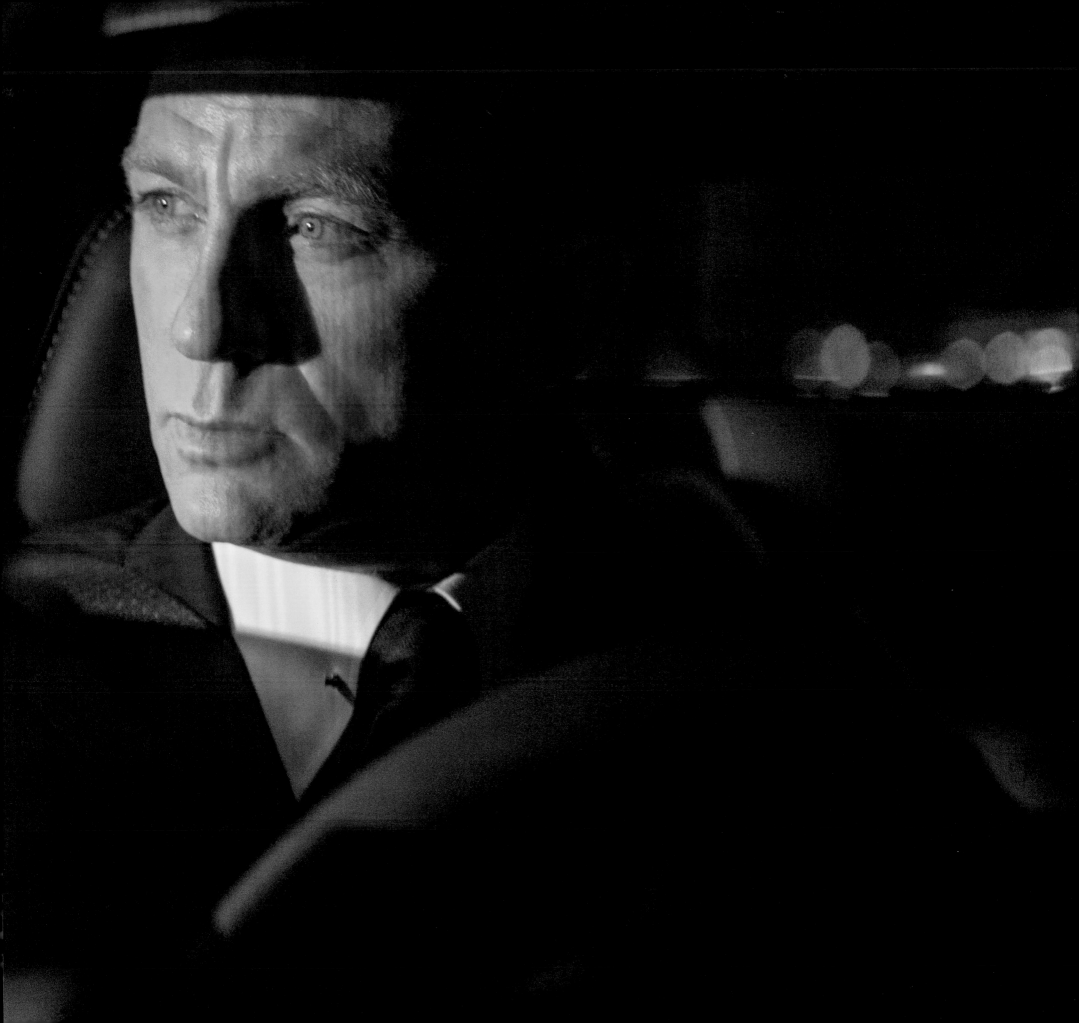

SPECTRE

"**D**uring *Skyfall*, Michael and Barbara said, 'Would you be interested in continuing the story?'" recalls John Logan. "I said, 'Absolutely,' because we'd created a wonderful emotion for the character to take into the next story. Then it was a very long process of exploring different scenarios. For a while I was toying with 'The Hildebrand Rarity', that unbelievably beautiful Fleming short story, as a basis of something. For a while, too, we were thinking about two movies, a two-movie arc called *The Death Collector* that took Bond to Africa, where he gets involved in Coltan [mineral] mining. So there was a lot of exploration, of trying different scenarios, writing different treatments, because it's always: What's the real-world connection of the plot and what's the personal connection for Bond?"

"We wanted it to be better than *Skyfall*," says Craig, who was credited as co-producer for the first time. "We didn't have a choice. We had to be bigger and better. With *Skyfall* we set something in motion and we wanted to go a bit further with it and experiment a bit more."

As part of the 2013 legal settlement between MGM and the estate of Kevin McClory, the way was cleared for Eon Productions to use both the SPECTRE criminal organisation, which had featured in three Fleming novels and six Bond movies, and its legendary leader, Ernst Stavro Blofeld, who had previously been played on screen by Donald Pleasence in *You Only Live Twice* (1967), Telly Savalas in *On Her Majesty's Secret Service* (1969) and Charles Gray in *Diamonds Are Forever* (1971). Logan was thrilled. "Like Holmes needs his Moriarty, Bond needs his Blofeld," he enthuses. "When we realised we could actually use Blofeld, that clarified everything in terms of what the story might be, how it might personally connect to Bond in some way. While the idea that Blofeld has been orchestrating all of these Daniel Craig stories for a particular end was very exciting. Then, of course, you're faced with, 'Okay, you can create Blofeld, and Blofeld can be *anything*, but you want him in a modern context.'"

Since the character's previous incarnation as a bald, scar-faced cat-stroking baddie had become the subject of endless parodies down the years – notably Mike Myers' Dr. Evil in the *Austin Powers* films – Logan wanted to make Blofeld scary

again, initially making him an arms dealer. "If you go back and read Fleming, the arms merchant, the death merchant was an appropriate umbrella under which to place Blofeld," he explains. "Africa was something we played with a lot, in terms of the Congo, Uganda, Rwanda. We also thought about going back to Japan and using the volcano from *You Only Live Twice* and visiting that haunted place from part of Bond's past. Along the way, we tried on a lot of Blofelds for size. Each had different aspects. It was a fascinating process, some of which turned out to be in the final movie and a lot of it didn't, but that's how it is when you have the world to explore, you have to explore a lot of countries. For most of my time on *Spectre* Blofeld was a woman, and there was a certain grotesquery to the character, based on pigmentation. Finally, it fell away for various reasons."

As Logan toiled away on various ideas and treatments, Mendes turned down the opportunity to return to the director's chair. "The problem I had after *Skyfall* was I couldn't work out what should happen next," he admits. "I know that sounds absurd, with a Bond movie, but it's everything for me. I didn't feel there was a story I could tell." However, neither the producers nor Craig were willing

ABOVE: Daniel Craig (James Bond) and director Sam Mendes on the MI6 Q Branch set.

RIGHT: Bond at the Day of the Dead parade in Mexico City.

to take no for an answer and, eventually, Mendes agreed to direct, becoming the first to oversee two consecutive Bonds since John Glen's five-film run – *For Your Eyes Only* (1981) to *License To Kill* (1989). "Having a bit of time off and doing something else, I was able to work out what I thought would be the beginnings of a really cool story," Mendes reveals. "There wasn't a script then, there was a treatment, although Barbara and Michael weren't one hundred percent about it, so it was a question of starting again. But once I got the smell of an interesting new story in my nostrils, then it became a little bit more exciting for me." However, Mendes was only interested in directing one film. "The thought of shooting two back-to-back made my stomach churn, because one is life threatening, two would have been the end. I said, 'Honestly, I don't think I could make two, but I could make one.'"

With Mendes on board, Logan began again. "We dialled into a lot of different things, like, 'Does Bond have a daughter, [either] from Vesper or from a previous relationship?'" says Logan. "A lot of my early work was figuring out what was the personal relationship beyond Blofeld. Is that a familial relationship or not? When I was working on it, it never was. That was something that came after me. Sam, Michael, Barbara and I talked a lot about Dante's 'Inferno', about the different levels of hell Bond would have to go through, with Blofeld as his guide. It was a very different movie than *Spectre* turned out to be."

Underpinning everything was the unspoken sense that *Spectre*, as *Bond 24* was eventually titled, would be Craig's final Bond, "So that was what we were working towards, to a large degree," says Mendes, who wanted to send his star off with a flamboyant flourish and give the character someone he would be willing to turn his back on MI6 and active service for. "I wanted there to be another love affair, a serious love affair, and I wanted Bond to walk away for her at the end. So, I had to construct a story in which he made the choice. For that, we needed to introduce a character who was worth walking away for. It seemed right she should be someone who was brought up in that world and connected to a character from Bond's past, so she understood him on a level that perhaps was only available to someone who had been raised by an assassin herself, and so was drawn back to the source of her pain in a way."

With that in mind, Logan conceived a daughter for Mr White, a character who had appeared in *Casino Royale* and *Quantum Of Solace*. Her name was Kaja and she was Scandinavian, just like her father. "The logline of *Spectre*, for me, was 'Bond falls in love'," notes Logan. "The challenge was to create a woman worthy of James Bond, but still having a fragility that makes the character attractive. When I look back at Daniel's Bond, the relationship with Vesper Lynd is powerful. So, for *Spectre*, I felt it was necessary we grapple with the emotional ghost that is Vesper. You got the sense he was still somewhat carrying a torch for this woman and he had to exorcise that demon to proceed further with his romantic and personal life." To that end, Logan wrote a scene with Bond in Tangier, finding a videotape of Blofeld torturing Lynd, "so we would specifically talk about Vesper in a way to put that ghost to rest, to let the new character flourish." The scene was never shot, although the video (Vesper Lynd: Interrogation) is seen when Bond discovers Mr White's secret room at the hotel L'Americain in Morocco.

Having played the contemplative card with *Skyfall*, Mendes, Craig and Logan were eager to dial up the levity, wit and quip levels this time around, harking back to Connery-era Bonds, as

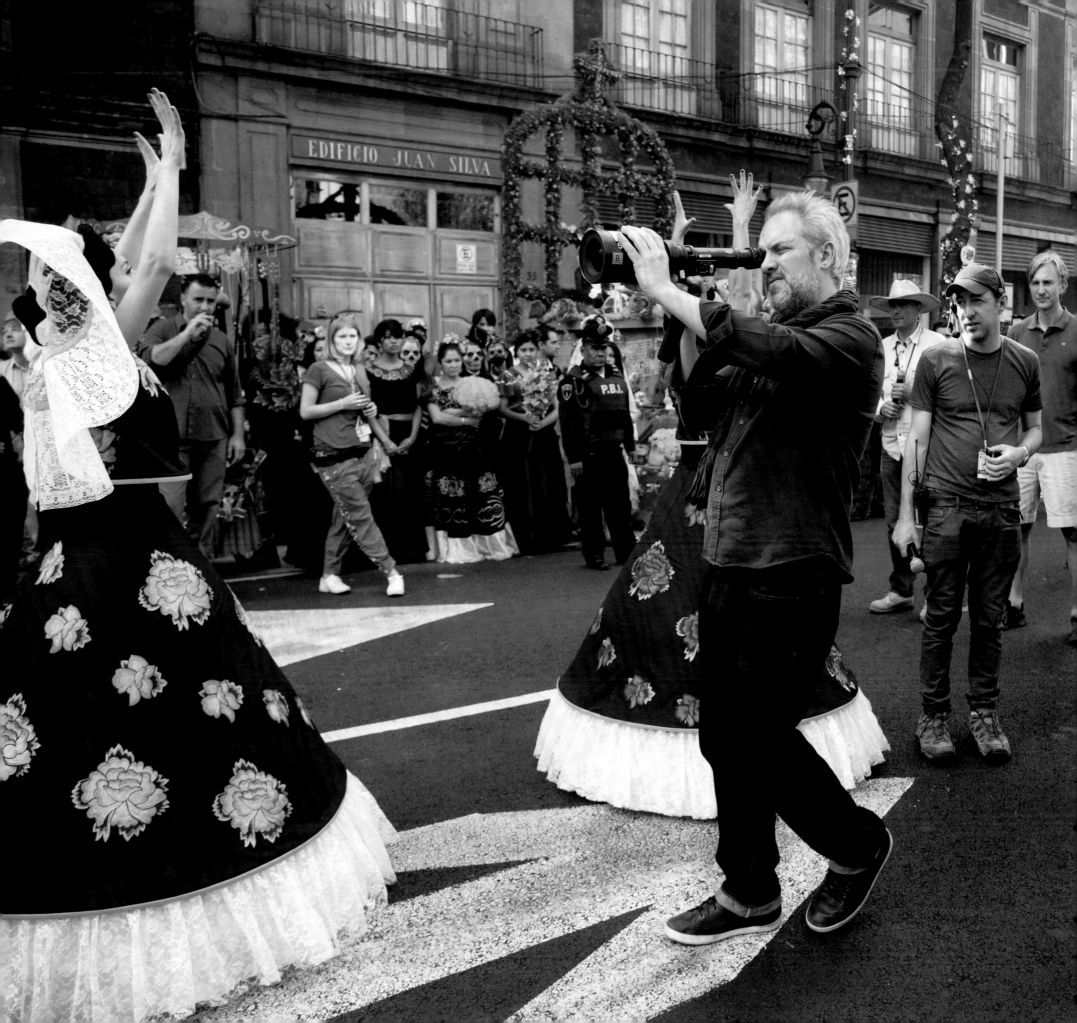

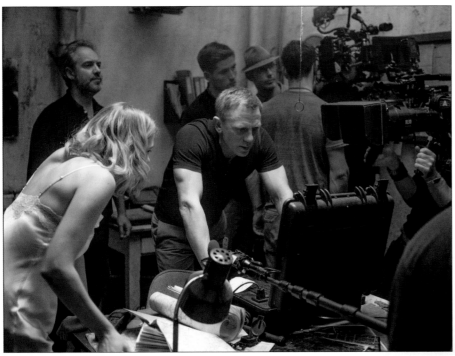

well as Roger Moore's early adventures. "I didn't want to just repeat *Skyfall*," insists Mendes, who was aiming to recall classic Bond in everything from the cars, tone, camerawork, to the cut of 007's suit. "I wanted to bring back the things I loved when I was an eleven-year-old watching *Live And Let Die*, and make something with that kind of exoticism, something more romantic, a little funnier, that had more glamour and old-school flamboyance in terms of the action and setting. *Skyfall* took place mostly under grey skies, in the rain and the bleak wilds of Scotland. On *Spectre*, I tried much harder to bring some of the Roger Moore-era relish into it, starting at the beginning when Daniel falls through that building in Mexico and lands on the sofa clutching a piece of light fitting and tosses it over his shoulder. We were definitely looking for those moments of Bond being aware of how absurd it was."

After many months working on *Spectre*, Logan left to oversee the first season of his gothic TV show, *Penny Dreadful*, starring *Casino Royale*'s Eva Green and former Bond Timothy Dalton. "It was in okay shape, but it wasn't great, and it wasn't done," reflects Logan of his script. Picking up the reins were Neal Purvis and Robert Wade, with the duo remaining on board right through production, working alongside playwright and screenwriter Jez Butterworth, who had contributed a dialogue polish to *Skyfall*. "It was more like *Mission: Impossible* and Bond was just part of a team," says Wade of Logan's draft. "The thing we felt John had done that was strong was give Bond a relationship with Madeleine

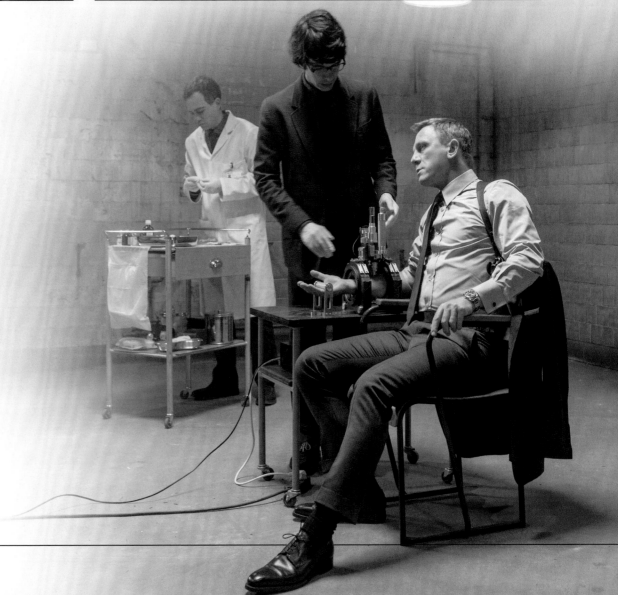

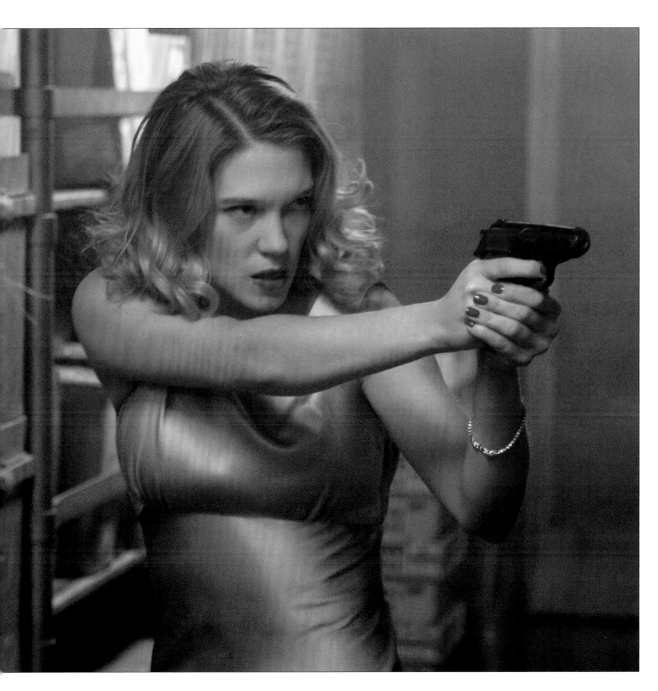

OPPOSITE TOP LEFT: Mendes, Léa Seydoux as Dr Madeleine Swann and Craig on the set of Mr White's secret room at L'Americain.

LEFT: Andrew Scott as C and Mendes on the CNS building interior set.

OPPOSITE BOTTOM: Bond being injected with Smart Blood by Q (Ben Whishaw) at MI6.

BELOW: Madeleine demonstrates her ability to handle a gun.

– although she wasn't called Madeleine at that point. We changed her name."

Not only did Kaja become Dr Madeleine Swann – "very Faustian," notes Wade – she also became French by virtue of the fact Mendes cast Léa Seydoux in the role. "Léa's wonderful," says the director. "There's something sphinx-like and unknowable about her, a bit mysterious, which I thought we could use and would draw Bond forward, the scene between them on the train being a pivotal part of that. Him assuming she didn't know how to handle a gun and her being able to dismantle it in seconds. That was a

big moment of revelation for him." (It would also prove a moment of revelation for future Bond director Cary Joji Fukunaga, but more on that later.) "She's a proper actor," adds Logan, "and you've got to set proper actors against Daniel Craig; that's the secret of everything. You can't do generic. You need proper actors, build a backstory and go toe-to-toe with Daniel. Léa absolutely does that."

"Madeleine is a doctor and she's a strong woman," says Seydoux of her character. "She is intelligent, independent and she doesn't want anything to do with Bond when she meets him for the first time. Madeleine is not impressed, but she understands Bond very well, because she has an insight into the world that he lives in. For his mission, he needs to understand things from his past and he needs Madeleine for the information she can provide. Eventually, it is a very strong relationship between them."

Purvis and Wade also felt Logan's script "needed a motor to get it going. So we had the idea of M leaving Bond a message from beyond the grave," says Purvis. "It meant Bond was being proactive. That was a [problematic] aspect of the previous draft – it was considered Bond wasn't quite active enough. M's message gave him a personal reason and he came out of the traps fast." As a result, the movie begins with Bond on a rogue mission to Mexico City, fulfilling the late M's dying wish. "It gave it a dynamic," concurs Wade, "and the idea he is operating in secret gave him the motivation to get Moneypenny and Q on his side, because the mission the old M has given to him is find this character and kill him. And make sure you don't miss the funeral. That sets Bond onto the trail of SPECTRE." The pair also added the surveillance subplot, introducing the character of C (played by Andrew Scott), the shady director general of the new Joint Intelligence Service, who, it transpires, is in cahoots with Blofeld. "The difficulty with Blofeld is it's such a big idea," says Wade. "Because of his legacy, Blofeld is the ultimate villain and how you embody that is quite tricky. Our initial idea was to give him a history that paralleled the one in the novels. He was in the French Foreign Legion with Mr White. They got trapped in the desert and Blofeld killed all the other men so they could eat them." The only element that remained of this cannibalistic backstory was having Bond travelling across the Sahara with Madeleine by train and getting off at a waystation in the middle of nowhere. "Originally, that trip into the desert was to get you to an abandoned legionnaire port where something terrible had happened," says Wade, "but that went out the window."

What did stick, however, was their rewriting of Bond and Blofeld's history to give them a personal connection, an idea inspired by the short story 'Octopussy' in which Bond makes reference to a man called Oberhauser who taught him to ski when he was in his teens and was "something of a father figure". "If in doubt, we go back to the Fleming," concedes Wade, who, together with Purvis, pieced together a cinematic backstory in which the teenage Bond, recently orphaned, was sent to live in Austria with Oberhauser and his son, Franz. "Franz is not the golden boy Bond is," says Mendes. "He's not talented, he's not a skier, and that engenders this hatred in his adopted brother, who then sets out to destroy him for the pains inflicted when he was a child." As a result, Franz would kill his father, stage his own death and transform himself into Ernst Stavro Blofeld. "I thought that was a really cool idea that both unlocked a section of Bond's past, but also linked him to all the various sources of his pain, as Blofeld puts it," continues Mendes. (Another of Purvis and Wade's unused ideas was having the young Blofeld in an iron lung. "He was going to be trapped, only able to look at the ceiling, while Bond was out getting on well with his dad," says Purvis, "and it drove him mad."). Once this "cuckoo in the nest" idea was established, then it became a case of retrofitting the plots of *Casino Royale*, *Quantum Of Solace* and *Skyfall* to reveal that Blofeld has been behind everyone and everything that has pained him. "There was a sense this was Daniel's last film, so Sam wanted to tie things up and have him walk away, throwing his gun into the river," says Purvis. "It was an attempt to make things feel like they've come full circle," adds Wade.

To play his Blofeld, Mendes cast Austrian-born Christoph Waltz, who had won two Best Supporting Actor Oscars®, for Quentin Tarantino's *Inglourious Basterds* and *Django Unchained*. "We were trying to find somebody who was the right age, the right look," Mendes reveals. "I like very much that moment in Rome when Bond first sees him from behind and feels like he recognises him and Blofeld senses someone looking at him and kind of twitches. That sense of *I know who this person is*. That was something I was trying to construct, a figure who has known Bond for years and observed him from afar and been behind everything, which, for me, is the nature of a super villain, someone who is really pulling the strings."

"We were there when Daniel and Christoph first sat down and acted out a scene together," recalls Purvis. "They were at different ends of this table, and Sam, Rob and I were on either side, and they very quickly got into this power struggle between them. They took up their positions as characters. It was quite enjoyable to watch."

"The question was how was Christoph going to approach it. He didn't want to do a flamboyant kind of interpretation of Blofeld," says Wade, "so it was trying to make it suit him."

While the *Skyfall* script had been pretty much locked once filming began, *Spectre* continued to be rewritten during production. "One of the things I loved on *Skyfall* was having the time to go down blind alleys, because it takes a long time to try and construct stories that are surprising and new," says Mendes. "With *Skyfall*, you knew from the very beginning where you were heading, with the death of M, but for *Spectre*, we didn't know, and that makes for problems. In a good movie, every scene is pointing towards the same place. If you don't know where you're pointing, it makes it a much more complex job to shoot, and you're having to give yourself multiple options for when you get to the cutting room. That's confusing and complicated for everyone, not least the actors. The whole experience was tenser, and there was more of a ticking clock, because they wanted to release the film at the end of 2015."

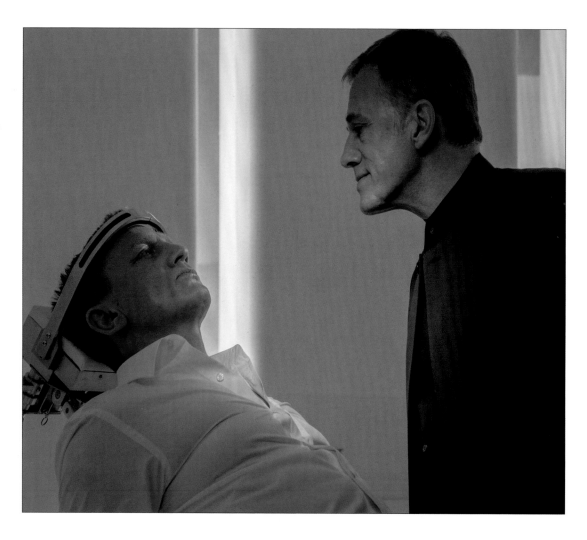

"Daniel always wants it to be really good, obviously," says Wade, "and he wants to motivate everyone to work hard. We were doing meetings in the evenings, when we were in Austria. Daniel does a whole day's shooting, then he works out in the gym, then he has to sit with me and Neal and Sam to talk about the script. He was working really hard."

For a while, *Spectre*'s pre-title sequence was to take place on the French Riviera against the backdrop of the Monaco Grand Prix. "I like that 1970s feeling of old-school European glamour you used to get from Martini adverts," says Mendes, "but I didn't feel there was enough going on except a lot of fast cars and I didn't feel Bond was central enough to it, so we abandoned that idea." Instead, the sequence was relocated to Mexico City during the *Día de Muertos*. "We talked about different festivals and processions, but the Day of the Dead really suited this story," says production designer Dennis Gassner, returning for his third Bond. "The celebration of the dead ties in thematically with what the movie's about," adds Mendes, "with Bond being haunted by someone he thought was dead." The Mexico City setting was inspired by Craig and Mendes' love for *Live And Let Die*, a film that features a

larger-than-life villain and voodoo sacrifice. "The Monaco Grand Prix was a cool idea for a Bond sequence, but you couldn't pin a lot of drama to it other than excitement," says Logan. "Once we started talking about *Live And Let Die* and the power of the Day of the Dead and voodoo imagery, we all got very excited. Then the idea of masks, of seeing Bond in a death mask, seemed appropriate, especially given what happens in the movie."

After *Skyfall*'s breathless "Russian doll" pre-credit chase, Mendes wanted to start *Spectre* a little more elegantly. "Even though I loved the opening of *Skyfall*, I felt it was a headlong pile-driver of a sequence and I wanted something that had a bit more shape and finesse, wasn't scored with music constantly and wasn't just breakneck action. I felt it needed something a little bit more flamboyant than I achieved on *Skyfall*. I wanted something that had shifts of rhythm and tempo, used score in a more inventive way and was perhaps a little less 'cutty'. That led me to the opening continuous shot, holding the score back until the middle

of the helicopter fight and dropping the audience down in this very potent atmosphere, exotic and strange and kind of heady, which is my memory of some of *Live And Let Die*."

Spectre begins with the words "The dead are alive" and finds Bond, wearing a death mask, top hat and long coat with a painted-on skeleton, in the centre of the crowded Day of the Dead parade, accompanied by Estrella (Stephanie Sigman). As SPECTRE assassin Marco Sciarra (Alessandro Cremona) passes by, the camera tracks with Bond and Estrella as they enter the Grand Hotel lobby, walk through, take the lift up, stroll along a corridor, into a room, where Bond sheds his costume (out of shot), revealing a sharp suit underneath. He tells a disappointed Estrella, "I won't be long," then steps out of the window carrying a Glock 17, onto the ledge, and walks across several rooftops, before ending up across from the building where Sciarra is planning a bombing. The scene, shot across two days, plays out as one continuous take, referred to as a "oner", although it was actually made up of

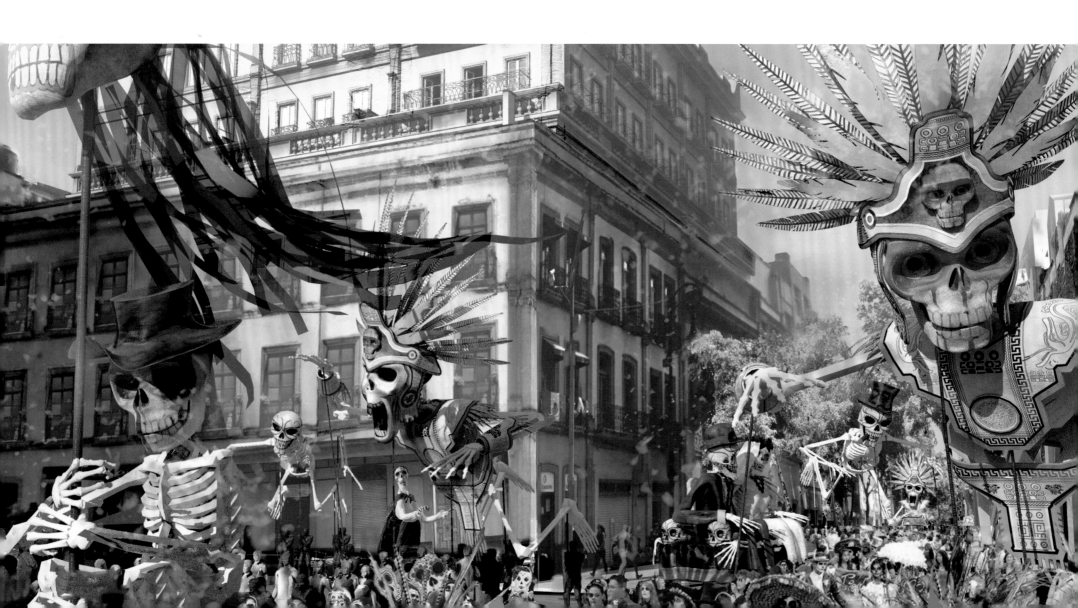

four separate shots digitally spliced together in post-production. "There's a blend on the poster going into the hotel, the lift was for real, a blend going into the hotel room and there was one coming out of the hotel room onto the roof," reveals executive producer Callum McDougall. "We built the bedroom as a partial set." The hotel had been used previously in *Licence To Kill*, "but no-one recognises it," says McDougall.

Once Craig steps out onto the balcony and strolls along the rooftops, the camera is mounted on a fifty-foot Techno crane, which, in turn, is attached to a hundred-foot-plus dolly track. This allowed the camera to track alongside and above the actor, who was tethered to a safety wire that was later removed by visual effects. "Initially I wanted to do the whole opening sequence as one shot, but that was before I conceived the helicopter part of the sequence," says Mendes. "The moment I got to that, I thought, *This is not going to be the best version if we have to stay in one shot*. But the idea remained for the first section. I wanted a feeling of immersion, to feel uncertain who was who, who was behind the masks."

The film's *Día de Muertos* parade was shot across several days in and around the Zócalo, Plaza Tolsá and Centro Histórico neighbourhood, and featured 1,520 extras, 77 dancers, musicians and ten giant puppets and floats, the tallest of which was eleven metres high, with the centrepiece being the La Calavera Catrina skeleton with a ten-metre-wide hat. Costume designer Jany Temime spent time in Mexico, alongside Anna Terrazas (the local Mexican costume supervisor), researching Day of the Dead traditions in order to design the thousands of masks and outfits required for the legions of locals. "There are four different themes," she explains. "You have traditional Mexican folklore; you have the theme of death, with all the skeletons; you have another huge theme, which is the wedding; and then you have a fourth theme, which we exploited more in the décor, and that is the old civilisation theme, Incas, Mayans.

(Continues on page 192)

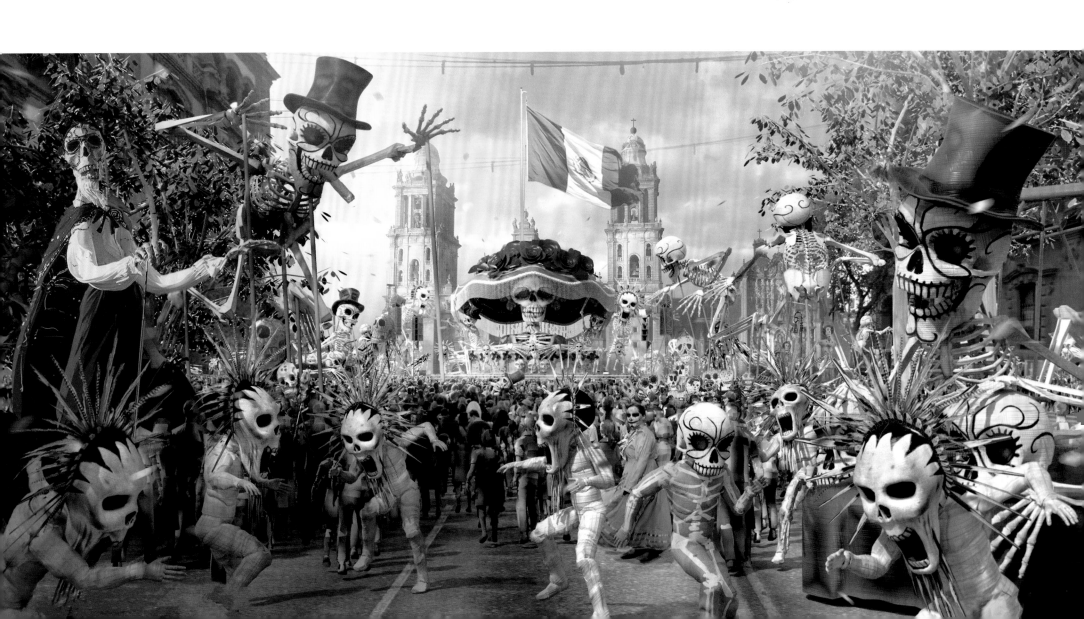

DAY OF THE DEAD COSTUME

"When I thought about Daniel's costume, I had two possibilities," says costume designer Temime, "because he is supposed to be one of the crowd. You are not supposed to recognise him. I decided I could either put him in a Mexican poncho on top of the suit and a mask or give him a long morning coat. I made them both and we went for the long coat, because it was sexier and had more allure. I had the mask specially made, because Daniel needed to wear it for a long while. I had twenty-five people, art students, painting masks and I selected one and I brought it to England to a fantastic mask artist to remake it for Daniel. The design is very specific. It is a skeleton, but a very sympathetic skeleton. They are not horrific. They are sort of cheerful skeletons. It's very interesting, the Mexican conception of death. It's not frightening. Anyway, Daniel loved it and we had the top hat made and the tie with a skeleton design and then I painted the skeleton on top of the long coat. Then we had to do ten the same, of course. What is incredible, though, is when Daniel was wearing it, he was one of 1,500 extras, but the way he was walking, the way he *was*, you knew it was him. You could pick him out of the crowd, because Daniel Craig has an incredible aura. He has magnetism. That's what makes the difference between an actor and a star."

BELOW & RIGHT: Estrella (Stephanie Sigman) and Bond attend the parade in costume.

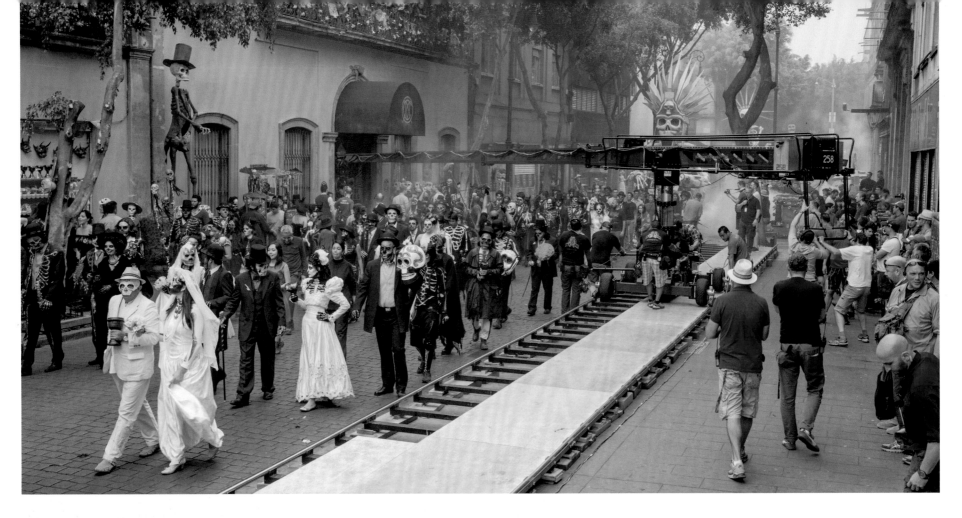

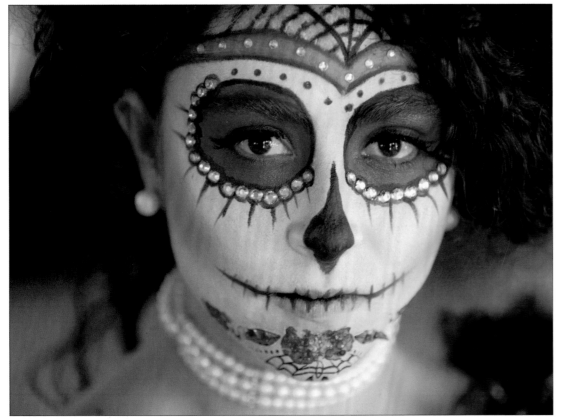

"I focused on wedding, traditional Mexican and death and designed twenty costumes by category, then those twenty costumes were multiplied in five different colours and those five different colours were multiplied by different fabrics. Because when you have to fabricate 2,500 costumes, you have to go by category. For instance, we had 150 wedding dresses and those 150 were done in five colours, which meant we had ten models and those ten models were done in different fabrics and then mixed up together. A crowd is a crowd, but that was fun to do, that was joyous. Mexican folklore and tradition is extraordinary."

To get 1,520 people ready each morning took military-style planning, with a production line set up to shepherd the extras through as efficiently as possible. "I had a costume supervisor who was very excited," laughs Temime. "I mean, that's his kick, how many people he could dress up in the morning. We had one dresser for four people. The first day it's messy, but after that they know their costume." Once an extra was dressed, they would move on to hair and makeup, led by makeup designer Naomi

ABOVE: Filming the parade.

LEFT: One of the extras with her finished Day of the Dead hair and makeup.

OPPOSITE LEFT: Craig on the roof location in Mexico City.

OPPOSITE RIGHT: Bond walks across several rooftops.

Donne, with a team of 230, including 170 makeup artists, the majority local, designing and painting every face individually. "It was like a pipeline," says McDougall. "We had lines and lines of makeup mirrors and devised a system where they had red and green lights on top of them, so when people came in they'd get their costume, then go into this room and look for a red light or a green light, and if it was a green light they'd go over to that makeup mirror and we'd get them ready and then we'd have them out on the set."

The end result of all that creativity and endeavour is one of the best Bond sequences of not just the Craig era, but the entire franchise. "The day we shot that scene, with the big maquettes and the smoke, I don't think I've ever felt so exhilarated in my life on set," recalls McDougall. "I've done big movies, but I'd never seen the scale of what we were trying to do there."

"It was quite emotional to see the artistry manifest itself," says Gassner. "When those 1,500 extras came out for the first time, I cried. I had tears running down my face, it was so beautiful to see that. The emotion of that many artists creating something of their own history."

"All of us veterans were standing there in the midst of all this and pinching ourselves and saying, 'My God, this is unbelievable,'" says Broccoli. "It felt like one of those great, epic David Lean-type movies. It's so rare you can do something on such a large scale. And it was a celebration of Mexico." Ironically, at the time of filming, Mexico City's *Día de Muertos* parade wasn't anywhere near as elaborate or well attended as the one featured in the film. However, since *Spectre*'s release and

the resultant increase in tourism, the city has put on a show comparable to the cinematic carnival, using many of the giant puppets and maquettes that were created for the film. "Mexico City embraced us," says Craig. "Mexico City turned out en masse. Mexico City got dressed up. Mexico City had some of the best extras I've ever worked with, who repeated and repeated and repeated like it was the first time they'd ever done it and made it look like there was a carnival happening in front of us. I don't know how many extras we had, thousands, who went into makeup at five o'clock in the morning and were all out by seven o'clock in the morning, and they looked amazing. The greatest thing is, they now really celebrate it. It's phenomenal. It's the nicest feeling that people are having a party because we were there."

The Mexico City opener concludes with a dramatic, death-defying stunt as Bond chases Sciarra onto a Messerschmitt-Bölkow-Blohm Bo 105 helicopter as it's taking off from Zócalo. The two men grapple inside and out, before Bond kicks Sciarra off. Bond then has to take care of the pilot as the helicopter spins, twists, corkscrews and barrel rolls. The entire sequence took months to rehearse under the supervision of stunt coordinator Gary Powell, working alongside fight choreographer Olivier Schneider, who had transformed Liam Neeson into an action star with *Taken*. "I wanted to separate the two jobs, stunt coordinator and fight choreographer," explains Mendes. "All the exterior stunt

work in the helicopter was Gary. The stuff on wires, hanging out of the helicopter, that's classic stunt coordinator territory. I brought in Olivier for the fight on the train between Bond and Hinx and he ended up working on the helicopter fight as well."

"It's not that we didn't have great people, but I'd been saying for a while, 'Can we find somebody to tailor the fight language?'" reveals Craig. "Because there's a tendency that all fights start to look like the next fight. Olivier came in and I said, 'Gloves off. Let yourself go with the ideas.' He had an amazing team of French stunt guys and they allowed me to be freer in the fighting and allowed me to be myself. I've always brought this sort of aggression. That's what fights are. I've seen real fights and they're just aggression and really shocking. So it was bringing that aggression, but making them a bit more lyrical."

For exterior shots of the helicopter, two stuntmen were filmed fighting on the skis and hanging off the sides as it hovered thirty feet above a crowded Zócalo, with extra stuntmen on the ground in case of emergencies. The stuntmen were tethered to the cockpit with safety wires. Their faces were then digitally replaced by Craig and Cremona's in post. However, due to Mexico City's altitude, there was a limit to the aerial stunts that were possible. "Because it sits at about 7,500 feet above sea level, helicopters can't do flips at that height," says McDougall, "so the flipping of the helicopter we did in Palenque." The helicopter was especially

BELOW: A set was constructed at Pinewood to film the explosion caused by SPECTRE assassin Marco Sciarra in Mexico City.

BELOW RIGHT: Filming the Messerschmitt-Bölkow-Blohm Bo 105 helicopter stunt on location in Mexico City.

modified for barrel-rolling and free-diving, and was piloted by Red Bull aerobatic ace Chuck Aaron.

The interior fight was mostly shot on stage at Pinewood, where special effects supervisor Chris Corbould built a full-size helicopter on a gimbal that was able to move up, down, all around. "Another of Chris's specials," says Craig. "You're tied into it and you're having to fight as well. It was incredibly exhausting, but it's a really good fight."

"That was the most complicated scene I have ever had to design," explains Schneider, who had to synch both fights to the movement of the helicopter. To prepare, he had a metal cage,

the same size as the interior, built at Pinewood that was capable of rotating 360 degrees. He started to rehearse the fight on the ground with Aaron, his stunt team and the actors, before slowly taking it into the air. "All of that took a lot of time to design and understand the geography," continues Schneider. "It was quite intense and quite dangerous and you just pray and hope everything is in place. I couldn't sleep the night before we filmed it, wondering if I had forgotten anything or there was some detail we didn't think of. We are stunt guys, our job is to take risks. We try to minimize that risk close to zero, but there is always a risk, otherwise you can't call it a stunt."

BELOW: The helicopter fight over Mexico City.

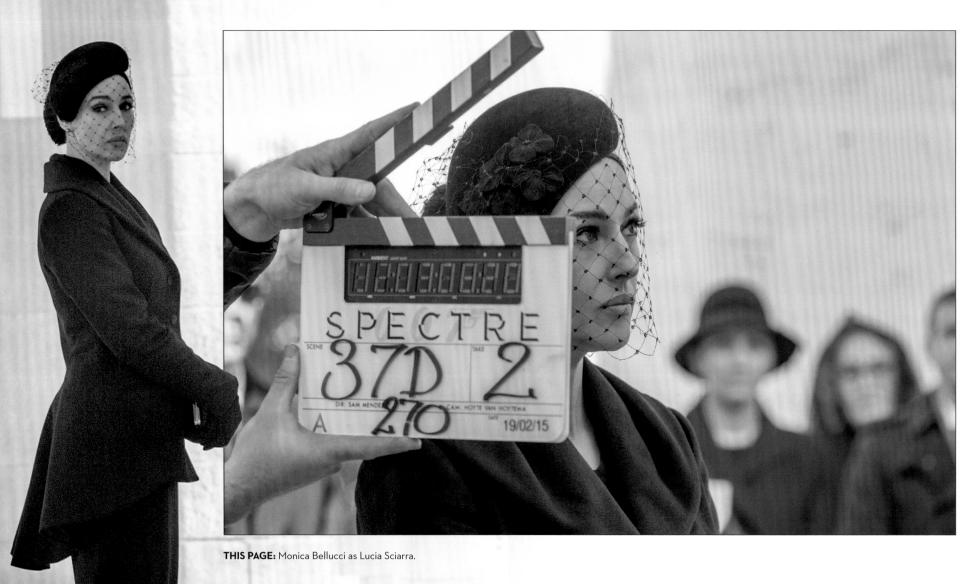

THIS PAGE: Monica Bellucci as Lucia Sciarra.

Following his exploits in Mexico City, Bond heads to Rome to see who shows at Sciarra's funeral. There, he meets and later sleeps with Sciarra's widow, Lucia, played by Italian actress Monica Bellucci, who, at fifty, was the oldest actress to play a Bond woman. "I had always loved her and had been determined to have her in something," says casting director Debbie McWilliams. "So when it came to *Spectre*, I said, 'We're having Monica Bellucci.' Sam asked, 'Can I at least meet her?' She came to London. I took her to the Covent Garden Hotel, showed them into a room together and that was that. They fell in love! I was so thrilled. At long last we got Monica. And the number of people who contacted me and went, 'Yes! Fifty-year-old Bond woman. Well done. Fantastic!'"

"All of that came out afterwards and became the story and, genuinely, it didn't even cross my mind," says Craig. "Maybe there's a naivety in me, but when someone says, 'Monica's going to do it.' Fuck, yes. How amazing is that. It's such a wonderful, lovely thing that someone like Monica Bellucci will be in the movie, like having a huge movie star play a small part in the film. It's a rare, rare thing."

The production spent five weeks in Rome, a first for Bond, filming at locations including the Ponte Sisto, Roman Forum, Vatican City, Museo della Civiltà Romana and the River Tiber. "When we were developing the script, Sam said to me, 'You've grown up on these films. You've been everywhere in the world. Where do you want to take Bond that he's never been before?'" recalls Broccoli. "It didn't even take me a second to say, 'Rome,' because I've always wanted Bond to go to Rome. It's the most extraordinary city and, of course, it's about the introduction of Bond to Blofeld and how else can you visually set the tone for power and opulence except go to Rome, where the architecture is all about power."

In addition, Rome also provided the backdrop for an

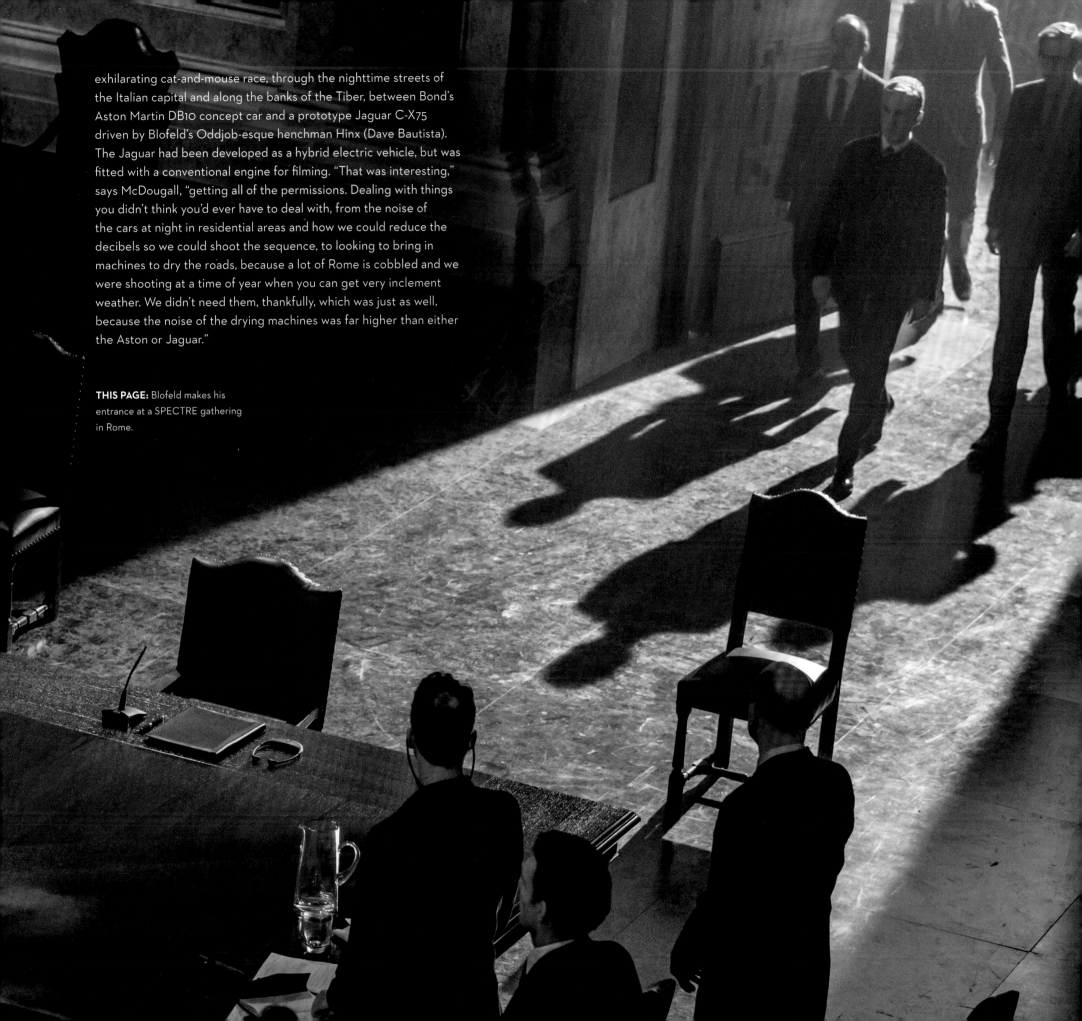

exhilarating cat-and-mouse race, through the nighttime streets of the Italian capital and along the banks of the Tiber, between Bond's Aston Martin DB10 concept car and a prototype Jaguar C-X75 driven by Blofeld's Oddjob-esque henchman Hinx (Dave Bautista). The Jaguar had been developed as a hybrid electric vehicle, but was fitted with a conventional engine for filming. "That was interesting," says McDougall, "getting all of the permissions. Dealing with things you didn't think you'd ever have to deal with, from the noise of the cars at night in residential areas and how we could reduce the decibels so we could shoot the sequence, to looking to bring in machines to dry the roads, because a lot of Rome is cobbled and we were shooting at a time of year when you can get very inclement weather. We didn't need them, thankfully, which was just as well, because the noise of the drying machines was far higher than either the Aston or Jaguar."

THIS PAGE: Blofeld makes his entrance at a SPECTRE gathering in Rome.

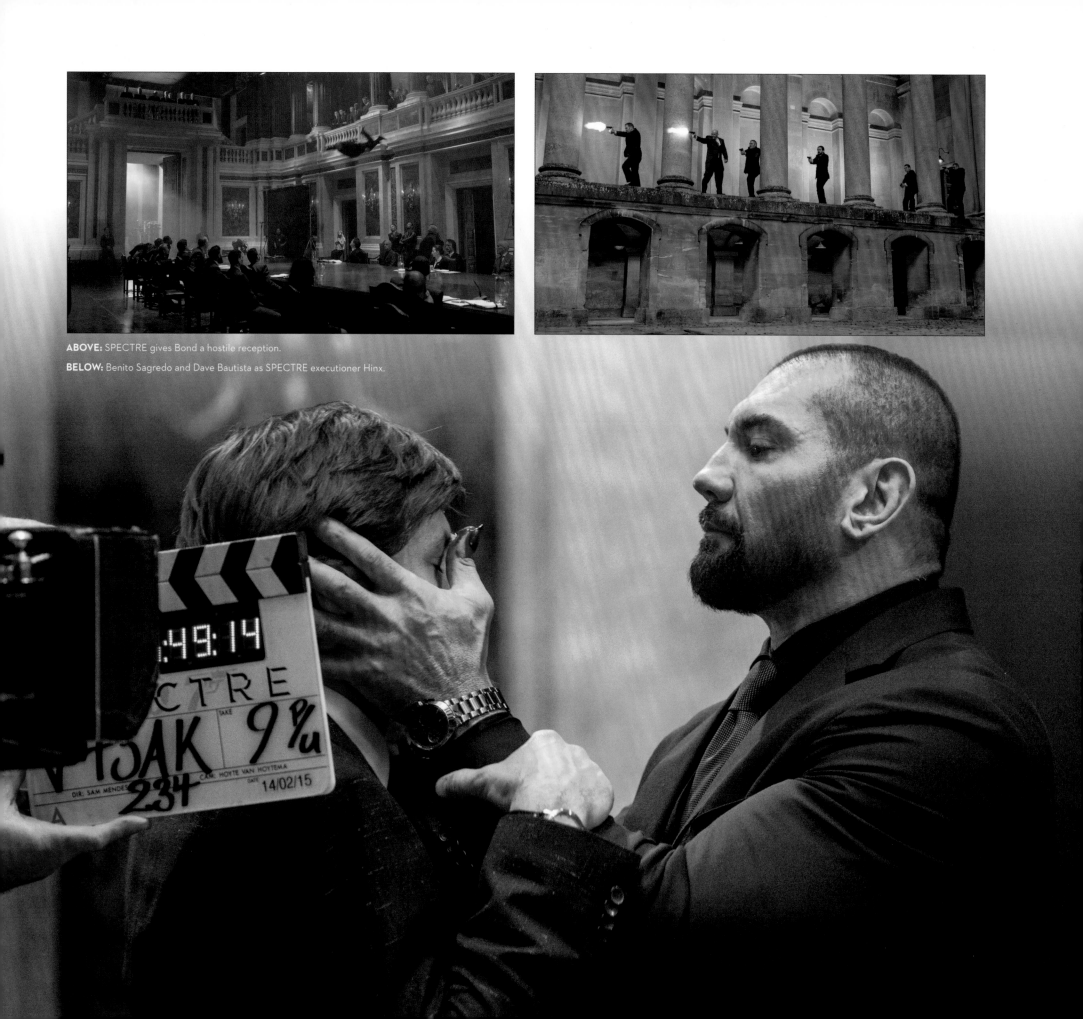

ABOVE: SPECTRE gives Bond a hostile reception.

BELOW: Benito Sagredo and Dave Bautista as SPECTRE executioner Hinx.

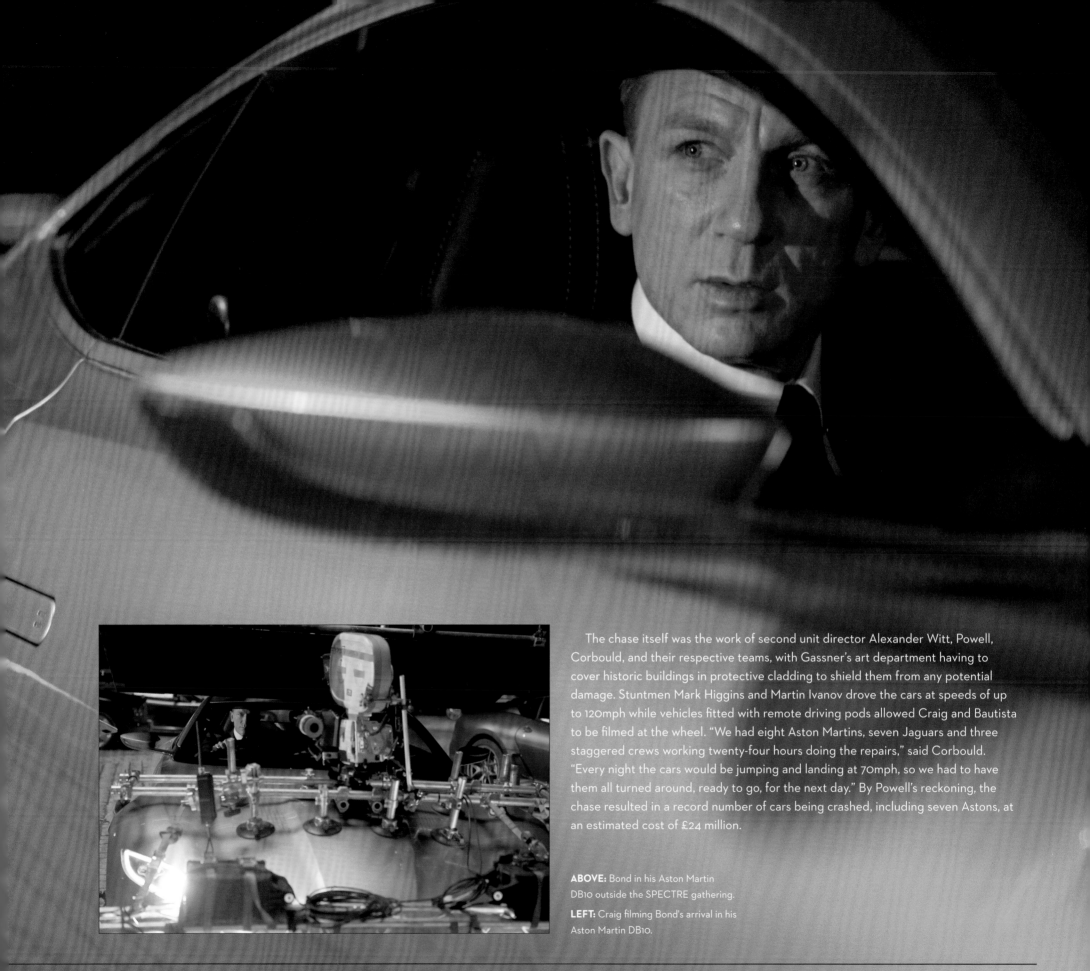

The chase itself was the work of second unit director Alexander Witt, Powell, Corbould, and their respective teams, with Gassner's art department having to cover historic buildings in protective cladding to shield them from any potential damage. Stuntmen Mark Higgins and Martin Ivanov drove the cars at speeds of up to 120mph while vehicles fitted with remote driving pods allowed Craig and Bautista to be filmed at the wheel. "We had eight Aston Martins, seven Jaguars and three staggered crews working twenty-four hours doing the repairs," said Corbould. "Every night the cars would be jumping and landing at 70mph, so we had to have them all turned around, ready to go, for the next day." By Powell's reckoning, the chase resulted in a record number of cars being crashed, including seven Astons, at an estimated cost of £24 million.

ABOVE: Bond in his Aston Martin DB10 outside the SPECTRE gathering.

LEFT: Craig filming Bond's arrival in his Aston Martin DB10.

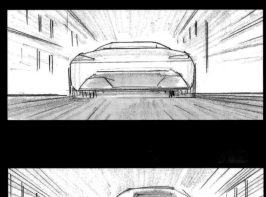

CRANE UP

ABOVE: Storyboards of the race through Rome between Bond's Aston Martin DB10 concept car and Hinx's prototype Jaguar C-X75 by Nick Pelham.

LEFT: Filming the race along the banks of the Tiber.

RIGHT: Concept art of the race along the banks of the Tiber by Chris Rosewarne.

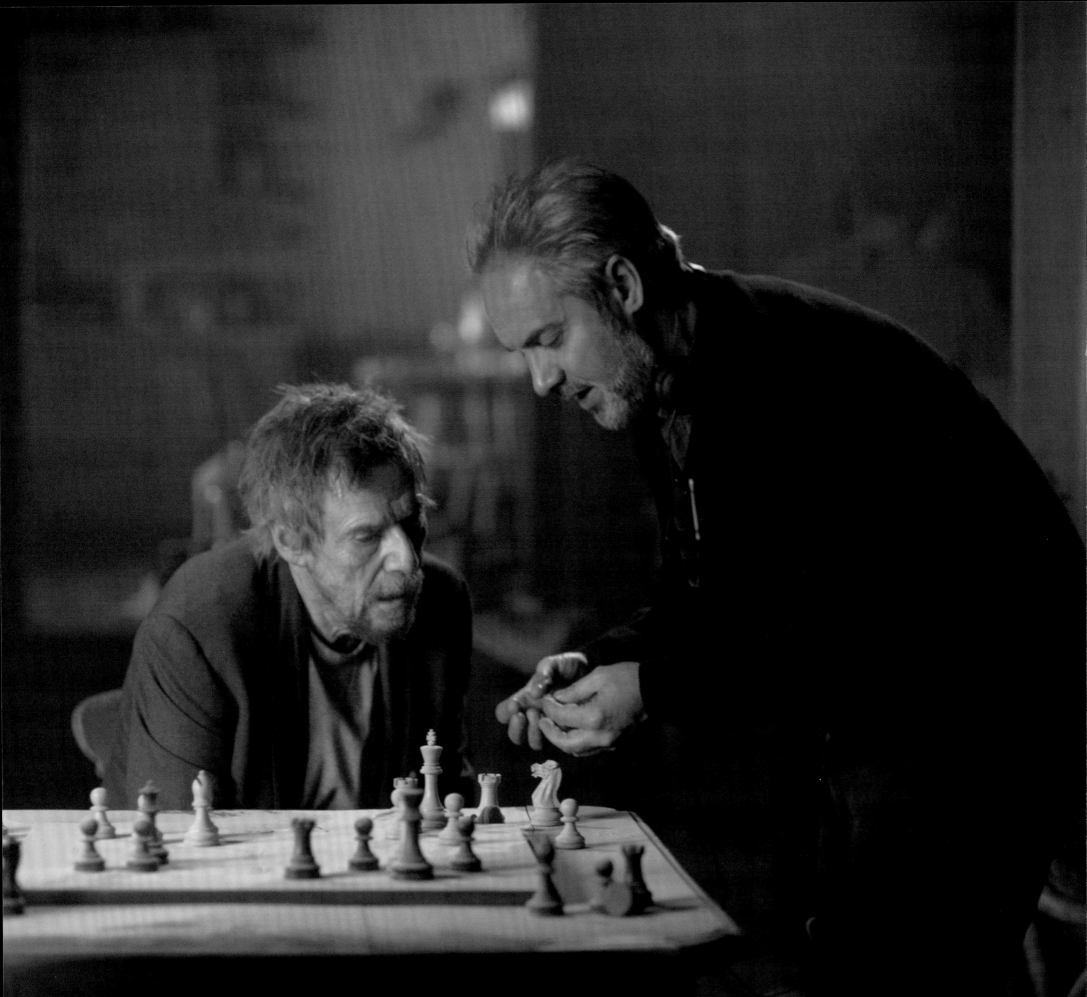

After Rome, Bond travels to Austria, where he finds a sick, poisoned Mr White (Jesper Christensen), who tells him how to find Blofeld in exchange for Bond protecting his daughter, Madeleine Swann. The scene between the two men in Mr White's Alpine chalet was a revamped version of one Purvis and Wade had written for their draft of *Quantum*. "They had this conversation about the life of an assassin, but that all got lost because, with Paul Haggis, the bad guys had people everywhere, so M's bodyguard was a bad guy and he freed Mr White," says Wade. "So that was good, because it meant we were able to have, basically, the same conversation between Bond and Mr White, but now have a plot dimension to it, where you introduce the idea of the daughter and Bond helping her."

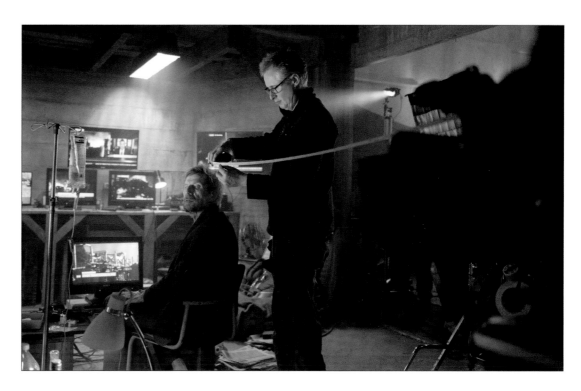

LEFT: Jesper Christensen and Mendes on the set for Mr White's alpine chalet panic room in Pinewood Studio.

RIGHT: 1st assistant camera Julian Bucknall getting focus marks for Christensen.

BELOW: Mendes and Craig on the set.

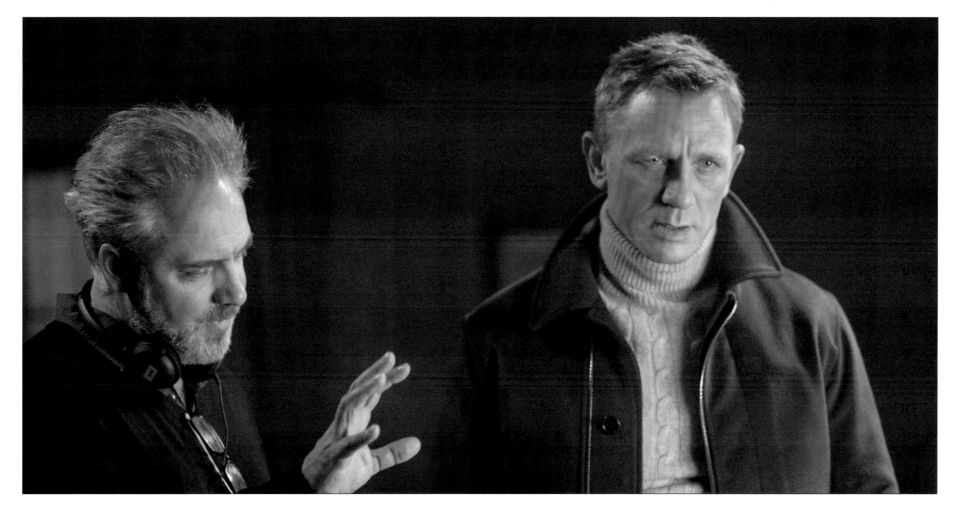

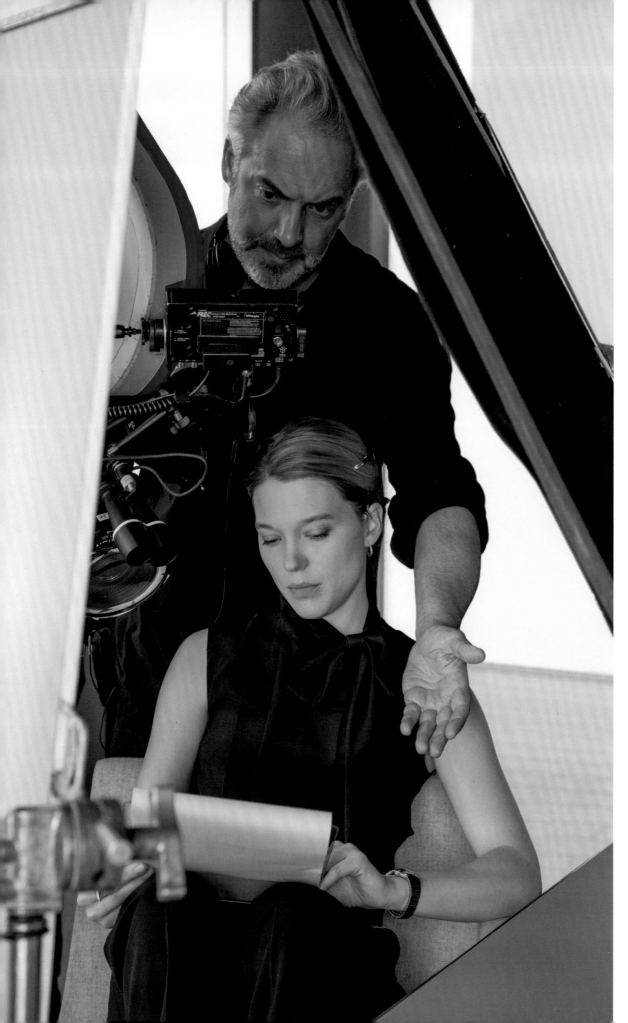

LEFT: Mendes and Seydoux on location at the Hoffler Klinik on Gaislachkogl mountain in Sölden, Austria.

Bond meets Madeleine at the Hoffler Klinik, an incredible mountain-top spot in the Austrian Alps. "I always try and boil a film down to a word, and if a director doesn't have one, I'll offer one up," reveals Gassner. "On *Spectre*, Sam had two. He said, 'Find me something hot and cold.' That was it. That was the meeting. I left, came back with 20,000 photographs and we started pouring through everything. What I was looking for was desert environments and something at the top of a mountain. Emma Pill, my location manager, and Gregg Wilson, associate producer, and I started in Switzerland, Austria, all of the Dolomites. [Taking] cable cars up and down every mountain that had anything possible we could look at." At the top of the 3,000-metre Gaislachkogl mountain in Sölden, Austria, the trio found the newly built ICE-Q restaurant and cable car. "Gregg had just bought a new drone, so we droned it and sent it to Sam, who said, 'That's it!'" recalls Gassner.

Once back at Pinewood, Gassner had a brainwave. Knowing his director's liking for symmetrical set design, he had his assistant "butterfly" the restaurant photo, "so we had a quad. I sent it to Sam. He said, 'Fantastic.' Then we had to build it." The glass-walled structure was fabricated on the Richard Attenborough Stage at Pinewood with a 360-degree photographic backdrop. "It was so amazing you actually felt cold," Gassner laughs. "You had to have a cup of tea to take the chill off." Mendes was, however, determined to film his exteriors on location. "We shot at the top of the mountain and very scary it was," continues Gassner, who added a central concrete entrance to the existing building. "The first time I went there with Sam and about six others, people got altitude sickness, because you're climbing very quickly and you need time to acclimatise," says McDougall. "And we were going to be up there for four, five, six days. But Sam really wanted to shoot there, and he was right, the views were spectacular."

The Alpine sequence was another nod to past Bond films, notably *On Her Majesty's Secret Service* and *The Spy Who Loved Me*. Craig was all for it, as long as he didn't have to ski. "I don't ski. I'm a terrible skier," he admits. "Also, I feel that's territory Roger did so brilliantly and I wanted to see my Bond's version of

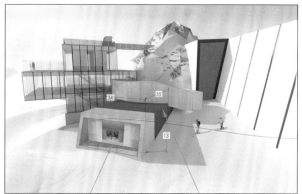
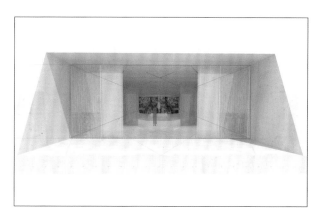

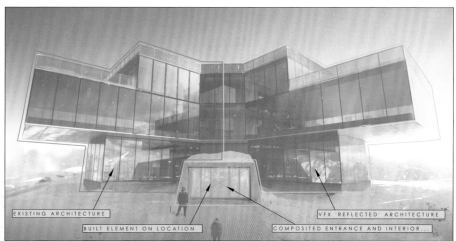

EXISTING ARCHITECTURE

BUILT ELEMENT ON LOCATION

VFX 'REFLECTED' ARCHITECTURE

COMPOSITED ENTRANCE AND INTERIOR...

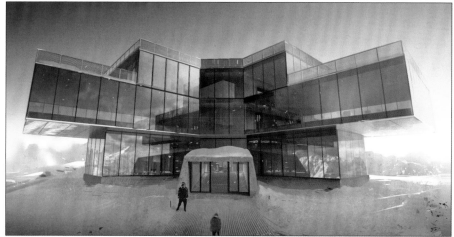

ABOVE: Details of the entrance and VFX composition schematic for the Hoffler Klinik exterior by Neal Callow and Ben Collins.

BELOW: Bond arrives at the Hoffler Klinik.

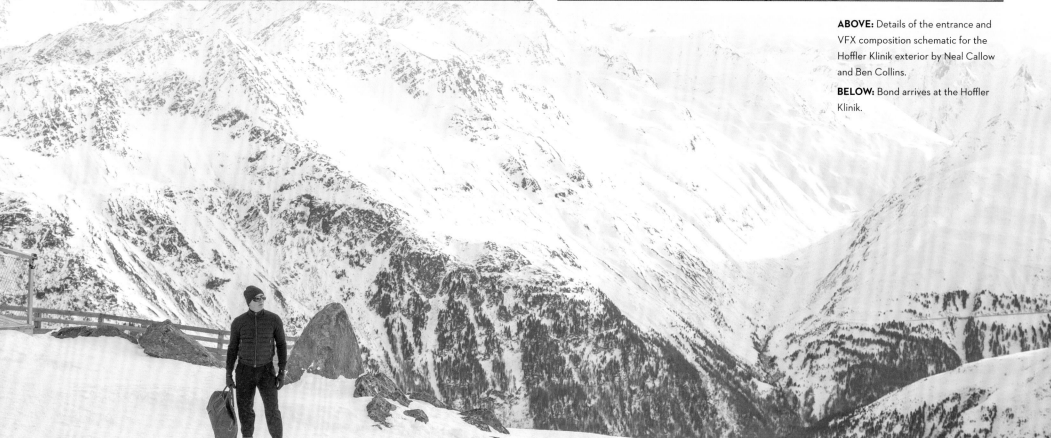

that. I feel like, instead of grabbing a set of skis and skiing down a mountain, he'd grab a drinks tray and slide down on his arse. That felt more in keeping with what my Bond was about."

"Daniel was very clear about that," says Mendes. "He said, 'I'm not getting on skis,' and as someone who doesn't ski either, I totally sympathised with him. The issue was trying to find a way for him to be part of the snow sequence without putting him on skis. For a while, it was a skidoo sequence, but then we had the idea of the plane and that took over."

In order to rescue Madeleine, who has been kidnapped by Hinx and his fellow henchmen in their Range Rovers, Bond commandeers a small plane and sets off after them, flying directly at them, then, after its wings are ripped off, tobogganing down the mountain. Corbould and his special effects team used eight

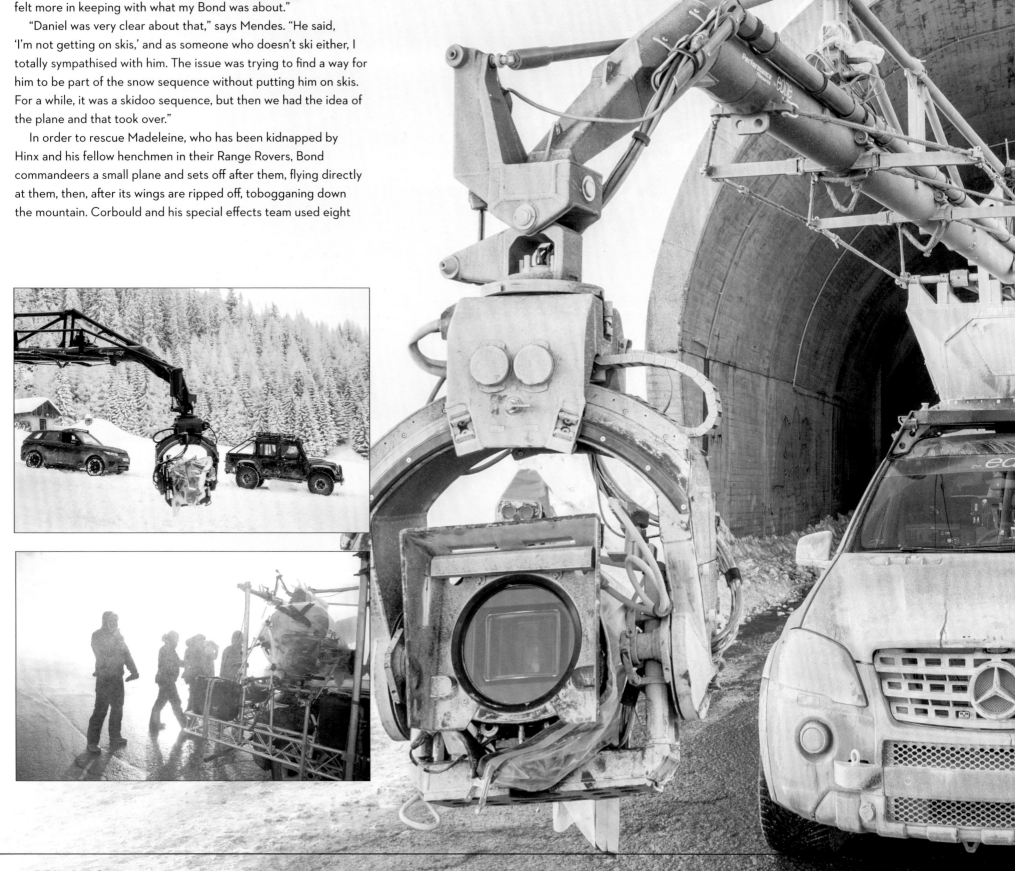

different planes in a number of separate rigs. Two of the planes could fly, another two were fitted onto the wire rig, another four were body shells fitted with hidden skidoos that the stunt team used to drive the plane down the mountainside. "It is a matter of getting the right vehicle for the right terrain and incorporating it and hiding it inside the relevant vehicle," says Corbould. At one point the plane smashes into a barn and explodes out the other end, dropping twenty feet.

The biggest challenge in Austria, however, was the snow. Or rather the lack of it. In the end, the weather was so unseasonal that the production had to use four hundred tonnes of man-made snow to cover the entire hillside.

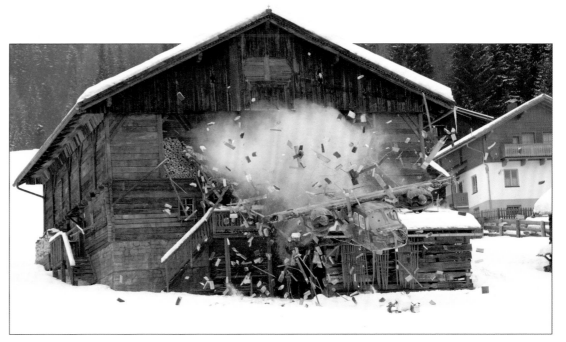

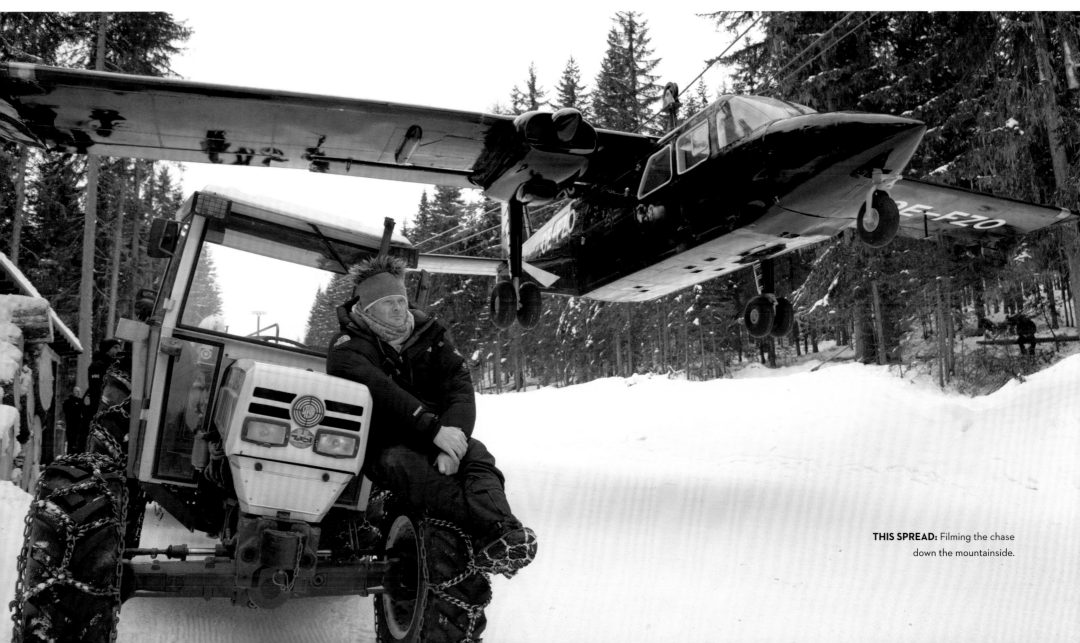

THIS SPREAD: Filming the chase down the mountainside.

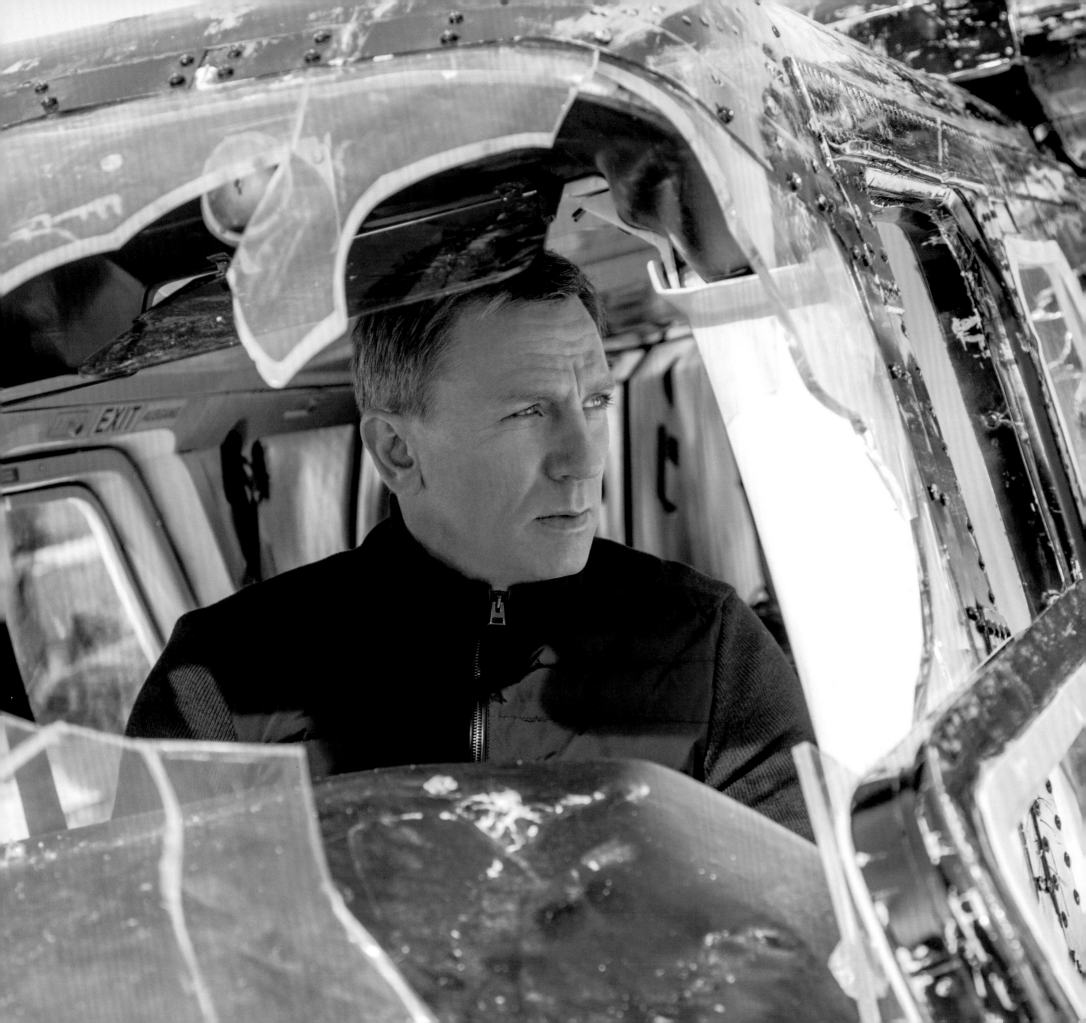

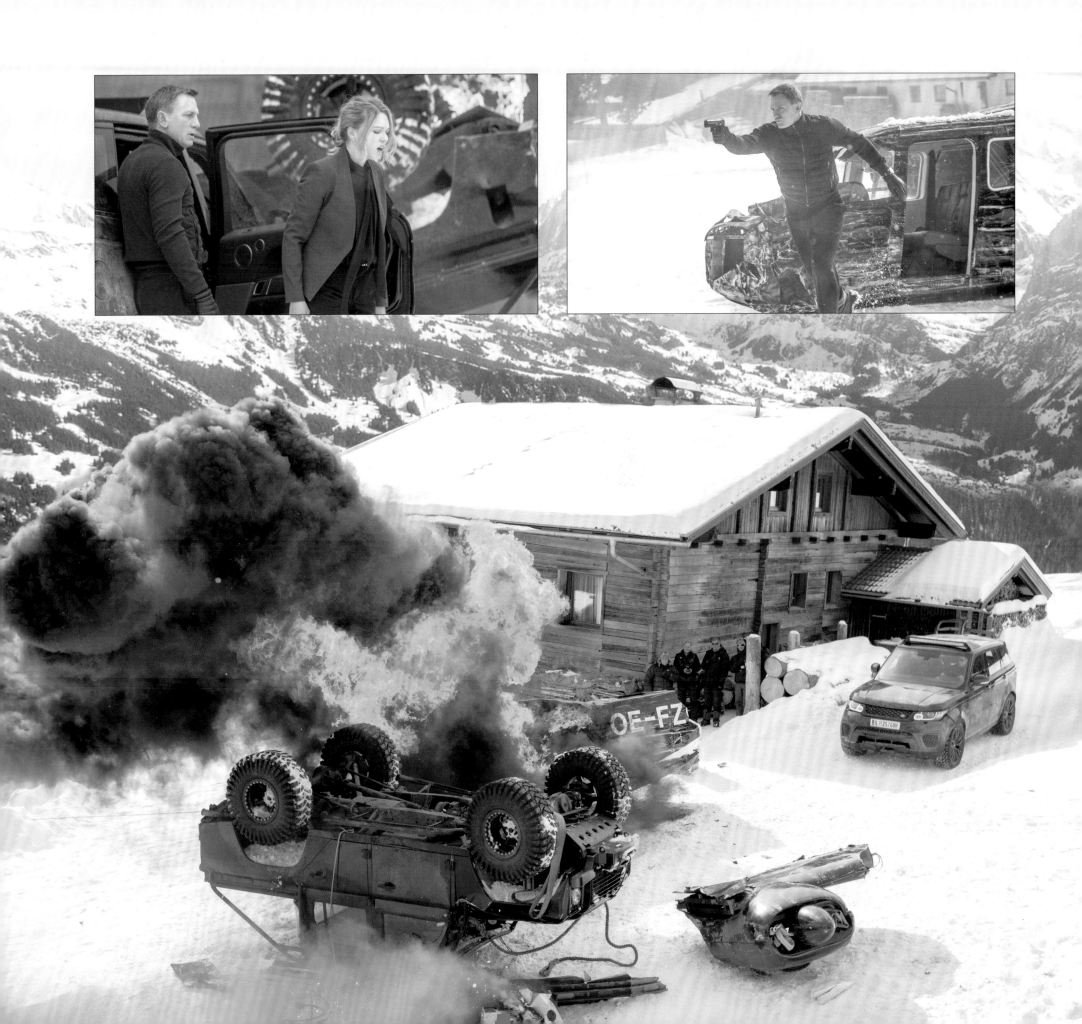

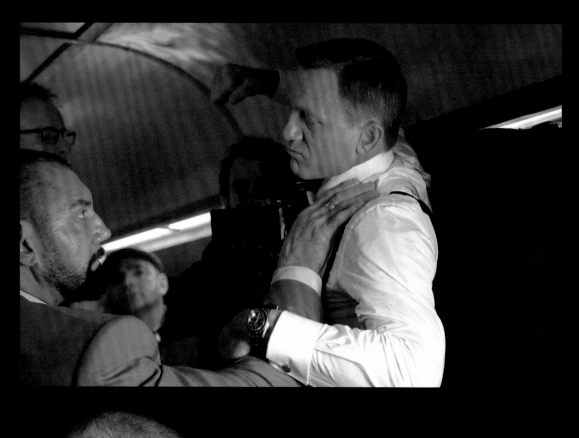

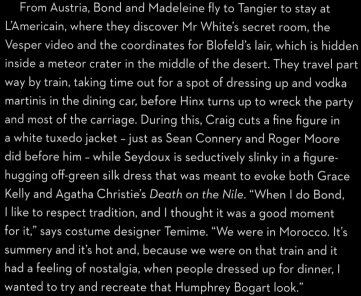

From Austria, Bond and Madeleine fly to Tangier to stay at L'Americain, where they discover Mr White's secret room, the Vesper video and the coordinates for Blofeld's lair, which is hidden inside a meteor crater in the middle of the desert. They travel part way by train, taking time out for a spot of dressing up and vodka martinis in the dining car, before Hinx turns up to wreck the party and most of the carriage. During this, Craig cuts a fine figure in a white tuxedo jacket – just as Sean Connery and Roger Moore did before him – while Seydoux is seductively slinky in a figure-hugging off-green silk dress that was meant to evoke both Grace Kelly and Agatha Christie's *Death on the Nile*. "When I do Bond, I like to respect tradition, and I thought it was a good moment for it," says costume designer Temime. "We were in Morocco. It's summery and it's hot and, because we were on that train and it had a feeling of nostalgia, when people dressed up for dinner, I wanted to try and recreate that Humphrey Bogart look."

The first day wearing the white tux, Craig plucked a red carnation from a vase on the table and slipped it into his buttonhole. Much to Temime's distress. "Daniel gave us a big fright and the whole costume department took a sharp intake of breath," she recalls, "because now we needed to have ten the same. You cannot stop the spontaneity of an actor. Then we run like maniacs to find ten [identical flowers]. Because they all had to stay the same, pristine, so we had to have artificial flowers."

"I don't remember exactly the reason I picked it up," reflects Craig. "In my head, there's an image of Connery wearing a white tux with a carnation. Although I could be completely wrong." (He's not. Connery sported the iconic look in *Goldfinger*.) "It's not the first time the costume department was pissed off with me, that's for sure. Or the last."

The train fight was also written with one eye on the past. "We talked about our favourite sequences from Bond movies," says Logan, "and one thing Sam and I loved was the Robert Shaw/Sean Connery train fight in *From Russia With Love*, which still hasn't been beaten in terms of a compressed fight sequence. Although the one in the elevator in *Diamonds Are Forever* comes very close. We wanted to do one of those, so when we realised there was a train journey, that seemed the obvious place for it. That was a tip of the hat." Adds Craig, "It was definitely reminding ourselves what the past movies were about and trying to reinvent it, so if you're a fan, you'd get the reference and if not, you'd just enjoy it, because it was a good fight."

Choreographed, once again, by Schneider, the fight begins in the dining car and decimates several carriages as Bond and Madeleine battle Hinx. "I

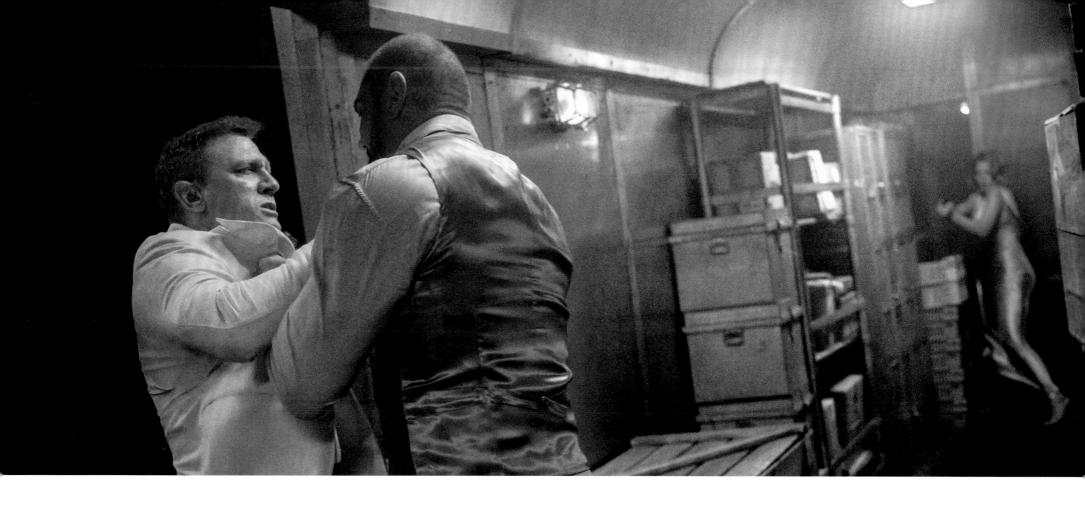

OPPOSITE: Bautista and Craig filming the fight scene on the train.

ABOVE: Bond and Madeleine battle Hinx along the train.

RIGHT: Seydoux, Bautista and Craig enjoy a break in filming.

was calling that fight 'the tornado', because behind these guys everything is destroyed," laughs Schneider. "The most complicated part was to make it big enough and believable." Schneider spent many weeks designing the sequence with a stunt double, the art department having built him a rough wooden train carriage to plot it out in. "I tried to have something different in terms of rhythm and style in each car and not have the fight repeat itself."

Helping sell the illusion were a soft set and breakaway props. "My first concern is always safety, then you have to decide what Daniel's going to do and what the stunt double's going to do. Daniel is so physical he did most of it. Daniel is always giving a thousand percent. He cannot go halfway. After one or two takes he's already sweating, because he doesn't try to preserve himself, he just goes for it, and you can see that on screen. He's good at it, too. He's very fit, he trains every day, he understands the rhythm. He understands that a fight is not just about the moves, it's also the emotional part of it, and the best way of doing that is to use the actor. We always try to keep the stunt guy to a minimum."

(Continues on page 214)

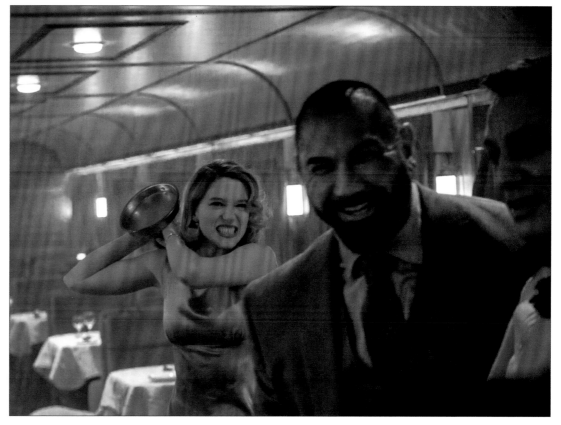

BLOFELD'S LAIR

The meteor crater inside which Blofeld has concealed his secret hideout was based on a real location production designer Gassner found during a scout to Morocco. "I saw it and said, 'This is going to be in the movie.'" However, the production wasn't able to use the real crater site, so recreated a large portion alongside it, "so it had the same light," says Gassner. "The rest was CG."

As Bond and Madeleine escape, the set was destroyed by the special effects department in one of the largest controlled explosions ever filmed. "It's definitely the biggest of my career," says special effects supervisor Corbould, who used more than 2,100 gallons of kerosene to fuel the massive blast. "It was complicated to plan and to pull off, but was more than worth it as it became another world record for a Bond production."

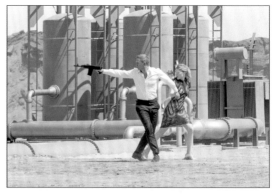
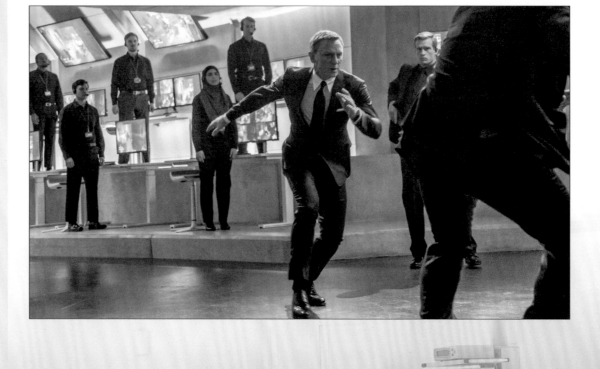

THIS PAGE: Craig, Seydoux and Waltz as Bond, Madeleine and Blofeld at Blofeld's secret lair.

RIGHT: Mendes and Craig on the set of Blofeld's lair.

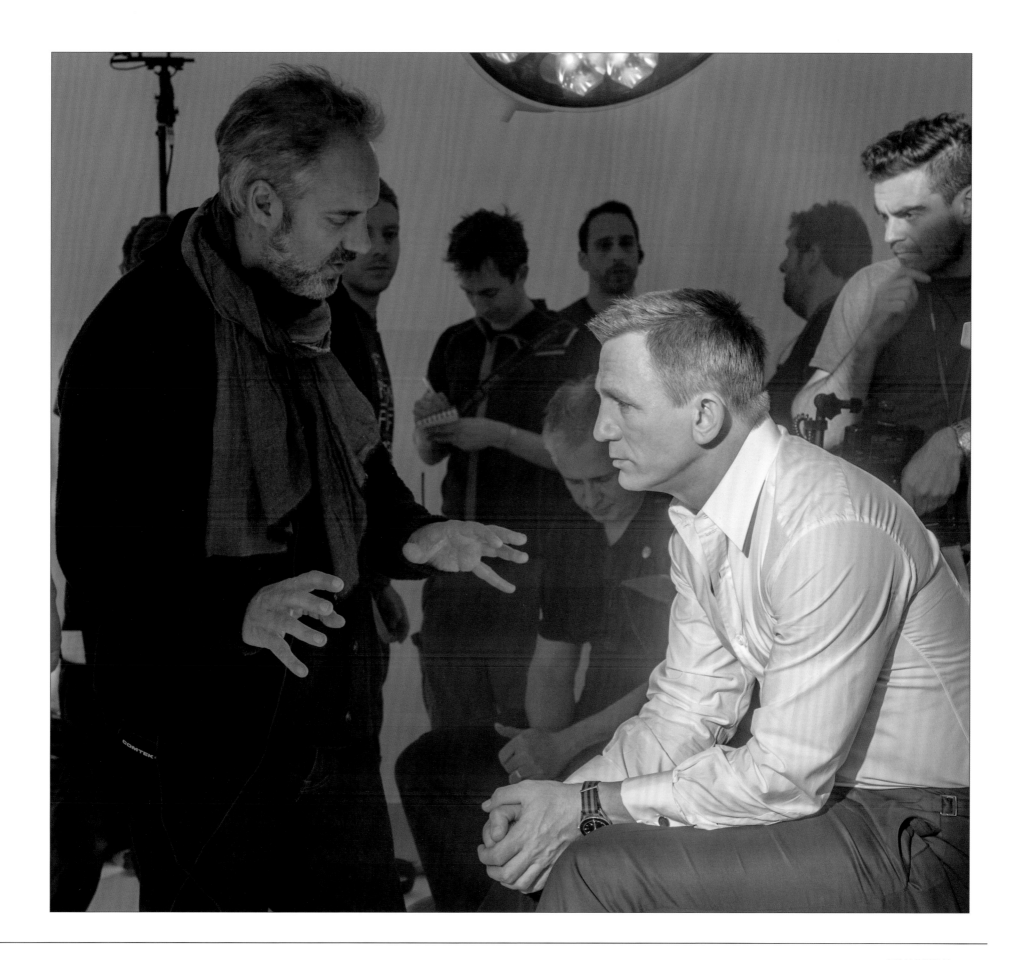

Spectre climaxes in London, with M (Ralph Fiennes), Q (Ben Whishaw), Moneypenny (Naomie Harris) and Tanner (Rory Kinnear) trying to stop C's surveillance system from coming online, Bond rescuing Madeleine from the former MI6 building in Vauxhall and a night-time boat and helicopter chase down the Thames, culminating in a crash on Westminster Bridge. "We all wanted to be back in London for the third act. We talked about Big Ben, about Battersea Power Station and the geography of London," reveals Logan. "John's last draft had a tanker full of nuclear waste crashing into London Bridge, being driven by Blofeld. Then they ran up the stairs of Big Ben and had a fight," says Wade. "The idea we brought to it was the old MI6 building that had been evacuated because of

what happened in *Skyfall* and was rigged for detonation, so we could blow that up."

"We originally had Blofeld go into the water and be presumed dead," adds Purvis. "They never found his body."

Shooting a chase at night along the Thames, involving both a high-speed river boat and a low-flying twin-engine AgustaWestland AW109 helicopter, "raised many organisational challenges" according to supervising location manager Emma Pill. For the six-night shoot the production required the support of the Port of London Authority. "The scheduling was very complicated due to the amount of events taking place in London at the time, which included the General Election, State Opening of Parliament and three weekends of Trooping the Colour,"

ABOVE: Exterior design for the CNS building by Greg Fangeaux.

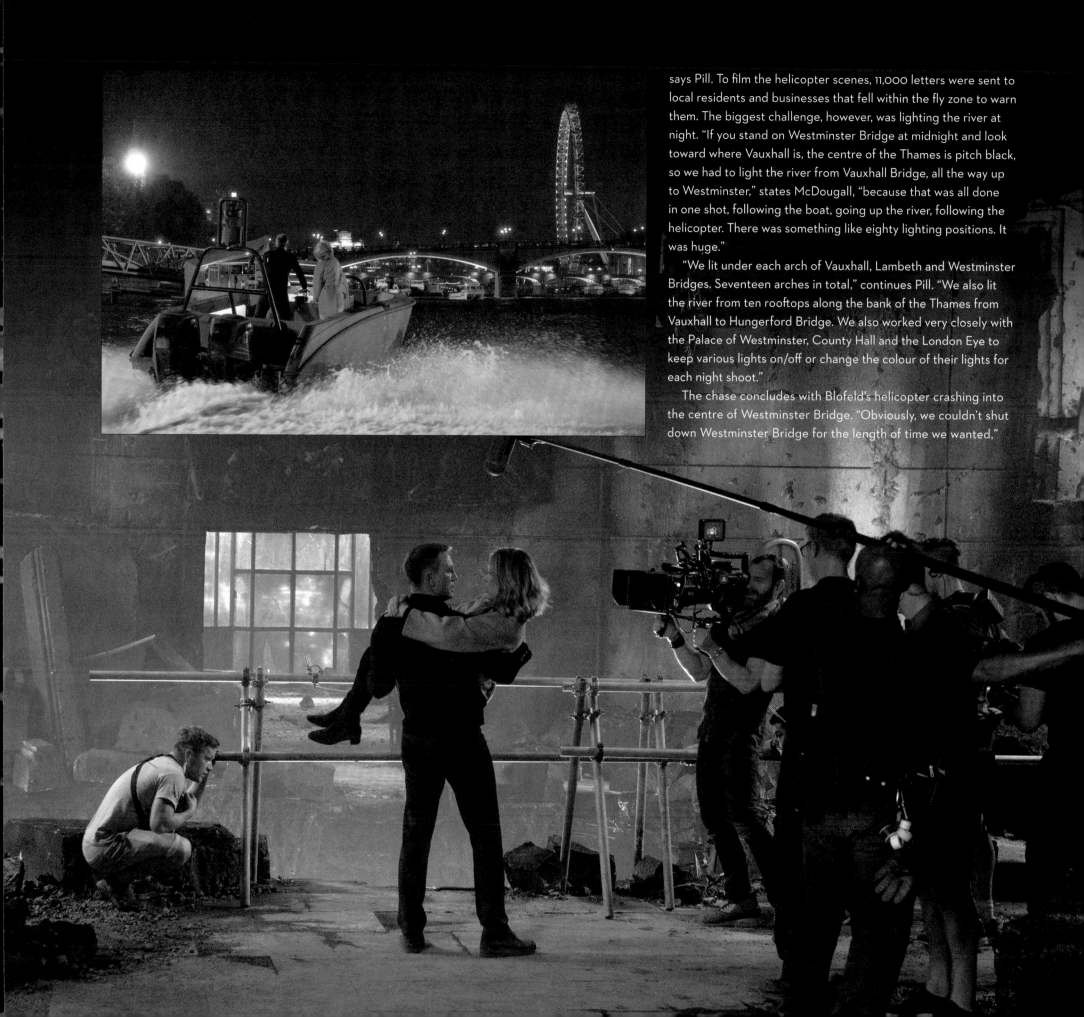

says Pill. To film the helicopter scenes, 11,000 letters were sent to local residents and businesses that fell within the fly zone to warn them. The biggest challenge, however, was lighting the river at night. "If you stand on Westminster Bridge at midnight and look toward where Vauxhall is, the centre of the Thames is pitch black, so we had to light the river from Vauxhall Bridge, all the way up to Westminster," states McDougall, "because that was all done in one shot, following the boat, going up the river, following the helicopter. There was something like eighty lighting positions. It was huge."

"We lit under each arch of Vauxhall, Lambeth and Westminster Bridges. Seventeen arches in total," continues Pill. "We also lit the river from ten rooftops along the bank of the Thames from Vauxhall to Hungerford Bridge. We also worked very closely with the Palace of Westminster, County Hall and the London Eye to keep various lights on/off or change the colour of their lights for each night shoot."

The chase concludes with Blofeld's helicopter crashing into the centre of Westminster Bridge. "Obviously, we couldn't shut down Westminster Bridge for the length of time we wanted,"

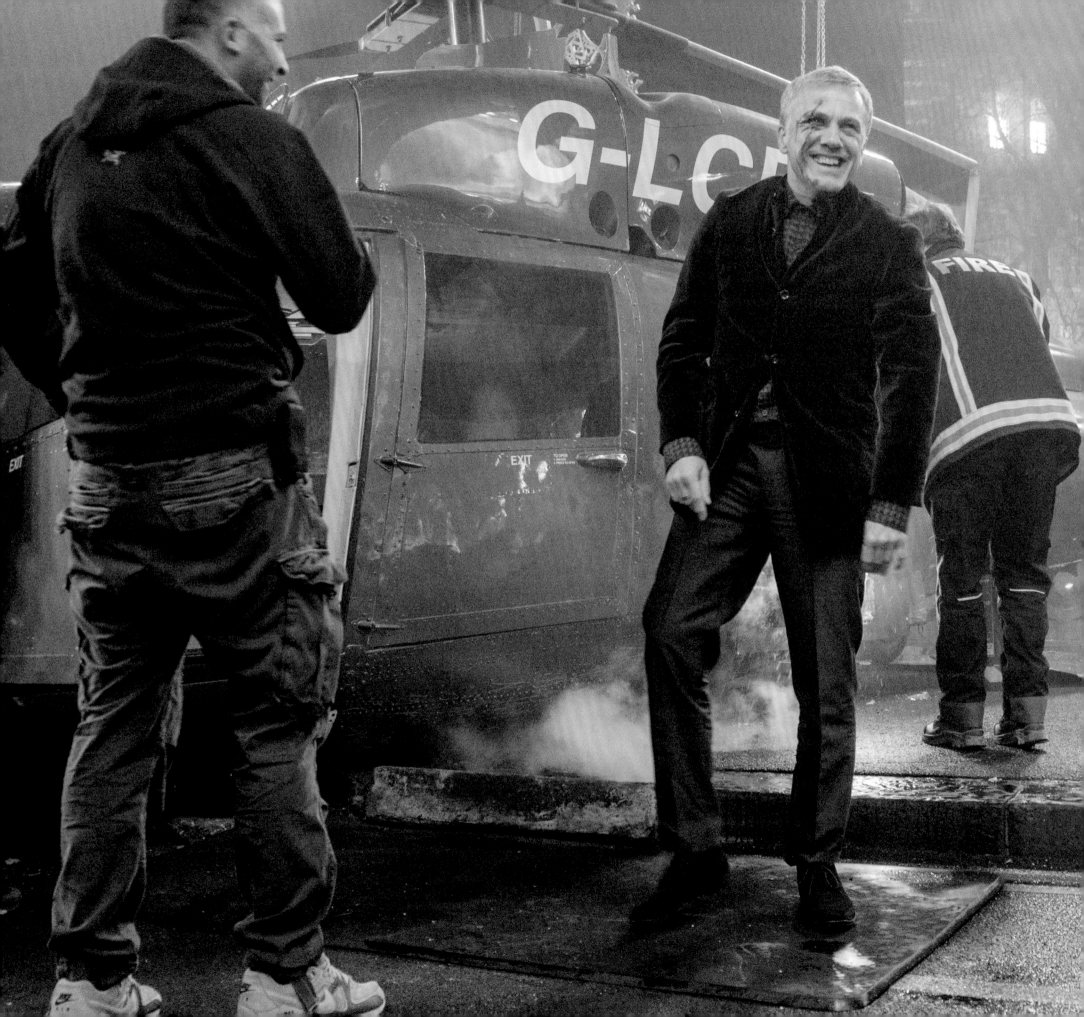

says Mendes. "We couldn't control the lighting and we couldn't put a crashed, burning helicopter on there either. We needed to do that for real on stage, then very skilfully cut back and forth between the real location and the set. When they enter onto Westminster Bridge in both directions, we shot the real bridge. We only needed to build for what happened in the middle between Bond and Blofeld."

Accordingly, Gassner designed his Westminster Bridge to fit inside the 007 Stage using forced perspective and a photo backing, while special effects took care of the helicopter and crash landing. "The bridge narrowed, so it looked like it was much longer than it was, and photo panels made it appear like there was depth to it," remembers Craig. "I love that old-fashioned in-camera trickery. There were all sorts of things going on on that bridge that gave me a big thrill, because those skills go back for as long as people have been making movies. It's the trickery of making believe."

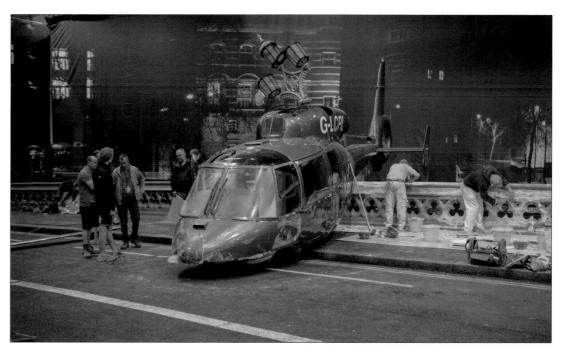

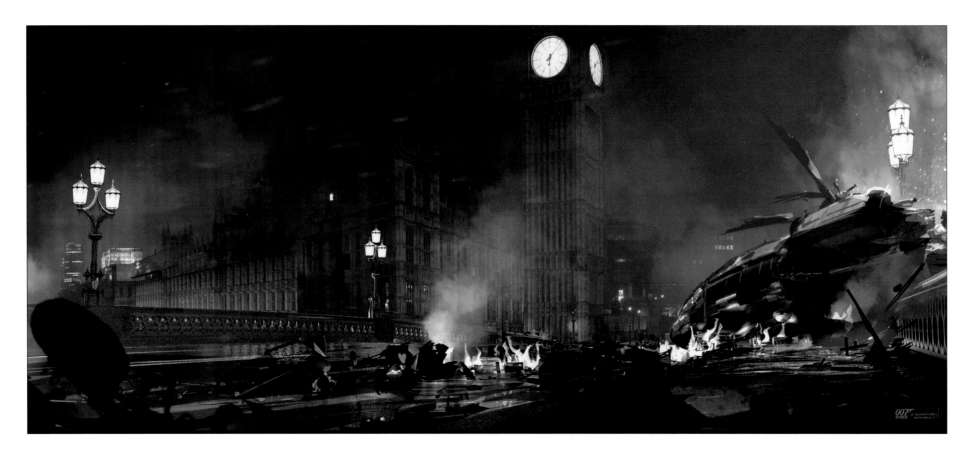

Spectre proved to be another smash hit with critics and audiences alike when it premiered on 25th October 2015, going on to gross more than $880 million worldwide. *The Guardian*'s Peter Bradshaw called it "a terrifically exciting, spectacular, almost operatically delirious 007 adventure... Deeply silly but uproariously entertaining." And once again, Craig was singled out for praise. "If this is to be Craig's last bow as 007," mused Kim Newman in *Empire*, "he'll be remembered as the man who brought Ian Fleming's grit back to one of the great British film franchises."

"Without a doubt, Daniel's my favourite Bond," says John Logan. "I grew up on Sean Connery and Roger Moore, then I read all the books and James Bond became the character Ian Fleming wrote. Daniel Craig brings that completely to life.

ABOVE: Concept art of the helicopter crash on Westminster Bridge by Kim Frederiksen.

RIGHT: Craig and Waltz flming the final confrontation between Bond and Blofeld.

OPPOSITE: Bond walks away from Blofeld, and MI6, at the end of *Spectre*.

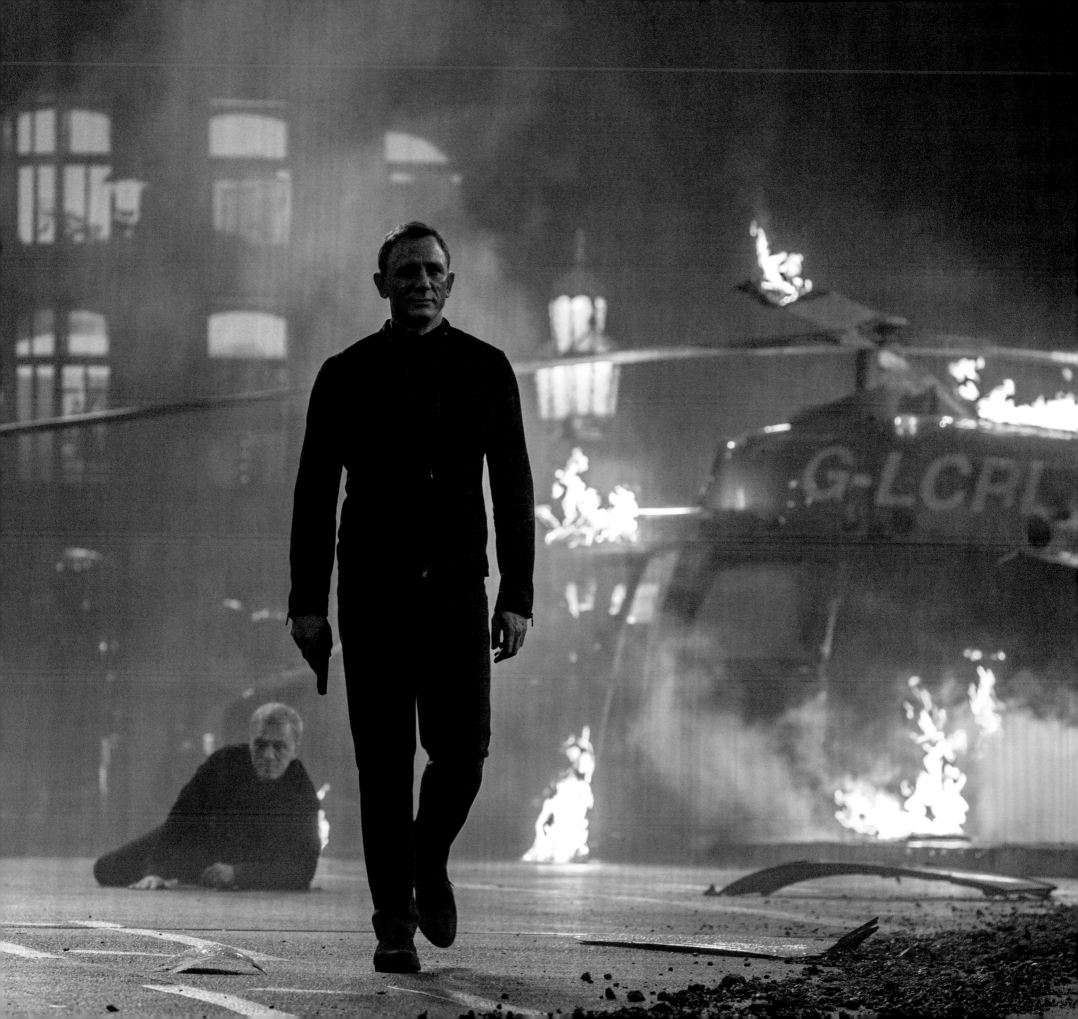

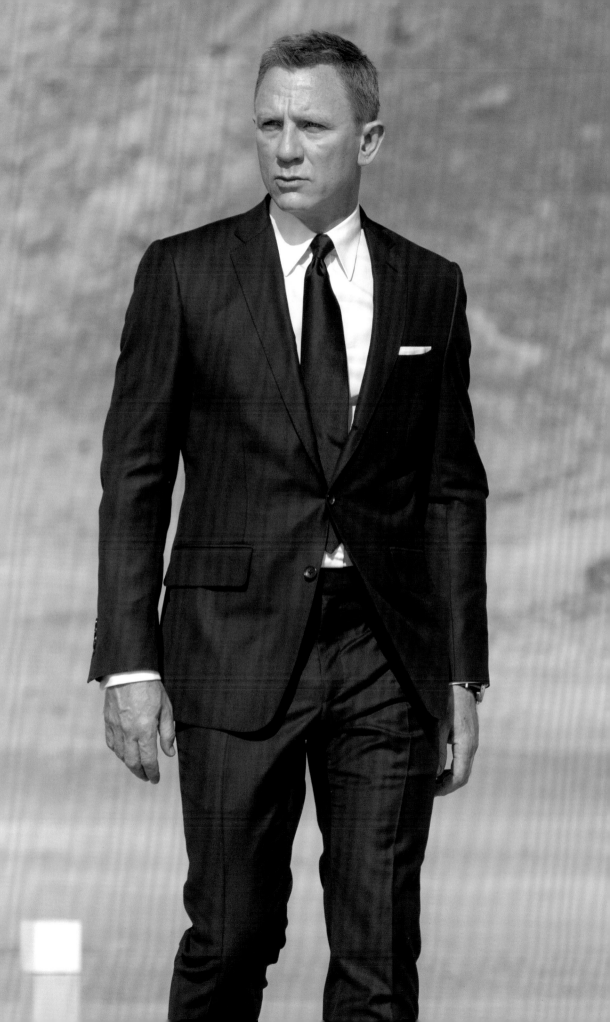

James Bond is not a superman. He has to train to do things. He gets hurt, physically and emotionally hurt, and Daniel captures that perfectly. When people punch him, he bleeds and when he's hurt emotionally, you can see it. And his eyes, those amazing eyes, are able to convey great pathos, as well as great ferocity and steely resolve. To me, he is the character Ian Fleming wrote."

For Craig, however, *Spectre* marked the end of his four-film contract. With Bond having tossed his Walther into the Thames, then driven off into the metaphorical sunset with Madeleine Swann, it felt to many that was that as far as Craig and 007 was concerned. "I felt we should round it off. We should make sure it feels like some sort of ending, because who knows," Craig recalls. "I'm always completely aware of the fact things move on quickly and if I don't do it for a couple of years somebody else is going to come along. That's a fact of life. So I wanted to make sure we at least left it with some sort of finality to it."

Then there was the fact that each film had taken its toll on Craig and his body. Craig injured his knee on 2nd February 2015, during a fight sequence with Dave Bautista. An examination showed he had ruptured his ACL and also had a torn meniscus. Initially, Craig did not have surgery, but underwent intensive physio and rehab in the hope his knee would be strong enough to get through the movie. However, in March, in Mexico, the action aggravated the knee injury, so Craig was compelled to have minor surgery to repair the meniscus, although had to wait until after filming to have the ACL operation. The crew continued filming in Mexico without him, but, incredibly, Craig was back in London two weeks later, albeit doing slightly less of his own action than before.

"They're always stressful to do, these films. They're intense to make," says Craig frankly. "And I was like, *I don't know if I can put myself through this anymore.* I love Bond, I love the franchise and loved every aspect of it – it's been one of the defining moments of my life, clearly – but you have to weigh things up a little bit, you have to go, *I don't know if my body can take this anymore. I don't know whether I can do this to me or my family.* It's not a nice phone call to make, to phone your wife and say, 'I've broken my leg.' Or my mother. Or any member of my family. So as much as I felt we had quite a lot of unfinished business in *Spectre*, that wasn't the conversation I was having in my head. The conversation in my head was self-preservation more than anything."

NO TIME TO DIE

During an interview conducted just days after he had wrapped on *Spectre*, but which was published to coincide with the film's release several months later, Craig was asked if he could imagine doing another Bond. "Now?" he answered. "I'd rather break this glass and slash my wrists. No, not at the moment. Not at all. That's fine. I'm over it at the moment. We're done. All I want to do is move on." Inevitably, on publication, Craig's "slash my wrists" comment went viral and became headline news around the world. However, context was key to understanding his response. Coming off the back of *Spectre*'s demanding eight-month-long shoot, Craig was exhausted and nursing a torn ACL, so, in that moment, the idea of returning to the role that had made him a global superstar was anathema to him. "Sam [Mendes] put it very eloquently, more eloquently than I obviously did in that quote," Craig told America's *Today* programme shortly after. "If you're 200 yards from the end of a marathon and someone comes running up to you and says, are you going to run another marathon? There's two words you use! So that's really what that was about. I had massive amounts of fun making this film. Probably more fun on this film than on all the others put together. But, at the moment, I don't want to think about it. I want to think about other things…"

It seemed that time had well and truly run out on Craig when almost two years went by without any news of another Bond movie in the works. "I think I felt that was enough," he admits. However, neither Michael G. Wilson nor Barbara Broccoli were willing to give up on their star just yet. "He took some time," says Broccoli, "and, at one point, I said – and I didn't realise it meant anything to him until many, many months later – 'The story is not finished with you.' And I really meant that. It wasn't just wanting to get him back. I didn't feel he'd completed his cycle." Eventually, Craig agreed to return, and in August 2017 signed on for his fifth and final Bond. "Enough time passed to get some distance," he says. "I just said, 'If we do it, we need to do something that really puts a button on the whole thing, so we finish the story.'"

Not only did Craig want to go out with a bang, he wanted his Bond to die at the end. It was an idea the actor had been hatching as far back as 2006. "I'm in Berlin with Barbara in the back of a limo, having just been to the premiere of *Casino Royale*, and I say to her, 'How many more have I got to do of these?' Because I'm notorious for never reading my contracts; it's the job that's interesting to me. She says, 'Four in total.' And I said, 'I don't mean to be ungrateful, but it seems like a mountain to climb. If I do all of them, can I kill him off at the end?' Without skipping a beat, she said, 'Yes.' It's not that I wanted to kill James Bond, because I know he'll survive long after me, but if I was going to do this, I wanted to be able to finish the story, to go, 'That's it. I'm no longer that.' By killing him off, I can walk away and never go back. It's final. Then, when the new Bond is picked, it's a fresh start, a whole new ball game and it has nothing to do with me. It was self-preservation, to be perfectly honest, because I knew the impact it was going to have on my life. And Barbara stuck to her promise."

Once again, franchise stalwarts Purvis and Wade were entrusted with the task of writing the script for what would be the twenty-fifth official James Bond adventure and their seventh. As such, the pair were keen to try something a little different, "a bit experimental," this time around. "We wanted to do a Bond that went back to basics and didn't globetrot as much," says Wade. "Our original idea was to try and set a film all in one place, like *Key Largo*. It was a very ambitious undertaking, but it felt right to go leaner." Their first script draft picked up from *Spectre* – as does the finished film – with Bond having retired from active service and living in Jamaica, where trouble comes calling in the shape of a new 007, precipitating a chain of events that would eventually lead Bond to Cuba. Once again, Fleming was a major influence. "We wanted to do the poison garden from the novel *You Only Live Twice*," Wade continues. "We had this poison garden in the silos where supposedly the Cuban missile crisis weapons were housed, and there was going to be a hurricane. It was a way of getting big, original action into the movie without it feeling like endless explosions."

Purvis and Wade delivered their first draft in early December 2017, but, according to the latter, there was some concern about

RIGHT: Daniel Craig and Rami Malek shooting the final confrontation between James Bond and Safin on the poison garden set.

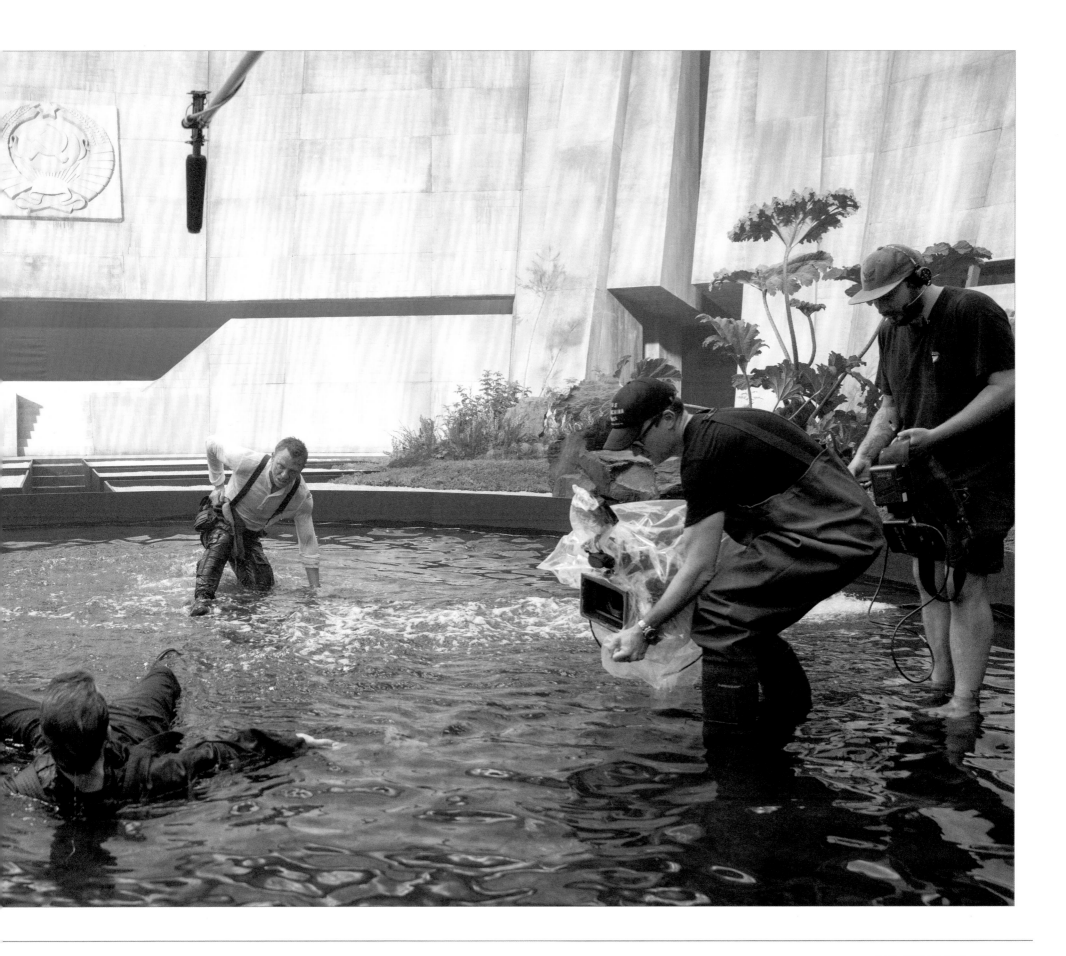

the lack of locations the film visited. "There was a lot of debate about going to other places, trying to fulfil the expectations people have of a Bond movie," notes Purvis. "You have a number of exotic locations." So the pair worked up a new treatment that added Pompeii to Jamaica and Cuba, relocating the poison garden to an island off the coast of Japan.

With Sam Mendes ruling himself out of returning for a third film, *Slumdog Millionaire* Oscar®-winner Danny Boyle was announced as director of the still untitled *Bond 25* in January 2018. Within days of signing on, Boyle, who had presided over the Opening Ceremony of the 2012 London Olympics that featured Craig's Bond escorting Her Majesty The Queen from Buckingham Palace to the Olympic Stadium by helicopter, drafted in long-time collaborator John Hodge, screenwriter of *Shallow Grave* and *Trainspotting*. Hodge's script began in a similar fashion to Purvis and Wade's, with Bond retired, this time in Majorca, where trouble again comes calling. The story took in Namibia and Russia before going into outer space with a giant rocket. "It had a very different tone. It felt like a pastiche in a way," says Wade. "It also had this idea that M had ordered a hit on Bond, which didn't ring true."

In their version, Bond still died at the end, but Boyle and Hodge created a new love interest, Maria, although the producers insisted the character be changed to Madeleine Swann to continue the love story from *Spectre*. "More by accident than design, Mr White ended up playing major parts in nearly all the films. He became Bond's nemesis in a subtle way," says Craig, "and fortunately or unfortunately, who's Bond going to fall in love with? Someone who understands the terrible risk and the cost of the profession he's in – the daughter of an assassin. They have an unspoken language. Although in *Spectre* it's not love at first sight. So bringing Léa back was a very easy decision, because we knew that she gives so much on screen and it's very emotional and we needed that."

Then, in August 2018, less than three months before the start of principal photography, with sets already being built – a giant rocket on the 007 Stage at Pinewood and a Russian mining town in the wilds of Calgary – Boyle exited the film due to unresolved "creative differences". "We all spent a lot of time developing a storyline," reveals Broccoli, "and got to a point where we looked at what we had and jointly decided that the film he wanted to make and the film we wanted to make were not the same. And he agreed. Sometimes it happens. Better we all decided early on than going through a long, painful process." The producers also decided Hodge's script "was not reflective of where we wanted to go with the twenty-fifth chapter," and went back to Purvis and Wade's original, which not only included Madeleine but gave her

and Bond a daughter.

Boyle's departure left the production in limbo. Wilson, Broccoli and Craig took the decision to keep the crew on while a replacement was found. The producers quickly settled upon American-born writer-director Cary Joji Fukunaga, whose blistering 2009 Spanish-language debut *Sin Nombre* put him on Hollywood's radar. He followed it with an atmospheric period adaptation (*Jane Eyre*), a child-soldier thriller (*Beasts of No Nation*), a mind-bending Netflix series (*Maniac*) and the entire first season of ground-breaking HBO show *True Detective*, demonstrating remarkable range and versatility. Fukunaga also happened to be a Bond fan and had met with Broccoli in 2012, following the release of *Spectre*, to express his interest in directing one.

LEFT: Bond and Madeleine (Léa Seydoux) in love.

BELOW: Director Cary Fukunaga and Craig on the Cuba set, constructed on the north lot at Pinewood.

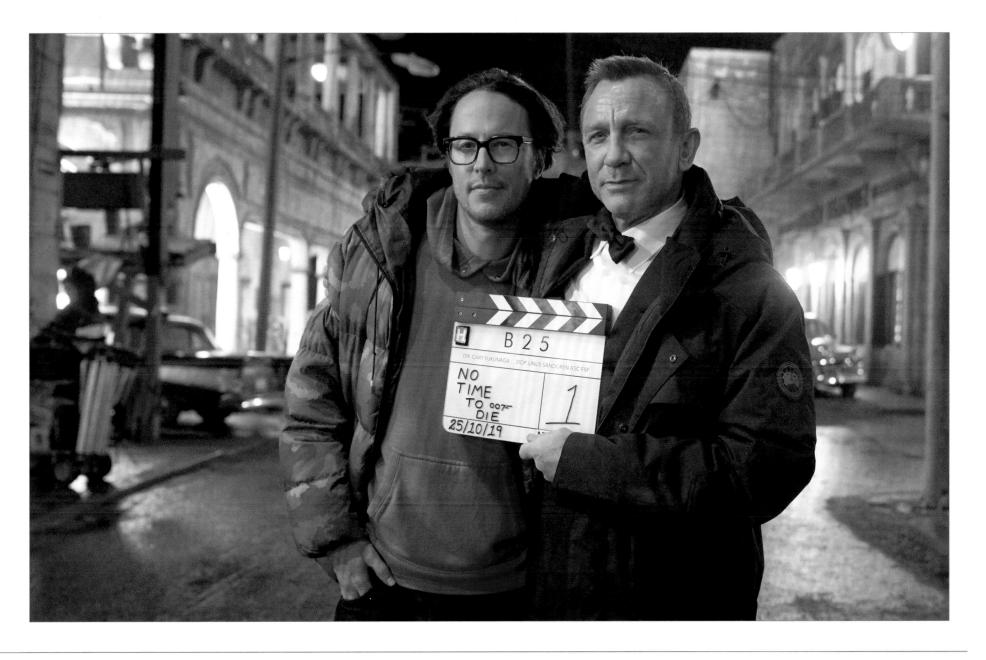

"We were lucky he was free," says Craig. "We were scouting around for a director to come and take on something which I'm pretty sure is very attractive, but also very daunting. It's a big machine. He's a writer as well, which is what we needed, because we had a lot of ideas we wanted to use and we needed someone who could come in and help us collate it. We had the ending. We needed to work backwards from that and make it whole. So his talent for writing was very important and I was very impressed by the fact he's got a very strong visual style. We needed the movie to look different, feel different and have a different aesthetic than the others, otherwise you're just watching the same movie over and over again."

Funkunaga is the first American to direct a Bond film. "Cary's

films are incredible and he is able to work in any kind of genre," says Wilson, "and he's also a wonderful writer. He is great with characters and with actors. Cary brings a level of complexity to everything he does, but is also able to make very complicated things understandable and that fitted so well with what we wanted from this story."

Fukunaga's introduction to the Bond stories came when he went to watch Roger Moore's final appearance as 007 in *A View To A Kill* (1985). "I remember loving the finale on the Golden Gate Bridge," he recalls. "It seemed liked Bond had crossed over into my world. It was just a cool film with Roger Moore kicking ass."

Like the producers, Fukunaga was particularly excited by Bond's emotional journey across the preceding films. "When

BELOW: Malek and Fukunaga on location in Windsor Great Park, standing in for a Norwegian forest.

ABOVE: Craig, Fukunaga and Lashana Lynch on the Poison Island set, constructed on the 007 Stage at Pinewood.

you're coming after *Casino*, *Quantum*, *Skyfall* and *Spectre*, you have a good idea of the arc that Bond's character has been going through," he explains. "In a way, the Bond films live very much in their own universe. But the character still has to feel like he's of now. That was part of the very first conversations we had together with the producers and with Daniel. You also want to bring something new to the story and also you want to honour all of the Bond films in terms of leitmotifs and expectations."

Fukunaga hit the ground running. His most immediate concern was reworking the existing script. "It was like triage, in a way," he

reveals. "Barbara and Michael had ideas of what they wanted the film to be, themes they wanted, characters they were interested in having, ideas they thought were important – these were the same things Danny had to work with. It was a question of what didn't work in the previous relationship and what could I bring in terms of my sensibilities to the project. Over the next couple of months we re-outlined the story and came up with the script."

From mid-September to mid-November 2018, Fukunaga sat with Purvis and Wade at Eon's London office and hashed out a new treatment. "There were four things that were given to me.

Bond dies. Child. Madeleine Swann. Female 007. Figure out how to make it work," Fukunaga recalls. "There was no villain, no evil device, no plot, just those characters. I never saw the Boyle/Hodge script, I just saw a treatment, and that was on purpose. I didn't want to be too heavily influenced. We wrote a script over December into Christmas. I did my pass over Christmas, then gave it to Daniel right around New Year's. I wasn't sure whether he'd like it or not. It turned out he did, so we all flew out to New York, he gave us notes and we started making changes." The script also saw the unsurprising return of Ernst Stavro Blofeld, who had been captured at the end of *Spectre*. "At one point Blofeld was the main villain," says Purvis. "Partly to do with it being Daniel's last film. It

was a case of tying up what wasn't tied up in *Spectre*."

Craig was full of ideas and suggestions. "He gets the first draft and says, 'Great story. What is my character actually doing? Where is Bond in this story? How is Bond discovering things? How is Bond pushing the story forward?'" notes Fukunaga. "In a [typical] Bond film, it's not like he's going to change. *Casino* is the only film you saw a different Bond from beginning to end, because it's an origin story. The rest, he's Bond. But with this one, there was an opportunity for change, for discovery, because of the child. It may not be a huge change, but it's significant enough to give up his life. So it's about these two people who are in love, but become separated, because of SPECTRE and Blofeld, and once they're

BELOW: Bond, Madeleine and their daughter, Mathilde (Lisa-Dorah Sonnet).

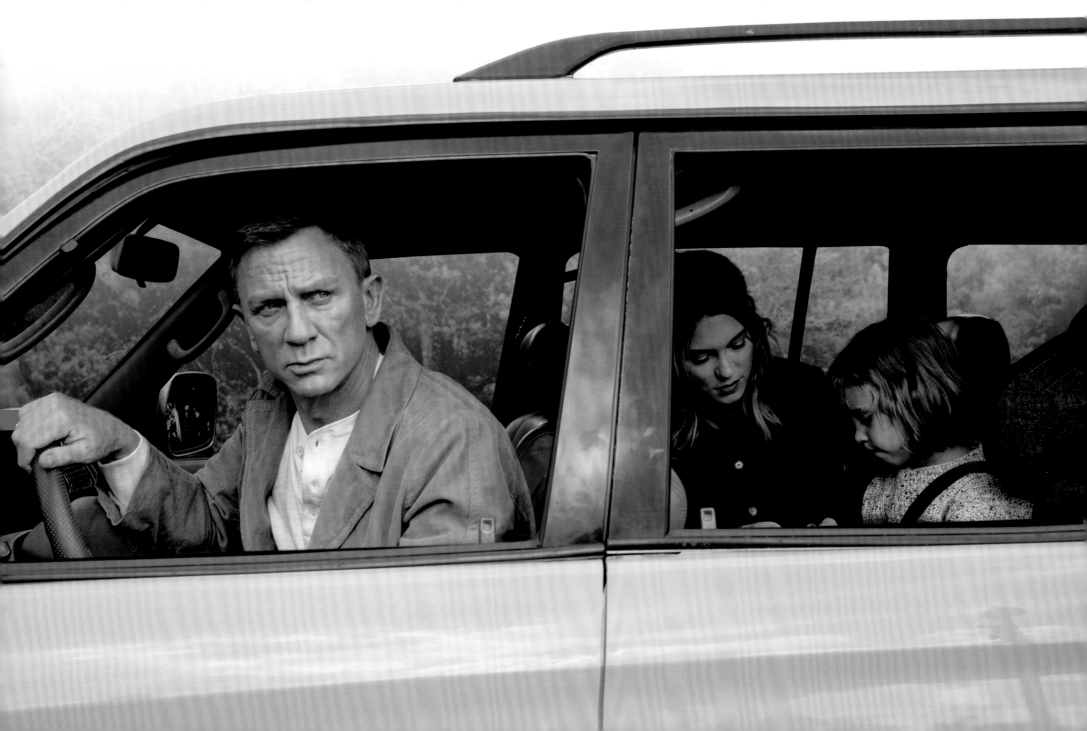

apart, what is the trajectory that throws them back together?"

Of the four things that needed to be included in the script, Madeleine was, insists Fukunaga, the most challenging. "If you want a story where Bond dies and it doesn't feel like it's a plot point, then he has to be dying not only saving the world, but also for something personal," he explains. "If it's for something personal, then that relationship with Madeleine has to work, has to be believable and [the audience] have to care for her."

To flesh Madeleine out, Fukunaga latched on to the scene in *Spectre* in which she tells Bond about a man who came to kill her father, SPECTRE assassin Mr White, when she was a twelve. Fukunaga used that to create an entire backstory that resulted in the opening flashback in which we are introduced to the film's main villain, Safin (Rami Malek), who saves young Madeleine from drowning, an unexpected act of kindness that he holds over her, "and therefore she's always indebted to him," Fukunaga explains. "To play that trope of a woman with a past, similar to Vesper Lynd, which might cause her to betray Bond. Not that she ever does. It's a red herring, but all of this was an attempt to not only make her a real person, but give their story some stakes, some history."

THIS PAGE: The man in the Noh mask pursues the young Madeleine onto a frozen lake outside her house in Norway.

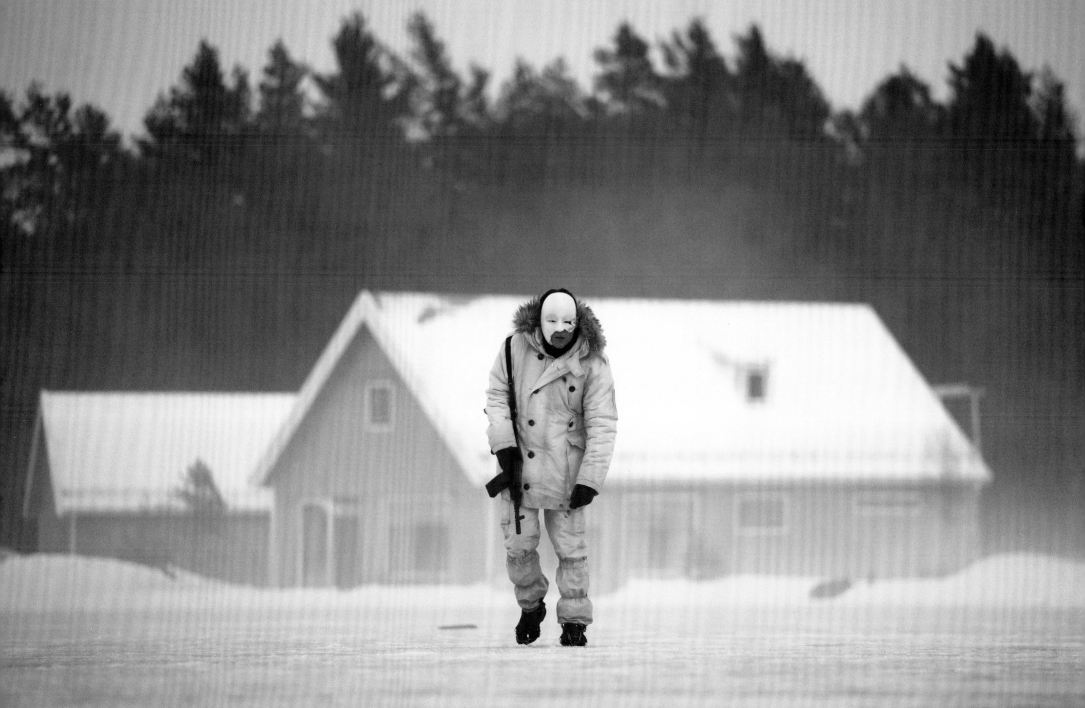

THIS PAGE: The man in the Noh mask pursues the young Madeleine onto a frozen lake outside her house in Norway.

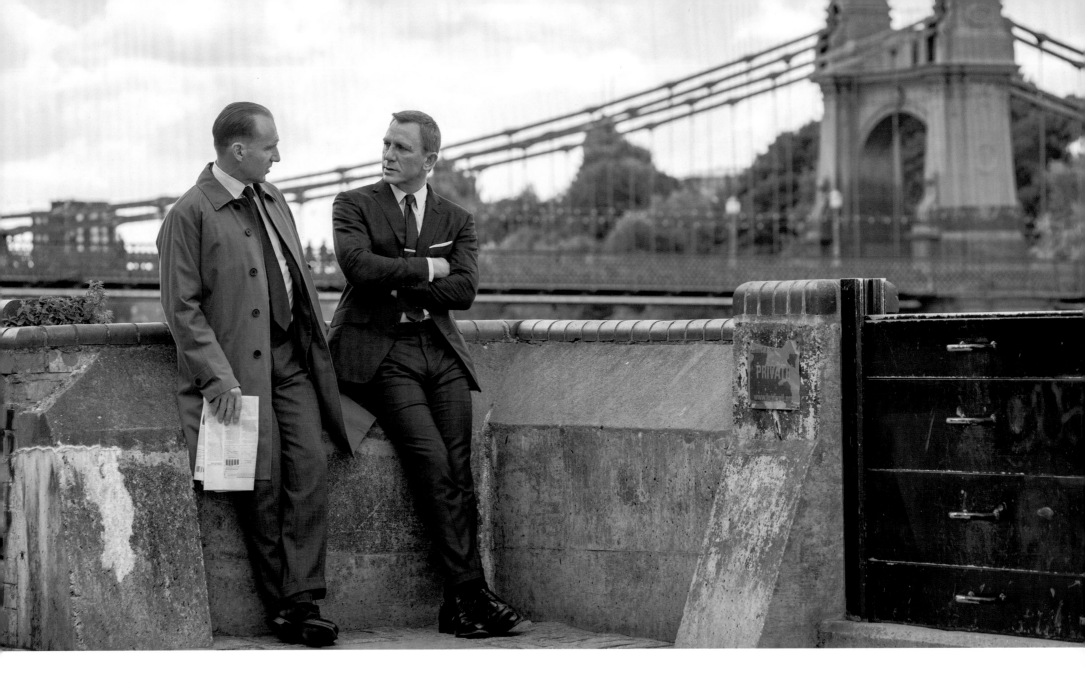

"At the end of *Spectre*, Madeleine is happy she's with Bond, and we think they are united for the best," says Seydoux. "But we find out they have problems to solve, and in *No Time To Die* we learn more about their initimacy, in a way. Cary wanted Madeleine to be more accessible and approachable this time around. He wanted to explore the relationship she has with Bond and it's a new aspect of the character that we see on screen."

With Fukunaga deep in pre-production, he enlisted the help of *Contagion* screenwriter Scott Z. Burns to implement the first round of changes, but "all we did was get deep into logic and pulled apart things that were working and ended up with a lot of different pieces," says Fukunaga. In any event, Burns was only available for six weeks due to a prior directing commitment, so

Craig suggested *Fleabag* creator Phoebe Waller-Bridge, whose darkly comic TV show *Killing Eve* he felt had the requisite mix of thrills and humour for Bond. "I was a big fan of hers. I'd loved *Fleabag*," says Broccoli, "and she's an extraordinary talent. She is so inventive. She brought a fresh approach, a female approach, and a certain type of very British wit."

"Phoebe is an amazing writer," concurs Fukunaga. "I wish we'd had her for more time than we did. She was doing her show in New York, prepping a new show in London, but she was able to come in and sprinkle some humour and rework some of the more dramatic scenes to add stronger character voices."

"They said they were open to any wild ideas, but to bring some wit when I can and just to go for it and not be afraid. To

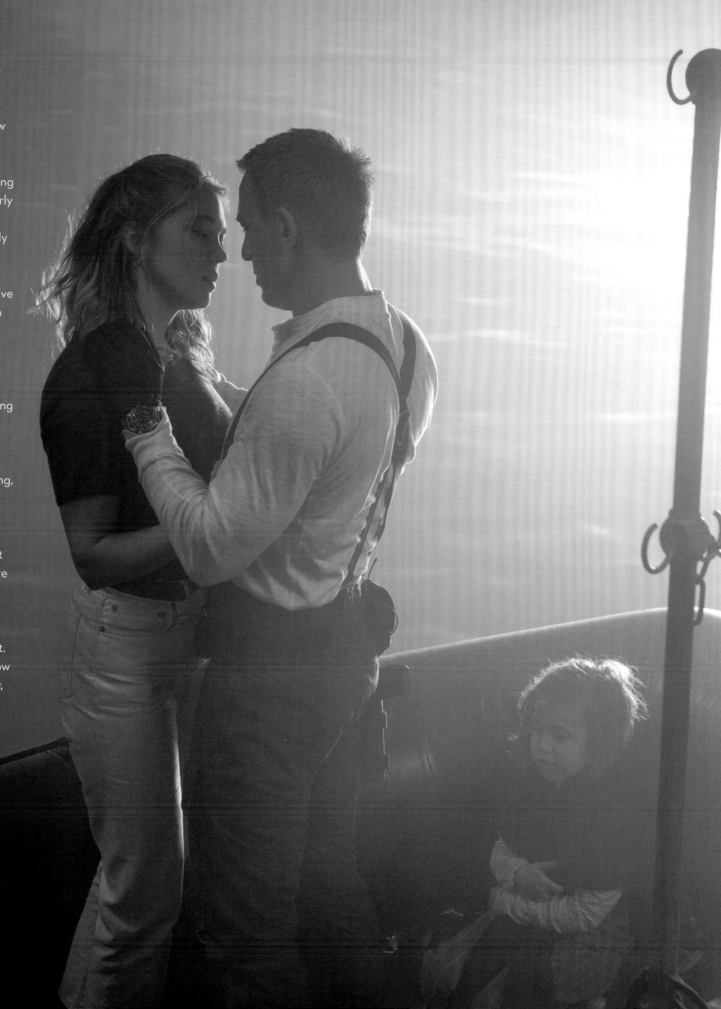

be truthful, funny and frightening all at the same time," reveals Waller-Bridge. "I started with the opening with Madeleine and Bond in Italy and I remember them being very encouraging, to allow it to have speed and wit and humour that felt dangerous and modern. Then, when we started talking about the bigger themes, I felt I could bring *anything* to it, fun, wit, but also depth. I particularly enjoyed working on the M and Bond scenes, because that was when the theme of legacy really came through. To be able to write these two incredibly masculine, proud men in moments of vulnerability was exciting, not only because they've got history in the films, but because they have an alpha-off every time they're together."

Legacy was key to *No Time To Die* as *Bond 25* was titled in August 2019: be it Bond living on through his and Madeleine's daughter, Mathilde (Lisa-Dorah Sonnet), M's obsession with his standing and reputation, Safin's desire to live up to his parents' legacy and poison millions in order to avenge their murder at Blofeld's hands, or Craig wanting to sign off as Bond in the most entertaining, engaging and emotional way possible.

"Daniel always wanted it to feel truthful, but also have levity, so he could have fun," reveals Waller-Bridge. "He's such a brilliant person to get a steer from. Some of the most exciting days were really early on when I would go to his apartment in New York and read bits of the current script and talk about where he wanted to go with the character and the things he felt passionate about. He knows the character so well, you can just throw loads of things at him and he will instinctively say,

THIS PAGE: Bond with Madeleine and Mathilde in the submarine pen on Poison Island.

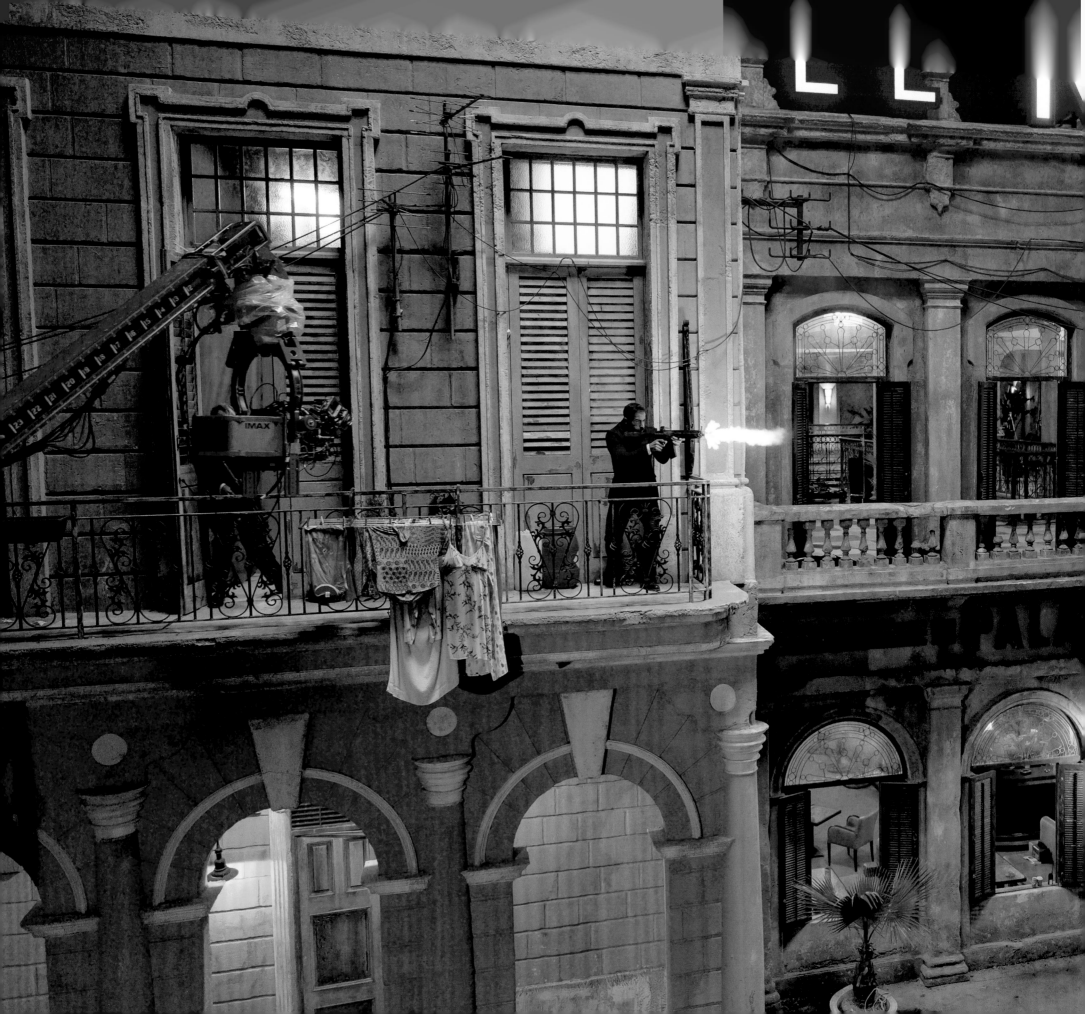

'That doesn't feel right. That feels right.' You could find your way through a scene that way, just following his beacon of, 'This feels like the right direction,' or, 'Get the hell out of there, Phoebe. I'm not interested in that stuff at all.' It's not like this is a character that was easy for him to let go of either. He wanted to do right by him, so it kind of raised everybody's game."

Waller-Bridge had no idea that the film ended with Bond dying when she read the script, such as it was, the first time. "I gasped out loud," she says. "In some ways, it felt like the bravest thing to do with the character and also the maddest thing to do, because we all love him so much. I think it is testament to the instincts of the producers and Daniel. Michael and Barbara were saying, 'How do we end this glorious reign of Daniel's?' and to them it felt inevitable. But I was completely blown apart by it, so to speak. Then the other surprise, the daughter, was completely unexpected and yet totally inevitable at the same time."

The script continued to evolve throughout pre-production, with production designer Mark Tildesley having to design sets without ever having a complete version to work with. "We didn't have a lot of time to think about things, which, in a design sense, is quite nice, because it catapults you into making decisions quickly," says Tildesley. "Most of it has changed completely, so we had to rethink and rework it. We had Phoebe, who's fantastic and saved our bacon, and we managed to pull something together. But it wasn't easy. It was 'wet paint', as we call it, the whole time."

In the end, Tildesley – another long-time Boyle collaborator who remained on board after his departure – and his team of art directors, concept artists, draftsmen and model makers oversaw the design and construction of around sixty sets at Pinewood, on the back lot, as well as on location in Norway, Jamaica, Italy and the UK.

"Everybody was up against it," avers Craig. "Certainly the designers and set dressers and construction had such a lot of work to do, because a lot of things were changing one day to the next, and it was very fluid. We'd say to Mark and his team, 'We need to shoot on that set next week,' and that set was not built or it wasn't quite ready. It's not just getting the set built, either, it's how detailed and how beautiful they are. All that work that goes on in the last couple of days to make them look real. They were Titans, those people, Titans. They did an incredible job."

LEFT: Shooting a gunfight on the Cuba set.

Cameras rolled on *No Time To Die* on 25th March 2019, with a pre-shoot in Norway, where the pre-credit flashback involving twelve-year-old Madeleine (Coline Défaud) and Safin was filmed. Production then moved to Port Antonio, Jamaica for the official start of principal photography on 28th April, returning to the island that featured in Bond's very first cinematic adventure, *Dr. No* (1962).

In a secluded spot an hour-and-a-half east of Ian Fleming's former home, GoldenEye, and surrounded on three sides by lush greenery, production designer Mark Tildesley designed a single-storey beach house for Bond. It's in Jamaica that Bond is visited, first by his old friend, CIA agent Felix Leiter (Jeffrey Wright), asking for a favour on behalf of the US Government, then by

Lashana Lynch's Nomi, a female MI6 agent, who, it's later revealed, has inherited his "007" designation and who warns him, in no uncertain terms, to stay retired.

As the production filmed in Jamaica, the script continued to be refined. "I brought in one of my story editors from *Maniac* and we re-outlined the rest of the film," reveals Funkunaga. "I gave that outline to Phoebe and I said, 'Here's what we're doing. I need you to write these scenes and I'm going to work on the third act.'"

"There are ideas that come about very early on. I've been working on *No Time To Die* for nearly four years now and there were lots of different ideas that came and went and some of it stuck," says Craig of the script development process. "The through line of the story is family and love, plus the fact we

BELOW: Bond and Felix Leiter (Jeffrey Wright) discuss a job in a Jamaican nightclub.

RIGHT: Bond at home in Jamaica.

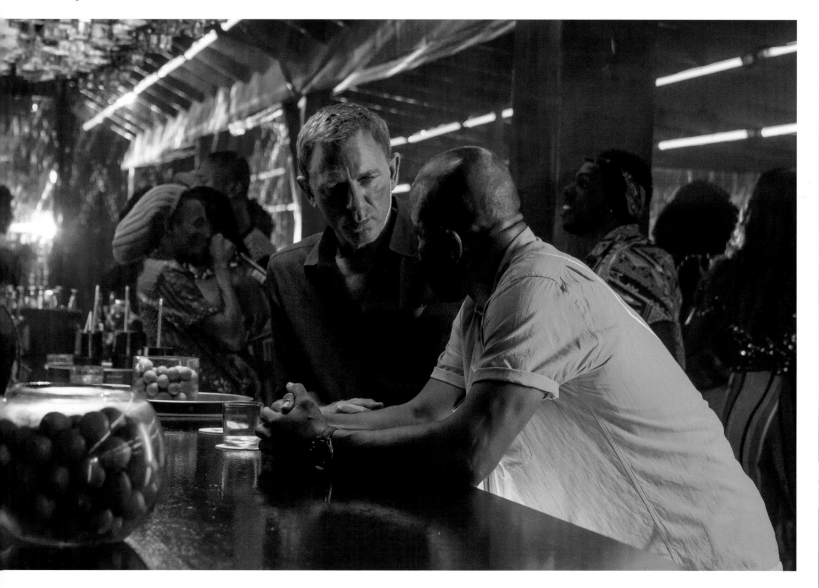

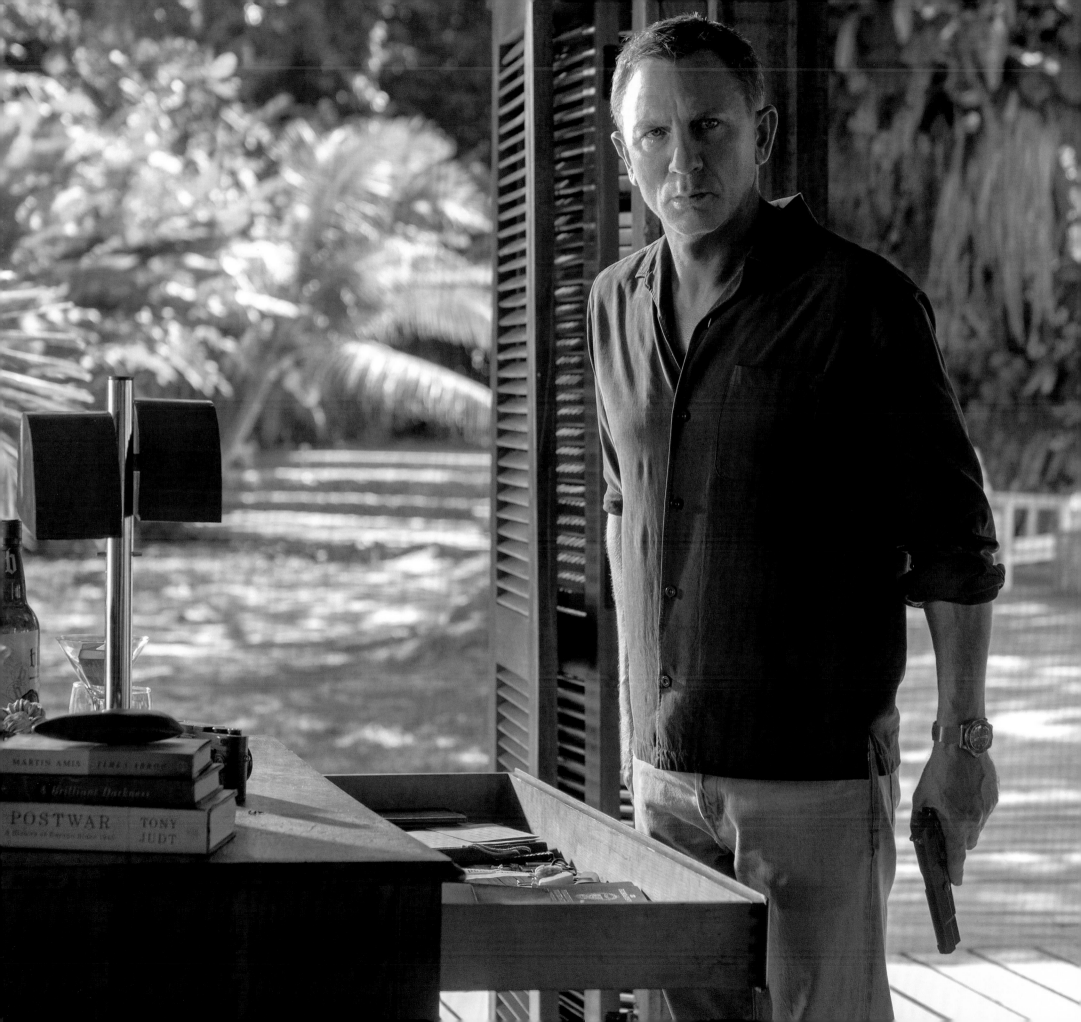

had an end and we knew where we wanted to get to, so it was about hanging the film off that. It's a massive collaborative effort with all of us, with the writers, with Cary, and I'm involved. Most nights, after filming, we would be in Cary's office just bashing out scenes to try and finesse the story. That was the headline really: make it better. We all input into it in varying ways. The only reason I want to get involved is because I want it to be the best it can be, and I tend not to shut up. Cary is incredibly open to it and a hell of a collaborator, so when we figured things out, it was really very, very satisfying."

On the penultimate day in Jamaica, the production suffered yet another major setback when Craig slipped while filming on the waterfront at Banana Wharf, tearing the tendons in his left ankle. "I wasn't particularly running fast, [but] I was in dress shoes," he explains, "which was part of the problem, they're hardly built for sprinting – and I slipped. I went down. I know my body, and I know when tendons snap, and I snapped a couple of tendons."

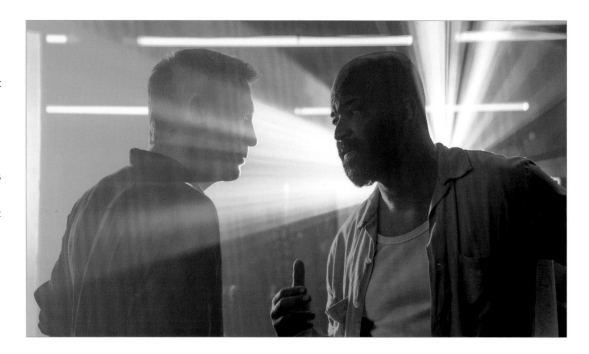

Although Craig had injured himself on all four previous Bonds, this time it required immediate surgery, followed by twelve weeks rest, during which he was unable to do anything physical – virtually impossible when you're James Bond. "You have to go through recovery and psychologically it's really, really difficult, because it takes all your confidence away and Bond is about confidence," he states. "Bond doesn't walk into a room. He never walks into a room. He *strides* into a room and *strides* out of a room, and if he's not striding out of a room, he's jumping out the window! That's every day on a film like this. You're constantly in motion. So, it's just a fact, something will happen. If you play a sport, you're going to get injured. When I do Bond, I know I'm going to get injured. It's *how* I'm going to get injured and then *how* I'm going to deal with it."

As a result of Craig's injury, *No Time To Die*'s release date was pushed back from February to April 2020 and the schedule revamped. "We never really shut down," notes Fukunaga, who was forced to shoot around the actor while he was recuperating, with filming extended by three months to late October. "Instead we had to keep moving forward, shooting things without Daniel. It changed how we could shoot things. Most of the film really got shot in August, September and October."

OPPSOITE TOP: Bond agrees to do a favour for the CIA.

OPPOSITE BOTTOM: Valdo and Bond escape Cuba in a sea-plane. Filmed on location at Kingston Container Terminal in Jamaica.

THIS PAGE: Valdo (David Dencik) and the DNA targeted toxin Heracles are taken from a top secret MI6 research laboratory in London by Safin's men.

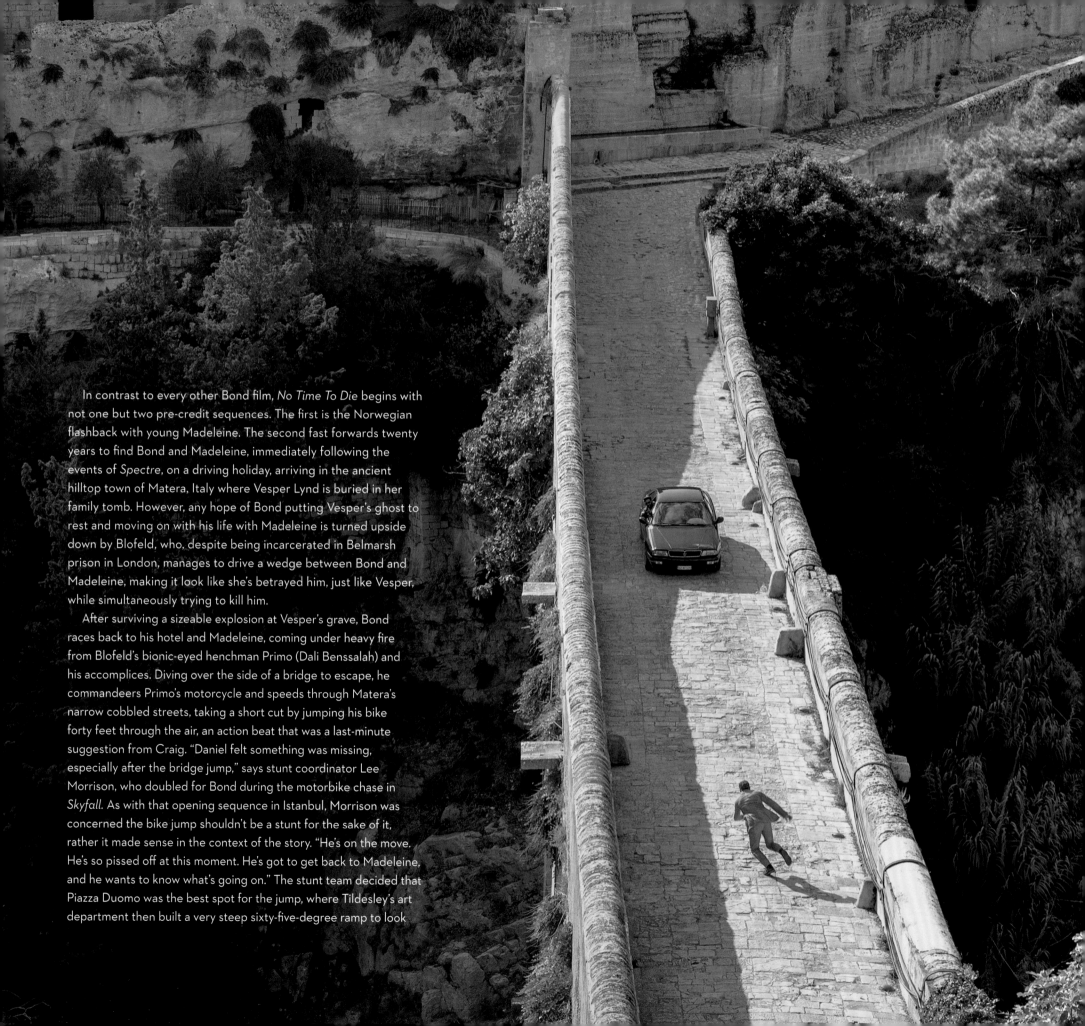

In contrast to every other Bond film, *No Time To Die* begins with not one but two pre-credit sequences. The first is the Norwegian flashback with young Madeleine. The second fast forwards twenty years to find Bond and Madeleine, immediately following the events of *Spectre*, on a driving holiday, arriving in the ancient hilltop town of Matera, Italy where Vesper Lynd is buried in her family tomb. However, any hope of Bond putting Vesper's ghost to rest and moving on with his life with Madeleine is turned upside down by Blofeld, who, despite being incarcerated in Belmarsh prison in London, manages to drive a wedge between Bond and Madeleine, making it look like she's betrayed him, just like Vesper, while simultaneously trying to kill him.

After surviving a sizeable explosion at Vesper's grave, Bond races back to his hotel and Madeleine, coming under heavy fire from Blofeld's bionic-eyed henchman Primo (Dali Benssalah) and his accomplices. Diving over the side of a bridge to escape, he commandeers Primo's motorcycle and speeds through Matera's narrow cobbled streets, taking a short cut by jumping his bike forty feet through the air, an action beat that was a last-minute suggestion from Craig. "Daniel felt something was missing, especially after the bridge jump," says stunt coordinator Lee Morrison, who doubled for Bond during the motorbike chase in *Skyfall*. As with that opening sequence in Istanbul, Morrison was concerned the bike jump shouldn't be a stunt for the sake of it, rather it made sense in the context of the story. "He's on the move. He's so pissed off at this moment. He's got to get back to Madeleine, and he wants to know what's going on." The stunt team decided that Piazza Duomo was the best spot for the jump, where Tildesley's art department then built a very steep sixty-five-degree ramp to look

BELOW & NEXT SPREAD: SPECTRE
henchmen pursue Bond and
Madeleine in the Aston Martin DB5
through the streets of Matera.

as if it was part of a wall. Stunt rider Paul Edmondson stood in for
Craig. "Standing at the bottom of the ramp, we both knew he had
to go for it. Full commitment," recalls Morrison. "To see him go over
the first time was a massive relief. Rehearsals went amazingly well.
Then we struck the scaffolding safety platforms I'd put in in case the
wind caught the motorcycle, because when you're jumping a ramp
that steep, you're not going forward, you're going up, so the wind
can catch you like a sail. The day we shot it, the wind was blowing
the wrong way, so we had to wait to time it between the gusts to
make sure the bike didn't get caught. We did it four times, then it
started raining, but we managed to get the shot."

Bond eventually makes it back to his hotel room to find
Madeleine has packed her bags, a simple act that further
compounds his feelings of betrayal and paranoia, despite her
protestations of innocence. He drags her outside, into his iconic
Aston Martin DB5, and then peels out with Primo and his thugs in
hot pursuit in cars and on bikes. "Matera has only ever been used
for period films. No one's ever shot a modern-day film there," says
Morrison, "so when Cary signed off on the city, we had to go about
breaking it down and work out how we were going to achieve a
high-speed car chase with motorcycles and with all the different
levels within the city."

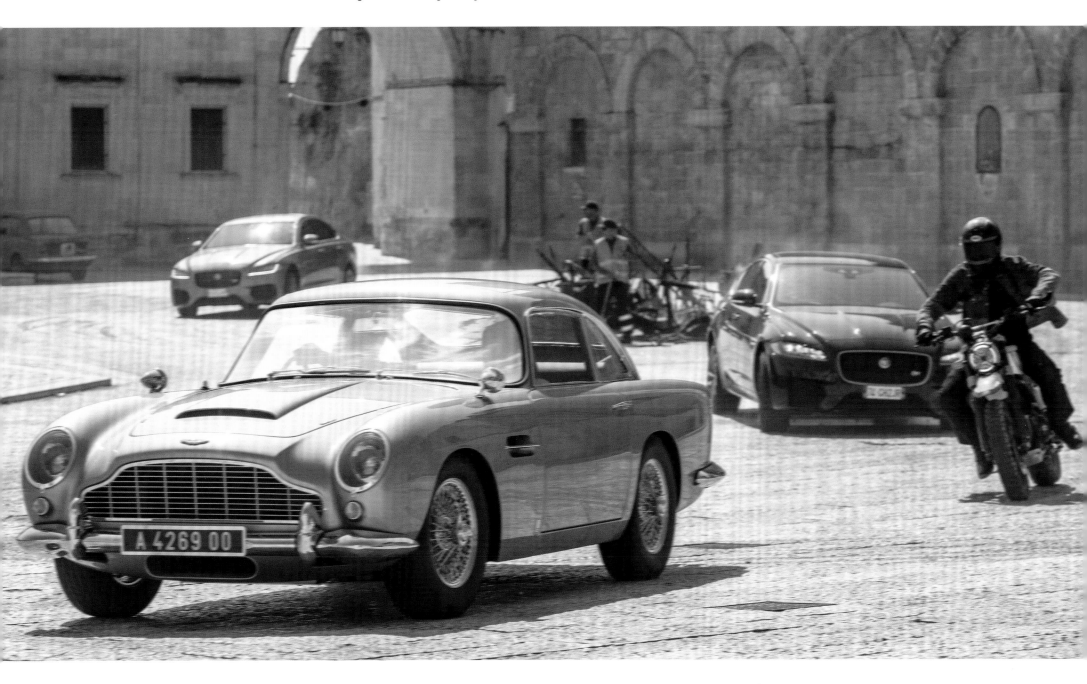

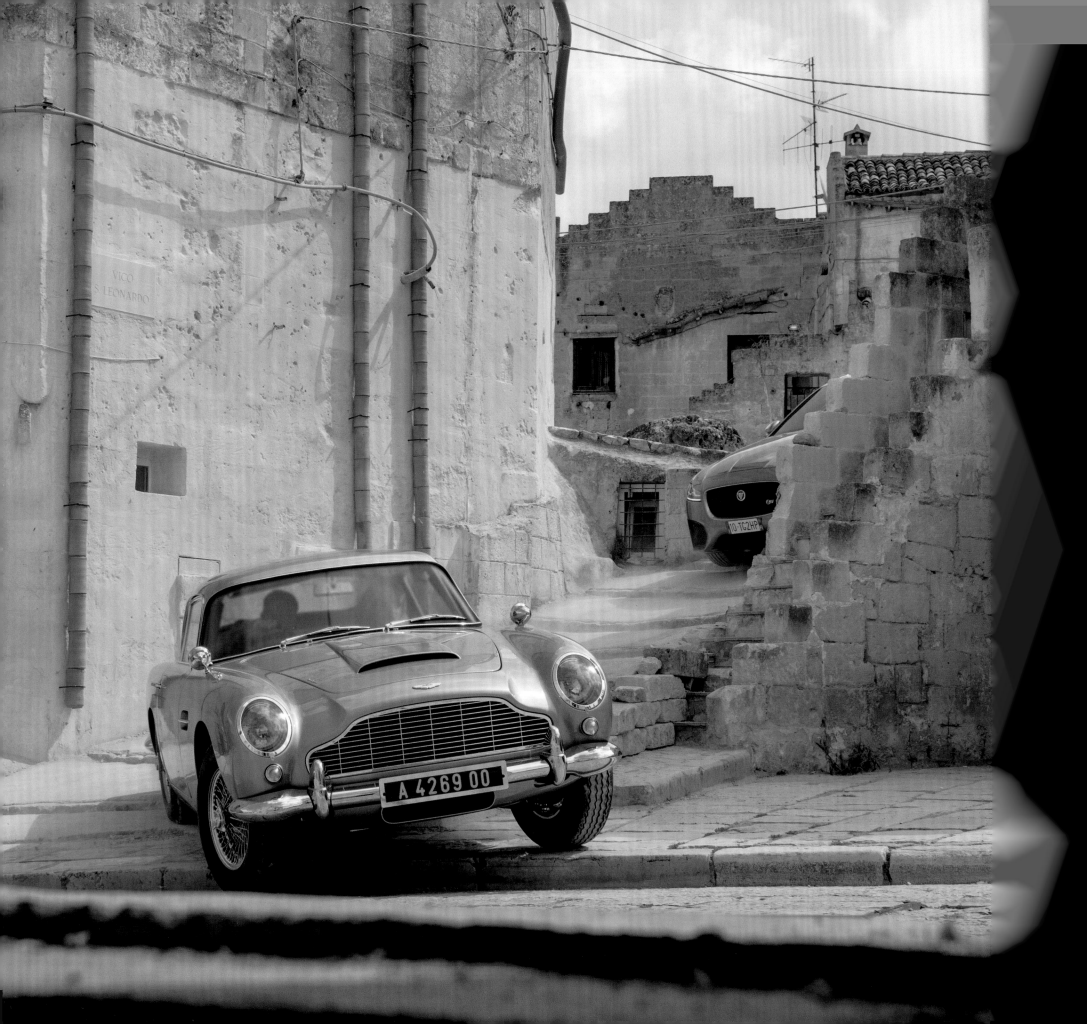

"Cary wanted it to be gritty, but he didn't want it to be over the top," reveals special effects and action vehicle supervisor Chris Corbould. "At one stage we were looking at going up steps, down steps, through narrow alleyways, finding the right combination of streets to do it in. Originally, we had a big exit from Matera where the DB5 crashed through a wall, went onto the rooftops, then crashed through a roof and went through rooms and then out the other end and onto the road. But we scaled it down to be a little bit less of a spectacle and more of a nuts-and-bolts driving scene."

The chase was filmed over several weeks by both Fukunaga's main unit and second unit director Alexander Witt and required a total of ten DB5s: two 1964 originals, referred to as "hero cars", six carbon-fibre stunt replicas and two fitted with driving pods. "To get shots with Daniel driving really, really fast, it would be too dangerous with Daniel driving and Léa inside. So we mount a pod on the roof and shoot in through the side windows, through the front window, and it will look like Daniel's driving," says Corbould. "But on top of the car is Pascal Lavanchy, who, with Daniel in the car, can donut it, handbrake turn it, scream along at eighty miles an hour." Another two DB5s were "kitted out with all the gadgets," according to Corbould. "The gadgets were based on the original *Goldfinger* car, but were upgraded. The original had Browning-type guns that came out the side lights. We upgraded those to mini guns coming out the headlights. We also had the traditional smoke screen, which was another throwback, and dropped little bomblets out the back, which disposed of a couple of the baddies' cars."

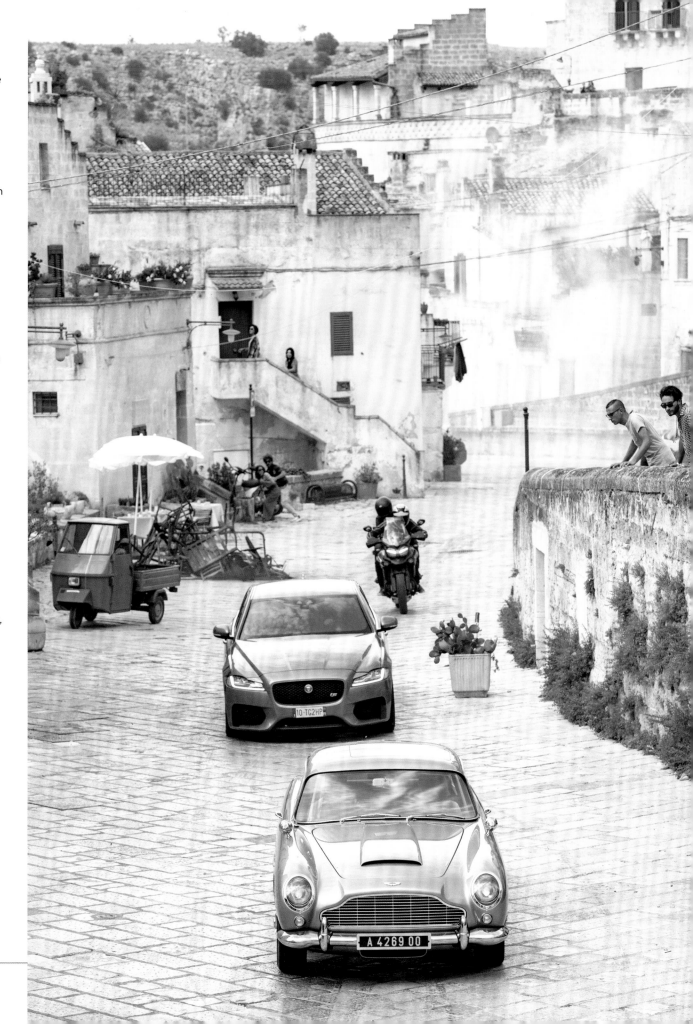

The Matera chase climaxes in Piazza San Giovanni Battista, where the DB5 is T-boned by Primo's classic Range Rover, bringing it to an abrupt stop. As Primo and his men surround the Aston Martin and open fire, bullets pinging off the windscreen, side windows and bodywork, Bond calmly engages the headlight guns, puts the car into a tyre-screeching spin, spraying bullets 360 degrees, before hitting the smoke and filling the plaza in order to get away. The crew dubbed the sequence "donut square" on account of the DB5 donuting around. "Daniel did that for real," notes Corbould. "Daniel lit the DB5 up and was drifting around in a really confined space. He loved it."

For Craig, who had driven the DB5 briefly in both *Skyfall* and *Spectre*, the chance to use the vehicle's full range of gadgets, just as Connery had, was, quite literally, a childhood dream come true. "I didn't have one of those Corgi toys as a kid," he says, in reference to the die-cast model of the *Goldfinger* DB5 that was popular in the sixties and seventies. "Friends of mine did, though, with the little guy that ejected out the top, and I coveted it so much. It was literally the most thrilling toy I'd ever seen, and now I get to drive the real thing. We discussed where the buttons go and I got to donut it in that square. I got to do all the things that were a child's fantasy, really. It was a fabulous, fabulous experience."

BELOW & RIGHT: The Matera chase climaxes with Bond driving the Aston Martin DB5 in a "donut" in Piazza San Giovanni Battista.

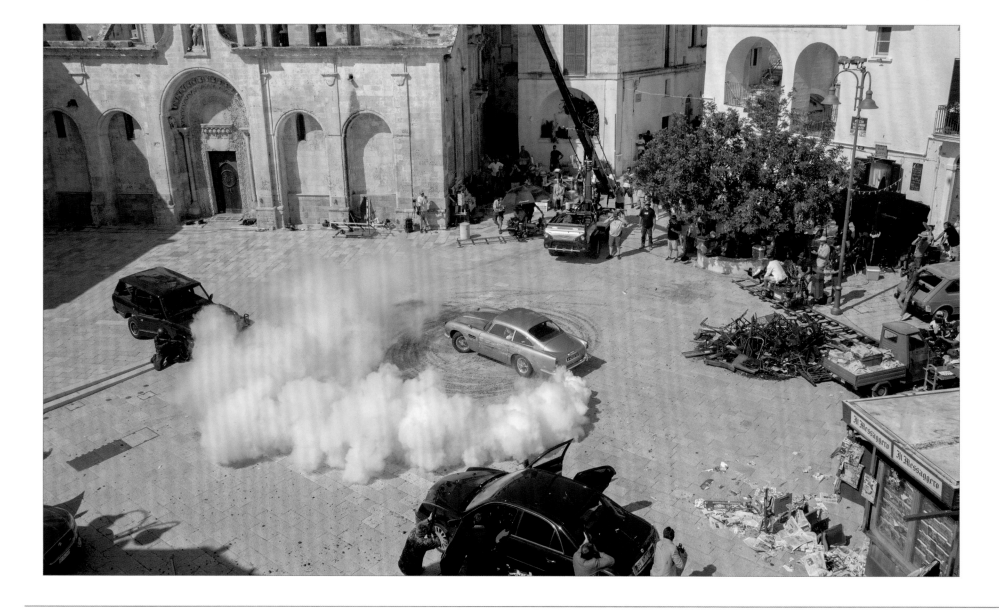

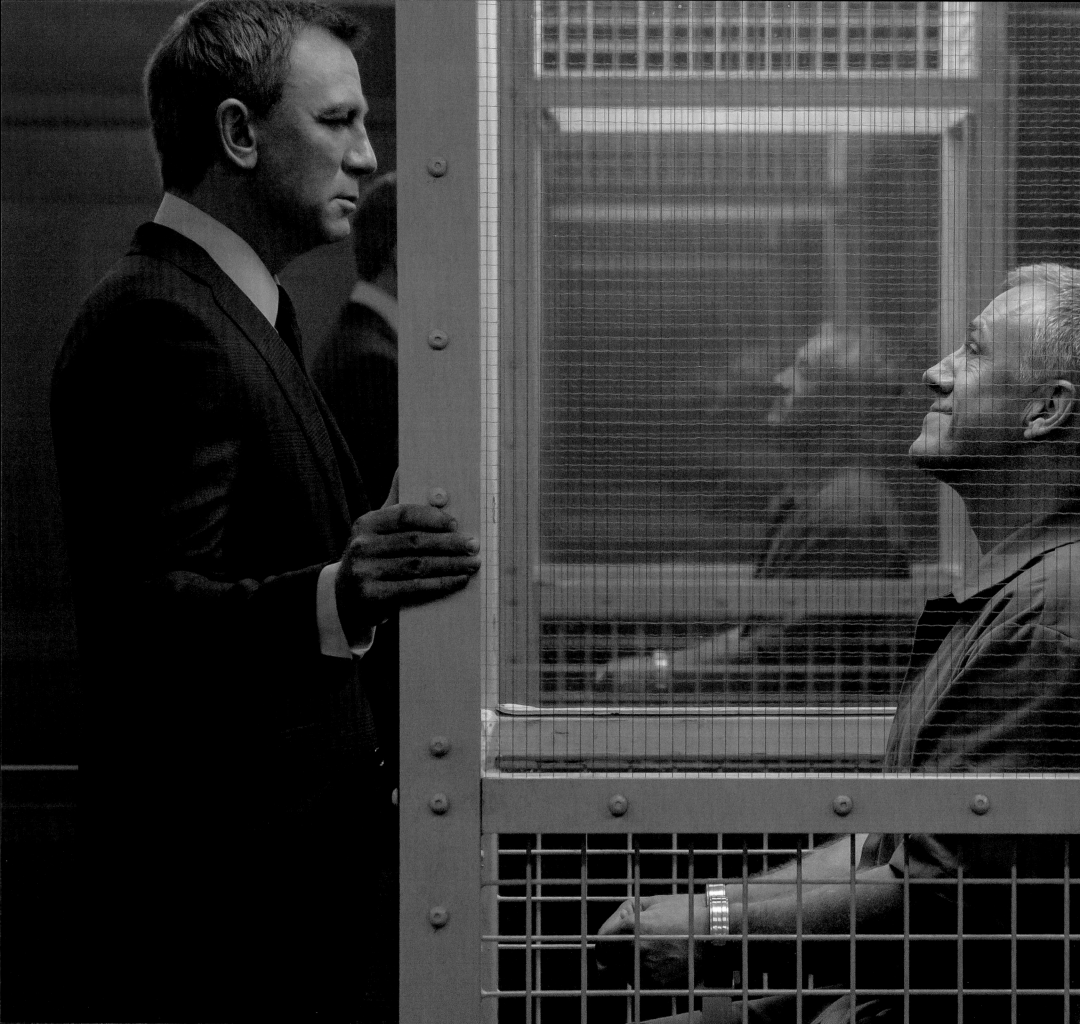

In a film full of bold gambits, one of the boldest is bringing back Blofeld and SPECTRE, only to wipe them out, courtesy of Safin's DNA-targeted poison. "I remember us talking about what would be the most satisfying way to end this run," says Fukunaga. "Here's a lifetime villain and here is this organisation that's been putting the pieces together since *Casino Royale*. Wouldn't it be satisfying if, in Daniel's last film, he defeats them?"

Before that, Bond and Blofeld (Christoph Waltz) meet face to face at Belmarsh, where the latter has been incarcerated for the past five years. "Daniel had a lot of ideas about the Blofeld scene," says Fukunaga. "I think there was something he wanted to say to Blofeld, things that didn't quite come out in *Spectre*. Phoebe and I went through it and edited it, but the bones of it are what Daniel wanted to say. He has good instincts for story. He definitely understands the character. He understands what's worked and hasn't worked in the past."

"We struggled with that scene," recalls Craig. "I wanted it to get very personal very quickly and I wanted them to talk to each other like brothers. I had a rush of inspiration and sat up one night and – pretty badly – wrote an outline and gave it to Phoebe. I think I've got pretty good ideas. My writing is not good, it's okay, but on *No Time To Die* I could write things down, then sit with Phoebe and she improved it no end."

"First of all, Daniel's 'not very good' versions are really good versions, so he's being very modest," insists Waller-Bridge. "He's really good at knowing what a scene needs. With that, it had to be the hero and nemesis meeting, and it had to feel like this huge epic moment."

LEFT: Bond confronts Blofeld (Christoph Waltz) in the interrogation room at London's Belmarsh prison.

BELOW: Waltz and Fukunaga on the Belmarsh prison set.

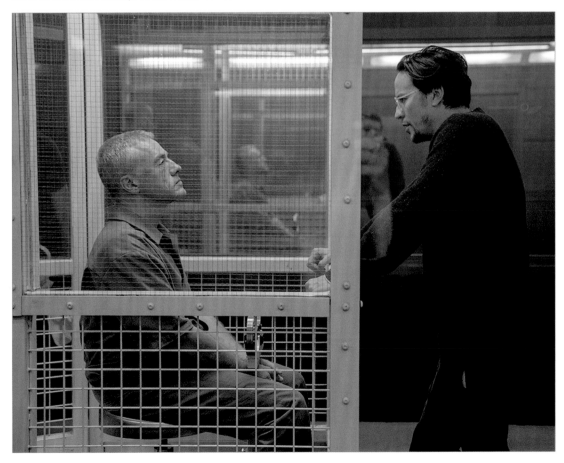

Indeed, throughout filming Craig would often ask, "Are we missing a trick?" determined to make the most of each and every scene. A case in point was the SPECTRE party in Cuba, where it seems that Bond has finally met his match, before the tables are turned and the entire criminal organisation is wiped out. Craig felt that the sequence "was missing a Bond moment" and had the idea of throwing a tray to knock down the villainous Valdo (David Dencik) as he's trying to escape. "I'm always looking for moments like that," says Craig. "Sometimes they happen, sometimes they don't. The waiters were carrying these very heavy stainless steel trays and I said, 'That would take someone down, wouldn't it?' And they were like, 'Yep!' So

we mocked one up and I said, 'Stick a martini on it, for God's sake.' So we stuck a martini on, I throw the tray and try not to spill the drink. I never know if those things are going to make the cut or not."

The SPECTRE party was designed to "bring some of the old-school Bond glamour to an otherwise gritty and isolating story, and put Bond in a tuxedo, the only time in this film," says Fukunaga. "I wanted to do something that felt bizarre and kind of out there. We've had a lot of story up to this point, but this is the first time we see Bond really being Bond again, and we've been waiting for it. So I wanted to create something fabulous. I wanted a spectacular end to SPECTRE, as well."

THIS SPREAD: Filming the SPECTRE party on the Cuba set.

Following Blofeld's death, Bond travels to Norway and Madeleine's childhood home, where he finds not just her, but their daughter, too. A daughter he didn't know he had. When it came to write the scenes between Bond and Mathilde, "It was very important they weren't sentimental and it wasn't a cute little twist, but it was complex and it wasn't easy for him to communicate with her," says Waller-Bridge. Father and daughter barely have time to become acquainted before Bond, fearing for their lives, bundles them into Madeleine's Land Cruiser and takes off. Pretty soon, Safin's men are hunting them down, like a pack, in Land Rover Defenders and on Triumph motorbikes.

Shot in Norway, Scotland and England, the off-road chase was designed by Morrison, who says he was "mindful about not having Bond jumping over gorges or doing things that were going to put the child in jeopardy. It was a father's instinct to protect his child throughout. He's met his daughter for the first time and it's a huge moment for Bond, for Bond fans, to see him with a child, then having to take that child in the car and try and get to safety. That, for me, was a huge challenge, because I didn't want to just do another Bond car chase, especially when he's carrying the most precious cargo he's ever had. He's not saving the world from something, he's trying to save his child. That whole chase was really, really special."

BELOW: Madeleine and Mathilde at Madeleine's childhood home in Norway.

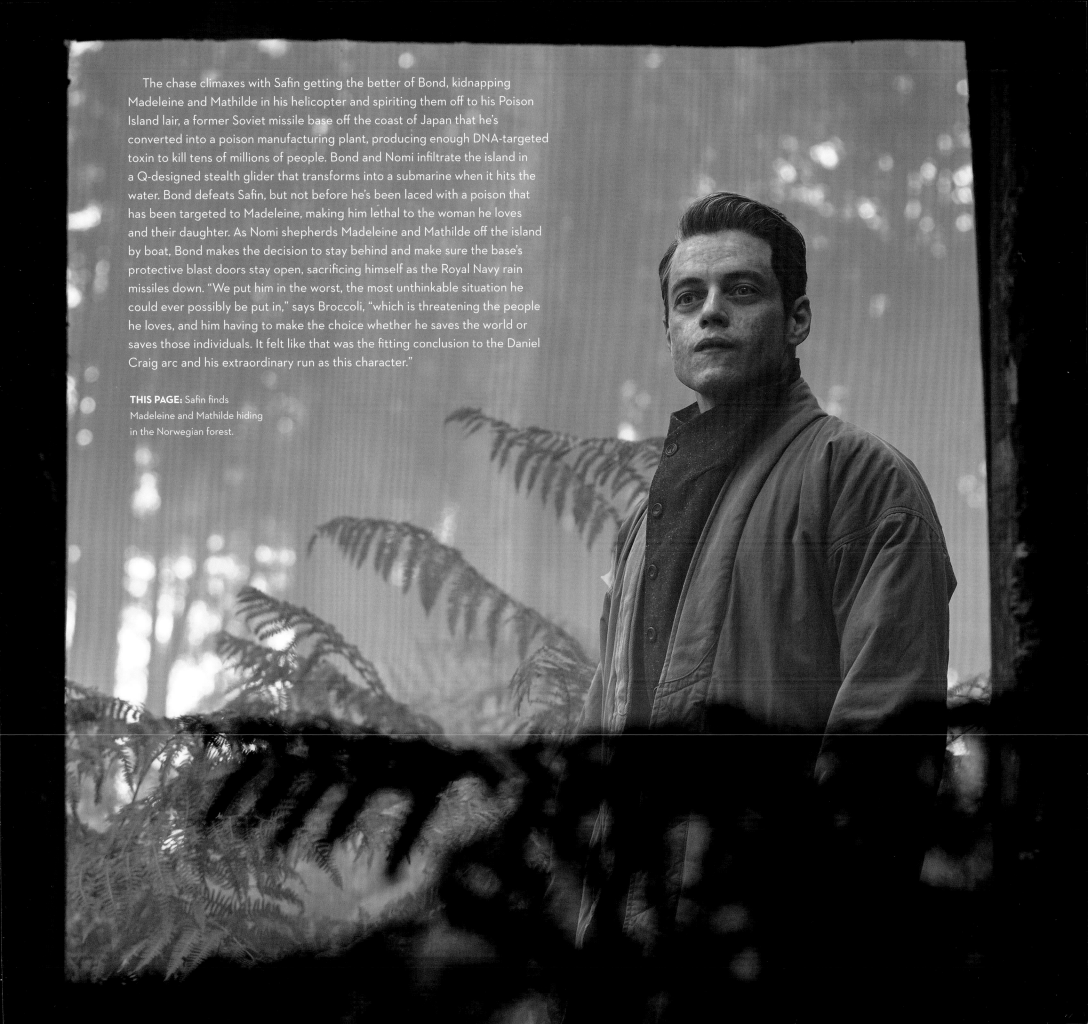

The chase climaxes with Safin getting the better of Bond, kidnapping Madeleine and Mathilde in his helicopter and spiriting them off to his Poison Island lair, a former Soviet missile base off the coast of Japan that he's converted into a poison manufacturing plant, producing enough DNA-targeted toxin to kill tens of millions of people. Bond and Nomi infiltrate the island in a Q-designed stealth glider that transforms into a submarine when it hits the water. Bond defeats Safin, but not before he's been laced with a poison that has been targeted to Madeleine, making him lethal to the woman he loves and their daughter. As Nomi shepherds Madeleine and Mathilde off the island by boat, Bond makes the decision to stay behind and make sure the base's protective blast doors stay open, sacrificing himself as the Royal Navy rain missiles down. "We put him in the worst, the most unthinkable situation he could ever possibly be put in," says Broccoli, "which is threatening the people he loves, and him having to make the choice whether he saves the world or saves those individuals. It felt like that was the fitting conclusion to the Daniel Craig arc and his extraordinary run as this character."

THIS PAGE: Safin finds Madeleine and Mathilde hiding in the Norwegian forest.

The explosion that results in Bond's demise was the work of special effects supervisor Corbould and was shot at the Ministry of Defence's Salisbury Plain Training Area before being digitally composited into the final film. "We had to do three explosions in the one shot, which represented the three underground caverns all blowing up," says Corbould. "The first explosion was 230 meters from the camera, the second 130 meters, and the last 30 meters from camera, and each one contained 40 kilograms of high explosive and around 30 to 40 gallons of fuel. We were trying to replicate the look of a bunker-buster bomb being pinpoint targeted into the blast doors of each individual cavern in Safin's lair. We were, essentially, killing Bond. Having done all of Daniel's films, it was a particularly poignant moment for me, so I wanted to make sure he got sent off in a great way. We went all out with these explosions to make them look dynamic, spectacular and fit for a good end and another world record."

No Time To Die was originally scheduled to premiere at the Royal Albert Hall on March 31, 2020, but its release had to be postponed due to the COVID 19 pandemic. The film finally premiered in London on September 28, 2021 to largely stellar reviews — "Craig bows out in terrific, soulful style," raved *The Times* — a fitting swansong to Craig's tenure, a record-breaking run that

BELOW: Bill Tanner (Rory Kinnear), Eve Moneypenny (Naomie Harris) and M wait for news of Bond and Nomi's mission to Poison Island.

RIGHT: Bond hiding in the shadows on Poison Island.

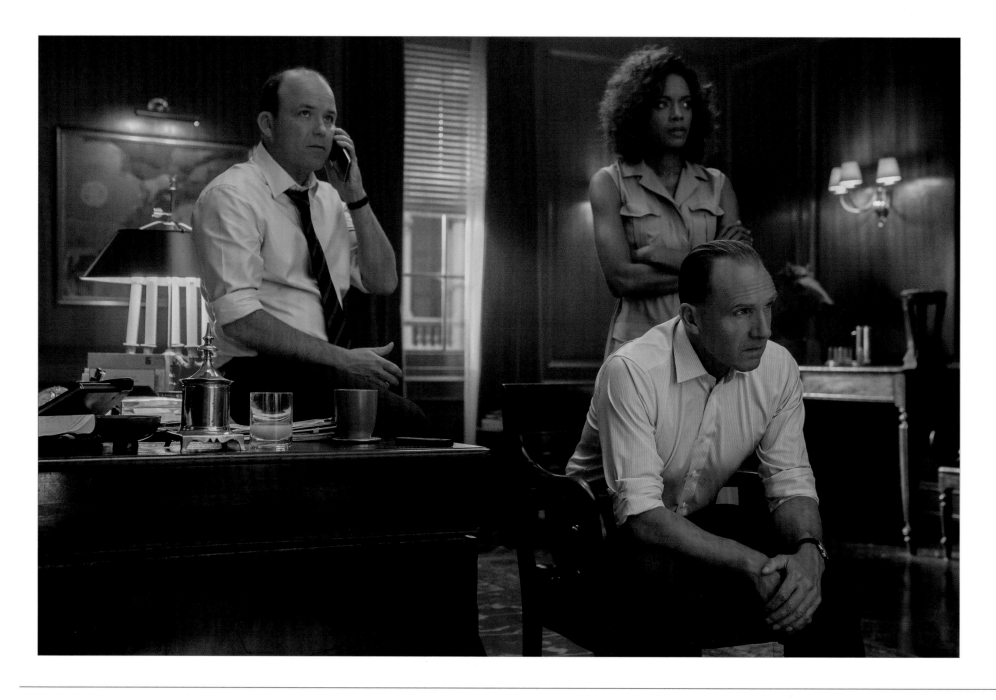

saw him surpass Roger Moore as the longest-serving Bond.

"What Daniel brought to Bond was a new generational style of acting, bringing in a different take on toxic masculinity," says Fukunaga. "Daniel is a very sensitive person. He brought a complexity to the role. His version was fresh and surprising."

"What Daniel has done with the franchise and with James Bond is humanise him and make him much more relatable," says Naomie Harris, who starred opposite Craig in three Bond films. "He's given him a heart and an ability for that heart to be touched. That is a wonderful thing to watch, because you don't think of him as invincible. You think, *Here is a damaged human being who's been through a lot in his childhood and it made him close down, but there are occasions where he meets people who touch him deeply enough that he feels safe enough to open up and reveal parts of himself and to connect.* That makes him a much more interesting, much more layered, much more empathetic character. I think the audience can recognise a lot of themselves in that, too, because, in some respects, we're all hiding, we're all a bit scared of love. That's a beautiful transition from the Bonds of old."

"Daniel created a character who's more vulnerable and more touching," says Seydoux. "His Bond is very human. He's an imperfect human being and that's why we are so moved by him. You see all the layers."

"Daniel is the ultimate professional," says Broccoli. "He's a very dedicated actor. So it was really distressing when we shot the last sequence. We were on the Cuba streets at Pinewood, and it's the moment when he runs down the road with Valdo, and it just turned out that that was his last shot and it was appropriate, because he's leaving the character behind, running down a street towards an unknown destiny. I don't think there was a dry eye in the crew!"

Adds Wilson, "Daniel has been a part of this franchise since 2005, and we have all been through so much together, and saying goodbye to him was really extremely emotional, everyone was feeling it. It was very, very palpable. It felt like a significant moment in cinema history."

"I'm massively proud of my time on Bond and I'm massively proud of it because of the crews I've worked with," concludes Craig. "That's the thing at the end of *No Time To Die* that was most emotional for me, saying goodbye to the people I've worked with over the years and [appreciating] the effort they all put into making a Bond movie. It's mammoth. It's bigger than any other movie, and that's saying something, because there are some big movies out there, but it really is. It shoots longer. It's always location work. It's massive sets. The crew who work on a Bond movie do it for love as well. They do it because they're fans. I'm a fan. The crews are fans. We're all fans of James Bond movies."

ACKNOWLEDGEMENTS

This book's journey began with a conversation with Stephanie Wenborn, Eon's head of publicity and marketing, in early 2018, but its roots go back many, many years earlier to birthday trips to the cinema with my late dad to see double bills of Sean Connery's Bond and later when he bought me my first Corgi DB5 (although I wish I'd kept the box). Thank you, Stephanie, for immediately getting the idea and being an advocate of the project.

In addition, I am deeply indebted to the long list of people who took the time to speak to me, chief among them Daniel Craig, Michael G. Wilson, Barbara Broccoli, Martin Campbell, Marc Forster, Sam Mendes, Cary Fukunaga, Neal Purvis, Robert Wade, Paul Haggis, John Logan, Phoebe Waller-Bridge, Jez Butterworth, Chris Corbould, Judi Dench, Gregg Wilson, Naomie Harris, Léa Seydoux, Debbie McWilliams, Dennis Gassner, Callum McDoughall, Gary Powell, Lee Morrison, Alexander Witt, Lindy Hemming, Jany Temime, Daniel Kleinman. I am hugely grateful to Claudia Kalindjian, Suzy Littlejohn, Debi Berry, Rosie Moutrie, India Flint, Zara Beyaz, Freddie House and Laura Symons for smoothing the wheels and helping sort interviews.

Thanks, too, to my editor Jo Boylett, and the other folk at Titan – Laura Price, Simon Ward, and this book's designer, Tim Scrivens – for your dedication, patience and hard work.

To my lovely wife Laura, son Milo, and mum, for their endless patience, support, understanding and love. Without whom...

And finally, a huge thank you to Julian Simpson, for your friendship and for being a mensch.

TITAN BOOKS would like to thank everyone who contributed their valuable time, for interviews, and material to this book. Thanks also to the team at Eon Productions for making this book possible and for their time and dedication to bringing it to fruition.

BEING BOND

ISBN: 9781789094404

Published by
Titan Books
A division of Titan Publishing Group Ltd
144 Southwark St
London
SE1 0UP

www.titanbooks.com

First edition: October 2022
10 9 8 7 6 5 4 3 2 1

A CIP catalogue record for this title is available from the British Library.

Printed and bound in China.

Did you enjoy this book? We love to hear from our readers.
Please e-mail us at: readerfeedback@titanemail.com or write to
Reader Feedback at the above address.

To receive advance information, news, competitions, and exclusive offers online, please sign up for the Titan newsletter on our website: www.titanbooks.com

Photographers

Christopher Raphael	Jasin Bolland	Nicola Dove
Ed Miller	Jay Maidment	Susie Allnut
François Duhamel	Jonathan Olley	
Greg Williams	Karen Ballard	